CHRISTIANITY, ART AND TRANSFORMATION

Theological aesthetics in the struggle for justice

Christianity, Art and Transformation explores the historical and contemporary relationship between the arts and Christianity with reference to the transformation of society. Several major themes are discussed, among them the power of images, the relationship between aesthetics and ethics, the nature of beauty and its redemptive capacity, aesthetic existence and Christian discipleship, and the role of art in the public square and in the life of the church. The book is a contribution to the study of theological aesthetics today from both an ecumenical and a Reformed perspective, global in its scope yet rooted in the author's South African context.

JOHN W. DE GRUCHY is Robert Selby Taylor Professor of Christian Studies and Director of the Graduate School in Humanities at the University of Cape Town. His published works include *The Church Struggle in South Africa* (1979), *Liberating Reformed Theology* (1991), *Christianity and Democracy* (1995) and *The Cambridge Companion to Dietrich Bonhoeffer* (1999). In August 2000, de Gruchy was awarded the Karl Barth Prize by the Evangelische Kirche der Union in Germany.

CHRISTIANITY, ART AND TRANSFORMATION

Theological aesthetics in the struggle for justice

JOHN W. DE GRUCHY

University of Cape Town

CAMBRIDGE
UNIVERSITY PRESS

PUBLISHED BY THE PRESS SYNDICATE OF THE UNIVERSITY OF CAMBRIDGE
The Pitt Building, Trumpington Street, Cambridge, United Kingdom

CAMBRIDGE UNIVERSITY PRESS
The Edinburgh Building, Cambridge CB2 2RU, UK www.cup.cam.ac.uk
40 West 20th Street, New York, NY 10011–4211, USA www.cup.org
10 Stamford Road, Oakleigh, Melbourne 3166, Australia
Ruiz de Alarcón 13, 28014 Madrid, Spain

First published 2001

Printed in the United Kingdom at the University Press, Cambridge

Typeface 11/12.5 pt Baskerville *System* 3b2 [CE]

A catalogue record for this book is available from the British Library

Library of Congress Cataloguing in Publication data
De Gruchy, John W.
Christianity, art and transformation / John W. De Gruchy.
p. cm.
Includes bibliographical references and index.
ISBN 0 521 77205 2
1. Christianity and art.
2. Art and society. I. Title.
BR115.A8 D44 2001
246–dc21 00–031288

ISBN 0 521 77205 2 hardback

To Isobel
in celebration of forty years

Contents

vii

Plates

Preface

Work on *Christianity, Art and Transformation* began in earnest during my research leave spent at the Universities of Cambridge and Durham in England from January to June 1998. At Cambridge I was honoured to be a Fellow of the Centre for the Advanced Study of Religion and Theology in the Faculty of Divinity, a Visiting Bye Fellow at Selwyn College and a recipient of a Chesthunt Trust Sabbatical Scholarship at Westminster College. At Durham I was equally honoured to be the Richardson Fellow in the Department of Theology and a Visiting Fellow at Van Mildert College. My thanks are due to the University of Cape Town for granting me research leave, to my colleagues in the Department of Religious Studies who assumed extra duties and to those at Cambridge and Durham who ensured that my sabbatical was an enriching experience. I am particularly grateful to Professor David Ford and Dr Jeremy Begbie at Cambridge, to Professors David Brown and Ann Loades at Durham, to our gracious hosts Martin and Pamela Cressey in Cambridge and Judy Turner, Principal of Van Mildert College, in Durham.

Many friends, students and colleagues have contributed to the writing of this volume. First of all, I wish to express my gratitude to the students in my graduate seminar on 'Christianity, Art and Transformation' in 1997 and 1999, and especially to my teaching assistants Gillian Walters and Robert Steiner. Robert has also been of great help in the development of the research project on the same theme which is located in the Research Institute on Christianity in South Africa (RICSA) at the University of Cape Town. Several colleagues at the University have taken considerable care in reading and commenting on various drafts of the typescript. In particular I would like to mention Paul Taylor, Peggy Delport, Pippa Skotnes, Sandra Klopper, Derek Japha and Julian Cooke, who was also

instrumental in stimulating the original idea. Thanks also to Geoff Grundlingh for providing the necessary photographic expertise for reproducing the illustrations and the jacket photograph. A colleague from further afield, William Everett, Professor of Christian Social Ethics at Andover Newton Seminary in Boston, has likewise provided warm encouragement and critically constructive comment. Lyn Holness, my personal assistant, has been exceptional in her support and provided much helpful critical comment. My thanks are also due to Kevin Taylor, the religious studies editor at Cambridge University Press, for his confidence and professional support.

Christianity, Art and Transformation is dedicated to my wife, Isobel, who has also helpfully commented on the text and, above all, has shared in the journey which has led to its completion. As I am writing this on the thirty-ninth anniversary of our wedding, but knowing that in all likelihood publication of the book will be nearer our fortieth celebration, I offer it to her in part as an anniversary present.

<div style="text-align: right">JOHN DE GRUCHY</div>

Introduction

The writing of *Christianity, Art and Transformation* has been a personal journey. Those familiar with my other writings may be surprised by it, for I have not previously indicated any serious interest in Christianity and art, or in aesthetics.[1] Yet there are continuities with what I have done before, and I regard this project as part of a broader post-apartheid process of doing theology in a new key.[2] It was a confirmatory surprise to discover that a similar development was evident in Latin American Christianity, bringing together a concern for justice and the recovery of the aesthetic in the life of the church.[3]

My journey began in earnest through conversations with my friend Julian Cooke, a professor of architecture at the University of Cape Town. Julian made me aware that apartheid was not only unjust but also ugly, and that this was reflected in the architectural landscape of our country. It all seems so obvious now, but it was a flash of insight when this first dawned on me. Exploring the connection between ugliness and oppression, and between beauty and redemption, made me aware that there is a deep underlying relationship between theological conviction, aesthetics and ethics. The gestation of the book had begun. In the course of my subse-

[1] In my little book *Cry Justice!* I did, however, make use of poetry, several lithographs by Patrick Holo, an African artist then attached to the Nyanga Art Centre, and indigenous South African musical scores in developing a spirituality for justice. John W. de Gruchy, *Cry Justice! Prayers, Meditations and Readings from South African Christians in a Time of Crisis* (London; New York: Collins; Orbis, 1986).

[2] See especially Barney Pityana, 'Beyond Transition,' dissertation, University of Cape Town, 1995; James R. Cochrane, *Circles of Dignity: Community Wisdom and Theological Reflection* (Minneapolis: Fortress Press, 1999); Robin Petersen, *Time, Resistance, and Reconciliation* (New York: Orbis, 1999).

[3] Alejandro García-Rivera, *The Community of the Beautiful: A Theological Aesthetics* (Collegeville, Minn.: The Liturgical Press, 1999). Rivera's book is not, however, primarily concerned about the arts as such.

quent journey I came to believe more firmly in the transformative potential of the arts and their importance for Christian faith and praxis. So the book became a celebration of art and a statement of faith.

For some reason the connection between aesthetics and social ethics, between beauty and social transformation, was not apparent to those of us who were engaged as theologians in the struggle against apartheid. We were concerned about truth and goodness rather than beauty; about theology and social ethics rather than aesthetics. This does not mean that there was no interest in the arts or an absence of the aesthetic in the life of the church. How could that possibly be given the drama of its liturgies, the architecture of its sanctuaries and the role of music and symbol in its worship? But there was a lack of critical theological reflection on such issues. This requires urgent attention if we are serious about doing theology in post-apartheid South Africa, or anywhere else for that matter.

The more I explored the themes in this book, the more I became aware of the complexity of the issues. This may not surprise those who are familiar with the history of art or the development of aesthetic theory. Such people may smile wryly at the audacity of a theologian who ventures into such fields of enquiry. What, after all, is art, how does it relate to aesthetics, and in what if any sense does it have moral significance? Theodor Adorno put the problem succinctly: 'Everything about art has become problematic: its inner life, its relation to society, even its right to exist.'[4] But if this is true of art, the same could be said of Christianity. 'Transformation' is an equally contested notion, not least in post-apartheid South Africa. So the reader of *Christianity, Art and Transformation* deserves at least a brief introductory explanation of these key terms. Let me begin with 'transformation'.

'Transformation', a word in danger of losing significance through over use and abuse, is, nonetheless, the term used to describe the kind of society we are trying to achieve in post-apartheid South Africa. While its nature and goals are contested, it broadly means the creation of a just and equitable democratic society.[5] Given the legacy of South Africa's colonial and apartheid past, the sobering realities that face us, and the limited resources available, there is no

[4] Theodor W. Adorno, *Aesthetic Theory* (London: Routledge & Kegan Paul, 1984), 1.
[5] For a detailed discussion of these issues see John W. de Gruchy, *Christianity and Democracy: A Theology for a Just World Order* (Cambridge: Cambridge University Press, 1995).

easy road to transformation. But there is no viable alternative other than seeking to achieve those fundamental changes that a stable future and the sustaining and enhancing of life demand. 'Transformation' as I use the term is an open-ended, multi-layered process, at once social and personal, that is energised by hope yet rooted in the struggles of the present.

In many languages no distinction is made between art in the sense of doing something skilfully and 'works of art' referring, for example, to a painting or sculpture. However, when we speak of 'the arts' in English we usually mean 'fine arts', that is 'works of art' which meet certain aesthetic criteria and in doing so can be distinguished from craft and 'popular art'. But the boundaries between 'fine' and 'popular art', or between 'art' and 'craft', are fluid. At best they are theoretical and functional, enabling us to recognise how works of art relate to social forces as well as cultural norms and values.[6] Art, after all, is subject to historical developments and as such it is constantly changing in character.

An interest in art can be a way of escape from reality, as, I believe, the aesthetic movement ('aestheticism') became in the nineteenth century. Yet to sideline art as an elitist pastime is short-sighted and potentially dangerous. This was recognised by many within the liberation movement, and it was strongly reaffirmed at the time of the transition to democratic governance in South Africa. In the government White Paper on arts and culture published in 1996, human creativity was recognised as a human right and support for 'the arts' as a necessary part of good democratic governance. In defining 'the arts' the White Paper indicated that these include but 'are not restricted to all forms and traditions of dance, drama, music, music theatre, visual arts, crafts, design, written and oral literature'.[7] This inclusive understanding of the arts is of fundamental importance, for the potential of art in the process of transformation resides in the arts as a whole, both in their complementarity and in their distinctiveness.

I have purposely concentrated, though not exclusively, on the 'visual arts'. The reasons for this will become evident as we proceed.

[6] See David Novitz, *The Boundaries of Art* (Philadelphia: Temple University Press, 1992), 20ff., 59f.
[7] The South African White Paper on 'Arts, Culture and Heritage', 1996; *The South African Handbook on Arts and Culture*, ed. Mike van Graan and Nicky du Plessis (Rondebosch, Cape Town: Article 27 Arts and Culture Consultants, 1998), 4, art. 12.

But a brief comment here may be in order. The visual arts, especially painting and sculpture, have been the most contested in the history of Christianity from its earliest days until the present. Yet it is precisely these arts, which have so powerfully stirred the human spirit and awoken the imagination for good and ill, and never so much as in the present day, that have been most neglected by theologians. There is, indeed, an urgent need for the visual arts to find their rightful place within the life and witness of the church. This is particularly so within Protestant churches, notably the Reformed, that have historically almost exclusively stressed the verbal arts and music. There are some notable and encouraging signs that this is changing. But there is much to be done and the need is ecumenical. It was a major twentieth-century Catholic theologian, Karl Rahner, who argued that 'theology cannot be complete until it appropriates' the non-verbal 'arts as an integral moment of itself and its own life, until the arts become an intrinsic moment of theology itself'.[8] To reduce theology to 'verbal theology', Rahner continued, unjustifiably limits 'the capacity of the arts to be used by God in his revelation'. Moreover, in so reducing theology we neglect a fundamental resource in relating Christianity to other religious traditions and to culture itself. Much of what I shall discuss would apply, of course, to the non-visual arts as well even if they are not mentioned very often, but to do them justice would require fuller treatment than is possible within this project.

Just as it is not possible to give equal consideration to all art forms, so it is impossible to do justice to Christianity in all its variety. My horizons are ecumenical though my roots are in the Reformed tradition,[9] something that will become evident in various parts of the text and in my references to John Calvin, P. T. Forsyth and Karl Barth. Part of my concern is the retrieval of the arts within this broad tradition.[10] But what I have said in this connection has wider ecumenical significance. In the same way, my particular focus on

[8] Karl Rahner, 'Theology and the Arts,' *Thought* 57, no. 224 (March 1982): 24.
[9] See John W. de Gruchy, *Liberating Reformed Theology: A South African Contribution to an Ecumenical Debate* (Grand Rapids; Cape Town: Eerdmans; David Philip, 1991).
[10] There has been a remarkable interest in the arts and aesthetics amongst Dutch and North American neo-Calvinists during the past century. See, for example, H. R. Rookmaker, *Modern Art and the Death of a Culture* (Leicester, UK: Intervarsity Fellowship, 1970); *Pledges of Jubilee: Essays on the Arts and Culture, in Honor of Calvin G. Seerveld*, ed. Lambert Zuidervaart and Henry Luttikhuizen (Grand Rapids: Eerdmans, 1995). For an indication of the growing interest in the broader Reformed family, see *Seeing Beyond the Word: Visual Arts and the Calvinist Tradition*, ed. Paul Corby Finney (Grand Rapids: Eerdmans, 1999).

South African Christianity has more than parochial relevance. Much of the initial research for this book was done in England, and I have discussed its themes with colleagues both there and elsewhere. The fact that the Christian tradition has been so profoundly shaped by its planting in Europe inevitably means that much of the initial discussion will be more Euro-centric than some might wish. But the context does change as we journey on. At any rate, the 'first-world' reader should not forget that Christianity is as much African as it is European, and is far more widespread and vibrant on the African continent today than it is in much of the West.

As this project has been a personal journey I have not hesitated to use the personal pronoun 'I' where appropriate. But I have also used the more inclusive 'we', not just through academic habit or literary convention but more as a means to include the reader in my explorations. Let me, then, provide a brief guide for our journey. The book is divided into three parts, each of which has two chapters. Part I is entitled 'Historical trajectories'; Part II 'Theological reflection'; and Part III 'Aesthetic praxis'. This structure reflects my conviction that Christian theology is critical reflection on historical experience in the light of Scripture and tradition; that it engages in such reflection in dialogue with other disciplines; and that it thereby informs our living and engagement in society.

In Part I, I first examine some of the major trajectories in Christian history on the relationship between 'Christianity and the arts' from the origins of the Christian movement, through the Iconoclastic Controversy, to the Protestant Reformation and Catholic response. The focus here is on the power of images. Images play a fundamental role in the shaping of cultural and religious identity, and in the construction, subverting and transforming of social reality. It is not surprising, then, that the production and control of images has been connected to struggles for ecclesial and political power. The sites of such struggles may well have changed in the modern world, but many of the issues remain. Political movements and advertising, for example, depend on the power of images, the one for the sake of selling policy and galvanising action for either the common good or self-interest, the other to establish the fashionable and the stylish in order to awaken desire and sell commodities. Our perception of the world is increasingly being redefined and reconstructed by the globalisation of media images. Those with the necessary skill and technology can exercise considerable control in

manipulating information and therefore in shaping values. The same is true in the world of entertainment, where art often provides a façade for real experiencing.[11] The globalisation of certain aesthetic values and commodities is therefore big business, and presents a challenge to those concerned about moral values and social transformation, not least theologians who take seriously their role as cultural critics.[12]

My attention shifts, in chapter 2, to the development of aesthetic theory within the post-Enlightenment European context in relation to Christianity. The word 'aesthetics' derives from the Greek αἴσθησις and literally means 'perception'. Aesthetics is about the way in which we see, hear and feel things through sense perception, primarily through the arts, and the way in which we evaluate and appreciate what we experience. The fact that my focus is on the post-Enlightenment European development of aesthetic theory is not meant to suggest that there was no aesthetic sense outside Europe, for that is clearly nonsense. But it is true that the debate about aesthetic theory, especially in relation to Christianity, was initially located in the West and only became an issue of discussion in post-colonial Africa.

In Part II I engage more specifically in theological reflection on aesthetics and the arts in dialogue with Hans Urs von Balthasar, Karl Barth and Dietrich Bonhoeffer. There are other theologians who have contributed to my enquiry who are neither male nor Teutonic. Feminist theologians, far more than others, have brought to the fore the sensual dimension of Christian theology, drawing fresh attention to the affective and physical, and reminding us of the centrality of the body.[13] The importance of this will be apparent, even if not by explicit reference to feminist theology, in my discussion of Bonhoeffer's aesthetics in chapter 4.

There are scholars who regard Balthasar's theological aesthetics as unhelpful in working out the relationship between Christianity and the arts because of his tendency to locate everything within a transcendental framework that inevitably dominates everything else.

[11] See the critique of avant-garde art in the 1980s in Donald Kuspit, *Signs of Psyche in Modern and Post-Modern Art* (Cambridge: Cambridge University Press, 1993), 273ff.

[12] I first became aware of theology as a form of cultural criticism in relation to the arts through attending Paul Tillich's seminars at the University of Chicago in the early 1960s. See, inter alia, Paul Tillich, *Theology of Culture* (New York: Oxford University Press, 1959).

[13] See, for example, Sally McFague, *The Body of God: An Ecological Theology* (Minneapolis: Fortress Press, 1993).

Others argue that Balthasar's theology has served reactionary causes within the Catholic Church, and for that reason is suspect as a whole.[14] These criticisms made me initially cautious. The reasons for choosing him as the senior partner in dialogue are, however, the theological profundity of his thought, his ecumenical concern, and the magisterial scope of his work. The significance of Barth lies partly in his role in renewing Reformed theology in the twentieth century, partly in his critical dialogue with Balthasar, his Swiss compatriot, but chiefly in the fact that a truly Christian aesthetics has to develop out of a trinitarian doctrine of God that relates directly to the transformation of the world.[15] Despite their patriarchal shortcomings, Balthasar and Barth together lay a solid foundation for doing Christian theological aesthetics even if we must go beyond them. Above all else, they inject into our discussion an understanding of aesthetics from the perspective of God's revelation in Jesus Christ that awakens faith, hope and love, and thereby transforms human existence. I should warn the unwary reader that the discussion in chapter 3 is, so some of my colleagues tell me, particularly demanding for those without a theological background. But I trust that those who plunge into it will soon recognise the importance of what has been attempted, and even discover that theology is as much about beauty as it is about truth and goodness because of the very nature of God.

Few twentieth-century theologians have been as influential as Bonhoeffer in enabling us to see the connections between faith and politics, spirituality and justice, and the renewal of the church within the life of the world. Despite my life-long interest in his theology, I had not, however, anticipated making much use of him in pursuing this project. Yet some cryptic comments in his *Letters and Papers from Prison* on 'aesthetic existence' and further hunches of my own spurred me on to examine his legacy in relation to my theme. I was overwhelmed by what I discovered, and it reshaped much of my thinking about aesthetics and the role of art in doing theology and in

[14] Hans Urs von Balthasar, *The von Balthasar Reader*, ed. Medard Kehl and Werner Loser (Edinburgh: T. & T. Clark, 1982), 4.

[15] In his important study of the neo-Calvinist approach to the arts, Jeremy Begbie rightly expresses the criticism that the neo-Calvinist doctrine of God is insufficiently shaped by a trinitarian understanding of God. Jeremy S. Begbie, *Voicing Creation's Praise: Towards a Theology of the Arts* (Edinburgh: T. &T. Clark, 1991), 158.

the life of the church. Hence, chapter 4 represents a key moment in my journey, one that I am particularly keen to share with others.

Part III is entitled 'Aesthetic praxis'. One of the most heated of all debates in aesthetics during the twentieth century has been on the social role of the arts. This is obviously a matter of some importance in considering the connection between the arts and transformation. In chapter 5, 'Art in the Public Square', I focus first of all on the social role of architecture, and then on the visual arts as an expression of political resistance and social healing. South Africa provides a rich milieu in which to pursue such an enquiry,[16] and theological reflection which is serious about public life must take cognisance of it. In chapter 6, which brings my study to a close, I examine the significance of the visual arts and architecture for the life, worship and witness of the church in the life of the world. In both these chapters I seek to draw together the main threads that have emerged throughout the book, relating them to issues of practical concern. But let it be said immediately that art should not and cannot be reduced to matters of 'practical concern'. Ultimately art has to do with the awakening of a sense of wonder, and it is in and through that awakening that aesthetic existence becomes possible and transformation begins to take place. That is what the journey is finally about.

[16] *Culture in Another South Africa*, ed. William Campschreur and Joost Divendal (London: Zed Books, 1989); Sue Williamson, *Resistance Art in South Africa* (Cape Town: David Philip, 1989); Sue Williamson and Ashraf Jamal, *Art in South Africa: The Future Present* (Cape Town: David Philip, 1996); Marion Arnold, *Women and Art in South Africa* (Cape Town: David Philip, 1996).

PART I

Historical trajectories

CHAPTER I

The power of sacred images

When Christianity became the dominant religion of the Roman Empire in the fourth century, the bishops of Rome insisted on the destruction of pagan works of art on the grounds that they were idolatrous. Notable amongst these early pontiffs was Gregory the Great (590–604), who commanded that all statues of Roman antiquity be thrown into the Tiber. They were seductive, having the power to corrupt true religion even though they apparently had no potency in themselves. The irony in this fear of powerless idols suggests that the power of sacred images is more complex than first meets the eye. Drowning them in the Tiber, instead of baptising them into the church, was evidence that Christ had defeated Caesar. The symbols of a defunct regime and the pantheon that gave it legitimacy were cast aside.[1] Wherever the church subsequently expanded in the ensuing centuries, its leadership decreed the breaking down of any images that represented the pagan past as a preliminary step to conversion. Thus in encouraging Edwin, 'the illustrious king of the English', to become a Christian, seventh-century Pope Boniface exhorted him to destroy all idols 'under the sign of the cross', the image of a new construction of social reality.[2]

One can imagine, then, the astonishment of nineteenth-century missionaries in southern Africa who, like Robert Moffat, discovered that there were no indigenous idols. The African mind, Moffat wrote, 'is not overwhelmed with the horrors which are to be found in countries where idols and idol temples are resorted to by millions of devotees'.[3] Unfortunately Moffat misread the situation because for him this meant that the Bechuana had no religion. It did not occur

[1] David Freedberg, 'Iconoclasm and Idolatry', in *A Companion to Aesthetics*, ed. David Cooper (Oxford: Blackwell, 1992), 208f.
[2] Bede, *The Ecclesiastical History of the English People* (Oxford: Oxford University Press, 1994), 88.
[3] Robert Moffat, *Missionary Labours and Scenes in Southern Africa* (London: John Snow, 1842), 244.

to him that Sotho-Tswana culture was profoundly religious, or that
Modimo, like Yahweh or Boniface's 'most high God', was beyond
conceptualisation or graphic representation.[4] If only the early
missionaries had recognised this, they would have discovered a
potential ally rather than an adversary in African culture. Instead,
they have been blamed for its destruction in much the same way as
the scholars of the European Renaissance blamed the destruction of
classical art on the conflict between Christianity and paganism. In
the Preface to his *Lives of the Artists* (1568) Giorgio Vasari, protégé of
Michelangelo and celebrated art historian of the Renaissance,
granted that Christians did not do this 'out of hatred for the arts but
in order to humiliate and overthrow pagan gods'. Nonetheless 'their
tremendous zeal was responsible for inflicting severe damage on the
practice of the arts, which then fell into total confusion'.[5]

This legacy of Christian antagonism towards classical art dis-
mayed and angered the artists of the European Renaissance, whose
fame, again ironically, became dependent on the patronage of the
church. No one expressed this more forcefully than the Florentine
sculptor Lorenzo Ghiberti (1378–1455), whose views became stan-
dard for art historians from Vasari onwards:

In order to abolish every ancient custom of idolatry it was decreed that all
the temples should be white. At this time the most severe penalty was
ordered for anyone who made any statue or picture. Thus ended the art of
sculpture and painting and all the knowledge and skill that had been
achieved in it. Art came to an end and the temples remained white for six
hundred years.[6]

Christian antagonism towards pagan works of art was premised on
the Second Commandment. Just as Israel had to resist the idolatries
of Canaan, so too Christianity had to counter the dangers of cultural
adaptation as it moved beyond the confines of Judaism into the
Graeco-Roman world. No one expressed the issue more provoca-
tively than the second-century North African Latin theologian
Tertullian with his rhetorical query: 'What has Jerusalem to do with
Athens, the Church with the Academy?'[7] This recalled St Paul's

[4] Gabriel M. Setiloane, *The Image of God among the Sotho-Tswana* (Rotterdam: A. A. Balkema,
 1976).
[5] Giorgio Vasari, *Lives of the Artists* (Harmondsworth, Middlesex: Penguin, 1981), 37.
[6] Quoted in Michael Camille, *The Gothic Idol: Ideology and Image-Making in Medieval Art*
 (Cambridge: Cambridge University Press, 1989), 342.
[7] Tertullian, *On Idolatry*, The Library of Christian Classics, v: Early Latin Theology (London:
 SCM, 1961), 36.

rejection of Greek wisdom. The 'message of the cross', wrote the apostle, makes 'the wisdom of this world look foolish!' (I Corinthians 1:18ff.) Wisdom here meant more than the prevailing philosophies of Hellenistic Greece: it included the sophisticated culture of classical antiquity as represented by the creativity of its great poets and dramatists. Just as Christians initially refused to engage in military service, so too they were discouraged by some theologians from becoming artists, for that would have placed them in danger of creating idols[8] or robbing God of the right to create.[9]

The tension between early Christianity and culture was experienced most sharply in the struggle against gnosticism. This complex phenomenon defies generalisation, but it represented the attempt to integrate Christian belief with other systems of thought and was invariably premised on the docetic conviction that while the spiritual is good, the material is evil. Much of the shape of canonical Christianity, the Christianity of the New Testament, was determined in the contest around such issues. On the one hand, there was a rejection by Christianity of any syncretism between the gospel and pagan philosophy or mythology; on the other, there was an affirmation of the material world as something good because created by God and redeemed through God's own embodiment in Jesus Christ. Despite this categorical affirmation of the material world, the cultured despisers of Christianity have often criticised it for its negative attitude towards the body and the sensual, just as they have derided its beliefs as irrational. This criticism introduces one of the main themes of our project and the background for our study of the power of sacred images.

CHRIST, APOLLO OR DIONYSUS?

Friedrich Nietzsche (1844–1900) and other nineteenth-century European critics of Christianity described the struggle between Christianity and classical culture as one between Christianity and the cults of Apollo and Dionysus.[10] All that was best in culture, whether ancient or modern, classical, Renaissance or Romantic,

[8] *Ibid.*, p. 85.
[9] Clement of Alexandria, *Stromata* 6.16, *The Ante-Nicene Fathers*, ed. Alexander Roberts and James Donaldson (Grand Rapids: Eerdmans, 1983), Vol. II, p. 512.
[10] Andrew Bowie, *Aesthetics and Subjectivity: From Kant to Nietzsche* (Manchester: Manchester University Press, 1990), 55f.

was located on the mythical Mount Parnassus, the dwelling place of
the gods and the home of the Muses, whose inspiration was essential
for human creativity. Parnassus was the symbol of poetry and great
literature. Between its twin peaks flowed water from the fountain
Castalia that inspired the poets. To climb Parnassus and imbibe the
waters meant writing elegant verse inspired by the Muses.

Apollo, the most Hellenistic of all the gods, and second only to
Zeus in power, was the god of wisdom whose prophetic oracle at
Delphi encouraged the virtues of civilised living, harmony, self-
knowledge, rhetoric, and moral earnestness, amongst all who sought
counsel.[11] To 'know yourself' was the basis of all knowledge, not the
'fear of the Lord' as the wisdom of Israel insisted. Apollo represented
human rationality and denigrated the world of passion. But he was
not the only god who dwelt on Mount Parnassus and spoke through
an oracle, nor was he the only alternative to Christ in the Hellenistic
pantheon. Only one peak on Parnassus was dedicated to Apollo; the
other belonged to Dionysus (the Greek Bacchus). If Apollo repre-
sented 'masculine' virtues of rationality and order, the Dionysian
cult had its roots in the more ancient cult of the Divine Mother with
its emphasis on the power of nature, the instincts and the non-
rational. Dionysian worship or bacchanalia, as the dramatist Eur-
ipides described it, was characterised by its devotees 'in ecstasy
flinging back the head in the dewy air'.[12] Induced by wine and
usually sexually promiscuous, it gained an enthusiastic following
even if only on the fringes of decent society, the society of Apollo.[13]
Such was its attraction that the Roman senate passed a decree
against bacchanalia as a serious threat to the well being of society.[14]
Yet Euripides discerned that inspired religious emotion cannot be
ignored, for while it may menace the good order of the *polis* and
dissolve the bonds of society, it is an elemental force that has to be
taken into account.[15]

The mythology of Parnassus may provide us with some under-

[11] Frederick W. Danker, 'Apollo', in *The Anchor Bible Dictionary*, ed. David Noel Freedman (New
 York: Doubleday, 1992).
[12] Euripides, *Bacchae* 864–5. See also the account by the Latin poet Catullus, poem
 64.255–64; 390–3. Catullus, *Poem 64*, trans. John Goodwin (Warminster, UK: Aris &
 Phillips, 1995).
[13] John M. Dillon, 'Dionysus', in *The Anchor Bible Dictionary*, ed. David Noel Freedman (New
 York: Doubleday, 1992).
[14] See Livy xxxix. 8.5ff. Livy, *Book XXXIX*, trans. P. G. Walsh (Warminster, UK: Aris &
 Phillips, 1994), 27, 181.
[15] Michael Grant, *The Classical Greeks* (New York: Charles Scribner's, 1989), 128.

standing of the background to the themes that recur in Paul's first letter to the Corinthians, in which he attacks both the wisdom of the world and the dangers of ecstatic worship and censures sexual promiscuity and drunkenness. The mythology has often surfaced and been variously adapted in the course of Christian history by those who have drunk deeply from the wells of classical culture. Both the Catholic Dante and the Puritan John Milton called on the Muses of Parnassus to provide inspiration for their poetry even though they did not take the mythology any more literally than did Homer or Nietzsche. Likewise, the same mythology, alongside themes from Christian tradition, inspired some of the greatest painters of the Renaissance, as can be seen in the work of Raphael, Titian, and later that of Nicholas Poussin. But it was at the hands of Nietzsche that the mythology of Parnassus was so sharply turned against Christianity as he struggled in vain to work out his own reconciliation between Apollo and Dionysus, between order and chaos, life and death.

The latter-day cult of Dionysus, as Nietzsche described the 'Anti-Christ' he espoused, was found in those who lived and worked 'beyond good and evil', such as the composer Richard Wagner and the philosopher Arthur Schopenhauer, who protested against binding art to morality. These confronted Christian faith head-on. Christianity, Nietzsche argued, 'wants to be, *only* moral . . . [it] relegates art, *every* art, to the realm of *lies*'. He went on to say:

Behind this mode of thought and valuation, which must be hostile to art if it is at all genuine, I have never failed to sense a *hostility to life* – a furious, vengeful antipathy to life itself; for all of life is based on semblance, art, deception, points of view, and the necessity of perspectives and error. Christianity was from the beginning, essentially and fundamentally, life's nausea and disgust with life merely concealed behind, masked by, dressed up as, faith in 'another' or 'better' life. Hatred of 'the world', condemnations of the passions, fear of beauty and sensuality, a beyond invented the better to slander this life, at bottom a craving for the nothing, for the end, for respite, for 'the sabbath of sabbaths' – all this always struck me . . . as the most dangerous and uncanny form of all possible forms of a 'will to decline' – at the very least a sign of abysmal sickness, weariness, discouragement, exhaustion, and the impoverishment of life.[16]

Nietzsche's critique of Christianity has remained one of the sharpest of all because it touches a raw nerve in exposing the way in which

[16] Friedrich Wilhelm Nietzsche, *The Birth of Tragedy* (New York: Vintage, 1967), 22–4.

Christianity – the religion of incarnation – has too often been guilty of denying the body, the senses and human creativity. In many ways this can be traced back to Augustine, who, knowing so well the desires and delights of the body, came to fear the power of the senses after his conversion.[17]

In so far as Christianity has more positively engaged classical culture in the course of its history, the pendulum has regularly swung between a preference for an Apollonian or a Dionysian emphasis, between what Paul Tillich referred to as a 'bourgeois righteousness and stability' and a spirit-filled ecstatic dynamism.[18] Yet, an inbred Christian sensing of the risk of releasing uncontrollable, even demonic, energies has generally preferred the values of Apollo to those of Dionysus. This much is already evident in the 'house-tables' of the pastoral epistles in the New Testament which describe Christian ethics in ways consonant with virtues extolled within ancient Roman society. A good society is one of sound moral value, harmony and order; it has to avoid being seduced by ecstatic visions and dubious life-styles that claim to live on an amoral plane beyond good or evil. Even though Apollo as the sun-god was vanquished by Christ, a mosaic beneath the high altar in St Peter's basilica in Rome depicts Christ as Apollo riding in the chariot of the sun. Yet it is surely noteworthy that Paul's letter to the Corinthians, in calling for order and harmony in the church, and therefore the need for prophecy to be regulated, also insists that the community should not 'quench the Spirit' (11:1–14:40). And throughout Christian history there has been a charismatic reaction to the deadening tendency of rationality and order often alongside a 'feminine' revolt against Christian 'masculinity' and a denigration of the body.[19]

The origins of what Nietzsche regarded as Christianity's hostility to the body can be traced back far more to the spirit of Apollo than to anything in the biblical text, though it has deeply penetrated the soul of Christianity through the ascetic tradition and residual elements of gnosticism. 'Christ and Apollo', writes Francesca

[17] See his discussion of the delights and snares of the various senses in Book x of the *Confessions*. Saint Augustine, *Confessions and Enchiridion*, The Library of Christian Classics, vii (London: SCM, 1955), 225ff. See also Margaret R. Miles, *Desire and Delight: A New Reading of Augustine's 'Confessions'* (New York: Crossroads, 1992).

[18] Paul Tillich, *Perspectives on Nineteenth and Twentieth Century Protestant Theology* (London: SCM, 1968), 48.

[19] See, for example, the essays on gender and the human body in medieval religion in Caroline Walker Bynum, *Fragmentation and Redemption* (New York: Zone Books, 1992).

Murphy, 'are two ways of being imaginatively turned toward the world: the way which will attune us to the finite, and the way which will not.'[20] When true to its doctrine of creation and its faith in the incarnation, Christianity must place a premium on the material and the body as gifts of God. Yet this affirmation of life is clearly not the same as Nietzsche's, for whom creative energy and moral goodness were disconnected. For Christianity the choice has always been between Christ and Apollo or Dionysus, neither of whom has the power to give life, to redeem a fallen world or to provide the foundation stones for its rebuilding. The inspiration of the Muses is inadequate; Apollo and Dionysus themselves need redemption. Does it follow from this, then, that there is no point of connection between the Holy Spirit and the poetic spirit of the Muses? Or that Christianity has always been, as Nietzsche insisted, anti-aesthetic and antagonistic to art in principle?

ART IN CHRISTIAN ORIGINS

Even Christian theologians who strongly advocated a positive relationship between Christianity and the arts, such as the nineteenth-century New Testament scholar B. F. Westcott, assumed that the 'antagonism of early Christians to contemporary art was necessarily essential and complete'.[21] To this extent Nietzsche's opinions had a solid foundation in the scholarly Christian opinion of his day. But such assumptions can no longer be maintained without qualification. In her seminal study on 'Art and the Early Church' published in 1977, Sr Mary Charles Murray challenged the prevailing view that early Christianity was aniconic, winning wide support for her claims.[22] Central to her argument is that the patristic evidence we have on art and Christianity was compiled by the Byzantine state in order to combat the use of icons in the church. She also challenged the presupposition that the views of some early church leaders represented the church as a whole, Tertullian being a case in point.

Murray's thesis is an important corrective to the traditional view,

[20] Francesca Aran Murphy, *Christ the Form of Beauty: A Study in Theology and Literature* (Edinburgh: T. & T. Clark, 1995), 111.

[21] Bruce Foss Westcott, 'The Relation of Christianity to Art', in *The Epistles of St. John* (London: Macmillan, 1883), 325.

[22] Mary Charles Murray, 'Art and the Early Church', *Journal of Theological Studies* 28 (Part 2) (October 1977): 303–45; Graydon F. Snyder, 'Early Christian Art', in *The Anchor Bible Dictionary*, ed. David Noel Freedman (New York: Doubleday, 1992).

yet, as Robin Lane Fox has countered, it too needs qualification. Murray, Fox argues, 'cites evidence from post- and pre-Constantinian dates without distinction; she does not emphasise the absence of Christian figure sculpture and portraiture, and is unconvincing in her contention that the 'early church was not hostile to art'.[23] Does this mean that we are back where we started, that early Christianity was aniconic, rejecting any visual representation of God even as incarnate in Jesus of Nazareth? The truth is surely more nuanced. While we cannot generalise from the polemical writings of some apologists, those Christian leaders who opposed the use of representational art in church were not speaking for all Christians, and the use of art was more widespread than aniconic authors of the period suggest. This resembles what happened in Judaism itself, the religious and cultural framework within which Christianity developed.

Given the prophetic strictures against idolatry, Judaism was largely aniconic at least until the period of the Second Temple, privileging the word rather than the image. Yet this did not mean any absence of aesthetic concern. Walter Brueggemann speaks of the tabernacle tradition (Exodus 25–31; 35–40) as 'preoccupied with beauty', and the temple tradition in which 'nothing is spared in order to create for Yahweh a place of beauty'.[24] The primary intent of the prophets was to desacralise images and declare their impotence; it was not to destroy the symbols of the covenant or prevent artistic creativity inspired by the Spirit. The decoration of the tabernacle, with its ornate images of cherubim, was as much part of the Mosaic tradition as was the denunciation of idolatrous images (Exodus 31:3–5). By the third century BCE, in post-exilic Judaism, the use of figurative motifs and representational art was common in synagogues and on sarcophagi, with pagan motifs, figures, and animals.[25] Even though images of God were excluded, the aniconic trajectory was compromised by 'the articulation of symbols, practices, and institutions that have long-term staying power'.[26] Thus, the prohibition on images did not prevent the development of Jewish art or its use of sources beyond its own cultural parameters.

[23] Robin Lane Fox, *Pagans and Christians* (London: Penguin, 1988), 745, n. 70.
[24] Walter Brueggemann, *Theology of the Old Testament: Testimony, Dispute, Advocacy* (Minneapolis: Fortress Press, 1997), 426.
[25] See Rachel Hachlili, 'Early Jewish Art and Architecture', in *The Anchor Bible Dictionary*, ed. David Noel Freedman (New York: Doubleday, 1992).
[26] Brueggemann, *Theology of the Old Testament*, p. 72.

The tension between illegitimate forms of art and those acceptable within the framework of the covenant is reflected throughout the development of Judaism, as it is within Christianity.[27] Moreover, as Claus Westermann reminds us, while the 'fine arts' played a minor role in Israel, 'the arts of writing and sound are absolutely predominant'. In Israel 'the power of images, which in other cultures was expressed by plastic and representational arts, found expression in the metaphorical power of language'.[28] Imagination was, in Brueggemann's terms, a 'crucial ingredient in Israel's rendering of reality'.[29] Without this capacity 'to generate, evoke, and articulate alternative images of reality', even if these were usually confined to rhetoric rather than visual representation, the prophetic testimony of Israel would have been impossible. Even so, such rhetoric was not confined to words, whether written or spoken, but also found expression in a dramatic mode. The plot of the Old Testament is a 'theo-drama'[30] which not only centres around the overarching themes of creation, covenant, exile and deliverance, but also portrays Yahweh in ways intended to be playful, inviting and teasing.[31]

To return to Murray's thesis that early Christianity was not aniconic in principle, it must be said that there is little evidence of any specifically Christian art until the latter half of the second century.[32] Only than do Christian pictorial representations begin to appear, usually depicting a biblical story or some aspect of the liturgy as carvings on sarcophagi or as frescoes in catacombs and house churches. That such artistic symbols, in contrast to representations of God, were approved by some important church leaders of the time can be seen in the writings of Clement of Alexandria:

Let our seals be either a dove, or a fish, or a ship scudding before the fair wind, or a musical lyre, which seal Polycrates used, or a ship's anchor, which Seleucus got engraved.[33]

[27] See Camille, *The Gothic Idol*, pp. 28f.

[28] Claus Westermann, 'Beauty in the Hebrew Bible', in *A Feminist Companion to Reading the Bible*, ed. Athalya Brenner and Carole Fontaine (Sheffield, UK: Sheffield Academic Press, 1997), 596f.

[29] Brueggemann, *Theology of the Old Testament*, pp. 67f.

[30] A term used by Balthasar. We shall consider its significance for a Christian theological aesthetics in chapter 4, but it is important to note that that discussion presupposes the Old Testament roots of the Christian 'theo-drama'.

[31] Brueggemann, *Theology of the Old Testament*, p. 69.

[32] See Snyder, 'Early Christian Art'.

[33] Clement of Alexandria, *The Instructor (Paedagogus)*, The Ante-Nicene Fathers, II (Grand Rapids: Eerdmans, 1983), 285, 3.11.

Such Christian pictorial art initially did not reflect the faith's Jewish origins, nor did its content reflect its Hellenistic milieu or match its aesthetic style. But gradually it adopted a Hellenistic style to such an extent that Christian art of the late second and third centuries, at least in this respect, was indistinguishable from contemporary Graeco-Roman materials. Not only were its first artistic symbols derived primarily from its Hellenistic social matrix, but they also included the use of pagan figures, such as the transformation of Orpheus, a figure of deliverance, into a representation of Christ, or that of the Shepherd into Christ, the Good Shepherd. While this may exemplify the Hellenisation of Christianity, the fact of the matter is 'that the Christian transformation of these symbols was successful because there was no other source for the visual than the late antique culture of the time'.[34] This indicates that Christianity was not only transforming culture, but also being transformed by it.

While there was more continuity between Christian art in the early church and post-Constantinian Christendom than was previously recognised,[35] some significant changes began to take place as a result of the new political dispensation. It was only during the Constantinian era, for example, that the cross became a public symbol of Christianity. Previously the cross was represented in arcane ways, as the mast and cross-beam on a sailing boat. But after Constantine's military success under the banner of the cross it became the sign of the redemptive power of Christ and of Christian victory over Caesar, and by extension, of the power of the Christian emperor as the representative of Christ. All of which made it mandatory for the cultic statues of ancient Rome to be cast into the River Tiber.

Paradoxically, as Christianity became powerful enough to cast down the images of imperial Rome, so there emerged a 'sacred visual art' within its own ranks, building on the rudimentary art forms of the primitive church. We know this partly because around the fourth century, theological criticism of iconography became more strident, giving rise to the later assumption that Christianity was in principle aniconic. Although the use of icons was condemned at the Council of Elvira in 306, criticism of the practice continued long after, indicating that popular practice did not always conform

[34] John Dillenberger, *A Theology of Artistic Sensibilities: The Visual Arts and the Church* (London: SCM, 1986), 11f.
[35] *Ibid.*, pp. 3ff.

to synodical decree. The intensity of criticism is evidence that visual and pictorial art was on the increase and that it found a home within the church buildings which were now being erected in many parts of the empire. Unless this were so it would be impossible to understand the Iconoclastic Controversy that finally erupted in the eighth century.

ICONS, IDOLATRY AND INCARNATION

The Iconoclastic Controversy was a defining moment in the history of both Christianity and Western art. As Hans-Georg Gadamer observes, the eventual rejection of iconoclasm was 'a decision of incalculable significance' and one which still largely determines European cultural consciousness.[36] While it is impossible to appreciate this decision without some knowledge of the controversy, our interest is not in its finer details, many of them now difficult to uncover, but in the underlying theological, aesthetic and political issues that have regularly resurfaced in Christian history. Central amongst these has been the distinction between sacred and secular art; the difference between image and idol; the role of the material in the representation and mediation of the transcendent; and the religious and political power of images. Such issues are of considerable importance to the theologian and the cultural historian, and especially so at the interface of these disciplines.[37]

For those who basked in the glories of empire, Byzantium was the New Israel, Constantinople was the New Rome, and the emperors were the successors of Constantine, the first Christian emperor.[38] Just as Constantine had defeated his enemy at the Milvan Bridge in 312 under the 'sign of the cross', so the armies of Byzantium would later go into battle with icons of Jesus, the Virgin Mary and the saints held aloft. The power of these sacred images was unquestioned as long as Byzantine forces won. But from the beginning of the

[36] Hans-Georg Gadamer, *The Relevance of the Beautiful and Other Essays* (Cambridge: Cambridge University Press, 1986), 3f.

[37] Jaroslav Pelikan, *The Spirit of Eastern Christendom (600–1700)*, The Christian Tradition: A History of the Development of Doctrine, 2 (Chicago: Chicago University Press, 1974), 91f.; Camille, *The Gothic Idol*, p. xxvii.

[38] For the political context of the Iconoclastic Controversy, see Mark Whittow, *The Making of Orthodox Byzantium, 600–1025* (Basingstoke, Hampshire: Macmillan, 1996), 134ff.; on Byzantine art during that period and more generally in Byzantium, see Lyn Rodley, *Byzantine Art and Architecture: An Introduction* (Cambridge: Cambridge University Press, 1994).

seventh century, victory became more elusive as town after town on
the eastern frontiers fell to Arabic Islamic power. Why this should
have happened was a question that perplexed emperors, patriarchs
and populace alike, spurring theologians to find a satisfactory answer
– a situation not unlike that which was debated in the British
newspapers at the time of the fall of Singapore during the Second
World War. With hindsight it is evident that the causes were
complex, but the obvious inference for the devout was that God was
displeased with his Chosen People. An initial hypothesis suggested
that the cause of divine anger was the schism that followed the
Council of Chalcedon (451), separating those who accepted its
formulae of the 'two natures' of Christ and those, labelled Mono-
physites by their opponents, who did not.[39] But attention eventually
shifted to the possibility that iconography was a disguised form of
idolatry and therefore the cause of God's wrath. The decision of a
council in Constantinople in 692 to give icons an official status
reinforced this fear.[40] So iconoclasm seemed the obvious solution to
regain God's favour even though the veneration of icons was now
deeply embedded within popular Byzantine piety.[41]

An imperial edict issued in 715 ordered that all images be removed
from churches throughout the empire. This command was widely
accepted by the synods in the East in deference to the emperor, but
firmly rejected in the West by Pope Gregory II. Gregory reminded
the emperor that images had been used in the church from earliest
times and that the emperor had no right to interfere in the liturgical
life of the church.[42] Although the historical accuracy of the pope's
claim is suspect, his resistance to imperial pressure gave the papacy
considerable prestige amongst the opponents of iconoclasm in the
East.[43] Opposition in Byzantium itself was largely confined to the
monasteries, which posed an alternative source of authority to that
of the imperial office. This was strengthened by the fact that all
bishops and therefore the powerful patriarch of Constantinople were

[39] At the Council of Chalcedon it was affirmed that Jesus Christ was fully God and fully
human in one person. This became the test of Orthodoxy. But there were those churches,
notably in Syria, Egypt (Coptic) and Armenia, which rejected the Chalcedonian Definition,
insisting that while Jesus Christ was fully divine and human, he did not have two distinct
natures. Their opponents labelled this view 'monophysitism', which was condemned as
heretical at the Sixth Ecumenical Council in 680–1.

[40] Whittow, *The Making of Orthodox Byzentium*, pp. 140ff. [41] *Ibid.*, p. 142.

[42] John Holland Smith, *The Great Schism: 1378* (London: Hamish Hamilton, 1970), 39.

[43] Joseph Gill, *The Council of Florence* (Cambridge: Cambridge University Press, 1959), 2.

appointed from the ranks of the monks. The monasteries were also far closer to the common people. In attacking icons as idolatrous the iconoclastic emperors were touching a very sensitive spot in Byzantine piety and culture, which set them on a collision course with the monasteries as the custodians of relics and icons. Even so, the emperors and the monks were not always at odds or bitterly opposed to each other. The emperor was, after all, the successor of Constantine. He ruled by divine right and had the authority to convene and preside over councils and synods. Moreover, all agreed that idolatry was wrong and affirmed the Orthodox faith as defined at the Council of Chalcedon in 451. What was at stake from the perspective of the patriarchs and monks was not so much imperial power but its abuse.[44] The iconoclastic movement represented, in Anthony Ugolnik's words, the exaltation of 'the secular royal image'.[45] For not only did the emperors remove icons of Christ from their palaces, but even worse, they placed portraits of themselves within church buildings.

Imperial iconoclasm gained ground as the armies of the empire began to win victories against the Arabs, successfully defending Constantinople from destruction in 716 under the sign of the imperial cross rather than the monastic icon.[46] A year later the Iconoclastic Controversy began in earnest after the accession of Leo III to the imperial throne. Banning the use of figural images from churches, Leo set in motion a bitter controversy that continued until the death of Theophilus, the last iconoclastic emperor, in 843.[47] Like all Byzantine emperors, those who supported iconoclasm took their role as defenders of Orthodoxy with appropriate seriousness, and some were sufficiently theologically informed to play a leading role in the debates. Their theological rationale was not merely an afterthought to legitimate imperial power against the monasteries

[44] Whittow, *The Making of Orthodox Byzantium*, p. 149.

[45] Anthony Ugolnik, 'The "Libri Carolini": Antecedents of Reformation Iconoclasm', in *Iconoclasm Vs. Art and Drama*, ed. Clifford Davidson and Ann Eljenholm Nichols (Kalamazoo, Mich.: Medieval Institute Publications, Western Michigan University, 1989), 11.

[46] The contrast between the cross and the icon, the one representing the emperor as God's instrument and the other the theology and devotion, as well as power, of the patriarchs and monasteries, is discussed in Belting, *Likeness and Presence: A History of the Image Before the Era of Art* (Chicago: University of Chicago Press, 1994), 144ff.

[47] A summary of the controversy and the issues at stake can be found in Pelikan, *The Spirit of Eastern Christendom*, pp. 91ff; Aidan Nichols, *The Art of God Incarnate: Theology and Image in Christian Tradition* (London: Darton, Longman and Todd, 1980), 76ff.; Dillenberger, *A Theology of Artistic Sensibilities*, pp. 56ff.

but one based on a genuine fear of idolatry in the life of the church over which they ruled.[48] It was one thing to respect and honour Mary and the saints; it was quite another to worship them and their images. Worship of God in spirit and in truth was, so the iconoclastic theologians and emperors argued, being subverted by pagan materialism smuggled back into Christianity in the guise of icons.[49]

Several synods, notably that of Constantinople in 754, gave their support to the iconoclastic position. But as the controversy developed during the latter half of the eighth century and entered a phase in which monks were persecuted, humiliated and put to death by Constantine V (741–75), the emperor rapidly lost popular support. The Second Council of Nicaea in 787 supported the veneration of icons, and iconoclasm lost its remaining appeal as succeeding emperors failed in battle or, as happened with embarrassing frequency in the final decades of the controversy, they fell prey to palace revolts. Much of the power play within the imperial household in the end was controlled by the iconophile empress Irene, a good example of one whose love of icons and whose support for the monks coincided with political ambition.[50] Irene eventually fell from grace, but it was later during the reign of another woman, the regent Theodora, that iconoclasm was finally condemned in 843 as an 'abominable heresy'.[51] Instead of destroying the icons and the cults with which they were associated the iconoclastic emperors had unintentionally empowered popular support for their use and veneration.

Our brief overview of the Iconoclastic Controversy brings us to a consideration of the substantive issues. While the New Testament warns against idolatry,[52] the source for iconoclastic conviction went back to the Old Testament. In contrast to the surrounding contemporary cultures, the Israelites were forbidden in the Decalogue to create or use any cultic representations. The story of the Golden Calf and the severity of the divine punishment it evoked (Exodus 32) was etched into the corporate memory of Israel as the epitome of

[48] Carl C. Christensen, 'Patterns of Iconoclasm in the Early Reformation: Strasbourg and Basel', in *The Image and the Word: Confrontations in Judaism, Christianity, and Islam*, ed. Joseph Gutmann (Missoula, Mont.: Scholars Press, 1977), 53.

[49] Pelikan, *The Spirit of Eastern Christendom*, pp. 112f.

[50] Whittow, *The Making of Orthodox Byzantium*, pp. 149ff.

[51] *Ibid.*, p. 154. [52] Acts 15:20; 1 John 5:21 et al.

disobeying the Second Commandment and the inevitable consequences of such disobedience.

You must not make a carved image for yourself, nor the likeness of anything in the heavens above, or on the earth below, or in the waters under the earth. You must not bow down to them in worship; for I, the Lord your God, am a jealous God. (Exodus 20:4–5a)

The reason for such a categorical ban was the danger that the Israelites would, like their pagan contemporaries, use images as a means of mediation between them and God as well as a way of manipulating God. This is clear from the exhortation in Deuteronomy to remember the day in which Israel stood before Yahweh on Mount Horeb and heard God's voice but saw no form (5:12). Israelites were even forbidden to utter the sacred name יהוה (Yahweh), for that would imply inappropriate familiarity with God. Israel's relationship with God was based on God's Word and liberating Deed alone, not on some material mediation created for that purpose. The prophetic attack on idolatry was a categorical rejection of superstitious beliefs and practices associated with 'sacred objects'.[53] God alone was holy, God alone had the power to create and redeem, and therefore whatever sacredness might be attached to the land, to the temple or to other natural objects was not inherent but derived.[54] Inert matter, the wood, metal and stone of the idol makers, was incapable of signifying and communicating the divine presence. 'Shall I bow down to a block of wood?' the prophet derisively asks (Isaiah 44:19; cf. 44:9–19; 46:5–7 et al.).

If the Iconoclastic Controversy initially centred around the prophetic prohibition on images, it soon shifted to Christological considerations, replaying debates of previous centuries but now around the question of idolatry. The iconoclastic theologians argued that any visual representation of Christ other than in the eucharist was idolatrous because of his divine nature. Constantine V, the most theologically articulate of the emperors, argued the case by asking how it was 'possible that there can be a drawing, that is an image, made of our Lord Jesus Christ, when he is one person of two natures in a union of the material and the immaterial which admits no confusion'.[55] This argument was based squarely on the Chalcedo-

[53] Cf. Exodus 23:24; Deuteronomy 4:15–16; 5:8; 27:15; Wisdom 13:10.
[54] Lionel Kochan, *Beyond the Graven Image: A Jewish View* (London: Macmillan, 1997), 30ff.
[55] Quoted *ibid.*, p. 112; see also Pelikan, *The Spirit of Eastern Christendom*, p. 116.

nian position to which all subscribed even though the emperors often had Monophysite sympathies. In reply, the iconophiles, quoting John of Damascus, a Palestinian theologian of repute, insisted that precisely because Jesus Christ was truly God *and* truly human he could be depicted materially without compromising his divinity. With telling effect they claimed that, contrary to the claims of the iconoclasts, 'the representation of Christ in an icon was a way of dispelling idolatry not of reinstating it'.[56] Moreover, in arguing from the incarnation to the fundamental role of the material and the body in the economy of salvation, they were able to challenge the docetic tendencies in the Christology of their opponents. Not only did the incarnation provide the necessary grounds for the production and use of icons, but the rejection of icons implied a denial of the full humanity of Christ and therefore a denial of the earthly reality of the history of salvation. To destroy icons was tantamount to crucifying Jesus afresh; to denounce them implied a denial of Mary the 'Mother of God' (*theotokos*) as affirmed at Chalcedon. Clear evidence for the iconophiles that their opponents did not really believe that Jesus was truly God and truly human.

During the course of the controversy the iconophile theologians developed arguments of considerable subtlety regarding the meaning of an 'image' as distinct from an idol, and therefore its power of representing Christ pictorially. This distinction became the real fault line in the controversy.[57] Christ, wrote St Paul, 'is the image (icon) of the invisible God' (Colossians 1:15). This meant that while God remains a mystery beyond human vision and grasp and therefore cannot be visually represented, in Christ God became fully present within the constraints of worldly existence and thus the object of human sense-perception. The four gospels themselves were replete with word-pictures describing who Jesus was and what he did, thereby providing a window through which the eyes of faith could discern the nature of God in human flesh. Such word-pictures and especially the key events in the gospel story, so the iconophiles argued, could and also should be depicted in visible art form.[58] Icons were a 'fifth gospel'. After all, the word-pictures in Scripture were themselves a form of art, but they presupposed literacy. On the other hand, argued John of Damascus in a phrase that recurs repeatedly in

[56] Pelikan, *The Spirit of Eastern Christendom*, p. 123.
[57] *Ibid.*, pp. 105ff. [58] *Ibid.*, p. 131.

later Christian debates on sacred art, 'what the book is to the literate, the image is to the illiterate'.[59] To honour such images was not to worship them any more than to honour Scripture was to worship it. With this in mind, the Damascene explained that iconography was not idolatry because the images were not of the invisible God but of the God made visible in flesh and blood in Jesus Christ. Hence the images of Christ, like those narrated in the words of Scripture, depicted his birth, his baptism, his miracles, his transfiguration, his sufferings and death, his resurrection and his ascension.[60]

The Iconoclastic Controversy provided the opportunity for theologians to develop a theology of icons that ensured that the veneration of icons not only was an expression of popular piety but also had a firm foundation within the liturgical life and spirituality of Orthodoxy.[61] Icons became a way to express the identity of Orthodoxy materially in which popular piety and dogmatic theology, image and word, liturgy and art were inextricably bound together. Icons were more than works of art. They were sacred images of Jesus Christ, the Virgin and the saints, and therefore along with the revelation contained in Scripture, a means of access to the true knowledge of God, a guide on the pathway to worship and prayer. Hence the setting of stringent conditions for the production of icons as vehicles of veneration lest they led to idolatry. The victory of the iconophiles certainly did not mean that idolatry had become acceptable, but that a clear distinction had been drawn between sacred image and demonic idol. Christianity was iconic and aniconic at the same time. How to maintain that tension creatively was the challenge facing the church then, and it remains so.

The tension between the material representation of the divine and the danger of worshipping false gods is, then, one that is always at the heart of the Christian debate about worship. Failure to maintain it has led to the destruction of works of art both in and beyond the sanctuary. There is, indeed, 'a deep-seated distrust of the duplicitous in image-making' that runs through Christian tradition.[62] The tension has wider ramifications beyond the confines of the church,

[59] St John of Damascus, *On the Divine Images* (Crestwood, N.Y.: St Vladimir's Seminary, 1980), 16. The possible significance of this argument within the predominantly oral rather than literary cultures of sub-Saharan African should be noted.

[60] *Ibid.*, p. 16.

[61] Leonid Ouspensky, *Theology of the Icon* (Crestwood, N.Y.: St Vladimir's Seminary Press, 1978).

[62] Camille, *The Gothic Idol*, p. xxvi.

relating as it does to the power of art forms in social and political
life. As Jean Baudrillard has observed, the Byzantine iconoclasts,
rather than despising or denying images, recognised their power.[63]
The iconophiles meanwhile feared the unmasking of the images in
case there was nothing behind them. These suggestive insights help
us make the link between the Byzantine controversy and contempo-
rary discussions on the power of images and the place of representa-
tion in art. Idols might be constructed of inert matter, but they are
not neutral.

The prophetic tradition understood this only too well. The
making of images gave power to those who constructed and
controlled them, enabling and legitimating domination and abuse.
Even to designate some object as 'holy' (land, book, temple) ran the
risk of idolatrous abuse. Hence Jesus' cleansing of the temple in
Jerusalem has always been regarded as paradigmatic for subsequent
Christian iconoclasts. From the perspective of the prophetic tradi-
tion, God's only image on earth is the image of God (*imago Dei*) as
reflected in humanity (Genesis 1:27; Psalm 8). Prophetic strictures
against idolatry are wedded to a concern for social justice and
righteousness. To worship and love God truly means respecting and
loving God's image in men and women. So it is that the Ten
Commandments, which begin by outlawing idolatry, proceed to
outlaw anything that is destructive of human being, human relation-
ships and the environment (Exodus 20:12–17). This, as we shall see
later, is linked to the notion of beauty in the Hebrew Bible, where, in
the creation narratives, God pronounces everything to be both
'good' and 'beautiful' (טוב). In God's sight, beauty is inherent in all
created things, including human beings.[64] To despoil or demean
what God has created is sinful and idolatrous. In the New Testa-
ment, idolatry is thus invariably associated with other sins that have
little to do with idols made out of wood or stone but everything to do
with human beings and human relationships (cf. I Corinthians
6:9–10; Romans 1:23–7). All of which has importance for how we
are to understand aesthetic taste and judgement.

The Iconoclastic Controversy not only reminds us of the dangers
of idolatry, but also reminds us of the dangers of iconoclasm. The
prophetic denunciation of idolatry can be used not only to check but

[63] Quoted from his essay on 'The Precession of Simulacra', *ibid.*, p. 350.
[64] Westermann, 'Beauty in the Hebrew Bible', pp. 586f.

also to enhance and entrench the power of rulers, even in the interests of reforming temple worship. The Deuteronomic reforms of King Josiah in seventh-century BCE Judah provide the paradigmatic biblical case. The key text that legitimated Josiah's reforms was God's command to the Israelites through Moses prior to the invasion and conquest of the Promised Land that required them

> to demolish completely all the sanctuaries where the nations whom you are dispossessing worship their gods, whether on high mountains or on hills or under every tree. Pull down their altars, break their sacred pillars, burn their sacred poles, and hack down the idols of their gods, and thus blot out the name of them from that place. (Deuteronomy 12:3)

Although ostensibly given by God centuries before to sanctify the conquest of Canaan, Josiah used this command to justify the destruction of all centres of power throughout his kingdom. This enabled him to concentrate all political, economic and religious power under his control and that of the temple hierarchy in Jerusalem. The importance of this paradigmatic event for Christianity can be seen in the fact that Josiah's iconoclastic reforms provided a pretext for later Christian rulers, including the Byzantine emperors, to consolidate their power.

The conflict over images, or between art as idolatrous and art as holy, was not resolved by the Iconoclastic Controversy for the church in the West, though as Gadamer suggests, it has had far-reaching ramifications for the Western world. Whereas the issues were resolved for the Eastern church, the situation in the West remained more ambiguous. Indeed, the Iconoclastic Controversy anticipated both the schism between East and West Christendom in 1054 and a widening gap in the understanding of both image and word, and their relationship. Nowhere is this more apparent than in the *Libri Carolini*, the writings of the Carolingian divines of the ninth century who guided the emperor Charlemagne's reforms of the Western church.[65]

PRIVILEGING THE WORD AND PATRONAGE OF THE ARTS

The position taken by the divines in the court of the Holy Roman Emperor reflects a different ethos from that of Eastern Orthodoxy.

[65] William R. Jones, 'Art and Christian Piety: Iconoclasm in Medieval Europe', in *The Image and the Word: Confrontation in Judaism, Christianity, and Islam*, ed. Joseph Gutmann (Missoula, Mont.: Scholars Press, 1977), 81.

One reason for this is that some of those most adversely affected by the outcome of the Iconoclastic Controversy moved to the West, where they had considerable influence. In particular, the Byzantine 'cult of Constantine', the 'Christian emperor', became embedded in Western Christendom, finding its expression in Charlemagne as the 'new Constantine'. Since the Byzantine Empire was then under serious threat from both within and without, the status and role of the Christian emperor in the western Holy Roman Empire was profoundly enhanced. Nothing demonstrates this more visibly or dramatically than the Palatine Chapel in Aachen (Aix-la-Chapelle),[66] where Charlemagne was crowned by Pope Leo III on Christmas Day in the year 800.

The impact of the Carolingian reforms on the Western church were far-reaching, not least with regard to church and monastic architecture and the development of its intellectual tradition. Both of these are germane to our discussion, though it is the latter that is of particular interest. Recent research on the *Libri Carolini* not only indicates a link between iconoclasts of Byzantium and the court of Charlemagne, but also shows that the iconoclastic tendencies associated with the Protestant Reformation centuries later can be traced to these reforms. It could also be argued that the Carolingian 'privileging of the word' has had a continuing influence into our own time, not least through modern critical theory. In the words of Ugolnik:

> The Carolingians show us that the Western hermeneutic has indeed been an integral process and the product of a long tradition. They also show us the birth of a distinctly Western aesthetic – an aesthetic which arises in reaction against the centrality of the image in Eastern Christian thought. In the *oculus mentis*, the 'mind's eye' of the *Libri Carolini*, we can see the first glints of a Reformation consciousness.[67]

Such a consciousness took several centuries to gestate. But the *Libri Carolini*, with their 'pronounced ideological sympathy with the iconoclastic emperors and their reliance on the cross as a central symbol', already 'testify to a distinctly Western attitude towards the arts – an attitude in harmony with the text-centred, word-anchored understanding of the Reformation reformers'.[68] Or, to put it more pithily: 'The text supersedes the image'.[69] For Eastern Orthodoxy

[66] Kenneth John Conant, *Carolingian and Romanesque Architecture 800 to 1200* (Harmondsworth, Middlesex: Penguin, 1973), 14.
[67] Ugolnik, 'The "Libri Carolini"', p. 29.
[68] *Ibid.*, p. 13. [69] *Ibid.*, p. 14.

the visible beauty of 'sacred images' can penetrate the 'interior soul'; for the authors of the *Libri Carolini*, the word or text alone has such power, for it penetrates the soul through the eye of the mind. Images are not forbidden, but they no longer have the same power to represent the divine. Rather, as Augustine had argued so persuasively, material beauty can get in the way of religious perception and true worship.[70] In sum, the Carolingian scholars 'consciously revised the epistemology of the Christian East as they laid the foundation from which the Reformation freely draws'.[71]

The 'privileging of the word' did not mean that the aesthetic was confined to words and metaphors. After all, Scripture itself became a very important art form in medieval Christianity, as it did in Islam. Bible manuscripts were magnificently illustrated and embellished by monastic scribes and craftsmen throughout Europe. Even prior to the Carolingian period the Lindisfarne Gospels, to name but one of the most famous examples, were, so the priest Aldred tells us, adorned 'with gold and with gems and also with gilded-over silver'.[72] In this way the text of Scripture itself was given an iconic character. The illustrations of the four evangelists in the Lindisfarne Gospels richly embody both Byzantine Orthodox and Celtic design.[73] Yet the purpose of such decoration of the Scriptures was symbolic and practical. As Janet Backhouse puts it: 'It visibly represented the Word of God which missionaries had carried to their converts.'[74] Just as icons were the library of the illiterate for John of Damascus, so for the missionary monks of the West the splendid appearance of Scripture was intended to make a profound impression on primitive peoples. The sacred books contained the revelation of the incarnate Word.

The production of sacred art was not controlled in the Western church in the way it was in the East following the Iconoclastic Controversy. For this reason many medieval Catholic bishops were concerned about the idolatrous abuse of images. The twelfth-century Bishop William of Auvergne in France criticised those within his diocese who regarded images of the saints 'as though they were true gods, gods made with men's hands'.[75] The same century

[70] Augustine, *Confessions*, pp. 232f., 10.34.
[71] Ugolnik, 'The "Libri Carolini"', p. 3.
[72] Quoted in Janet Backhouse, *The Lindisfarne Gospels* (London: Phaidon Press, 1981), 7.
[73] Backhouse, *The Lindisfarne Gospels*, pp. 33ff. [74] *Ibid.*, p. 33.
[75] Quoted in Jones, 'Art and Christian Piety', p. 86.

also witnessed the reforming zeal of the Cistercian and Carthusian monasteries against extravagant and luxurious church decoration. The issue at stake was not that of icons or aesthetic appearance but 'whether the churches should be decorated sumptuously if the children of God were living in poverty'.[76] As St Bernard of Clairvaux observed:

> there is such a wondrous diversity of figures, such ubiquitous variety, that there is more reading matter than in books, and one could spend the whole day marvelling at one such representation rather than in meditating on the law of God. In the name of God! If we were not ashamed at its foolishness, why at least are we not angry at the expense?[77]

Bernard's complaint was about the use of the aesthetic for financial gain, though his critique was also levelled against the distracting power of art in devotion. Greed, avarice, usury and idolatrous iconography were all part of the same parcel. This was a somewhat different concern from that which lay at the heart of the Iconoclastic Controversy, where sacred art was a means to worship. Nonetheless, the problem of idolatry caused the Fourth Lateran Council in 1215 to establish rules to control artistic innovation and creativity with their implicit danger of a return to paganism or the promotion of new heresies.[78] Idolatry, Thomas Aquinas argued, resulted from 'natural delight in skilfully fashioned images'.[79]

Despite Cistercian criticism and the nuanced statements of council and theologian, the thirteenth century witnessed an un-controllable explosion in the production of sacred images and art. Society, as Michael Camille graphically demonstrates, was 'saturated with an hitherto unprecedented conglomeration of competing images'. Image worship, he continues, 'became a common part of Western religious experience . . . often appropriated to work for one group and, all too often, against another'.[80] Carefully considered distinctions between worship and veneration, between images and idols, were lost in the frenetic activities of popular piety in search of divine pity and consolation. The doctrine of transubstantiation, codified at the Fourth Lateran Council, with its emphasis on the

[76] Umberto Eco, *Art and Beauty in the Middle Ages* (New Haven: Yale University Press, 1986), 6.
[77] Quoted *ibid.*, p. 8 from St Bernard, *Apologia ad Guillelmum*, chap. 12, PL 182, cols. 914–16.
[78] Camille, *The gothic Idol*, pp. 13f., 205ff.
[79] St Thomas Aquinas, *Summa Theologiae: A Concise Translation*, trans. Timothy McDermott (Westminster, Md.: Christian Classics, 1989), 411.
[80] Camille, *The Gothic Idol*, p. xxviii.

image of Christ imprinted on the host, gave impetus to a much wider belief in the miraculous power of the material to convey grace, and thereby radically reshaped devotional practice.[81] New cultic practices, the festival of 'Corpus Christi', for example, produced fresh sacred images, as did the shrines that attracted increasing numbers of pilgrims. Images were indicators of God's power, and therefore at the heart of the conflict between contending religious ideologies. The charge of idolatry, ironically, was levelled against Jews, Muslims and Cathars alike as it would be later used in Africa, to justify pogroms, crusades and inquisitions while, at the same time, giving birth to new sacred images of triumphal ecclesial power.[82]

If the late Middle Ages witnessed an explosion in sacred art, during the Renaissance the emphasis in art production shifted decisively away from the sacred to the secular, though paradoxically under ecclesial patronage as it was of the wealthy citizens of Florence and elsewhere. Sculpture, always regarded with suspicion within the church, was reborn along classical lines, and the great painters of the period drew heavily on pagan mythology. 'Secular' here does not imply a lack of religious themes, for classical paganism now provided the models for depicting biblical scenes and narratives as well as more contemporary cultic practices. Not for nothing did Abelard object to the likeness depicted between Venus and the Virgin, one of many examples of a much wider phenomenon.[83] Anthony Blunt speaks of the laxity of the church which 'allowed stories to be acted or depicted, even if they were legendary or invented, provided that they did not go directly against any ecclesiastical practice or doctrine'. 'Pagan doctrine and symbols', he continues, 'were incorporated into Christianity, and the revival of classical ideals was not only tolerated but actively furthered by most of the Popes from Nicholas V to Clement VII.'[84] One reason for this was that the Roman church was not as yet under any serious threat to its position and power, as it would be during the Protestant Reformation. It was able to embrace artists and patronise their work within St Peter's basilica and the Vatican itself.

In this way Western Christianity conquered through assimilation and thereby gained control over the images of paganism, clutching them, as it were, to its bosom and rendering them harmless.

[81] *Ibid.*, pp. 215f. [82] *Ibid.*, chapters 3–4. [83] *Ibid.*, p. 237.
[84] Anthony Blunt, *Artistic Theory in Italy 1450–1600* (London: Oxford University Press, 1968), 109.

Whereas in the ancient world sculptors of the gods had sacred power, at once feared and scorned by medieval popes and priests, for Renaissance artists and their patrons such images were nothing more, but also nothing less, than great, beautiful and noble works of art. This was the period, as Walter Benjamin reminds us, when the 'secular cult of beauty developed'.[85] The notion of 'art for art's sake' was being gestated long before its embodiment in the nineteenth-century cult of the aesthetic. Classical art objects were to be cherished, emulated, but also freely recast in new forms. Artistic creativity, genius and energy were now applauded as artists sought to express the bursting into flower of a new age. Artists were no longer consigned to hell, as they were by Dante, because of their arrogance; their talents were harnessed by their patrons, whether ecclesiastical or secular, as signs of their prestige and power.

The powerful Italian city-states gave patronage to the arts with clear intent to signify their new status, and art collections became a way in which cities projected their own self-image. Camille refers us to Donatello's famous bronze statue of David now in the Museo Nazionale in Florence. Here, he writes,

is a symbol of Florentine power in the form of a Roman idol – Florence as the new Rome, suggested by the positive appropriation of its main type of image. All the negative associations with which medieval Christian tradition weighed down the pagan idol until it fell from its pedestal are here reconstituted. the nakedness that signalled shame to the medieval beholder and phallic fallen nature has become more ambiguous. David parades his nudity as a fetishist (the boots, helmet, and feather up the thigh), and Donatello follows no specific classical model, Mercury or otherwise, in this dazzling redefinition of the Old Testament hero in the guise of one of his own beautiful apprentices.[86]

David, and other such sculptures of biblical figures, represented neither the gods of the past nor the saints of the biblical story, but the freedom and power of Florence. But they did embody 'ideas *in the body* that had, for more than a millennium, been banished to the margins of discourse'.[87] Old Testament heroes had been recast as the patron saints of civic – not just religious – pride. Sacred images were no longer venerated as a window onto the kingdom of God or a bridge between this world and the next, but opened a window into the values of the kingdoms of this world. In another strange, ironic

[85] Quoted in Camille, *The Gothic Idol*, p. 342.
[86] *Ibid.*, p. 345. [87] *Ibid.*, p. 345.

twist, the Hebrew Scriptures rather than Hellenistic mythology provided the images to express secular power and reassert human freedom and sexuality.

There were many within the Catholic Church itself who, not unlike Bernard in the twelfth century, protested against Renaissance developments and thereby prepared the way for the eruption of iconoclasm that accompanied the Protestant Reformation. Notable amongst them was the Dominican preacher Savonarola, whose denunciations, not of art in general, but of lascivious art in particular and the moral laxity which accompanied it, led to his martyrdom. The issue at stake was not so much that of sexual morality, however, but the threat which the monk's preaching presented to the prestige and power of Florence. Savonarola was an iconoclast of the new age who might well have gained the support of the monastic iconophiles of Eastern Orthodoxy as much as the iconoclasts. He was in some senses a forerunner of the Protestant Reformation even though the issues facing such reformers in the Italian cities of the Renaissance were rather different from those which sparked off the Reformation in Germany and Switzerland. Camille's observation is again to the point:

If the Italian Renaissance saw the rebirth of pagan idols in the guise of Old Testament heroes and saints, in northern Europe medieval patterns of image production and consumption were longer lasting as both demonic and divine aids and ultimately had more violent consequences.[88]

The Protestant iconoclasts were not simply in the business of reforming the morals of prelate and city council: they wanted to replace an old order, morally corrupt and theologically perverted, with a new order based on the Word of God alone.

STRIPPING SANCTUARIES AND CHASTENING ART

In his account of the alienation of the aesthetic in Protestant theology, Balthasar notes a 'terrible duel to the death between Christ and Apollo'. Indeed, 'any kind of regularity, of immanence which is seen as a perduring, inherent *qualitas*, as Being-in-repose, as *habitas*, as something that can be manipulated, is already by that very fact identified with demonic corruption'.[89] For Protestant Christianity,

[88] *Ibid.*, p. 346.
[89] Hans Urs von Balthasar, *The Glory of the Lord. Vol. 1: Seeing the Form*, The Glory of the Lord: A Theological Aesthetics, 1 (Edinburgh: T. & T. Clark, 1982), 67.

argues Balthasar, the criterion of Christian art is whether the event of the beautiful can ever become a pointer to the event of Christ.[90] In coming to his conclusions, Balthasar had the benefit of hindsight. But already in 1526 Erasmus, the Catholic Humanist reformer, held Protestantism responsible for the decline of art in Germany, expressing the matter with his acerbic barb: 'here the arts do freeze!'.[91] Even a Scottish theologian like P. T. Forsyth, with his positive appraisal of Calvin, would later concur. 'If our spirits habitually think of Nature as cursed and God-forsaken', he declared in his lectures on *Religion and Recent Art* in 1889, 'we can have no more Art than Calvinism has left to Scotland.'[92]

The problem with such an analysis, whether by the Catholic Balthasar or by Protestants themselves, is that it fails to recognise that the struggle between 'Christ and Apollo' was, as we have seen, common to Christianity long before the Reformation. There is no denying, of course, that Protestant Christianity was largely aniconic, nor can it be gainsaid that the Reformation resulted in a new wave of iconoclasm. But it stood in continuity with a venerable tradition that stretched back through the early church fathers to the Hebrew prophets. Moreover, while the common assumption that Protestant Christianity has no aesthetic sensitivity or made little contribution to the arts is an understandable generalisation, it is an uninformed generalisation. In the Introduction to his history of Scottish art, Duncan Macmillan refers to this as a misleading, yet durable, misunderstanding of the Reformation, which has put 'the visual arts in Scotland at a permanent disadvantage'. It is a simplistic notion that suggests, for example, 'that there is a fundamental incompatibility between Protestantism and painting'. On the contrary, he argues, the Scottish contribution to the humanising of Western culture is an extension of the Reformation.[93]

The debate about the Reformation as initiating a humanising process has been extensive. There is a large body of scholarly opinion that argues that the Reformation was, to the contrary, an attempt to shore up Christendom against the forces of human emancipation. Others, again, have contended that the Calvinist

[90] *Ibid.*, p. 65.

[91] Sergiusz Michalski, *The Reformation and the Visual Arts: The Protestant Image Question in Western and Eastern Europe* (London: Routledge, 1993), 192.

[92] P. T. Forsyth, *Religion in Recent Art* (London: Hodder & Stoughton, 1905), 145.

[93] Duncan Macmillan, *Scottish Art, 1460–1990* (Edinburgh: Mainstream, 1990), 8.

branch of the Reformation in particular should be regarded more as a vital and contributing link in the chain of events that led to the Enlightenment.[94] That there is truth in both arguments is undoubtedly the case, for the Reformation like all such historical events was complex in its character and ambiguous in its achievements. Yet Macmillan is making an important observation, one which counters the simplistic notion that Protestantism (and in Scotland that means Calvinism) is by its very nature aniconic or iconoclastic, and therefore has neither contributed much to the arts nor is capable of doing so.[95] Whether we refer to Scottish art or to the far more noteworthy flourishing of painting in seventeenth-century Calvinist Netherlands,[96] the evidence suggests otherwise. How, then, are we to reconcile such conflicting views about Protestantism and the aesthetic?

The question of images went to the heart of Reformation theology in its quarrel with Rome and, by implication, with Eastern Orthodoxy. The practice of indulgences may have sparked off Luther's protest, but it was the whole system of late medieval Catholic religion that was at issue. The cult of the Virgin, prayers to the saints and pilgrimages to their relics, passion plays, the endowments of masses for the dead, indeed, the mass itself, along with the veneration of images, were, for the Reformers, all part of the same popish parcel. During the two centuries that preceded the Reformation such practices reached a new level of intensity, and developed a character in sharp contrast to that of earlier times. Faith was fixed on images and salvation was bound up with a system of iconic signs.[97] As in the case of the sale of indulgences, much of it had to do with the economic well being of the papacy, the monasteries, and the shrines that housed saintly relics and attracted pilgrims. So, 'any assault on religious art would have been threatening to the financial as well as the spiritual interests of a large part of the population'.[98]

By the time of the Reformation sporadic outbreaks of iconoclasm

[94] William J. Bouwsma, *John Calvin: A Sixteenth Century Portrait* (New York: Oxford University Press, 1988).

[95] See the discussion in *Seeing Beyond the Word: Visual Arts and the Calvinist Tradition*, ed. Paul Corby Finney (Grand Rapids: Eerdmans, 1999). Cf. Abraham Kuyper, *Lectures on Calvinism* (Grand Rapids: Eerdmans, 1953), 142ff.; Peter S. Heslam, *Creating a Christian Worldview: Abraham Kuyper's Lectures on Calvinism* (Grand Rapids, Mich.: Eerdmans, 1998), 196ff.

[96] Finney, *Seeing Beyond the Word: Visual Arts and the Calvinist Tradition*, pp. 343ff.

[97] Camille, *The Gothic Idol*, pp. xxvi, 125.

[98] Jones, 'Art and Christian Piety', p. 87.

encouraged by theological attacks on the use and veneration of images were commonplace. But it was undoubtedly the Reformation assault on the papacy and the system of salvation which it supported that gave rise to the most radical iconoclastic movement since the Iconoclastic Controversy. The Reformation may even be regarded as a contest over the meaning and control of images, their power to save or damn, and the legitimate authority or tyranny they represented. As the nineteenth-century French historian of the Reformation, J. H. Merle D'Aubigné, put it: 'the doctors attacked the pope and the people the images'.[99]

Protestant iconoclasm did not occur only or even chiefly on the radical fringes of Protestantism. The most widespread acts of iconoclasm were not those conducted by the followers of Karlstadt in Luther's Wittenberg or the Calvinist Huguenots in France, but those instigated by the authority of Henry VIII in England after his break with Rome. In pursuing this course of action, Henry, as the 'Christian prince', was heartily encouraged by Archbishop Thomas Cranmer, who, like others before him, quoted Josiah's example to justify the removal of the images from the churches of the realm and the dissolution of the monasteries.[100] This was part of the process whereby the monarch stamped his authority over the land as well as stamping out that of the papacy. Much iconoclastic activity was clandestine and embarked upon on individual initiative. But official policy and rhetoric, dangerously ambiguous as they were, prompted radical action. Rood screens were smashed, crosses and crucifixes were broken, images were destroyed, ceremonial fires burnt popish paraphernalia, and the ubiquitous paintings on churches were whitewashed. Passion plays and pilgrimages to holy shrines were proscribed. Margaret Aston paints a graphic picture of the process which, she says, compares in some ways with those events which took place during and after the collapse of communism in Eastern Europe with the smashing of the statues of Lenin and Stalin:

We can see a kind of counterpoint developing between the private and public destroyers: between the official, publicized, propagandist acts of iconoclasm, and the spontaneous, clandestine, illicit breakings or burnings

[99] Quoted in Carlos M. N. Eire, *War Against Idols: The Reformation of Worship from Erasmus to Calvin* (Cambridge: Cambridge University Press, 1986), 6.

[100] Joseph Gutmann, 'Deuteronomy: Religious Reformation or Iconoclastic Revolution?', in *The Image and the Word: Confrontations in Judaism, Christianity, and Islam*, ed. Joseph Gutmann (Missoula, Mont.: Scholars Press, 1977), 5ff.

undertaken by private groups or individuals. Strange though it may now seem, the public iconoclastic spectacle became part of the repertoire of government propaganda almost as soon as Henry VIII decided, under Thomas Cromwell's guiding hand, to sponsor the process of reform.[101]

The 'stripping of the altars', as Eamon Duffy describes the Protestant destruction of traditional Catholic religious devotion and practice in England, took place over more than a century and varied in character and intensity from one part of the country to another. Even though, as Duffy argues, 'the Reformation was a violent disruption, not the natural fulfilment, of most of what was vigorous in late medieval piety and religious practice',[102] the effect was to displace the religious world-view of a nation and replace it with another sponsored by royal authority. Or, to put it differently, the sites of 'image power' had been redistributed and secularised. Moreover, the balance of power had shifted from the visible image to the word read and preached.[103] The medieval iconic antidote to demonic powers was now regarded as the source of idolatry. In Aston's words, 'Christians were ushered into a reshaped spiritual world. God was to be heard, not seen. In learning to live by the Word, people gradually learned to find in their Bibles the compensation for that huge deprivation of their century, the enforced withdrawal of "goodly sights" that had accumulated over generations.'[104] The emphasis had shifted decisively from the eye to the ear. The privileging of the word had won out, at least for the moment, for the popular piety of Protestantism could not endure without visual aids even if its images were differently regarded.[105]

For Luther it was the 'power of the word' which defeated the power of Rome and by implication the power of visual images. Nonetheless, the question of images was a matter of secondary importance (*adiaphora*) on which Luther did not think it necessary to take a stand. When he was forced to do so, however, it was to oppose more radical followers who, during his enforced absence from

[101] Margaret Aston, 'Iconoclasm in England: Official and Clandestine', in *Iconoclasm Vs. Art and Drama*, ed. Clifford Davidson and Ann Eljenholm Nichols (Kalamazoo, Mich.: Medieval Institute Publications, Western Michigan University, 1989), 49.

[102] Eamon Duffy, *The Stripping of the Altars: Traditional Religion in England, 1400–1580* (New Haven, Conn.: Yale University Press, 1992), 4.

[103] Camille, *The Gothic Idol*, p. 347.

[104] Aston, 'Iconoclasm in England', p. 81.

[105] David Morgan, *Visual Piety: A History and Theory of Popular Religious Images* (Berkeley, Calif.: University of California Press, 1998).

Wittenberg, embarked on an orgy of image breaking. In short, Luther was no iconoclast, but neither was he a great lover of the visual arts. For him, both ontologically and iconographically, 'it was less important what a work of art was than what it meant for the Christian believer'.[106] For this reason it was perfectly appropriate to retain the crucifix in the sanctuary as well as altar-pieces which depicted the passion and other themes in the grand narrative of redemption. Luther's interest was, in this regard, confined to the extent to which visual art served as a means of Christian formation. Art existed to serve the gospel; its only value was didactic. In this, Luther stood very much in line with much of patristic and early medieval tradition. Like many reforming monks before him, he believed that works of art like sermons should be straightforward, erring on the side of simplicity rather than ostentation. 'I like pictures that are painted as simply as possible', he once told his friend the famous painter Albrecht Dürer.[107] Of course, Dürer's famous etchings played a remarkable role in the propaganda war unleashed by the Reformation, demonstrating in another way the power of images aided by the invention of the printing press. But Luther's own contribution to the place of the arts in the life of the church lay in his great love for music. It is not surprising, then, that the Lutheran Reformation made its major aesthetic contribution through the legacy of Johann Christian Bach.[108]

By the time of Calvin's ascendancy in Geneva, art had already been abolished from the churches of the canton.[109] Such a task was not something he had to advocate or oversee, though he supported what had been achieved. For Calvin what was important was that everything should be done, as Scripture required, 'decently and in order', that is under the direction of properly instituted authority. He was therefore dismayed and scandalised when, in 1561, near the end of his life, French Huguenots committed acts of iconoclastic vandalism which he regarded as the theft of public property for personal gain. He was also concerned that such actions would

[106] Michalski, *The Reformation and the Visual Arts*, p. 37.
[107] Michalski, *The Reformation and the Visual Arts*, p. 39.
[108] Jaroslav Pelikan, *Bach among the Theologians* (Minneapolis: Fortress, 1986), 14ff.
[109] In seeking to recover the aesthetic dimension in the Reformed tradition it is important to deal with Calvin's seminal role at some length. On Calvin and the visual arts, see Philip Benedict, 'Calvinism as a Culture? Preliminary Remarks on Calvinism and the Visual Arts', in *Seeing Beyond the Word: Visual Arts and the Calvinist Tradition*, ed. Paul Corby Finney (Grand Rapids: Eerdmans, 1999), 19ff.

undermine the Reformation in France even though it was aimed at getting rid of those objects that prevented the flourishing of true faith and worship. Calvin's reasoned pleas were powerless in preventing Protestant mobs 'led by local leaders' and with 'a penchant for rituals of denigration and destruction' from engaging in iconoclastic mass action.[110] Though French Catholics were no less engaged in destroying pulpits and pews – symbols of Protestant worship – at the same time![111] How else could they attack the power of the word?

Calvin was conversant with the arguments used by both sides in the ancient Iconoclastic Controversy, and assumed with many others that pre-Constantinian Christianity was aniconic. The decline in early Christianity was, he believed, linked to the introduction of images.[112] He was also cognisant of the pronouncements of the Carolingian divines, which, with the rediscovery of the *Libri Carolini* in 1549, came in handy for the writing of the final editions of his *Institutes of the Christian Religion*.[113] He had already attacked the use of images long before on the basis of Scripture and those selections from the fathers which had been favoured by the Byzantine iconoclasts. While his use of these sources left something to be desired, his argument was deeply grounded in his theology. It is a pity that his approach to the subject was shaped by anti-idolatry polemics rather than by his constructive Christology, with its emphasis on God's 'accommodation' to human comprehension through his revelation in Jesus Christ.[114]

God, Calvin argued, is far greater than human thought can imagine, and far greater than human beings can represent through their image making. Since 'God has no similarity to those shapes by means of which people attempt to represent him . . . all attempts to depict him are an impudent affront . . . to his majesty and glory'.[115] In plain terms, the use of images is idolatry. Artists should only paint what the eye can see and not attempt to portray the majesty of God.[116] Hence his negative attitude towards human creativity and

[110] See Michalski, *The Reformation and the Visual Arts*, p. 74.

[111] Dillenberger, *A Theology of Artistic Sensibilities*, p. 70.

[112] John Calvin, *Institutes of the Christian Religion, I–III.19*, The Library of Christian Classics, xx (Philadelphia: Westminster Press, 1960), I.xi.13.

[113] Calvin, *Institutes* I.xii.14. Michalski, *The Reformation and the Visual Arts*, pp. 66f.

[114] Ford Lewis Battles, 'God was Accommodating Himself to Human Capacity', *Interpretation* 39 (January 1977).

[115] Calvin, *Institutes* II.ii.15–16. [116] *Ibid.*, I.xi.

imagination, which, for him, were sheer fantasy.[117] Yet Calvin was scornful of a Stoic refusal to enjoy and delight in the beauty of creation. God's creation is a 'beautiful theatre', he wrote, and it would be sinful not to take pleasure in it.[118] The problem did not lie in creation, the material, or in artistic ability. Human nature was the problem. In response to those who argued sacramentally that the material was good, not bad, and that Christ could be represented in this way, Calvin replied that human nature was fallen and invariably abused God's good gifts. Calvin, like Augustine, had a very low estimate of the human body in its fallen state, perhaps more neo-Platonic than biblical,[119] but he was no gnostic. Men and women are idolatrous, not matter, because 'they try to reverse the order of creation by attempting to bring God down to their level'.[120] Being carnal, humans inevitably put their reliance on what is tangible rather than on the grace of God which we receive through faith awakened by the preaching of the Word.

Calvin's warnings against idolatry echoed the rhetoric of the Second Commandment and were aimed especially at the doctrine of transubstantiation and the power of the priesthood. Idolatry had to do with the dangers of localising the transcendent – the human desire to control God and put our trust in the work of our own hands. Calvin was fully aware that it is impossible to get rid of the idolatry of the heart simply by getting rid of statues and paintings from church buildings. The stripping of the sanctuary was secondary to and required the conversion of hearts and minds. Nevertheless, the symptoms had to be tackled as well. So Calvin attacked the way in which the pomp of the late medieval church demonstrated a proud and vain spirit:

In what manner will the temple of God be properly used? . . . This will not happen when various rites are celebrated with great pomp, when the temple is full of gilding, gold and silver . . . for the glory of the temple of God does not consist in this . . . God cannot be grasped in visible houses of worship, magnificent altars or ceremonies.[121]

Like the earlier Cistercian reformers, Calvin was concerned about the ostentatious decoration of churches not just because of the

[117] Bouwsma, *John Calvin*, p. 80.
[118] Calvin, *Institutes* III.x.1.3. Cf. Bouwsma, *John Calvin*, p. 135.
[119] Bouwsma, *John Calvin*, p. 80; Benedict, 'Calvinism as a Culture?', p. 28.
[120] Eire, *War against Idols*, p. 232.
[121] Quoted in Michalski, *The Reformation and the Visual Arts*, p. 69. *Calvini Opera*, 41:562; 31:460.

possible hindrance to worship, but also because it was a misuse of money which should be given to the poor.[122] Avarice was as much idolatry as the worship of a graven image. The dehumanising of the 'image of God' in men and women was, as the Hebrew prophets insisted, as serious as the idolatry of placing sacred images in the sanctuary.[123]

Calvin did not mean that Christian worship should be disembodied, invisible or silent. But for him, the visible signs and symbols of Christian worship are the sacraments. Together with the preaching of the Word, the sacraments are the material means of grace. For Calvin, as for all those who followed in his footsteps, 'in profane places an image took on an entirely different meaning'.[124] Works of art that were proscribed in the sanctuary were quite appropriate in the public square. Images in secular places are not harmful; 'even idols kept in such places are not worshipped'.[125] Indeed, the Holy Spirit was the source of genuine artistic creativity, and artistic gifts sometimes flowered more brilliantly amongst those who were not believers.[126] All arts, sculpture and painting amongst them, come from God and can bring pleasure.[127] Calvin was, after all, a Humanist scholar by training, his *Institutes* remain a French classic of style and rhetoric, and, as Donald Davie puts it, he 'clothed Protestant worship with the sensuous grace, and necessarily the aesthetic ambiguity, of song'. Of course, as Davie goes on to say about French and Swiss Reformed worship, it is an aesthetic in which 'everything breathes *simplicity, sobriety,* and *measure* – which are precisely the qualities that Calvinist aesthetics demands of the art-object'.[128] In other words, what, for many others both then and now, are negative aesthetic virtues become, through Calvinism, positive ones. It is not the denial of sensual pleasure, but its redefinition.

The fact that Calvin regarded works of art as a source of pleasure might strike those who read Calvin through the eyes of some Puritans as unexpected, though those familiar with the works of the

[122] Benedict, 'Calvinism as a Culture?', p. 27.
[123] See the discussion in John W. de Gruchy, *Liberating Reformed Theology: A South African Contribution to an Ecumenical Debate* (Grand Rapids; Cape Town: Eerdmans; David Philip, 1991), 103; see also Camille, *The Gothic Idol*, pp. 258ff.
[124] Michalski, *The Reformation and the Visual Arts*, p. 70.
[125] *Ibid.*, p. 71.
[126] Calvin, *Institutes* ii.2.15–16. [127] *Ibid.*, i.11.12, ii.2.16.
[128] Donald Davie, *A Gathered Church: The Literature of the English Dissenting Interest, 1700–1930* (London: Routledge & Kegan Paul, 1978), 25.

New England Puritan divine Jonathan Edwards would not be surprised at all. In England itself, it is true, under the influence of the Puritans and in combination with the monarch's own agenda, 'painting and sculpture virtually dropped out of English lives, except for the collections of the nobility and the crown itself, to which the average person had no access'.[129] While Macaulay's representation of the Puritans as tone-deaf and colour-blind iconoclasts may be a caricature, there was sufficient evidence to make it credible.[130] But Puritans generally did not object to the arts as such (consider the poets Edmund Spenser, Philip Sidney, John Milton and Andrew Marvel), not did they lack appreciation of the beautiful. What they objected to was the adornment of the sanctuary in a way that distracted from the dignity and simplicity of true worship. In any case, the situation varied depending on both local culture and patronage, a not insignificant factor.[131] Many artists were also converts to the Reformed faith.[132] To infer, then, that Calvinism as such lacked aesthetic taste is to misjudge it and give scant recognition to the role of its artists in the development of art in the Western world. Nonetheless, if taken as a whole, the contribution of the Protestant Reformation to Western art has not been chiefly in the field of the visual arts or those, as Tillich remarks, 'in which hearing and seeing are equally important, as in religious dance and religious play'.[133] Its chief contribution has been in the field of music, hymnody and poetry, that is the arts that appeal to the ear and add enrichment to the Word.

Amongst the visual arts perhaps it was architecture which was above all destined to become 'the art form of Protestantism'.[134] Yet Calvin said little about church architecture except that it should be simple and serve the preaching of the Word. All that he would allow was the use of biblical texts to adorn the walls of church buildings, a custom that was widely followed in Reformed churches.[135] Once again, the Word became an image of adornment. Reformed archi-

[129] Dillenberger, *A Theology of Artistic Sensibilities*, p. 73.
[130] See the discussion of art and music in Puritan worship in Horton Davies, *The Worship of the English Puritans* (Westminster: Dacre Press, 1948), 268ff.
[131] Benedict, 'Calvinism as a Culture?', pp. 38ff.
[132] *Ibid.*, p. 36.
[133] Paul Tillich, *Systematic Theology*, Systematic Theology, 3 (Chicago: Chicago University Press, 1963), 200.
[134] Dillenberger, *A Theology of Artistic Sensibilities*, p. 213.
[135] Architecture has played a defining role in the Calvinist tradition. See Finney, *Seeing Beyond the Word: Visual Arts and the Calvinist Tradition*.

tecture, nonetheless, varied considerably depending as much on historical context as on theological principle.

If Calvin said little about church architecture, he did say interesting things about civic architecture and town planning. Calvin, Michalski tells us, 'stressed the importance of "elegance and splendour" in the construction of a city; moreover, he emphasised the necessity of "conformity" between the structure of a city, the spirit and manners of the inhabitants and its architecture'. What is particularly interesting is the affinity between his views, influenced no doubt by the vision of the 'new Jerusalem', his wishes for Geneva, and later models of 'utopian, social and architectonic order'.[136] Art lovers misjudge Calvin and the Calvinist mainstream if they regard them as artistic vandals; they were, in fact, engaged in the reconstruction of society according to a new vision,[137] and this vision embodied a new aesthetic, as became apparent pre-eminently in Scotland, the Netherlands and New England. Daniel Hardy aptly sums up these developments when he says that 'the vitality of the visual arts eventually outstripped the clear principles laid down by the Reformers, allowing the arts to escape the limitations the Reformers placed on them'. But, he continues, it 'would be a mistake to suppose that this points to the inadequacy of the Reformers' views of the visual arts, for they are powerfully self-consistent in their conception of the manner in which God acts in the world, and in drawing its implications for the arts'.[138]

Consider the art of Rembrandt, a product of the Dutch Reformation living and painting in the shadow of that most ultra-Calvinist of all Reformed events, the Synod of Dort.[139] Reared within this tradition, Rembrandt went beyond it, leading it from 'earlier years of groping with the dichotomy of art and faith to the deeper understanding of art as an expression of faith'.[140] Rembrandt's art appropriately for the tradition arose out of a direct encounter with

[136] Michalski, *The Reformation and the Visual Arts*, p. 70; J. Hexler, 'Utopia and Geneva', in *Action and Conviction in Early Modern Europe*, ed. T. Robb (Princeton, N.J.: Princeton University Press, 1969), 77–89.
[137] Eire, *War against Idols*, p. 314.
[138] Daniel W. Hardy, 'Calvinism and the Visual Arts: An Introduction', in *Seeing Beyond the Word: Visual Arts and the Calvinist Tradition*, ed. Paul Corby Finney (Grand Rapids: Eerdmans, 1999), 16.
[139] Tim Gorringe, 'Rembrandt's Religious Art', *Theology* 98 (781) (1995): 15f.
[140] James R. Tanis, 'Netherlandish Reformed Traditions in the Graphic Arts, 1550–1630', in *Seeing Beyond the World: Visual Arts and the Calvinist Tradition*, ed. Paul Corby Finney (Grand Rapids: Eerdmans, 1999), 394.

Scripture, and many of his works, some of them amongst his greatest, focused on biblical themes. Free from the control of the Roman curia, Rembrandt was able to depict these in a way which was not only realistic, but which interpreted the present through the images of Scripture. 'Ecce Homo', Tim Gorringe writes, 'is not a depiction of Christ so much as a meditation on the ambiguities of legal power and a condemnation of the religious fanaticism which Rembrandt knew so well. Gorringe continues:

> In his portrayal of the gospel scenes, Rembrandt turns to stories where the humanity of Jesus – not Jesus as God-Man – is in the foreground . . . In the painting of the risen Lord and Mary Magdalen in the Garden, Jesus is no ethereal figure but a man firmly grasping a spade and wearing a broad-brimmed hat and a pruning knife in his belt. 'I am the Resurrection and the Life' is thus not understood in an otherworldly sense but in an Irenaean way as the joyful affirmation of earth – all marks of the crucifixion have disappeared.[141]

For artists imbued with the spirit of the Reformation, true piety was not to be found in the monastery but in the market place and the home, amidst the ordinary things and events of daily life. The biblical narrative was not a reservoir of dogma giving authority to 'mother church' and enabling its mission, but the uncovering of the dynamics of human relationships, of love and joy, of hope and fear, of the abuse of power and the struggle for truth. This collapsing of the boundaries between the sacred and the secular, while remaining centred on biblical themes, undoubtedly had its antecedents in the Renaissance. But that its images were no longer controlled by a classical past or by saintly icons is nowhere more obvious than in the Netherlands amongst the much later artistic heirs of Calvinism. No one expressed this better than Vincent Van Gogh, the son of a Dutch Reformed pastor who turned to art only when he failed to become a theologian himself. In rejecting paintings of the *Annunciation, Christ in the Garden of Olives* and the *Adoration of the Magi* by his friend Emile Bernard, Van Gogh declared: 'I bow down before that study, powerful enough to make a Millet tremble – of peasants carrying home to the farm a calf which has been born in the fields.'[142]

The impact of the Reformation on art was not confined to

[141] Gorringe, 'Rembrandt's Religious Art', p. 17.
[142] Letter to Bernard, B 21, quoted in Cliff Edwards, 'Pursuing the Elusive Van Gogh', *Christian Century*, 20 January 1999, 56.

Protestant circles, nor was its legacy only appropriated later in some forms of secular art; it also led the Roman Catholic Church to reconsider the nature and role of sacred art. At the outset, this led Catholic theologians to revive the arguments of the Byzantine iconophiles and use them against the Protestants. Sacred art became part of the propaganda struggle for the soul of Western Christendom. This found formal expression during the last session of the Council of Trent in December 1563 when the bishops reaffirmed a commitment to the veneration of images of Christ, the Virgin and the saints, emphasising above all their didactic role. But significantly they also called for a more 'chaste' form of art in the sanctuary:

That the images of Christ, of the Virgin Mother of God, and of the other Saints, are to be had and retained, particularly in churches, and that due honour and veneration are to be given them; not that any divinity, or virtue is believed to be in them on account of which they are worshipped; or that anything is to be asked of them; or that trust is to be reposed in images, as was done of old by the Gentiles who placed their hope in idols; but because the honour which is shown them is referred to the prototypes which those images represent; so that by the images which we kiss and before which we uncover our heads and prostrate ourselves we adore Christ, and we venerate the Saints whose likeness they bear.[143]

This, as the Council fathers pointed out, was in continuity with the decision of the Second Council of Nicaea. So they counselled the bishops of the church to teach carefully 'that by means of the stories of the mysteries of our Redemption, portrayed by paintings and other representations, the people are instructed and confirmed in the habit of remembering, and continually revolving in mind the articles of faith'. Sacred images would also provide examples of God's power to work miracles through the saints and so inspire the faithful 'to adore and love God and to cultivate piety'.

The position adopted at Trent was by no means a baptising of all art, least of all the more pagan art of the Renaissance that had previously found its way into the inner sanctum of the church under its patronage. Works such as Michelangelo's *Last Judgement* in the Sistine Chapel came under increasing attack by the more puritanical

[143] *Canons and Decrees of the Council of Trent*, Session xxv, Tit. 2, quoted in Blunt, *Artistic Theory in Italy*, pp. 107f. The same general position was adopted at Vatican II: see *Sacrosanctum Concilium*, Constitution on the Sacred Liturgy, articles 122–5, Walter M. Abbott, *The Documents of Vatican II* (London–Dublin: Geoffrey Chapman, 1966), 174f. But Vatican II showed greater awareness of the issues and reflected a 'new alliance', as Pope Paul VI expressed it, between the church and artists. *Ibid.*, p. 174, n. 61.

amongst the Roman clergy. There could be no compromise with classical antiquity and paganism.[144] So criteria were now brought into play to ensure that art in the sanctuary was neither heretical nor secular, neither profane nor indecent. 'No image shall be set up', decreed the Council fathers, 'which is suggestive of false doctrine or which may furnish an occasion of dangerous error to the uneducated.'

There was more at stake, however, than ensuring that art was kept within controlled limits; art also had to be produced which would serve the interests of the church. For that reason works of art had to be accurate representations, faithful to the biblical text and tradition; they also had to be chaste. Nudity that, since Augustine, had been a sign of human fallenness could not be tolerated. There could be no 'art for art's sake', nor should there be any delight in the beauty of works of art, but only in the truth they represented. All of this had to do with the 'theory of decorum' which now came into operation. Works of art had to be appropriate to both the subject they represented and to the place in which they were located.[145] Church architecture, likewise, had to follow ecclesiastical and theological rather than artistic considerations. Unlike Protestant architecture, however, it had to be beautiful because God is beautiful; cruciform and not round, because it represented Christ, not paganism.[146] Art and architecture had returned to their role as the handmaids of the church; they were to be undertaken by artists and theologians working in collaboration for the sake of the church's own goals. Nothing demonstrates this better than the work of Gian Lorenzo Bernini, the great architect of High Baroque who was responsible for the colonnades which surround St Peter's Square in Vatican City. Christian Rome and its sculptured apostles had clearly supplanted the emperors of classical Rome.

While the Council of Trent sought to codify the art of the Catholic Church, the position was more ambiguous than in Eastern Orthodoxy and far more open to human creativity. There were also voices within the Catholic Church who were less demanding in seeking to control artists, and who tried to encourage art which appealed as much to the senses as it sought to be faithful in its representation. This was reflected in the dispute over art between the Dominicans,

[144] Blunt, *Artistic Theory in Italy*, pp. 114ff. [145] *Ibid.*, pp. 122ff.
[146] For example, St Charles Borromeo's *Instructiones Fabricae et Supellectilis Ecclesiasticae* (1572). See Blunt, *Artistic Theory in Italy*, pp. 127ff.

with their insistence on purity of doctrine, and the Jesuits, for whom the *Spiritual Exercises* of St Ignatius Loyola provided a model for spiritual reflection and growth through the use of all the human senses.[147] This laid the foundations for that remarkable outburst of Baroque art which occurred in the seventeenth century, encapsulating the triumphalism of Rome.

The flourishing of the arts during the Renaissance coincided with the military, commercial and missionary expansion of Europe into other parts of the world. This influenced the way in which Christendom perceived and evaluated other, alien cultures. What was considered theologically sound and in good taste, whether sacred or secular, was defined on the basis of European experience and debate. 'In Asia', as Andrew Walls remarks, missionary Christianity 'met artistic traditions shaped by other faiths; in Africa traditions that seemed uncouth and barbarous, perhaps childish'.[148] In neither case was Western Christianity really prepared for the task of appreciating and evaluating the religious or aesthetic significance of what it encountered.

THE STRUGGLE CONTINUES

Contemporary interest in iconoclasm on the part of cultural analysts concerned with production and manipulation of mass-media images or the icons of nationalism indicates the range and continuing relevance of the phenomenon.[149] Whether located in a religious context or not, iconoclastic motives are invariably mixed, ranging from sheer vandalism and pathological violence to reasons of high principle. David Freedberg's account includes the desire for publicity; the fear that an image is alive or the desire to demonstrate that it is not; the belief that an image is pornographic; the view that too much wealth relative to social need is invested in a material object; the sense that an image is too beautiful or too stylish to convey its message; and the desire to draw attention to a felt social or personal injustice, or avenge such an injustice by destroying a work that is popularly venerated – or one which has become a particularly

[147] Blunt, *Artistic Theory in Italy*, pp. 134ff.

[148] Andrew F. Walls, *The Missionary Movement in Christian History: Studies in the Transmission of Faith* (New York; Edinburgh: Orbis; T. & T. Clark, 1996), 174.

[149] See, for example, Albert Boime, *The Unveiling of National Icons: A Plea for Iconoclasm in a Nationalist Era* (Cambridge: Cambridge University Press, 1998).

important local symbol.[150] Although the post-apartheid government in South Africa was remarkably restrained in this regard, the removal of colonial and apartheid-era works of art from Parliament and some other public spaces was a form of iconoclasm. But iconoclasm need not necessarily be directed towards a visual image of 'work of art'. Censorship is a form of iconoclasm; book burning another.

John Dillenberger suggests that iconoclasm is about two related but different perceptions, namely when 'art objects are conspicuous enough to challenge other values' and so 'appear to get in the way of competing claims', and when 'the arts are singled out as having extraordinary power'.[151] The producers and venerators of images are, ironically, closer to the iconoclasts than might at first be assumed, for they both recognise the power of images. Their fundamental disagreement is whether that power is divine or demonic, redemptive or destructive. For just as images have the power to do good, they can also do a great deal of harm. Iconophiles revere certain images as sacred (or beautiful) because for them they mediate the divine, bring about healing, and thus renew and sustain society. Iconoclasts reject certain images as idolatrous because they promote evil even though, for the iconoclast, they are vacuous, mere sticks and stones. To return to Baudrillard's observation, the passion with which iconophiles (or advertising agents or political propagandists) defend their sacred images might well hide the subconscious fear that if uncovered there will be nothing behind them and thus the prophets and social critics will be proved right. At the same time, the passion with which iconoclasts set about destroying images often proves disastrous for society, with motives tainted by greed and a lust for power. What cannot be denied is the extent to which the production or destruction of icons and images is bound up with cultural politics and contested ideologies.

The notion of ideology first arose in order to emphasise the power of ideas rather than visual images.[152] Ideology belongs, strictly speaking, to the domain of the word. It expresses perceived truth,

[150] See David Freedberg, *Iconoclasts and their Motives* (Maarssen: Schwartz, 1985); David Freedberg, *The Power of Images: Studies in the History and Theory of Response* (Chicago: Chicago University Press, 1989). For a summary of Freedberg's discussion see his essay 'Iconoclasm and Idolatry', pp. 207–9.

[151] Dillenberger, *A Theology of Artistic Sensibilities*, p. 56.

[152] Camille, *The Gothic Idol*, p. 71.

and legitimates or challenges power through the use of rhetoric, discourse, metaphor or slogan. It is the normal medium of the prophet, preacher, poet or politician. So nothing I have said in this chapter or in those that follow is intended to disparage the importance and power of 'the word'. On the contrary, in a world dominated by consumer images controlled by global economic and military interests, the word of prophet and poet is of critical importance. The issue at stake is not, then, whether we should exalt image over word or vice versa, but rather that we need to recognise the power of images and that they, like words, are always ideological, never neutral, always affirming identity and constructing or undermining social reality. In his study of five dominant icons in African art, Herbert Cole demonstrates how each not only 'touches a few accessible root ideas', but also provides channels for power and ideology.[153] They signify and communicate values and meaning.

Images, however, do not remain static, for they are continually being reworked in the light of changing circumstances even though they generally remain in continuity with the past. Likewise their signification may change over time. Their original meaning may be lost, subverted or hijacked, so that they become sterile and closed in upon themselves in the service of domination and oppression. Hence the prophetic cry against injustice often implies or even promotes the destruction of national icons, for example, in the burning of a national flag.[154] By the same token, the images and symbols which artists create may have the potential to help reconstruct society in terms of the new order, indeed, to represent that new order. In fact, the power of images to change consciousness and bring about social change can be seen by the extent to which authorities go in order to repress them.[155] So we need to recognise that the visual arts can and often do play a socially critical role. It is not only the word of the prophet and poet that challenges injustice, but also the work of the painter, sculptor and architect. Ironically, major advances in art have often been iconoclastic, but for this very reason. Iconoclasm is therefore not necessarily anti-art at all. It is a reaction to and a

[153] These icons are: the male and female couple; the woman and child; the forceful male with a weapon; the rider of horses and other animals; and the stranger or outsider. Herbert M. Cole, *Icons: Ideals and Power in the Art of Africa* (Washington, D.C.: Smithsonian Institution Press, 1989), 12ff., 16off.

[154] Boime, *The Unveiling of National Icons*.

[155] Deborah J. Haynes, *The Vocation of the Artist* (Cambridge: Cambridge University Press, 1997), 50.

rejection of certain images and symbols associated with particular ideologies and powers, values and meaning. This is precisely the point at which Christian theology and aesthetics enter into critical dialogue, and the relationship between Christianity and the arts should be debated. All this anticipates our discussion in chapter 5.

We have travelled a great distance since we began our journey in this chapter. But we return at its conclusion to Pope Gregory's decision to cast the statues of classical Rome into the Tiber, a decision not motivated by aesthetic judgement but by theological conviction. The same conviction has led missionaries throughout the history of the church to reject the cultural artifacts of 'the other' as evil. However, what if images no longer have sacred or demonic power but are now regarded as 'works of art' to be valued for their own sake? Does this neutralise their significance or does it bring other factors into prominence such as wealth and status, factors that concerned the Cistercians in the twelfth century, or Savonarola and Calvin later on? If so, how do we distinguish this from the Nazi attack on 'degenerate art' in Germany in the 1930s? And what about those visual arts, including film, that glorify political power, whether it be colonialism, communism or fascism, or sectarian graffiti which promote violence as in Northern Ireland? Is iconoclasm the only way to respond to what has traditionally been labelled idolatry, or does it lead to the breaking out of other destructive powers? It may be that the fight against idolatry can be managed by a more correct reading of the role of images, of their inevitable presence, and therefore by a more disciplined consideration of the positive as well as negative role they play. We shall return to such issues, especially when we consider the role of art in the public square. But now we must turn our attention to the development of aesthetic theory and the relationship between Christianity and the arts in post-Enlightenment Europe.

The beautiful, the ugly and the holy

John Ruskin, arguably the greatest British art and social critic of the nineteenth century, described the cities created by the industrial revolution in concerned tones and vivid images:

The great cities of the earth, which ought to be the places set on its hills, with the Temple of the Lord in the midst of them, to which the tribes should go up, – centres to the Kingdom and Provinces of Honour, Virtue, and the Knowledge of the law of God, – have become, instead, loathsome centres of fornication and covetousness – the smoke of their sin going up into the face of heaven like the furnace of Sodom, and the pollution of it rotting and raging through the bones and the souls of the peasant people round them, as if they were a volcano whose ashes broke out in blains upon man and upon beast.[1]

Such monstrosities of misguided technology and sinful greed were in strong contrast to the beauty of the surrounding countryside, the beauty of nature. Their brutish ugliness was both a sign and a symptom of human sin. The beauty of nature, by contrast, reflected the holiness of the creator. Such beauty could be reflected in the work of architects if only they pursued their craft in awareness of its shape and form. For Ruskin, this was the achievement of the greatest of all English landscape artists, J. M. W. Turner.[2] As the sub-title to his first volume of *Modern Painters* expressed it, the superiority of Turner and other English painters could be proved with reference to examples in their work of 'The True, the Beautiful and the Intellectual'.[3]

For Ruskin, a deeply spiritual person, artistic creativity was a divine gift. Hence art at its noblest could only arise out of religious

[1] 13 August, 1880, John Ruskin, *Letters to the Clergy on the Lord's Prayer and the Church* (London: George Allen, 1896), 30f.
[2] George Pattison, *Art, Modernity, and Faith* (London: SCM, 1998), 54ff.
[3] J. Ruskin, *Modern Painters*, vol. 1 (1843); see also Ruskin, *The Seven Lamps of Architecture* (1849).

conviction, and its spiritual authority was dependent on the moral
virtue of the artist. Such a view, akin to that which insists that art in
the sanctuary should be produced by artists whose personal life is
consonant with the values of Christianity, no longer carries the same
weight as it did in Ruskin's day. Yet few art critics have raised the
question of the morality of art, of the connection between beauty,
truth and goodness, and by contrast of the connection between
ugliness, falsehood and evil, as sharply as Ruskin. Nor have they
done so in a way that embraced the insights both of aesthetic
judgement and of social criticism.[4] Despite problems with his
theoretical position, caused in part because of his somewhat eclectic
manner, his dual passion for beauty and social justice go to the heart
of our enquiry.

The connections Ruskin made between beauty and moral good-
ness were not, however, as self-evident to those German scholars
who, since the middle of the eighteenth century, were engaged in
developing the new academic discipline of aesthetics. With the
decline in the authority of theology and the abandonment of its
philosophical presuppositions within the academy, the meaning of
art and the relationship between beauty, morality and reason
became matters of contention in a new way.[5] This was particularly
so for those who were Protestant by tradition if no longer orthodox
by conviction. Philosophers and artists alike 'were in search of self-
awareness, of new ground on which to stand', not least because, as
Peter Gay puts it, the 'Christian myth, once and until recently a
fertile source for plays, paintings, and poems, now appeared less
credible, and less creditable, than before'.[6] Like everything else art
was subjected to critical reason. The nature of beauty could only be
discovered in the search for truth. This demanded a new approach
to art, indeed, a new art.

In the previous chapter we explored together certain moments in
the development of the Christian tradition which have had a
formative influence on the way in which Christianity has related to
the arts, but also on the way in which art in the Western world

[4] Although Ruskin and Nietzsche held diametrically opposite world-views, like Nietzsche,
Ruskin eventually also despaired of the human condition; both went insane, and later died
in the same year, 1900.
[5] Andrew Bowie, *Aesthetics and Subjectivity: From Kant to Nietzsche* (Manchester: Manchester
University Press, 1990), 3f.
[6] Peter Gay, *The Science of Freedom*, The Enlightenment: An Interpretation, 2 (London:
Wildwood House, 1973), 219.

developed and gained legitimacy. In what follows, our primary interest is examining some of the key developments in philosophical aesthetics that followed the Enlightenment and that have had a direct bearing on the relationship between Christianity and the arts in the modern period. Chief amongst these has been the secularisation of Western art, its break with its Christian origins, and the Romantic reaction to technical reason in its endeavour to recover the spiritual dimension of art. For what legitimacy does art have if it serves neither the interests of faith nor the practicalities of daily life? To whom or to what is the artist accountable if no longer in the employ of prelate or prince, or in solidarity and communication with the broader society or 'popular culture', but isolated as a 'social outsider' committed solely to art for its own sake?[7]

AESTHETICS OF MODERNITY AND THE ROMANTIC SPIRIT

The relationship between the eighteenth-century Enlightenment and art was intimate, and its significance for the development of art in the Western world was enormous.[8] For the first time in the history of art, philosophers across Europe, especially in Germany, made concerted efforts to develop a scientific approach to the subject. Two major figures stand out in this regard as they do more generally in setting the agenda, Immanuel Kant (1724–1804) and G. W. F. Hegel (1770–1831). But their influence was not confined to philosophical enquiry, for both philosophers had a decisive impact on the way in which Protestant theology in particular developed in response to the issues raised by the Enlightenment.

Alexander Baumgarten, who coined the term 'aesthetics' for the new discipline in his *Reflections on Poetry* (1735), saw it as his task to apply Descartes's 'turn to the subjective' to the field of art.[9] If the only certainty left was the conviction that the self exists ('I think, therefore I am'), and if, also following Descartes the mathematician, truth had to be established according to logical and assessable criteria, then how are we to understand and evaluate the sensory

[7] Hans-Georg Gadamer, *The Relevance of the Beautiful and Other Essays* (Cambridge: Cambridge University Press, 1986), 7.

[8] Ernst Cassirer, *The Philosophy of the Enlightenment* (Princeton, N.J.: Princeton University Press, 1951), 275ff.; Monroe C. Beardsley, *Aesthetics from Classical Greece to the Present* (New York: Macmillan, 1966).

[9] On Baumgarten, see Cassirer, *The Philosophy of the Enlightenment*, pp. 338ff.

perception of the poet? Baumgarten was fully aware of the difference between the scientific and the artistic mind. Yet even though the logic and language of the mathematician and the poet served different ends, they both worked with symbols. The problem was that art, whether poetry and music or painting and sculpture, lacked the necessary precision appropriate to its specific aims.[10] Hence the need for a 'science of sensitive cognition'. But whereas for Baumgarten this was chiefly a matter of epistemology, aesthetics soon came to be equated with the philosophy of art or even more narrowly with the study of beauty. For Kant, Baumgarten was an 'excellent analyst' who cleared the path for the science of aesthetics, but he failed to provide an adequate theory for the art of modernity. This task Kant set out to achieve in his *Critique of Judgement* (1790), even though he 'found music irritating and painting boring!'.[11]

One of Kant's major concerns was to demonstrate how matters of subjective taste could be universally valid. Taste was undeniably a subjective matter; it had to do with that which stirred the individual's imagination and gave the individual pleasure. But aesthetic pleasure, if it is to be of more than random significance, requires the category of the beautiful. The beautiful, Kant argued, awakens pleasure. But how do we define the 'beautiful' when it is a matter of taste? The problem is that there can be 'no science of the beautiful, but only a Critique'. A 'science of the beautiful would have to determine scientifically, i. e. by means of proofs, whether a thing was considered to be beautiful or not; and the judgement upon beauty, consequently, would, if belonging to science, fail to be a judgement of taste'.[12] Taste is subjective by its very nature. At the same time 'fine art' communicates a sense of pleasure that is not just a matter of private sensation, but also one based on reflective judgement. In other words, a taste for the beautiful can be developed and widely recognised even though not everyone will always agree on what it is. Most people would regard a colourful sunset over the Atlantic west of Cape Town as more beautiful than a smog-plagued concrete highway in mid-summer Los Angeles. This is not just a matter of national bias, for the reverse would be true if we changed our examples to those of a Redwood forest in comparison to the concrete

[10] Beardsley, *Aesthetics from Classical Greece*, pp. 156ff.
[11] Gay, *The Science of Freedom*, p. 217. On Kant's aesthetics, see Salim Kemal, *Kant's Aesthetic Theory: An Introduction* (London: Macmillan, 1992).
[12] Immanuel Kant, *Critique of Judgement* (Oxford: Clarendon Press, 1952), 163.

road system that now cuts Cape Town off from the sea. Why, then, is there more or less universal agreement on such matters? Especially given that experience of the beautiful, as that which gives pleasure to the senses, and the judgement of taste that enables us to appreciate such beauty is of a different order from that of rational knowledge and moral action?

Kant points us to nature, for it is the form and coherence of nature, nature as art, which provides us with our knowledge of the beautiful and thereby enables us to evaluate works of human creativity.[13] But there is a fundamental difference between the beauty of nature and that of art. 'A beauty of nature is a *beautiful thing*; beauty of art is a *beautiful representation*.'[14] Our experience of nature often goes beyond the category of beauty to that of the sublime, as when we experience a sunset or a thunderstorm. The pleasure or awe this evokes is innate. But the pleasure we experience in viewing or hearing a work of art is different because such art is the product of genius, and it requires the cultivation of taste to appreciate it. When such taste is cultivated we can reasonably assume that the beauty of the work of art will be widely, if not universally, appreciated. Taste may be subjective, but it is also communicative.

In order to clarify the difference between the beauty of nature and the beauty of a work of art, Kant refers to the way in which 'fine art' (*die schöne Kunst*, literally 'beautiful art') can portray something which, in nature, is ugly, in a way that is remarkably beautiful:

Where 'fine art' evidences its superiority is in the beautiful descriptions it gives of things that in nature would be ugly and displeasing. The Furies, diseases, devastations of war, and the like can (as evils) be very beautifully described, nay even represented in pictures. One kind of ugliness alone is incapable of being represented conformably to nature without destroying all aesthetic delight, and consequently artistic beauty, namely that which excites *disgust*.[15]

Art, then, is not the same as nature, for it is dependent upon human skill; it is not science or handicraft, even though it demands discipline and technical expertise. True or 'fine art', 'beautiful art', Kant insists, requires *soul*, in fact, a *free* soul, for this alone can give life to the work. But it also requires the ability to present *aesthetic*

[13] Bowie, *Aesthetics and Subjectivity*, p. 31.
[14] Kant, *Critique of Judgement*, p. 167. [15] *Ibid.*, p. 168.

ideas, that is the faculty to represent what is imagined in such a way that it evokes not just pleasure but also critical reflection or taste. And taste, which is 'the discipline (or corrective) of genius', not only 'clips its wings, and makes it orderly and polished; but at the same time it gives it guidance, directing and controlling its flight, so that it may preserve its character of finality'.[16]

Despite critical reflection, taste remains taste and therefore subjective, the product of works of genius and the imagination. This, Kant argues, requires that we recognise the difference between aesthetic judgement and judgements of scientific rationality or ethical values and goals. This leads him to conclude that art is an end in itself, something that we may enjoy in private. Pleasure in the beautiful is disinterested and non-utilitarian. We appreciate and enjoy the beautiful simply because it is beautiful. It is 'disinterested delight' in that art serves no other purpose than to provide such enjoyment.[17] This is similar to Calvin's verdict that the only purpose of works of art is to give us pleasure. In other words, they do not serve a 'sacred' or any other end. If this is so, then differences of opinion with regard to 'the beautiful' cannot be resolved through rational argument or an appeal to what is moral. Indeed, good public order requires that differences of aesthetic taste and judgement be allowed. Science and ethics, on the other hand, Kant continues, are teleological: they serve goals beyond themselves which are of public consequence.

The Kantian notion of 'disinterestedness', whereby subjective taste and universal judgement are reconciled, is an important one as long as we do not make it absolute. If adopted, it prevents art from being ideologically abused. By the same token, according to Kant, sensuous knowledge must not be allowed to control our reason and determine our morality, for then truth and goodness would be subject to the vagaries of subjective taste. While beauty may be in the eye of the beholder from a Kantian perspective, truth and goodness dare not be relativised in the same way. The ban on idolatry in the Ten Commandments is necessary in order 'to prevent the imagination running riot in the production of sensuous images'.[18] So while Kant argued for the autonomy of art in order to prevent its public abuse, it was also to ensure that the aesthetic

[16] *Ibid.*, p. 183. [17] Gadamer, *Relevance of the Beautiful*, p. 19.
[18] Bowie, *Aesthetics and Subjectivity*, p. 37.

would not impose itself on the spheres of knowledge and morality. J. M. Bernstein sums up this twofold significance:

In securing an autonomous domain of aesthetic judgement, a domain with its own norms, language and set of practices, Kant was simultaneously securing the independence of the domains of cognition and moral worth from aesthetic interference.[19]

This separation of spheres is a benchmark of modernity. Beauty, truth and goodness must 'develop their own self-sufficient practice: modern science and technology, private morality and modern legal forms, and modern art'. This 'categorical separation of domains represents', so Bernstein observes, 'the dissolution of the metaphysical totalities of the pre-modern age'.[20] With Kant, art has been privatised and secularised. If the iconoclasts literally removed art from the sanctuary and destroyed its sacred power, Kant provided the theory for those Protestants who enjoyed the pleasures of art in a 'world come of age'. Art had nothing to do with either dogma or ethics. Moreover, the distinction between 'fine art' or 'high art', and what might be called 'popular art', and art as distinct from craft was now firmly entrenched in the post-Enlightenment Western consciousness.

Kant's philosophy has had considerable influence on the development of liberal Protestant theology. But just as his moralising of Christianity eventually failed to satisfy the human spirit in its search for meaning and redemption, so his privatising of art failed to satisfy those for whom art had a deeper than secular and broader than private significance. As Gadamer puts it: 'the question of how one can do justice to the truth of aesthetic experience and overcome the radical subjectivisation of the aesthetic' that began with Kant had to be addressed. It was precisely at this point that Hegel made his major contribution by recognising that the truth that lies in every artistic experience is mediated with historical consciousness. 'Hence aesthetics becomes a history of world-views, i. e. a history of truth, as seen in the mirror of art.'[21]

Hegel gave his first series of lectures on *Aesthetics* (published as the *Philosophy of Art*) in Heidelberg in 1817, demonstrating both a wide knowledge of the history and theory of art and a rich artistic

[19] J. M. Bernstein, *The Fate of Art: Aesthetic Alienation from Kant to Derrida and Adorno* (Oxford: Polity Press, 1992), 5.
[20] *Ibid.*, p. 6.
[21] Hans-Georg Gadamer, *Truth and Method* (New York: Crossroad, 1988), 87.

experience and appreciation. If Kant had little personal interest in
the arts, the same was not true of Hegel. Described by Ernst Bloch
as 'almost a latent painter, sculptor and dramatist', Hegel 'appears
among his peers, present and alive *in the very midst of art*'.[22] It was, as
it were, from inside the field that Hegel developed his aesthetic
theory. Hegel's Idealism, imbued with the new spirit of Romanticism
in revolt against Rationalism, sought to unify what had been
separated in a majestic and all-embracing synthesis. God as *Geist*
(Absolute Spirit), not as ethical postulate or metaphysical principle
but as free, life-giving, intersubjective and creative energy, realises
itself in history through human consciousness and its activity, expres-
sing itself in religion through spiritual representation (*Vorstellung*), in
philosophy in speculative concept (*Begriff*) and in art in the shape of
sensible intuition (*Anschauung*).[23]

For Hegel, beauty is the manifestation of *Geist* in sensuous form.
Such beauty is to be found in works of art rather than in nature. In
order to appreciate it, to grasp its significance, it is necessary to
know the symbolic conventions that are employed in describing it.
This is what aesthetics is about. The clue is the recognition that the
human struggle for spiritual freedom finds its expression in the
'universal need for art'. Men and women satisfy their need for
spiritual freedom by making explicit what is within themselves and
correspondingly by giving outward reality to their selves, thereby
bringing what is internal into sight and knowledge both for them-
selves and for others. Works of art are expressions of human
consciousness; they arise precisely because human beings are ra-
tional, thinking beings. Through art, as through religion and
philosophy, the mind comes to know itself. Or, to put it in Hegel's
own words: 'man draws out of himself and puts *before himself* what he
is and whatever else is'.[24] Art, then, serves Apollo's advice that we
should learn to know ourselves. Yet it is not just self-knowledge that
is at issue, but also the consciousness of the human race.

If *Geist* articulates itself in art, then the history of art is the
manifestation of the dialectical unfolding of its self-realisation in

[22] Quoted in Hans Küng, *The Incarnation of God: An Introduction to Hegel's Theological Thought as Prolegomena to a Future Christology* (New York: Crossroad, 1987), 338.

[23] Peter Hodgson, *G. W. F. Hegel: Theologian of the Spirit*, The Making of Modern Theology (Minneapolis: Fortress Press, 1997), 6ff., 137. Hodgson provides some of the key texts in his selection from Hegel's *Encyclopedia* on 'Absolute Spirit: Art, Revealed Religion'.

[24] G. W. F. Hegel, *Aesthetics: Lectures on Fine Art, Vol. 1* (Oxford: Clarendon Press, 1975), 31.

sensuous form. Hegel points first to the ancient art of India and Egypt, labelled *symbolic art*, with the Sphinx as its symbol. While such art embodies *Geist*, it does so in a way that is crude and profuse. The second stage in the historical development of art is the *classical art* of ancient Greece, an art form that freely and adequately embodies *Geist*. A block of marble is transformed by Spirit 'into a sensuous representation of itself'.[25] The third, and for Hegel, the final stage is that of *Romantic art*, in which *Geist* is grasped in its 'infinite subjectivity' and 'absolute inwardness' in such a way that it cannot be sensually represented. Such art, which brings the arts, as previously known, to their climax and end is, for Hegel, best expressed in music and poetry. These stand at the pinnacle of the hierarchy of arts, with architecture and the plastic arts at the base. But it is also the art that is most appropriately spiritual and Christian, for it 'often takes as its theme the very inadequacy and insufficiency of bodily beauty; representations of the crucifixion, for example, can be seen as negations of the perfect, unblemished bodies of Greek sculpture. If classical art is supremely beautiful, romantic art is more spiritual.'[26]

Hegel's thought was undoubtedly influenced by Luther's 'theology of the cross' seen through the lenses of Greek mythology and Romanticism.[27] God freely chose to enter nature, to become flesh, and thereby to experience the agony of self-alienation until, through resurrection and ascension, God is reunited. This is the perspective necessary for understanding beauty.

Christ scourged, with the crown of thorns, carrying his cross to the place of execution, nailed to the cross, passing away in the agony of the torturing and slow death – this cannot be portrayed in the forms of Greek beauty; but the higher aspect in these situations is their inherent sanctity, the depth of their inner life, the infinity of grief, present as an eternal moment in the Spirit as sufferance and divine peace.[28]

The story of the passion provides the Romantic artist with subject matter that most profoundly expresses the embodiment of *Geist*. This narrative, rather than the norms of Classical art or enlightened reason, provides the criteria for beauty and the way in which it is represented. Yet the resurrection and ascension, through which *Geist*

[25] Bowie, *Aesthetics and Subjectivity*, p. 136.
[26] Gary Shapiro, 'Hegel, Georg Wilhelm Friedrich', in *A Companion to Aesthetics*, ed. David E. Cooper (Oxford: Blackwell, 1992), 185.
[27] Küng, *The Incarnation of God*; Bowie, *Aesthetics and Subjectivity*, p. 138.
[28] 'Art, Revealed Religion, Philosophy' §537, in Küng, *The Incarnation of God*, p. 343.

is reunited with itself, is precisely the reason why art cannot portray the ultimate, why the material finally cannot represent the Absolute. The Christian Idea, Hegel contends, 'cannot be pictured by art in sensuous terms'.[29] In continuity with the Decalogue's ban on images, therefore, he insists that God 'should be known as *Geist* and in *Geist*. His element of existence is thereby essentially inner knowledge and not the external form via which he will only be representable immediately and not according to the whole depth of his concept'.[30]

Romantic art, like the Gothic art of the Middle Ages that often inspired it, was originally, as Hegel describes it, more explicitly Christian. Gradually it became secular in character, emphasising themes which have to do with the knightly life of chivalry – honour, love and fidelity – and then with the 'formation of modern characters . . . that have an independence and freedom not known in art's earlier phases'. Hegel's claim, writes Gary Shapiro, 'is that the Romantic concentration on inwardness and subjectivity' then 'led to a condition in which art is no longer determined by any specific content; rather, the artists themselves' are 'liberated through criticism and reflection', and become 'radically free in their choice of styles and themes'.[31] In a wonderful description of the work of Dutch masters such as Rembrandt, Van Dyck and Wouwerman, Hegel gives us an account of what Romantic art is really about:

[W]ith the Dutch in their taverns, at weddings and dances, at feasting and drinking, everything goes on merrily and jovially, even if matters come to quarrels and blows; wives and girls join in and a feeling of freedom and gaiety animates one and all. This spiritual cheerfulness in a justified pleasure, which enters even pictures of animals and which is revealed as satisfaction and delight – this freshly awakened spiritual freedom and vitality in conception and execution – constitutes the higher soul of pictures of this kind.[32]

Such art, for Hegel, is neither sacred nor religious, but neither is it secular in the sense that it is bereft of spiritual import. On the contrary, it is profoundly spiritual in that it expresses the human yearning for freedom, for life, for joy, all integral to *Geist*. Yet art itself can never be a substitute for true religion, a powerful tendency in Romanticism. Romantic or 'fine art', Hegel writes, is 'only a stage

[29] Quoted in Küng, *The Incarnation of God*, p. 336.
[30] Quoted from Hegel's *Aesthetics* in Bowie, *Aesthetics and Subjectivity*, p. 136.
[31] Shapiro, 'Hegel', p. 185. [32] Hegel, *Aesthetics: Vol. 1*, pp. 169f.

FOR G. LEADS TO THE BEAUTY OF
HUMAN RELATIONSHIP

in liberation, not the supreme liberation itself'.[33] However signifi-
cant, art cannot be ultimate. 'Fine art has its future in authentic
religion'.[34]

In his essay on 'The Meaning of the Creative Act' Nicolas
Berdyaev compared classical or 'canonical art' to Romantic art in a
way which helps us to understand better why Hegel and others such
as Ruskin regarded the latter as Christian in origin and ethos.
Classical art, Berdyaev argued, sought to reproduce reality and as
such 'it contains much that is eternal and deathless but also much
that is all too temporal, confining, reactionary in the deepest sense of
the word'. While it may be 'the eternal source of creativeness and
beauty' it may also 'become a confining conservative force, hostile to
the spirit of prophecy'.[35]

In Christian art there is always a transcendental intention towards another
world, towards an upsurge beyond the limits of the immanent world; there
is romantic longing . . . Romantic Christian art sees unearthly beauty in
imperfection, in the lack of finality itself, in this groping toward an upsurge
beyond the limits of this world. Christian art does not leave us in this world,
in beauty already finally attained, but leads us out into another world, with
beauty beyond and outside the limits of this.[36]

The idea of the Romantic and its origins in Christianity was first
developed by Hegel's compatriot, August Wilhelm Schlegel, in his
Berlin and Vienna lectures in 1809–11. Beardsley summarises
Schlegel's argument: 'Romantic poetry embodies a striving for the
infinite; it stems from Christianity, and is marked by inner division of
spirit, a sense of a gap between actual and ideal, hence an unsatisfied
longing'.[37]

While Romanticism might have had its roots in medieval Chris-
tianity, the Romantics were not Christian in any dogmatic sense if
they were Christian at all. But they were deeply spiritual and
established a tradition of art that inculcated and transmitted spiritual
values that have endured well into our own time. Romanticism also
struck deep chords in the hearts of many Christians who felt
constricted by the rationalism of the Enlightenment, the moralism of
Kant and the dogmatism of Orthodoxy. Friedrich Schleiermacher,
himself a Reformed theologian, was but one, though pre-eminent

[33] 'Art, Revealed Religion, Philosophy' §562, in Hodgson, *Hegel*, p. 142.
[34] *Ibid.*, p. 143.
[35] Nicolas Berdyaev, *The Meaning of the Creative Act* (London: Victor Gollancz, 1955), 229.
[36] *Ibid.*, pp. 228ff. [37] Beardsley, *Aesthetics*, p. 245.

amongst them as the pioneer of nineteenth-century liberal Protestant theology. But Romanticism comprised various strands all striving to express the deepest human emotions across the artistic and intellectual spectrum of Europe in the nineteenth century.

Despite its conceptual elusiveness, we can identify several features that enable us to grasp Romanticism's significance for aesthetics and our theme.[38] The first was a change in basic values, giving strong emphasis to the senses. What was important for a work of art was not its classical form and balance, but its expression of the inner emotions of the artist. Of all the arts, music (Beethoven, Wagner) and poetry (Goethe, Hölderlin, Novalis, Wordsworth, Coleridge, Blake, Shelley and Keats) were regarded as most able to communicate the deep, inner feelings of the artist. For Romanticism it was the 'poet's state of mind, the spontaneity and intensity of his emotions', which was the focus of attention.[39] But the same was true for those landscape painters, such as Turner and Constable, who discovered in nature intimations of transcendence which resonated deeply with their own inner being.

This sense of transcendence indicates a second feature of Romanticism. Whereas the Enlightenment had privileged reason and empiricism, Romanticism sought the truth through emotional intuitionism. Art provided its own way of gaining access to the truth; it was the way of 'imagination', a secular equivalent of Orthodox icons. This included the faculty not only of 'inventing and reassembling materials, but . . . of seizing directly upon important truth'.[40] Grasping the truth and creativity went together, for 'on the one hand nothing can be known without being to some degree molded by the knower, and on the other the imagination cannot invent anything, however wild, without seeing something new'.[41] Art was essentially a spiritual activity of discerning what was being revealed primarily in nature, and in expressing what was experienced through the act of creative imagination.

A third feature of Romanticism was its sense of organic wholeness, a notion especially developed in England by Coleridge and Blake and in Germany by Herder and Goethe. What it meant was 'a deep sense of the organic unity of all nature, and of man as a part of nature, and of works of art, as growing out of, and expressing, man's

[38] *Ibid.*, pp. 246ff. [39] *Ibid.*, p. 248. [40] *Ibid.*, p. 253. [41] *Ibid.*, p. 254.

unity with nature'.[42] Of course, while the Romantics had a deep awareness of the beauty of nature, they also sensed its cruelty. Their artistic vocation, like that of the creator, was to bring order out of chaos through the powers of imagination and creativity, yet not standing outside the world but within as part of it. The theological consequences of this were invariably panentheist if not pantheistic. Humanity's relationship to nature was not to be understood in terms of difference and separation, which was the philosophical basis of the natural sciences and technology (including the camera, which could 'freeze' nature as an object of observation), but organically. Unlike photography, which developed during this period, art was not meant to represent nature but was the medium through which the artist received inspiration at once from beyond and from within.

In summary, Romanticism was intent on creating a new consciousness, some might even say a new *religious* consciousness. This was particularly true of German philosophical Romanticism, associated with J. G. Hamann, J. G. Fichte, Friedrich Hölderlin, Novalis and Schlegel, which anticipated Nietzsche in attempting to replace what they regarded as a largely discredited theology (whether sterile orthodoxy or rationalist religion) with a new mythology that was, at least for some, post-Christian. Central to this mythology was the god Dionysus, a source of fascination for the early Hegel. 'Don't enter the metaphysics of the arts', exclaimed Hamann already in 1762, 'without being versed in the orgies and Eleusinian mysteries. But the senses are Ceres, and Bacchus the passions; – the old foster parents of beautiful nature.'[43] Romanticism was 'analogous to Dionysus, the God who combines creation with destruction'[44] in an endless process. The shades of Dionysus are omnipresent, yet held in check by the spirit of Apollo so that freedom does not degenerate into licence and destroy itself. 'Not at different moments', wrote the Romantic philosopher Schelling, 'but at the same moment to be simultaneously drunk and sober is the secret of true poetry [*Poesie*]. This distinguishes the Apollonian enthusiasm from simply Dionysian enthusiasm'.[45] Romanticism's 'spirit of prophecy', to use Berdyaev's phrase, resonates with the Dionysian tradition and the spirit of Parnassus' Muses. None of this

[42] *Ibid.*, p. 259.
[43] Quoted from his *Aesthetica in Nuce*, in Bowie, *Aesthetics and Subjectivity*, p. 55.
[44] Bowie, *Aesthetics and Subjectivity*, p. 56.
[45] Schelling, *Philosophy of Art*, II/4, 25, quoted in Bernstein, *The Fate of Art*, p. 222.

is surprising since Romanticism was responsible for the retrieval of
classical mythology, and of myth as an epistemological category.
Goethe and Wagner are prime examples, as are Schlegel and
Schopenhauer, and the latter's protégé Nietzsche. Thus, with Ro-
manticism, we finally return in our discussion to Nietzsche's chal-
lenge to Christianity, with which we began in our first chapter.

Nietzsche's thought goes through several permutations that reflect
what Bernstein refers to as 'bewilderingly diverse views' and areas of
'baffling complexity'.[46] But it is not necessary to unravel the
intricacies of Nietzsche's intellectual and emotional struggles in
order to discover the roots of his Dionysian challenge to Christianity
and the arts. Nor do we have to accept his largely inadequate
answers in order to appreciate the importance of his questions. For
Nietzsche, as for much of Romanticism, the aesthetic had to be
separated from ethics and science, as Kant had decreed, but for a
different purpose. For Kant it was largely to prevent the aesthetic
from controlling reason and morality; for Nietzsche it was to prevent
reason and morality from controlling the aesthetic. Reason was,
after all, an illusion, and morality, now that 'God is dead', had lost
its categorical claims. Meaning, if there is any, can only be found in
pursuit of the aesthetic. If this is the case, then great art has nothing
to do with ethics.

The separation of aesthetics and ethics, or art and morality,
eventually had frightful social and political consequences, especially
when combined with the 're-birth of German myth',[47] 'social
Darwinism' and Nietzsche's doctrine of the 'will-to-power' (*Über-
mensch*) as the basis for action. Even though Nietzsche later turned
anti-nationalist and broke with Wagner, the damage had been done.
Although we cannot blame Nietzsche alone for providing the
foundations of Nazism (Hegel's shades are certainly also evident), he
made a major contribution. And, in so far as these same Romantic
nationalist views, combined with a twisted interpretation of Calvin,
provided the ideological basis for apartheid in South Africa, all this
has a significance beyond Europe. Nietzsche's Romanticism remains
a constant reminder of the inevitably horrendous and tragic political
consequences of placing the mythologically inspired interests of
'blood and soil' over the constraints of reason and morality. If art is
to contribute to the process of just social transformation, it dare not

[46] Bernstein, *The Fate of Art*, p. 224. [47] *Ibid.*, p. 225.

go this route. The aesthetic has to be grounded elsewhere than in the spirit of Apollo and Dionysus, however much it may listen to the Muses. Bernstein sums it up:

The reason for Nietzsche's importance is precisely that he illustrates the extremes which result from the divorce of aesthetics from metaphysics. It is the problem of most modern art. The divorce leads to contradictions which Nietzsche often tries to ignore, not least by re-introducing metaphysics in the form of the will to power. What, though, is the serious alternative in aesthetics when its metaphysical ground has been removed?[48]

The problem lies, on the one hand, in the fact that art and the aesthetic has lost its traditional theological foundations, but on the other, in the fact that if art is to flourish and to serve the humanising transformation of society truly, it cannot be made subject to ideological control. The arts were able to flourish in ways not possible before once they had dissociated themselves from the constraints of religion. But having become secularised, as Theodor Adorno, a leading figure in the Frankfurt School and pioneer in modern aesthetic theory, observed, 'art was condemned, for lack of any hope for a real alternative, to offer the existing world a kind of solace that reinforced the fetters autonomous art had wanted to shake off'.[49] In pursuing independence, art, especially bourgeois visual art, forfeited its social role. In order to recover that role aesthetics has to be reconnected with truth and morality without becoming subject to ideological control.

From a Christian perspective it is equally essential to reconnect art and theology. For that purpose let us revisit Mount Parnassus in company with P. T. Forsyth, the British Congregationalist theologian who was amongst the first of the modern theologians to embark on this task. It should be added that Forsyth's thought has attracted me personally since my student days, and much of what follows, though dated in certain respects, resonates with my own convictions.

CHRIST ON PARNASSUS REVISITED

Forsyth (1848–1921), regarded by some as a forerunner to Barth, by others as a combination of Paul Tillich and Reinhold Niebuhr, and most recently as a theologian for the new millennium, provides a

[48] *Ibid.*, p. 252.
[49] Theodore W. Adorno, *Aesthetic Theory* (London: Routledge & Kegan Paul, 1984), 2.

helpful bridge between Romantic aesthetics and Reformed Christianity.[50] Influenced most by his Puritan heritage and the more contemporary theologies of F. D. Maurice in England and Albrecht Ritschl in Germany, his thought reflects a much wider critical reading of major literary and philosophical figures in post-Enlightenment Britain and Germany. Not least amongst these are Kant and Hegel, but others include the novelists and poets George Eliot, Hardy, Browning, Milton, Carlyle, Ibsen and Goethe, the art critic Ruskin and the German philosophers Lessing, Schelling, Schopenhauer and Nietzsche. Quite apart from his specific writings on art and aesthetics, Forsyth's work provides a unique blend of liberal Protestant theology's positive appraisal of the achievements of Western culture and an evangelical Calvinism with its sense of God's holiness, human sinfulness, and the need for redemption by grace alone.[51] What binds all this together is Forsyth's profound belief in the moral order of the universe seen both in the power of the human conscience and in the righteous demands of a holy God. The critical distinction between Athens and Jerusalem, Forsyth argues, is not one of hostile repulsion but of creative tension within the womb of Christianity that gives birth to the best in Western culture.

Forsyth's work on art and aesthetics reveals a remarkable knowledge of the history of art and art criticism, as do passing references elsewhere in his writings. *Religion in Recent Art*, based on a series of popular 'lay sermons', as Forsyth labelled them in his Preface, was the first of his many books to be published (1887), though reprinted several times. His more scholarly *Christ on Parnassus*, published at the height of his career in 1911, is not widely read even by those who keep an interest in his theology alive. Both books reflect the pre-1914 Western Christian cultural optimism of Forsyth's generation. They also reflect the extent to which middle-class Protestant Christianity found an affinity with the pre-Raphaelite movement. Yet we can already detect in them, especially in his later writings, the note of God's holy judgement which became such a central theme in his later theological development. His scepticism about the utopian doctrine of inevitable progress, and his prophetic critique of his own

[50] See Ralph C. Wood, 'Christ on Parnassus: P. T. Forsyth Among the Liberals', *Journal of Literature and Theology* 2, no. 1 (March 1988): 83–95; *P. T. Forsyth: Theologian for a New Millennium*, ed. Alan P. F. Sell (London: United Reformed Church, 1999).

[51] On Forsyth's intellectual background, see W. L. Bradley, *P. T. Forsyth: The Man and his Work* (London: Independent Press, 1952), 90ff.

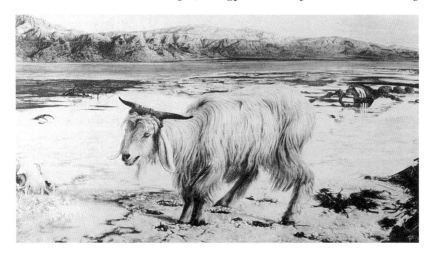

1 *The Scapegoat.* Holman Hunt (1854–6)

society, surfaces time and again in his writings. But first let us consider some of the themes of his lectures on the pre-Raphaelites Rossetti, Burne-Jones, Watts, Holman Hunt (see plate 1), and the Romantic composer Richard Wagner published as *Religion and Recent Art.*

Christianity, I would affirm with Forsyth, provides an interpretative framework from within which we can understand art without denying art its own legitimate sphere of autonomy.

The content of Art, being in the nature of Inspiration, must not be limited to the direct and conscious horizon of the artist. It is of no private interpretation – even when the artist himself expounds. We must indeed avoid and reprobate interpretations which are as alien to his intention as the chief baker's three baskets are to the doctrine of the Trinity, or the 'badgers' skins dyed red', in Exodus, are to the Atonement. But while we refuse to do violence to the text, we must equally refuse to go no further than itself on its own road . . . The great spiritual products of an age or a civilisation reflect something much more than their artist or even their art.[52]

If we are to 'get a true taste for Art afloat as a social power' then we must feel free to discover in it perhaps more than the artist intended.[53] Great art speaks to the soul, and while it may oust

[52] P. T. Forsyth, *Religion in Recent Art* (London: Hodder & Stoughton, 1905), ixf.
[53] *Ibid.*, p. x.

religion, it can also save religion from becoming closed and hardened. Both art and religion need each other if they are to avoid sentimentalism: faith cannot find an escape from moral challenge in beauty, nor can beauty find an escape in faith without moral commitment. Without devotion and intelligence 'Art will not be rich or high . . . Bald devotion and trivial art are alike symptoms of that spiritual poverty which underlies the hard-featured piety of our pushing Christian type.'[54] The subtitles to Forsyth's lectures convey a great deal. Rossetti's art is that of 'the religion of natural passion'; Burne-Jones is 'the religion of praeternatural imagination'; Watts is 'the religion of supernatural hope'; the two on Holman Hunt are about 'the religion of spiritual faith', and the first on Wagner is simply sub-titled 'pessimism', while the second is on Parsifal. Perhaps nothing better conveys the spirit of Romanticism understood as spiritual and even Christian, though Forsyth is aware that the two are not the same.

 Forsyth's phrases often lack precision and sometimes historical accuracy, yet amidst his rhetoric there is penetrating insight into some of the key issues that concern us.

In Greece it was Art that destroyed Religion; in Europe it was Religion that destroyed Art. In Greece, the people, in the name of Beauty, ceased to believe; in Christendom, the people, in the name of Truth, ceased to delight and enjoy. In Greece, Faith sank as taste spread; in Christian Europe, Faith rose and taste decayed.[55]

In Greece, then, Art slew the Religion; in Christian Europe the Religion slew the Art. In Greece the Imagination destroyed the Conscience, in Europe the Conscience paralysed the Imagination. But again mark the difference. Art cannot revive Religion; Religion can revive and regenerate Art. Art may be the *vehicle* of the Spirit; Religion is the *power* of the Spirit . . . Give us power in the Spirit, and then Art will come; but the taste for Art will not arrest the decay of the Spirit.[56]

The influence of Hegel is obvious and becomes more explicit in *Christ on Parnassus*, where Forsyth situates the various art forms in hierarchical order from architecture to poetry, assuming the correctness of Hegel's interpretation of the history of art. Christianity, Forsyth argues, provides the creative synthesis for the dialectical interaction between ancient Greek and ancient Hebrew culture. There is a never-ending struggle between spirit and nature in which

[54] *Ibid.*, p. xi. One can only guess at what 'pushing Christian types' really are!
[55] *Ibid.*, p. 2. [56] *Ibid.*, p. 3.

the material is always striving to achieve its freedom from the constraints that bind it to the earth. Such an Idealist understanding of the development of Western culture is open to serious critique and is no longer tenable, at least along such lines.[57] But as George Pattison reminds us, Forsyth does not accept Hegel's conclusion, namely that art, in the unfolding historical process, is left behind as belonging to the past.[58] For Forsyth, history remains open-ended. Art is as much part of the present and future as it is of the past.

Forsyth's insistence that while art may enhance faith it cannot make people religious is a clear statement that grace and not nature saves, and that God's glory in nature can only be truly discerned with the eyes of faith. Yet he is equally insistent that faith without a sense of beauty, or a religion severed from imagination and 'over-engrossment with public and practical affairs', leaves us with 'a drought in our own souls'.[59] It no longer evokes a sense of wonder. Art, in fact, is 'not a luxury' but 'a necessity of human nature'. Thus no 'religion can be a true religion if it does not encourage great art'.[60] This explains the importance of the pre-Raphaelite artists he chooses for consideration. For however we assess their technical ability, 'they are prophets as well as painters, and to no small extent apostles and martyrs' – a remarkable compliment when the faith and morals of some were open to suspicion. We shall return to this issue in chapter 5.

Forsyth sees their achievements in continuity with the work of 'those great first realists Giotto and Cimabue, who began to lift Italian art to its glory from the inanities of Byzantine convention-alism and ecclesiastical pomp'. In making this claim, Forsyth, possibly implying the use made by the Orthodox iconophiles of the doctrine of the incarnation, turns it around in defence of his own argument. Deism certainly is incompatible with Art.[61] And spiritual does not mean 'something vague, shadowy, and unsubstantial', but has to do with the Christ of history, with God who is 'artist enough to reveal his heart in concrete human form'.[62] What the great Italian artists and the pre-Raphaelites have achieved in contrast to Orthodox iconographic convention and Protestant spiritualising is 'to humanise the unspeakable sanctities, to set the Incarnation forth as a real, concrete historic principle'. The 'principle of art', Forsyth

[57] See Pattison, *Art, Modernity, and Faith*, p. 80. [58] *Ibid.*, p. 98.
[59] Forsyth, *Religion in Recent Art*, p. 7. [60] *Ibid.*, p. 145.
[61] *Ibid.*, pp. 142f. [62] *Ibid.*, pp. 151f.

continues, 'is the incarnation of God's eternal beauty; the principle of religion is the incarnation of God's eternal heart'. At the same time, Forsyth is critical of Michelangelo and Rubens because they make the bodily form heroic, and turn the apostles into 'lords of the superman rather than the God Man'.[63]

In Forsyth's opinion, the greatest Protestant artist, comparable to Bach as Protestantism's greatest composer, was Holman Hunt, and it is in his chapters on Hunt that he speaks most clearly about 'Christian art'. That there is such a thing derives from the fact that there 'is a distinctive Christian interpretation of the world and the soul'.[64] For this reason, however highly he ranks Hunt's work, Forsyth expresses the conviction that great Christian art requires the recovery of the ethos of the Middle Ages. That is when 'we possess a theology which is not only tolerated by public intelligence, but is welcome for the life, and commanding for the reason, and fascinating for the imagination of the age'.[65] A catholic rather than a sectarian spirit is necessary, hence Forsyth's bother about a Nonconformity which has no aesthetic sensibility.[66] Yet equally the prophetic dimension of Reformation Christianity must not be lost, for imperialism and nationalism are the death of true art and religion.[67] Thus Forsyth boldly declares: 'the most distinctively Christian art is art based on Protestant principles and the doctrine of the resurrection'.[68] For Forsyth, the great Catholic artists, Dante amongst them, are really crypto-Protestants! But what are the principles to which he refers? Reverent fidelity, spiritual veracity, thirst for truth, passion for reality, and an 'inability to enjoy any beauty which had the flavour of carelessness or insincerity'.[69] Such is the canon of good Protestant taste.

Forsyth's theology matured considerably during the years that separated *Religion in Recent Art* from his *Christ on Parnassus*. But certain themes remain, if somewhat deepened by further reflection. In keeping with his strong emphasis on the moral nature of the gospel, the holiness of God, the uniqueness and self-emptying (kenosis) of Christ, and the cruciality of the cross, Forsyth insists that the very notion of beauty has been moralised by the beauty of holiness revealed in Jesus Christ. As a result, while Christian theology still insists that 'Art must be beautiful', it also gives 'a wider scope to

[63] P. T. Forsyth, *Christ on Parnassus* (London: Hodder & Stoughton, 1911), 105.
[64] Forsyth, *Religion in Recent Art*, p. 147. [65] *Ibid.*, p. 149. [66] *Ibid.*, p. 150.
[67] *Ibid.*, p. 161. [68] *Ibid.*, p. 162. [69] *Ibid.*, p. 162.

Beauty through a new treatment of sorrow, and a deeper significance for Love. We have expanded the whole modern canon of what beauty is through the Christian beauty of holy, saving sorrow.'[70] He writes:

Art dies if it be severed from this moral passion in any community. And the centre, source, and supreme object of moral passion is Christ; whom we love, not simply because of his moral beauty, but because of his moral victory for us, for our forgiveness, and the release of the world's conscience from guilt and doom.[71]

For this very reason, Forsyth argues, 'no man does justice to beauty till he feel the moral beauty of resisting beauty – upon due occasion'.[72] This insight anticipates my discussion of the 'alien beauty' of the cross in the next chapter.

Forsyth would undoubtedly have chosen Christ rather than Apollo or Dionysus, if that was the only choice, and he said as much. But as the title of his book suggests, he would have preferred Christ and the Greek Muses, though always subservient to Christ. The fact is, great art and true religion are complementary and Forsyth wished that 'the divorce between them were more nearly healed'.[73] Acknowledging that much Western art had lost touch with its religious source, advocating the holiness of beauty rather than the beauty of holiness, Forsyth was nevertheless able to put a positive construct on it. For what began in faith has ended in 'glorious sight'.[74] Even so, faith is needed to 'fix the colour of beauty' and beauty is required to 'sweeten and soften the vigour of faith'. Beauty might not be *the* way to God, but it is *a* way. We 'shall not go far in a true sense of the beauty of holiness without gaining a deeper sense of the holiness of beauty'.[75] The danger lurking in the notion of the 'holiness of beauty' is giving beauty an ontological status or making it an absolute value without defining what beauty is.

There is little in Forsyth's later writings on art and aesthetics, but isolated comments suggest that he has become more aware of the dangers of aestheticism. In *The Principle of Authority*, for example, he refers to the aesthetic as one of the 'three great monopolies today which rival and threaten the true monopoly of Christianity, and threaten it from within'. The other two were philosophical speculation and rational orthodoxy. The aesthetic 'peril to religion' derives

[70] Forsyth, *Christ on Parnassus*, p. 42. [71] *Ibid.*, p. 274. [72] *Ibid.*, p. 280.
[73] Forsyth, *Religion in Recent Art*, p. 83. [74] Forsyth, *Christ on Parnassus*, pp. 128f.
[75] Forsyth, *Religion in Recent Art*, pp. 84f.

from its 'monopoly of the feelings'. Whether in literature or art, impression 'is mistaken for regeneration, and to move men is prized as highly as to change them'. The fundamental error 'is the submersion of the ethical element, of the centrality of the conscience, and the authority of the holy'.[76] And then, in 1918 as the horrors of the First World War brought down all optimism about Western culture, Forsyth speaks again of art as 'life's friend, but not its guide'.[77] Any understanding of beauty that fails to recognise the reality of human fallenness is inadequate. The problem with the human social condition is not bad taste but original sin. The solution is not aesthetic sentiment but the holy and redemptive love of the cross. If this is so, how are we to engage in aesthetic judgement? What is beauty or ugliness, good or bad taste, and how do they connect to human fallenness?

BEAUTY, BAD TASTE AND SIN

One of the most eccentric contemporary attacks on the aesthetics of modernity is the fantastical Hundertwasserhaus in Vienna.[78] Friedenreich Hundertwasser's approach to art and architecture does not fit most aesthetic canons, and his work is shunned by those for whom the legacy of the Bauhaus, Germany's celebrated school of aesthetic modernity, remains the symbol of good taste.[79] In his essay 'On False Art' Hundertwasser firmly lays the blame 'for the crimes of our rational modern architecture' on the Bauhaus. 'Modern art', he writes, 'became intellectual masturbation enforced as a short-lived status symbol: ugly, empty, cold, godless, without beauty, without heart, an art which creates unhappiness.' True art, he insists, must not try to intervene in events. It is not meant to serve a cause or be relevant. Nevertheless without intervening, art is about values.

Art must create values and not destroy values. One should feel with art protected as if you were really at home. Art must be beautiful, true and positive. Art must return to simplicity in our more and more complicated

[76] P. T. Forsyth, *The Principle of Authority* (London: Independent Press, 1952 (first published 1913)), 105ff.
[77] P. T. Forsyth, *This Life and the Next* (London: Independent Press, 1953 (first published 1918)), 13.
[78] Harry Rand, *Hundertwasser* (Cologne: Bededikt Taschen, 1993).
[79] Magdalena Droste, *Bauhaus* (Berlin: Benedikt Taschen, 1993).

world, and find solutions to reduce the problems in which we are more and more entangled, and not create new problems. [80]

Thus we can both enjoy art because of the values it embodies and yet value it for its own sake rather than as something promoting a cause. We may enjoy a great novel because of the profound insight which it sheds on the human condition and the values which it affirms, yet at the same time enjoy it because of its literary quality. Precisely in this way and not by haranguing us, art begins its subtle way of changing consciousness and thereby influencing society, as Theodor Adorno has suggested.[81]

But what, for Hundertwasser, is 'beauty'? In answer to that question, Hundertwasser, perhaps not surprisingly, speaks positively about kitsch. 'Why don't you ask your grandmother what is good and beautiful?' he suggests. 'The absence of Kitsch makes life unbearable . . . The average man who prefers well painted land-scapes or the Virgin Mary over his bed or garden dwarfs to the fabrications of avant-garde art, is not a backward reactionary but just someone who waits for better days because he cannot find satisfaction and happiness in modern art.' To put it briefly, one person's kitsch is another person's beauty.

Hundertwasser's understanding of kitsch resonates well with a great deal of popular religious art. In a recent study on the history and theory of popular religious images entitled *Visual Piety*, David Morgan has documented the extent to which such art plays a key role in the life and experience of many Christians, Protestant and Catholic alike.[82] His main subject of study is the work of Warner Sallman, whose *Head of Christ* (1940) and *Christ at Heart's Door* (1942) achieved iconic stature amongst North American Protestants in the first half of the twentieth century, comparable in Catholic circles to the *Sacred Heart of Jesus*. This brings to mind the occasion when, in the early 1960s, I visited an African colleague minister in rural Natal and discovered the *Sacred Heart* hanging on the wall in his lounge. I recall how amazed I was at seeing it in the home of a Protestant pastor who had received graduate education in one of the citadels of North American Congregationalism! But obviously it meant some-thing to him as it does for many others. Perhaps the reason for their

[80] Friedenreich Hundertwasser, *On False Art* (n.p., 1981).
[81] See Adorno, *Aesthetic Theory*, p. 344.
[82] David Morgan, *Visual Piety: A History and Theory of Popular Religious Images* (Berkeley, Calif.: University of California Press, 1998).

almost canonical status is that such images, as Morgan argues, enable many believers to cope with an oppressive and indifferent world.[83] More aesthetically sensitive Christians may scorn such prints as simple-minded, escapist kitsch, yet this is often an elitist reaction to a genuine popular piety that enables its practitioners to survive and keep the faith. For them sweetness, sentimentality and tenderness are virtues to be nurtured, not scorned, virtues that help make life bearable. The issue for such believers is not about aesthetic merit but religious significance amidst the realities of everyday life, which is precisely the appeal of icons for Eastern Orthodox believers.

Popular religious art obviously meets a deeply felt need. It has filled a vacuum that other forms of art, especially since the Enlightenment, have failed to do, especially in Western Christianity. Like Orthodox icons, it can embody the divine and give the believer a sense of being in close relation to the transcendent. All of which indicates the extent to which art is fundamental to religion, and if good artists are alienated from the church and the piety of popular faith, then kitsch is the inevitable consequence. But this does not mean that there is no difference between good and bad taste, and therefore good and bad art. Nor does it imply that good art is elitist. The distinction is not between 'fine art' and 'popular art', but between good art of all kinds and kitsch, that is art which is mediocre and banal. People will always find comfort in kitsch, for that is the whole point of it. But this does not alter the fact that kitsch obfuscates reality, ignoring the ugly as the necessary counterpoint to the beautiful and becoming a dangerous 'poisonous substance',[84] the 'epitome of all that is spurious in our times'.[85] The totalitarian art of Nazism and Soviet Russia was invariably kitsch. It was, as Timothy Gorringe observes, 'training on a mass scale, in untruth'.[86] Kitsch is, in fact, closely related to a vulgarity that derives, to quote Adorno again, from a 'posture of condescension' to the masses.

The forces of domination would like nothing better than to be able to say that what they do to the masses is what the masses deserve. By contrast, art

[83] *Ibid.*, pp. 23f. [84] Adorno, *Aesthetic Theory*, pp. 70, 340.
[85] Clement Greenberg, *The Collected Essays and Criticism. Vol. 1: Perceptions and Judgements, 1939–1944*, ed. John O'Brian (Chicago: University of Chicago Press, 1986), 12.
[86] Timothy Gorringe, 'Kitsch and the Task of Theology,' *Theology Today* 56, no. 2 (July 1999): 232.

respects the masses by opposing this attitude. It puts before them an image of what might be, rather than adapting to their dehumanized condition.[87]

Theology must certainly take popular piety and its images into account, sensitive to the role they play, and the challenge which they present to elitist religion and art. This is especially the case in contexts such as South Africa where such art resonates with the experience of the victims of oppression and is an essential ingredient in doing theology.[88] But where such art reinforces prejudice, encourages jingoism and prevents Christians from maturing in their faith, coming to a deeper appreciation of what is 'good, true, and beautiful' and responding to the needs of society, theological and aesthetic criticism is necessary. The fact that theology must be sensitive to 'popular religion' does not excuse it from critically evaluating kitsch and taking a stand against vulgarity in all its forms, especially when coated with religiosity. Much of the rest of this chapter addresses this issue.

Popular religious art is intended to provide comfort to believers, not challenge injustice or contribute to social transformation. But can any art actually do the latter? Many modern art critics are sceptical about the moral power of art, even though they do not normally deny the value of beauty in itself.[89] Reacting to those who believe that art can only be justified if it expresses moral outrage at the hypocrisy of the world, Donald Kuspit asks: 'Is the beauty of the world less important because of the moral horrors of society? Are those moral horrors the exclusive truth about society?'[90] Whatever else is said about the power of beauty, it has the ability to enhance life, to improve its quality. There is, we might say, a strange necessity for beauty.[91] Perhaps this is why popular religion finds little sustenance in avant garde art and therefore sees the beautiful in its preferred images. After all, for many believers life is ugly and brutal, so why should they appreciate art that reinforces what is daily experienced? Anne Michaels in her novel *Fugitive Pieces* about life in

[87] Adorno, *Aesthetic Theory*, p. 340.

[88] See James R. Cochrane, *Circles of Dignity: Community Wisdom and Theological Reflection* (Minneapolis: Fortress Press, 1999).

[89] Robert Hughes, *The Shock of the New: Art and the Century of Change* (London: Thames and Hudson, 1991); Donald Kuspit, *Signs of Psyche in Modern and Post-Modern Art* (Cambridge: Cambridge University Press, 1993).

[90] Kuspit, *Signs of Psyche*, pp. 138f.

[91] Cf. the commemoration plaque to Sir Clough Williams Ellis, architect and landscape designer of the rather bizarre Italianate village of Portmeirion, Wales, which reads that he had fought for beauty, 'that strange necessity'.

a Greek Jewish ghetto during the Second World War draws this lesson from one of her characters: 'Find a way to make beauty necessary; find a way to make necessity beautiful.'[92] For this, if for no other reason, beauty, which has often been relegated in importance in modern aesthetics, needs to be restored to a primary place.[93] Gadamer heralded such a recovery in his lecture on 'The Relevance of the Beautiful' given in Salzburg in August 1974. While admitting that we can find 'no universality comparable to the laws of nature' that enables us to determine categorically the nature of beauty, he argued that truth is encountered in the beautiful, and that this truth can be shared. The 'kind of truth that we encounter in the experience of the beautiful', he declared, 'does unambiguously make a claim to more than merely subjective validity. Otherwise it would have no binding truth for us.'[94] Art, he argued in conclusion, enables us to 'go beyond ourselves', so there is something there which is more than we bring to it.

Beauty, then, is not just in the eye of the beholder. Yet undoubtedly some see beauty where others see dirt. Vincent Van Gogh wrote in one of his letters: 'This morning I visited the place where the streetcleaners dump the rubbish. My God, it was beautiful!'[95] For artists such as the Dadaist Kurt Schwitters, who created art out of bits and pieces picked up off the street, Van Gogh's exclamation would make complete sense. But that is not so for most of us. Likewise the Surrealist ideal: 'Beauty will be erotic-veiled, explosive-fixed, magical-circumstantial, or it will not be at all'[96] has a certain appeal, but the claim that this view of beauty is the only possible one is by no means universally accepted or convincing. Nonetheless, Adorno's contention that the beautiful 'needs the ugly as a negation through which to actualize itself' is to the point. 'Art', he writes, 'has to make use of the ugly in order to denounce the world which creates and recreates ugliness in its own image.'[97] If aesthetics were just about the beautiful we would never really understand 'the dynamic life inherent in the concept of beauty'.[98] Beauty may have the potential to redeem, as I shall argue in the next chapter, but

[92] Anne Michaels, *Fugitive Pieces* (London: Bloomsbury, 1997), 44.
[93] Guy Sircello, *A New Theory of Beauty* (Princeton, N.J.: Princeton University Press, 1975); Mary Mothersill, *Beauty Restored* (Oxford: Oxford University Press, 1984).
[94] Gadamer, *Relevance of the Beautiful*, p. 18.
[95] Quoted in Hughes, *The Shock of the New: Art and the Century of Change*, p. 63.
[96] Quoted *ibid.*, p. 335. [97] Adorno, *Aesthetic Theory*, p. 72. [98] *Ibid.*, p. 75.

ugliness has the equally necessary capacity to subvert and decon-
struct that which destroys life.

That there can be many different ways in which beauty is under-
stood and expressed is undeniable and not at issue here. We may
even agree that the beauty found on a rubbish dump or the beauty
of the erotic are aspects of beauty that have to be taken into account
if we are to arrive at any worthwhile understanding of beauty. In
Derridean fashion we may well say: 'here is beauty', yet at the same
time declare with equal force: 'but it is not beauty'. Beauty is only
something for which we long, not something we possess. Like truth
and justice, beauty cannot be reduced to a philosophical formula,
even Hegel's 'sensuous showing of the Idea'. As Gadamer insists, it
can only be experienced as mystery in an act of creativity. But, and
this is the crucial point, such experience 'is the invocation of a
potentially whole and holy order of things, wherever it may be
found'.[99] This breaks open the notion of beauty and, by the same
token, of ugliness, in a way that allows for a wide range of
interpretations appropriate for different contexts and cultures. It
also helps rescue the notion of taste from the norms of Rationalism
and Romanticism, making it possible for its theological and religious
appropriation.

In a helpful contribution to this task Frank Burch Brown argues
that because aesthetic excellence is 'generative of human commun-
ity, it is a moral good in itself', and therefore a 'part of the
glorification and enjoyment of God that is possible through the
moral life'.[100] There is 'an analogy between aesthetic experience
and the experience of the holy or divine'.[101] Aesthetic discernment
or good taste is thus a central element in religion.[102] This has
seldom been recognised in Christian tradition, where bad taste is not
considered a deadly or even a venial sin. Nor is it normally
condemned as a hindrance to sanctification or spiritual maturity.
Impeccable 'taste is hardly deemed to be one of the "fruits of the
spirit"'.[103] Yet, as Brown indicates,

The possibility that bad taste may be a *moral* liability is suggested in fact by
the quite traditional notion that sin – which is not only wrong but also
profoundly ugly – looks alluring to the unwary, whereas virtue – which is

[99] Gadamer, *Relevance of the Beautiful*, p. 32.
[100] Frank Burch Brown, *Religious Aesthetics: A Theological Study of Making and Meaning* (Princeton:
Princeton University Press, 1989), 146.
[101] *Ibid.*, p. 146. [102] *Ibid.*, p. 147. [103] Brown, *Religious Aesthetics*, p. 136.

not only right but also profoundly beautiful – frequently appears drab at first sight. It follows that failure to distinguish genuine beauty from counterfeit can lead to moral error. Moral and aesthetic discernment often go hand in hand.[104]

Taste obviously implies subjective judgement, but it is not simply a private matter, for bad taste can infect a whole society while good taste may well contribute to its healing. For this reason taste needs to be considered within a broader communal framework if we are to understand how it is formed and how it functions. This means that taste is historically and contextually formed. At the same time good taste is not the sole possession of a particular ethnic community or some company of the culturally elite, nor is bad taste a characteristic of those who do not belong there. If this were so, then questions of taste could not be of importance to Christianity in its struggle to be both contextual and universal, both inclusive of all and yet committed to the formation of a disciple community. From a Christian point of view we dare not leave the definition of good or bad taste in the hands of cultural aesthetes, or in the hands of the ideologists. Quite apart from the question of 'beauty', or perhaps precisely in relation to it, we have to deal with taste in terms which also encompass the categories of sin, the holy, and the redemptive. This is a task that has to take place within the community of faith within particular cultural contexts in dialogue with artists and their critics, a subject that will concern us in the final chapter.

In helping us to define 'sinful taste', that is bad taste theologically understood, Brown suggests four representative types, the aesthete, the philistine, the intolerant and the indiscriminate, whose taste reflects four main Christian views about sin, namely idolatry, not delighting in God, pride, and sloth.[105] While these types cannot be regarded in any compartmentalised way, especially not when they are related directly to specific contexts, they are helpful and we shall employ them as appropriate. But first we need to introduce the nineteenth-century Danish philosopher Søren Kierkegaard into our discussion for reasons that will become apparent.

Those familiar with Kierkegaard's *Stages on Life's Way*, in which guests at a dinner party discuss love and women, will recognise elements in his characters of some of Brown's representative types of

[104] *Ibid.*, p. 136. [105] *Ibid.*, p. 151ff.

bad taste.[106] They will also detect Kierkegaard's own personal struggles to live authentically beyond aestheticism, irrevocably scarred as he was by a deep sense of guilt for having broken off his engagement to Regina Olsen. Woven into that biography was his philosophical conflict with Hegelian Idealism and the aestheticism of Romanticism, as well as his struggle to be a Christian disciple going against the stream of a comfortable and complacent bourgeois Christian society.[107] Yet, precisely as a result of his existential struggle, Kierkegaard provides us with an alternative aesthetics to that propounded by both the Hegelians and the Romantics.

Kierkegaard regarded our capacity for aesthetic experience as an essential part of what it means to be human.[108] Throughout his writings, as Sylvia Walsh shows, he maintained 'a fundamentally positive understanding of the poetic as an essential ingredient in, and in certain works even identical to, ethical and religious forms of life'.[109] She goes on to say that 'even in those works that are most critical of poetry and the aesthetic mode of life' Kierkegaard provides 'a positive perspective of the poetic in which the distinction between the aesthetic-poetic and the ethical-religious is significantly relativized'.[110] So although there is truth in the dominant interpretation of his move from the aesthetic through the ethical stage to the religious, it is far too facile a reading to assume that in doing so Kierkegaard leaves the aesthetic behind. What is rejected is a particular understanding of the aesthetic, not the aesthetic as such. The aesthetic is, rather, continually reinterpreted within the sphere of the ethical and religious. This explains Kierkegaard's pithy remark that the 'aesthetic is *always* hidden; insofar as it expresses itself it is coquettish'.[111] Aestheticism is undoubtedly coquettish, yet aesthetics lies at the heart of Kierkegaard's works, and it is profoundly reflected in his struggle to discern beauty beneath the surface of life and to 'live poetically' as a Christian.[112]

Nonetheless, Kierkegaard came to regard aesthetic creativity in

[106] Søren Kierkegaard, *Stages on Life's Way*, trans. Walter Lowrie (Princeton, N.J.: Princeton University Press, 1940).

[107] See Walter Lowrie, *Kierkegaard*, Kierkegaard, 1 (New York: Harper & Brothers, 1962), 232ff.; Sylvia Walsh, *Living Poetically: Kierkegaard's Existential Aesthetics* (University Park, Penn.: Pennsylvania State University Press, 1994), 21.

[108] George Pattison, *Kierkegaard and the Crisis of Faith* (London: SPCK, 1997), 73ff.

[109] Walsh, *Living Poetically*, p. 2. [110] *Ibid.*, p. 3.

[111] *Journals*, no. 43 [1843]:130. Quoted in John Vignaux Smyth, *A Question of Eros: Irony in Sterne, Kierkegaard, & Barthes* (Tallahassee, Fla.: Florida State University Press, 1986), 229.

[112] See the discussion in Smyth, *A Question of Eros*, pp. 223ff.; Walsh, *Living Poetically*, pp. 56ff.

itself as incapable of healing and overcoming the deep alienation of the divided self because of the gulf between aesthetic experience and reality. The reconciliation promised by art is illusory and cannot be fulfilled. There is a need to move beyond the aesthetic stage to the ethical. This did not mean a rejection of the aesthetic, however, but an acceptance of its limitations and an awareness that 'art can only nourish the ethical self when it is itself based on a firmly held ethical position'.[113] But ethics, and especially the ethics of rationalism as reflected philosophically in Idealism or in the morality of bourgeois society, was itself barren and incapable of healing the individual person. Hegel's system in particular left no room for the surprising breaking of transcendence into experience with its offer of newness, its gift of radical freedom, and therefore the possibility of and need for ethical decision. The only way out of the closed circle of rationalism, the iron cage of historical inevitability, or the banality of bourgeois morality was a 'leap of faith' in which we discover our true selves as a gift of grace. There was, so Kierkegaard contended, no possibility of having things both ways: an either/or decision is demanded.[114] But if we choose to follow Christ, then we must be prepared for a life of discipleship and the inevitability of suffering. We might also be required to break with accepted moral norms, like Abraham obeying God's command to sacrifice Isaac, what Kierkegaard calls the 'teleological suspension of the ethical'.[115] Only in such a 'leap of faith' do we overcome our alienation, discover our freedom to act and the ability to reach out to the other. With Kierkegaard's insights in mind, let us reflect again on the representative types of bad and sinful taste.

FROM AESTHETICISM TO FASCISM

For the aesthete, art exists for its own sake independently of any religious or moral purpose or sanction. The phrase 'art for art's sake' was coined in 1835 by Théophile Gautier in *Mademoiselle de Maupin*, a manifesto on Romantic art.[116] The true artist, Gautier insisted, is sovereign in the sphere of art and is concerned with

[113] Pattison, *Kierkegaard and the Crisis of Faith*, p. 86.

[114] Søren Kierkegaard, *Either/Or* (Princeton: Princeton University Press, 1987).

[115] Søren Kierkegaard, *Fear and Trembling* (Princeton: Princeton University Press, 1983).

[116] Deborah J. Haynes, *The Vocation of the Artist* (Cambridge: Cambridge University Press, 1997), 112.

aesthetic issues alone. Artistic freedom, rather than adherence to a school or tradition, is essential to the true artist's work. Moreover, aesthetic perfection is achieved through expressing an inner vision rather than the outer appearance in form. Creative imagination dominates cognition and reflection. The paradigmatic form of aestheticism was the Bohemian art-culture of Paris that emerged in the cultural and social chaos of the post-Napoleonic era and soon spread across Europe. William Gaunt aptly describes its character:

Bohemians had one law, one morality, one devotion, and that was – Art. It had to be so, for it was their sole justification. They were responsible for it, as, in the previous century, noble patrons had been. They must, now that so few others were interested, preserve it like a sacred mystery.[117]

Such artists did not accept the obligations of bourgeois society or established religion: quite the contrary. There was 'a sort of religious exaltation in choosing the necessary martyrdom of vice, a saintly courage in exploring sin, a religious belief implicit in the defiance of religious rule'.[118] This epitomises what Nicholas Wolterstorff calls 'the basic image of the artist underlying modern Western art', namely 'that of the artist as a center of consciousness who challenges God by seeking to create as God creates'.[119] 'Art for art's sake' was a clarion call to recognise 'that moral purpose, deep thought, sage and prudent reflexions, all the worn and respectable trappings of the creative spirit were irrelevant to its free exercise; positively hampered it, in fact'.[120] Like ascetics of old in their protest against the Constantinian captivity of Christianity, artists committed to the 'aesthetic movement' even espoused poverty as a sign of their commitment to art and its integrity. But in their pursuit of 'art for art's sake', they were alienated from the broader public who could no longer understand, let alone appreciate, their work. Ironically, artists now free from church or civic patronage, and no longer serving the common good, became the captives of the wealthy art collector and dealer. What was now of value was no longer the truth served by art, but the aesthetic value of a work of art, and this was increasingly judged in terms of its economic value.

Aestheticism is idolatrous because it makes aesthetic value an absolute. Like Kierkegaard's Don Juan or 'Johannes the Seducer',

[117] William Gaunt, *The Aesthetic Adventure* (Harmondsworth, Middlesex: Penguin, 1957), 14.
[118] *Ibid.*, p. 17.
[119] Nicholas Wolterstorff, *Art in Action* (Grand Rapids, Mich.: Eerdmans, 1980), 56.
[120] Gaunt, *The Aesthetic Adventure*, p. 18.

the aesthete is not committed to any values other than his or her own, or to love any other than himself or herself. In his comparison of Nietzsche and J. S. Bach, Jaroslav Pelikan makes this explicit by reference to the way in which beauty for Nietzsche is given ultimate value. The genius of Bach, on the other hand, was in part his refusal 'to follow the True for its own sake, be it ever so orthodox; or the Good for its own sake, be it ever so moral; or the Beautiful for its own sake, be it ever so enlightened'.[121] But it was even more the genius of one who found in the service of the holy God 'a new and more profound conception of the Beautiful as well'.[122] The heart of the problem, as Pelikan indicates, is that values such as truth, goodness and beauty are 'peculiarly susceptible to idolatrous perversion',[123] because of their transcendental character. But it is the aesthetic which is the 'subtlest and most appealing of the attempts to domesticate the Holy' because of the fascination which the Beautiful has for men and women.[124]

To a greater extent than either intellectualism or moralism, aestheticism has been able to satisfy yearnings deep within the human breast. For that reason, those who possessed the Beautiful could very easily be deluded into supposing that they had taken hold of the Holy itself. Such a supposition was only intensified by the subordination of both the Holy and the Beautiful to either the True or the Good in the history of Western thought.[125]

Neither dogma nor ethics has ever managed to express the awesomeness of creation and the mystery of redemption as have intimations of beauty. Nor have they had the same power of attraction for those in search of the divine. On the contrary they have too often degenerated in ways that have repelled such enquirers. From this perspective dogmatic systems and ethical codes cannot easily compete with the power of beauty in touching the heart and affections. Augustine recognised this when, in his *Confessions*, he wrote of the power of beauty to allure and unite us to the things we love.[126] Unlike truth and goodness, beauty attracts us

[121] Jaroslav Pelikan, *Human Culture and the Holy: Essays on the True, the Good, and the Beautiful* (London: SCM, 1959), 154. In his later discussion of Bach, Pelikan recognises the 'secular' side of Bach, the professional musician, but concludes that the 'sacred' side remained ultimate. Jaroslav Pelikan, *Bach among the Theologians* (Minneapolis: Fortress Press, 1986), 140.
[122] Pelikan, *Human Culture and the Holy*, p. 155.
[123] *Ibid.*, p. vii. [124] *Ibid.*, p. 118. [125] *Ibid.*, p. 124.
[126] Saint Augustine, *Confessions and Enchiridion*, The Library of Christian Classics, VII (London: SCM, 1955), 88, 4 xiii.

precisely because, of the three transcendentals, it 'is the most *embodied*, the most *incarnate*, the one which is virtually inseparable from matter – from the created, temporal, mutable realm'.[127] So, according to the biblical narrative, the seduction of beauty leads to idolatry, and the fatal attraction of the fruit of the tree of the knowledge of good and evil, which promises that humans will become 'like God', is experienced as 'a delight to the eyes' (Genesis 3). The wise in Israel knew that 'beauty is vain', a snare and a trap (Proverbs 31:30).

There are, however, two different kinds of aestheticism. The one insists that art is absolute, the supreme value; the other affirms art as an end in itself. The difference may be one of degree, but the distinction is important. For while the first kind is, theologically speaking, simply idolatrous, the second indicates what is potentially the best within Romanticism even though it may well turn works of art into surrogate gods.[128] Indeed, the latter is in continuity with Kant's notion of 'disinterestness' because it is asking us to forget about the practical effects of art and simply enjoy it for its own sake. This need not imply in any way a renunciation of moral values, just as it does not make any absolutist claims for itself either. Beardsley puts it in this way: 'the great artist is always exploring new perspectives, inventing intense new regional qualities, putting things together in hitherto unheard-of ways; and if what he makes is good, it will be the enemy of some established good that is not quite as good'.[129] In pursuing art as an end in itself, without absolutising it, the artist can thus serve society. Human imagination and creativity are essential for social well being, for they evoke a transforming sense of wonder. The challenge is how they can be exercised in such a way that they do not lead to the 'vain imaginations of the heart' against which the prophetic tradition warns. Wolterstorff captures the dialectic when he reminds us that art cannot save us from 'the root of evil' because it is not 'the Absolute', but goes on to speak with sadness of the fact that too often conventional religion drives away those who are sensitive to the aesthetic. He writes:

There are those whose nature responds so deeply to this heritage (of art) that if forced, by the spokesmen of the religion in which they have been

[127] Carol Harrison, *Beauty and Revelation in the Thought of St Augustine* (Oxford: Clarendon Press, 1992), 271.

[128] See Wolterstorff, *Art in Action*, p. 50.

[129] Monroe Beardsley, *Aesthetics* (Hackett, 1981), 562f.

reared, to choose, they will, with sorrow, suffering, and anger, depart from home for a far country.[130]

Such people may not find art in the sanctuary, but they do find sanctuary in good art.

Kierkegaard's decision to pursue the ethical was not so much the rejection of the aesthetic, the place of the imagination or the role of creativity, but its dethroning.[131] The problem was not art but the values that Romanticism made absolute. The issue at stake was not beauty, but the feelings elicited by beautiful objects that led to a self-centred focus. But there is a further problem that Kierkegaard identified in his turning away from the aesthetic stage. Instead of being a redemptive force, art fell 'victim to the dialectics of modernity'. People became spectators rather than actors, money replaced passion, and idle chatter took the place of serious conversation.[132] Aestheticism gave men and women a false sense of importance and sheltered them from moral claims. Art might help us to forget our pain, it might distract us from the burden of reality, but, as Forsyth insisted, it can neither expunge our guilt nor heal our souls. There was, for Kierkegaard, the urgent need to break with such innocence and plunge ahead in full acknowledgement of guilt, that is to move beyond the aesthetic to the ethical stage. But that, too, was not a solution because it led to a self-righteous self-sufficiency. Only the religious stage reached by the leap of faith in response to the gospel could solve the dilemma.

Kierkegaard's evangelical reaction to the aesthetic has evoked amongst Protestant theologians a 'certain aversion to style and rhetoric, a vague and often implicit feeling that beauty is, if not something foppish, at least dispensable and extraneous'.[133] But as Pattison suggests, Kierkegaard also 'offers an intimation of one area of possible convergence between art and religion in the modern world: the prophetic assault on all consolatory images and prema-

[130] Nicholas Wolterstorff, 'Art, Religion, and the Elite: Reflections on a Passage from André Malraux', in *Art, Creativity, and the Sacred*, ed. Diane Apostolos-Cappadona (New York: Crossroad, 1988), 272.

[131] Kierkegaard, *Either/Or*. Cf. David Robert's comment: 'Kierkegaard tends to use the term "aesthetic" to refer to the way of life devoted to the immediate and often to the sensual: but his usage also overlaps the more customary sense, denoting that which pertains to art and beauty.' David E. Roberts, *Existentialism and Religious Belief* (New York: Oxford University Press, 1957), 198, n. 31.

[132] Pattison, *Kierkegaard and the Crisis of Faith*, p. 86.

[133] Edward T. Oates, *Pattern of Redemption: The Theology of Hans Urs von Balthasar* (New York: Continuum, 1994), 52.

ture solutions to the issues of human suffering and death'.[134] It might well be that Kierkegaard would now see art as 'a precious part of the Christian attempt to rescue the modern world from its self-afflicted sickness'[135] rather than being symptomatic of that cultural 'sickness unto death' about which he wrote with such force. Kierkegaard, with his deep love for the aesthetic but his rejection of aestheticism, has been the true iconoclast of twentieth-century theology. We cannot avoid his trenchant critique if we are to recover a genuine sense of the aesthetic for today, but we have to move beyond him. How we do this, in company with Bonhoeffer, will be central to our discussion in chapter 4.

But what of the philistine, or Kierkegaard's bourgeois civil servant? Such people are guilty because they do 'not highly value or personally appreciate anything artistic or aesthetic that cannot be translated into practical, moral, or specifically religious terms'. They are guilty of what Wolterstorff labels the sin of not delighting.[136] This widespread form of sinful bad taste is concerned about function and goals at the expense of texture and tone. Philistinism is artlessness, 'the antithesis *par excellence* of aesthetic behaviour'. It is not simply vulgarity; it represents 'indifference to or hatred of art'.[137]

Philistinism expresses itself in many different forms. For example, a lack of care and respect for the environment arises out of the failure to take delight in the beauty of nature. But there are other forms of philistinism which are perplexingly problematic because they seem to be so morally correct. For example, can a society afford to sponsor works of art when many of its citizens eke out their lives in poverty? This is certainly a question that those of us who live in the 'developing world' cannot ignore, just as it was one which was addressed to medieval society by St Bernard. It is also a question of global significance. Should not world poverty force us all to become aesthetic 'philistines' in the pursuit of economic justice? The issues are complex. Yet the danger of allowing philistinism to set the agenda would be disastrous for the long-term well being of society. D. H. Lawrence put the case powerfully in his essay 'Nottingham and the Mining Country' (1929):

The great crime which the moneyed classes and promoters of industry committed in the palmy Victorian days was the condemning of the workers

[134] Pattison, *Art, Modernity, and Faith*, p. 26. [135] *Ibid.*, p. 29.
[136] Wolterstorff, *Art in Action*, pp. 78ff. [137] Adorno, *Aesthetic Theory*, p. 342.

[handwritten: How is forg arrived at? Thru the sun but on to the beauty of humanity.]

To ugliness, ugliness, ugliness: meanness and formless and ugly surround-
ings, ugly ideals, ugly religion, ugly hope, ugly love, ugly furniture, ugly
houses, ugly relationship between workers and employers. The human soul
needs actual beauty even more than bread.[138]

To deprive people wilfully of beauty and intentionally create such
ugliness is from a Christian perspective nothing less than sin in its
most cynical form. Anyone familiar with the ugly realities of
apartheid will immediately recognise some striking parallels, but also
the remarkable attempts by those affected to transcend their situa-
tion through township art, home decoration and the music, dance
and colourful vestments of African-initiated churches.

William Morris, founder of the Arts and Crafts Movement in
Britain in the second half of the nineteenth century and a pioneer in
modern design, provides a striking example of someone who recog-
nised the linkage between beauty and social justice, ugliness and
dehumanising injustice. Instead of pursuing ordination to the priest-
hood he embarked on 'a crusade against both the vulgar taste of the
age and its social injustices'.[139] Christoph Gestrich's exposition of
the Christian doctrine of sin confirms the insights of Morris and
Ruskin, but now in terms of the cultural condition of contemporary
European society. When 'things no longer have any splendor', he
writes, 'their destruction is imminent'. He goes on to say: 'People
who are headed for destruction are first deprived of their honor,
stripped of their rights, and their outward appearance takes on a
pathetic, ugly form'.[140]

Of course, it could be argued that this has not yet proved the case
for the production of 'works of art' as such, but only for the
preservation of the beauties of the environment or the creation of
humanising living conditions. Yet the problem has to do with an
attitude to that which is beautiful, whether in creation or in art. It is
a failure to appreciate not just the beauty of nature, but also the
achievements of human creativity. And it is particularly dangerous
because of the 'high moral ground' which it can, with apparent
justification, claim. Society no longer has room for artists or 'cultural
workers' because of the cost involved. Sanctuaries without style are

[138] Quoted by Margaret Drabble, *A Writer's Britain: Landscape in Literature* (London: Thames
and Hudson, 1979), 224.
[139] Eleanor van Zandt, *The Life and Works of William Morris* (Bristol: Paragon, 1995), 1.
[140] Christoph Gestrich, *The Return of Splendor in the World* (Grand Rapids, Mich.: Eerdmans,
1997), 1.

erected for the poor that reinforce the dreary and ugly surroundings in which they are condemned to live. But as Dillenberger comments:

> It is simply a fact, not a judgment about desirable social policy, that great works of art are created and distinguished buildings are erected and appreciated in cultures where social disparities are pronounced . . . There is a sharing in a reality that unites individuals and groups across disparities that is grander than any segment in a body politic. Most of us would not give up on great cathedrals, ambiguous as their creations were from a limited social viewpoint.[141]

But is not philistinism inherent in Christianity, as Nietzsche would argue? Is not the fear of beauty and sensuality that can be traced back to Augustine, and behind him to the desert fathers, endemic to the tradition? Nietzsche argued, we recall, that Christianity brought into disrepute the very values of classical culture, turning virtues into vices. All that was good, noble and beautiful was regarded as sinful. Christianity was an agent of the barbarisation of civilisation. This misfortune, symbolised by the crucifixion which became its conquering sign was, for Nietzsche, a victory for the foolish and ignoble, and the more excellent way of culture and its values was destroyed.[142] If Kierkegaard attacked aestheticism as idolatry, Nietzsche attacked Christianity as the enemy of the aesthetic.[143] Theological aesthetics has to respond adequately to the challenge of both if it is to be taken seriously.

Aesthetic intolerance is a further instance of bad taste and, like aestheticism or philistinism, it manifests itself in different ways. One form is the misuse of art as an ideological tool by politicians and religious authorities alike in the persecution of others. Here it is not 'art for art's sake', but art for the sake of 'our cause' which is at issue, or the destruction of art that does not fit our particular ideology. The most notorious example in modern times of such cultural arrogance was The Degenerate Art exhibition in Nazi Germany in 1937.[144] But

[141] John Dillenberger, *A Theology of Artistic Sensibilities: The Visual Arts and the Church* (London: SCM, 1986), 213.

[142] See the exposition of Nietzsche in Karl Barth, *Church Dogmatics III/2* (Edinburgh: T. & T. Clark, 1960), 238f.

[143] See the comparison made between Kierkegaard and Nietzsche in J. Kellenberger, *Kierkegaard and Nietzsche: Faith and Eternal Acceptance* (London: Macmillan, 1997), 121f.

[144] On art in Nazi Germany, see Peter Adam, *Art of the Third Reich* (New York: Harry N. Abrams, 1992). On the Romantic roots of Nazi aesthetics and their use in nationalist mass mobilisation, see George L. Mosse, *The Nationalization of the Masses: Political Symbolism and Mass Movements in Germany from the Napoleonic Wars Through the Third Reich* (New York: Howard Fertig, 1975).

already in 1933, Hitler had begun to attack 'the disastrous influence of the Jews in matters of art' and the opinions of phony art critics which seduced the people into believing that 'the worst rubbish in painting' was 'the expression of the height of artistic accomplishment'.[145] The repercussions of this were even felt in South Africa at the time, where the work of three of the country's leading Expressionist painters (Irma Stern, Maggie Laubser and Wolf Kibel) was condemned in similar terms.[146]

What was undeniably demonic in Nazi Germany is, however, evident within the broader cultural public of a particular nation when the art and artifacts of other cultures are designated inferior. In the West the attitude of aesthetic elitism has created a tradition in which art has self-consciously fed off its own history.[147] But this attitude has not been confined to the arts. Even well-intentioned European missionaries were blind to the aesthetic values of other cultures, and were often guilty of manipulating and dominating them.[148] An unintentionally revealing example is found in an address given in 1884 to the students at Lovedale College in the eastern Cape of South Africa, by the principal, a well-known Scottish missionary:

Do you not know that it is partly because in most natives this part of their nature has been entirely neglected, that we have 100,000 African villages scattered over this vast continent and each one of these villages like all the others, – nothing but the dead uniformity of a collection of beehives, or gigantic molehills . . . Do you not know that straight horizontal lines, and straight vertical lines perfectly true, and true curves of varying forms are at once the elements of stability and beauty, and that without these, you can never produce what shall be at once permanent, useful and beautiful. Do you not know also that God has filled this world of His with such lines and curves. Do you know also that one of the most difficult things to get a native of this country to understand, is the beauty of a straight line or a true curve, each in its proper position or relation to each other.[149]

The intolerant cultural elitist makes his or her standards the ultimate criteria for good taste. What Richard Wollheim referred to as the

[145] Albert Boime, *The Unveiling of National Icons: A Plea for Iconoclasm in a Nationalist Era* (Cambridge: Cambridge University Press, 1998), 361.

[146] Esmé Berman, *Art and Artists of South Africa* (Cape Town: Southern, 1996), 9.

[147] Wolterstorff, 'Art, Religion, and the Elite', p. 59.

[148] John L. Comaroff, and Jean Comaroff, *Of Revelation and Revolution: The Dialectics of Modernity on a South African Frontier*, Of Revelation and Revolution, 2 (Chicago: Chicago University Press, 1997), 236ff.

[149] 'The Experiment of Native Education', *The Christian Express*, 2 June 1884.

culturally determined character of representation and art[150] is given an absolute status. Here we have to do with the sin of pride, even though such bad taste has often been regarded as the epitome of good taste. The most obvious example of such bad taste in the guise of good taste is that of the art critic who claims to know what 'good art' is, and who scorns the opinions of others, including those who find solace in popular religious art.

If some claim that their taste is the only criterion for what is good, there are others who shrug their shoulders indifferently, insisting 'that really there is nothing good or bad in matters of taste . . . in art anything goes'.[151] Such indifference disallows any ties between aesthetics and morality, between right and wrong, sin and right-eousness, wholeness and brokenness, or freedom and captivity. For that reason it is especially vulnerable to the demonic.[152] And therein lies its danger, a danger already identified in respect of religious kitsch. Those who wish to abuse art for the sake of ideological goals capture the loyalty of those who have no sense of discrimination between what is good or bad taste. Sectarian graffiti in Northern Ireland are a case in point. But so too is much vulgar advertising and, even worse, advertising or propaganda that uses good taste for morally questionable or even evil purposes.

In this regard Wolfgang Welsch reminds us that we are 'currently experiencing an aesthetics boom'.[153] We are being forced to see and hear reality differently not through any reasoned choice of our own, but because of the way in which aesthetics has been put to use in the modern world as a global strategy. Welsch distinguishes between two complementary forms in which this process of the everyday is taking place. There is, first, a 'surface aestheticization' in which 'the most superficial aesthetic value dominates: pleasure, amusement, enjoyment without consequence'.[154] This serves economic interests, for what is primarily at issue is not the utility or quality of the product but what will sell it. The second form of aestheticisation is 'deep-seated'; it is the result of the fundamental technological and especially micro-electronic changes that are literally reshaping our world, changing our consciousness and 'our whole *apprehension* of reality'.[155] Reality has become virtual and manipulable in a way

[150] Richard Wollheim, *Art and its Objects* (Cambridge: Cambridge University Press, 1996), 21.
[151] Brown, *Religious Aesthetics*, p. 155. [152] *Ibid.*, p. 156.
[153] Wolfgang Welsch, *Undoing Aesthetics* (London: Sage Publications, 1997), 1.
[154] *Ibid.*, p. 3. [155] *Ibid.*, p. 5.

that was previously inconceivable. The process is not only irreversible but expanding at a phenomenal rate. Reality is continually being deconstructed and reconstructed, not least by the media. Morality is no longer shaped by traditional values but by the style of role models whose interests coincide with those of the magazines which propagate them. Beauty has been redefined to serve commercial and ideological ends. This abuse of art does not necessarily reflect a lack of aesthetic sensibility; rather it manipulates it to great effect because people do not have the ability to evaluate its character or consequences.

The *cause célèbre* is undoubtedly the case of the Nazi film maker Leni Riefenstahl, whose post-war rehabilitation proved as perplexing as it was controversial. Few who have seen her documentary film of the Nazi rallies at Nuremberg, *The Triumph of the Will*, would deny its artistic skill and, on many occasions, its remarkable albeit eerie beauty. Yet the purpose of the film was to glorify the Führer and the goals of National Socialism. It was a victory for Nietzsche's *Übermensch*, and one of the most blatant examples of the separation of aesthetic values from ethical considerations created in the name of art. Riefenstahl has always denied any evil intent, stressing that she was only interested in artistic creation and the expression of beauty. That her claims eventually won support can be gauged from the fact that none other than Herbert Marcuse came to refer to her work as compelling and 'beautiful'.[156]

In an essay published in 1972 entitled 'Fascinating Fascism' Susan Sontag suggested that one of the reasons for the change in attitude towards Riefenstahl was 'the new, ampler fortunes of the idea of the beautiful'. Something to which we referred earlier as the 'recovery of the beautiful' (Gadamer). The line taken by Riefenstahl's defenders, which included 'the most influential voices in the avant-garde film establishment', is that she was always concerned with beauty.[157] This, despite the fact that she 'is the only major artist who was completely identified with the Nazi era and whose work, not only during the Third Reich but thirty years after its fall, has consistently illustrated many themes of fascist aesthetics'.[158] In a much more recent critique of *Triumph of the Will*, Mary Devereaux acknowledges that 'it is possible to appreciate the beauty of the film's vision without compro-

[156] Haynes, *The Vocation of the Artist*, p. 65.
[157] Susan Sontag, 'Fascinating Fascism', in *Under the Sign of Saturn* (Farrar, 1972), 84.
[158] *Ibid.*, p. 90.

mising ourselves morally. But', she continues, 'it is important to note, one of the central aims of *Triumph of the Will* is to move its audience to take this step, to find the historical realities and doctrines of National Socialism attractive'.[159] Therein lies its evil character.

But what precisely does Sontag mean by fascist aesthetics? Her answer provides the clue to Reifenstahl's technique in using beauty for the sake of the cause.

Fascist aesthetics include but go far beyond the rather special celebration of the primitive . . . they flow from (and justify) a preoccupation with situations of control, submissive behaviour, extravagant effort, and the endurance of pain; they endorse two seemingly opposite states, egomania and servitude. The relations of domination and enslavement take the form of a characteristic pageantry: the massing of groups of people; the turning of people into things; the multiplication or replication of things; and the grouping of people/things around an all-powerful, hypnotic leader-figure or force. The fascist dramaturgy centers on the orgiastic transactions between mighty forces and their puppets, uniformly garbed and shown in ever swelling numbers. Its choreography alternates between ceaseless motion and a congealed, static, 'virile' posing. Fascist art glorifies surrender, it exalts mindlessness, it glamorizes death.[160]

Features of fascist art and architecture are to be found elsewhere in totalitarian societies, whether of the right or the left, a subject to which we shall return in chapter 5. They are misguidedly utopian even though their legitimising rhetoric may be different, the right stressing idealism, the left realism. As Sontag observes, the 'tastes for the monumental and for mass obeisance to the hero are common to both fascist and communist art, reflecting the view of all totalitarian regimes that art has the function of 'immortalizing' its leaders and doctrines'.[161] But what distinguishes the connection between art and politics in the Third Reich from other totalitarian contexts is that National Socialism 'appropriated the rhetoric of art – art in its late romantic phase'.[162] This, Sontag says, finds resonance with the ideals of our own time: 'the ideal of life as art, the cult of beauty, the fetishism of courage, the dissolution of alienation in ecstatic feelings of community; the repudiation of the intellect; the family of man (under the parenthood of leaders)'.[163] To return to an earlier

[159] Mary Devereaux, 'Beauty and Evil: The Case of Leni Riefenstahl's "Triumph of the Will"', in *Aesthetics and Ethics: Essays at the Intersection*, ed. Jerrold Levinson (Cambridge: Cambridge University Press, 1998), 249.
[160] Sontag, 'Fascinating Fascism,' p. 91. [161] *Ibid.*, p. 91. [162] *Ibid.*, p. 92
[163] *Ibid.*, p. 96.

observation, this may explain Riefenstahl's rehabilitation, but it also indicates how potentially dangerous are the ethical and cultural issues that are raised. For if it is true that art can be so misappropriated in the service of demonic causes, it is a matter of concern that cultural norms and values in the late twentieth century are open to the same abuse as they were in the 1930s.

From a Christian perspective sinful bad taste cannot be countered merely by the cultivation of good taste, by education in aesthetic appreciation of beauty, any more than the destruction of the environment can be overcome through encouraging rambles through the countryside – pleasant and important as these may be. Hitler Youth were certainly enthusiastic participants in such pursuits. The apartheid regime strongly supported and encouraged the 'high arts' in South Africa, including the building of the Cape Town Nico Malan opera house, while at the same time demolishing the nearby District Six community in pursuit of its racial policies. The answer to bad taste, as Brown suggests, is grace, not simply acquiring 'good taste'. Beauty, however defined, cannot transform humanity or society by its own power to arouse good feelings or engender moral conviction independently. But this does not mean that 'good taste' is unimportant, or that beauty is bereft of redemptive power. What it does indicate is that we need a different perspective from which to evaluate the aesthetic and determine the nature of beauty as a prelude for appreciating art as a source of transformation. From a Christian perspective, this demands a theological aesthetics that can address the issues we have raised. Hence the need for us to continue our journey and explore the way in which Hans Urs von Balthasar has, in our time, restored aesthetics to the centre of theological endeavour.

PART II

Theological reflection

The redemptive power of beauty

Prince Myshkin's claim, in Fyodor Dostoyevsky's *The Idiot*, that 'the world will be redeemed by beauty' is often quoted but seldom explained. Understandably so, for the phrase remains a riddle throughout the story. We only have hints of its meaning. Yet they are evocative even in their opaqueness, as though a revelation were seeking to break through the barriers of hidden silence into the realm of seeing and hearing, but never finally managing to do so. We begin with a scene where the phrase first occurs, though in a slightly different form.

Mrs Yepanchin examined Nastasya Filippovna's portrait for some time in silence, slightly scornfully, holding it at arm's length in a way that was calculated to make an effect.

'Yes', she said at last, 'she's good-looking – very good-looking. I've seen her twice, only at a distance. So this is the kind of beauty you admire, is it?' she said, turning to the prince.

'Yes, I do', the prince replied with some effort.

'Do you mean this kind especially?'

'Yes, especially.'

'Why?'

'Because, you see, there is so much suffering in that face', the prince said, as though involuntarily, as though speaking to himself and not in answer to her question.

'I daresay you're talking nonsense', Mrs Yepanchin declared firmly, throwing down the portrait on the table with a haughty gesture.

Alexandra picked it up. Adelaida went up to her and the two began to examine it. At that moment Aglaya came back into the drawing-room.

'What power!' Adelaida cried suddenly, looking eagerly over her shoulder at the portrait.

'Where? What power?' Mrs Yepanchin asked sharply.

'Such beauty is power', Adelaida said warmly. 'With such beauty one can turn the world upside down.'[1]

[1] Fyodor Dostoyevsky, *The Idiot*, Penguin Classics, trans. David Magarschack (London: Penguin, 1986), 103.

The nature and power of beauty remain a mystery throughout the story. As this and other passages suggest, it is undeniably erotic, having the power to intoxicate and seduce. But as the narrative unfolds a fuller profile emerges through the mystical insight of the prince, especially following his frequent epileptic fits. Beauty is erotic and seductive, and can lead to idolatry; but it is also divine, and can lead to God and worship.[2] So we sense that beauty implies joy, it brings a sense of proportion and reconciliation, it calls forth prayer, and it awakens wonder and self-awareness.[3] The novel also suggests that one of the goals of beauty is the creation of social harmony, the utopia of the kingdom of God.[4] Yet none of this empties the riddle of its mystery, which, for Dostoyevsky, is essentially its power to evoke both worship and lust. As Alyosha expresses it in *The Brothers Karamazov*:

Beauty is a terrible and awful thing! It is terrible because it has not been fathomed and never can be fathomed, for God sets us nothing but riddles . . . Beauty! I can't endure the thought that a man of lofty mind begins with the ideal of a Madonna and ends with the ideal of Sodom . . . The awful thing is that beauty is mysterious as well as terrible. God and the devil are fighting there and the battlefield is the heart of man.[5]

Much later in *The Idiot* than the passage quoted above, Myshkin is challenged by an inebriated companion, Ippolit. 'Is it true, Prince, that you once said that the world would be saved by "beauty"? Gentlemen', he shouted in a loud voice to all the company,

'the prince says that the world will be saved by beauty! And I maintain that the reason he has such playful ideas is that he is in love. Gentlemen, the prince is in love. I could see it as soon as he came in. Don't blush, Prince, or I shall be sorry for you. What sort of beauty will save the world? Kolya told me that . . . You're a zealous Christian, aren't you? Kolya says you call yourself a Christian.' The prince looked attentively at him and made no answer.[6]

Like Jesus before Pilate, for the comparison is apt, the prince remains silent. The painting of Christ over the gloomy doorway in Rogozhin's house which so torments him has 'no trace of beauty'.[7]

[2] Eduard Thurneysen, *Dostoevsky: A Theological Study* (London: Epworth Press, 1964), 24.
[3] Richard Peace, *Dostoyevsky: An Examination of the Major Novels* (Cambridge: Cambridge University Press, 1971), 73.
[4] *Ibid.*, p. 81.
[5] Fyodor Dostoyevsky, *The Brothers Karamazov* (London: Heinemann, 1968), 106.
[6] Dostoyevsky, *The Idiot*, p. 394.
[7] *Ibid.*, p. 418.

Attempting an explanation, Myshkin falls into an epileptic fit.[8] The truth is veiled, hidden from his sight. The prince, 'who proclaims that beauty will save the world, is confronted with the image of a Saviour of the World devoid of beauty. Art, the vehicle for beauty, has, in this picture, destroyed beauty.'[9] The icon is flawed.

Dostoyevsky had seen Hans Holbein's painting *The Entombment of Christ* in a Basle museum while travelling to Geneva (see plate 2). Therein lies the key to the story, for the picture made a tremendous impact on him at the time and haunted him long after. Holbein's image of Christ was devoid of all beauty. Later, his wife recalled that Dostoyevsky 'stood for twenty minutes before the picture without moving':

On his agitated face there was the frightened expression I often noticed during the first moments of his epileptic fits. He had no fit at the time, but he could never forget the sensation he had experienced in the Basle museum in 1867: the figure of Christ taken from the cross, whose body already showed signs of decomposition, haunted him like a horrible nightmare.[10]

Prince Myshkin is not only the ridiculed 'idiot' haunted by a Christ-figure bereft of beauty, Dostoyevsky's alter ego in search of redemption; he is at one and the same time the 'Christ-figure' whose foolishness bears witness to the saving power of God. Hidden within his inability to fit into society, his tragic yet innocent love for the harlot,[11] lies the clue to the redemptive rather than the seductive power of beauty. It is precisely this fool, whose naïveté embarrasses all and sundry, in whom there is neither guile nor will to power nor seduction, who reveals the power and paradoxical rationality of divine beauty and love.

There are those who argue that the only kind of art that can make any contribution to changing the world is that which depicts its immoralities, its decadence and its ugliness. Unless they are unmasked there can be no way forward. Ironically, art's main contribution to social justice may well be its iconoclastic function. It is equally true that only an understanding of beauty that has been chastened by exposure to the gross inhumanities and hypocrisies of our century and others can be considered as a potential source of

[8] See the discussion in Peace, *Dostoyevsky*, pp. 71f.
[9] *Ibid.*, p. 88.
[10] From the translator's introduction. Dostoyevsky, *The Idiot*, p. 7.
[11] William Hamilton, *A Quest for the Post-Historical Jesus* (London: SCM, 1993), 82ff.

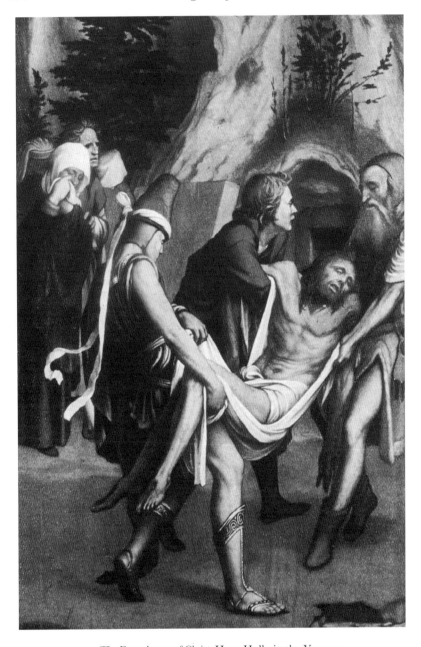

2 *The Entombment of Christ*. Hans Holbein the Younger

transformation. This is Dostoyevsky's own experience as a former inmate of a Siberian forced labour camp. There can be no redemption without beauty's descent into hell. In this way Dostoyevsky plunges us into the deep end of any theological attempt to engage in aesthetics. Theoretical issues about the relationship between Christianity and the arts pale into insignificance alongside Dostoyevsky's tortured struggle to find salvation in a Christ devoid of beauty, the Christ of tragic innocence.

Christian theological aesthetics is, at its best, an attempt to explore the issues that *The Idiot* raises; to ponder on the 'beauty that saves' from the perspective of faith. It approaches Prince Myshkin's insight not from the perspective of literary or aesthetic theory, but from the perspective of Dostoyevsky's own world-view and iconography, and his struggle to believe the Christian gospel. Theological aesthetics is not a sub-discipline of philosophical aesthetics, but an enquiry that assumes the biblical grand narrative of creation and redemption, of paradise lost and paradise regained, of incarnation, death and resurrection, of the gift of the Spirit and the hope of a 'new heaven and earth'. It was this narrative which provided European art with both its substance and legitimation from Constantine to the Enlightenment, though it clearly does so no longer. The heirs of modernity, like Prince Myshkin's companions, have lost faith in the redemptive power of beauty. Ugliness has become far more prevalent and potent while beauty has become subjective taste, not a power beyond ourselves that has the capacity to transform or – in Dionysian frenzy – to destroy the world.

Dostoyevsky and Nietzsche, both deeply tortured souls, were united in their common rejection of the glib answer to human suffering or the surface definition of the beautiful. Both were likewise repulsed by the cross. Yet for Dostoyevsky the tragic awfulness of Golgotha conceals the hope and beauty of redemption, while for Nietzsche it signifies dehumanising folly and impotence. *The Idiot* undoubtedly influenced Nietzsche's understanding of Jesus and his rejection of Christianity in *The Antichrist* and in *Thus Spoke Zarathustra.*[12] But what if we dare to believe against Nietzsche but with Dostoyevsky that in some mysterious way this corrupt world is redeemed by the beauty concealed in the crucified Christ? Indeed,

[12] J. Kellenberger, *Kierkegaard and Nietzsche: Faith and Eternal Acceptance* (London: Macmillan, 1997), 68, 137, n. 32.

what if we believe that such beauty is an attribute of God, or at least an aspect of God's revealed glory? What, then, does beauty mean, and how does it save the world? Such questions bring us to the remarkable contribution of Hans Urs von Balthasar to the recovery of theological aesthetics in the twentieth century.

THE GLORY OF THE LORD

Aesthetics is central to all Balthasar's theological endeavours, but it is in the seven volumes of his magnum opus, *The Glory of the Lord* (*Herrlichkeit*), that the subject receives its most extensive exposition.[13] The scope of what he attempts is magisterial. Not only does he enter fully into the classical debates about aesthetics, seeking to overcome their deficiencies in the service of theology, but he warmly embraces the witness of artists of many kinds, whether believers or not. His purpose is undeniably apologetic. While art can and does provide us within insight, sometimes overwhelming us with its beauty and power, like everything else, it only finds its true meaning and goal when brought within the orbit of Christian faith and made subject to Jesus Christ. This is demonstrated with great erudition in the second and third volumes of *The Glory of the Lord*, where he examines the way in which the glory of God in Jesus Christ has been expressed in the course of Christian history. He describes this in terms of the 'styles' of theology of those who 'were able to treat the radiant power of the revelation of Christ both influentially and originally, without any trace of decadence'.[14]

Significantly, the 'clerical styles' he examines, beginning with Irenaeus and ending with Bonaventure, all lived and wrote before the advent of late medieval scholasticism. From then on Balthasar's focus shifts to 'lay styles',[15] those of Dante, Pascal, Péguy, Hamann, Soloviev, Hopkins and others whom he describes, in contrast to the 'run-of-the-mill clergy' as 'representatives of the ecclesiastical

[13] Hans Urs von Balthasar, *The Glory of the Lord. Vol. 1: Seeing the Form*, The Glory of the Lord: A Theological Aesthetics, 1 (Edinburgh: T. & T. Clark, 1982).

[14] Hans Urs von Balthasar, *The Glory of the Lord. Vol. 2: Studies in Theological Style. Clerical Styles*, The Glory of the Lord: A Theological Aesthetics, 2 (Edinburgh: T. & T. Clark, 1984), 15.

[15] By 'lay' Balthasar does not mean 'lay people', for he includes John of the Cross and Gerard Manley Hopkins under this label. Rather he is referring to those who were not 'professional theologians' and who wrote both in the vernacular and out of their own experience. See Aidan Nichols, *The Word has been Abroad: A guide through Balthasar's Aesthetics* (Edinburgh: T. & T. Clark, 1998), 68.

"opposition"', the 'exiled, the misunderstood, the outlawed'.[16] In their company he places Erasmus, Luther, Las Casas (an interesting inclusion given his status amongst liberation theologians), Leibniz, Boehme, Kierkegaard, Bernanos and Newman. He also refers to the many saints (from Benedict to Charles de Foucauld) and artists (from the painter Giotto to the composer Schoenberg, from the architects of Gothic cathedrals to the poets Milton and T. S. Eliot) whose work would have enriched his enquiry if space had permitted. His intention, he writes, is to explore

the glory of the divine revelation, as it is presented and unfolded in the length and breadth of the theology of the Church. Therefore not immediately (and more narrowly) the form and beauty of theology, but the ultimate, objective ground which lies in the biblical revelation, as it gives shape and form to theology.[17]

That 'ultimate, objective ground' is the splendour or glory of God (*doxa* according to biblical tradition), or beauty, which, according to the Platonic tradition,[18] is the 'third transcendental' alongside truth and goodness. Thus, from the outset, Balthasar conceives his task in terms that link biblical revelation and classical philosophical insight. In other words, his intention is 'to develop a Christian theology in the light of the third transcendental, that is to say: to complement the vision of the true and the good with that of the beautiful (*pulchrum*)'.[19] Beauty understood in this way is not the property of anything, but characterises the form of ultimate reality. Beauty is part of the nature of God; it is the essence of God's glory (*doxa*). Every created object, humanity included, partakes to some extent in this beauty. Hence the inherent potential of all creation to express the beauty of God, which presupposes an analogous relationship.

The Thomist doctrine of 'analogy of being', or *analogia entis*, as reinterpreted by Erich Pryzwara, Balthasar's Jesuit teacher, is funda-

[16] Balthasar, *The Glory of the Lord: Vol. 2*, p. 15.

[17] *Ibid.*, p. 14.

[18] Plato's thought was complex and embraced a wide range of areas of enquiry. This is reflected in the different and often diverse strands of neo-Platonism. While there were those who strongly opposed neo-Platonism (for example, St Athanasius), its influence on the early formation of Christianity was profound, especially in the development of the Christian mystical tradition. It was also appropriated in different ways as represented, for example, by Origen, St Augustine and Denys the Areopagite. Plato's idealism or doctrine of the Ideas, Forms or Transcendentals, recast in terms of faith in a personal God, is fundamental to them all. Andrew Louth, *The Origins of the Christian Mystical Tradition: From Plato to Denys* (Oxford: Clarendon Press, 1983).

[19] From the Foreword to Balthasar, *The Glory of the Lord: Vol. 1*.

mental to Balthasar's project.[20] The 'analogy of being' refers to the intrinsic relationship between God and creation (including humanity), but as retrieved by Pryzwara and adopted by Balthasar it becomes 'a doctrine of participation, of a sharing in the divine life' which moves the creature towards God.[21] The implication of this for theological aesthetics is far-reaching. It means that the beauty of God can be discerned in nature as well as in great works of art. The more such art 'is known and grasped', says Balthasar, 'the more concretely are we dazzled by its "ungraspable" genius'.[22] Analogy, in other words, is fundamental to the representative capacity of art, or what Plato called *mimesis*. But, insists Balthasar, we cannot know the true nature and meaning of this beauty by beginning with creation or human creativity in the manner of Romanticism. Beauty as a transcendental is not primarily that which pleases the senses as mediated through nature or art; it can only be known in and through revelation. The secret laws of nature would have remained unknown for ever were it not for their manifestation in this way. Beauty is 'the manner in which God's goodness (*bonum*) gives itself and is expressed by God and understood by man as the truth (*verum*)'.[23]

Plato, who had a low opinion of artists, insisted on the interrelationship between truth, beauty and goodness. The beauty portrayed in art had to be judged according to its truth and its ethical quality, for it had the power to influence people and society for good or ill. So, for Balthasar, the three transcendentals (truth, goodness and beauty) interrelate, and need to be evaluated in relation to each other. They are all integral to God's being and revelation, and therefore to our transformation. But it is beauty that attracts those who are encountered by it, drawing them to the truth and the good. Beauty understood in this way is redemptive. Hence the revelation

[20] The doctrine of the *analogia entis*, and the use of analogy in theology are complex historical and theological matters. The way in which the *analogia entis* first developed within Thomist (it was not employed by Thomas Aquinas himself) thought made revealed and natural theology commensurate. God could therefore be known through nature, even though redemption came through grace. Some leading neo-Thomists, notably Pryzwara, questioned this understanding and provided an alternative interpretation which gave priority to God's revelation in Jesus Christ, without which God cannot be known in nature. Balthasar's use of the *analogia entis* is closer in some ways to the synergistic understanding of analogy in Orthodoxy than the more conceptual use of the term in the West.

[21] Nichols, *The Word has been Abroad*, p. xiii.

[22] Balthasar, *The Glory of the Lord: Vol. 1*, p. 186.

[23] From the Foreword, *ibid*.

of God's beauty is the medium of our transformation. As Balthasar puts it:

> The form as it appears to us is beautiful only because the delight that it arouses in us is founded upon the fact that, in it, the truth and goodness of the depths of reality itself are manifested and bestowed, and this manifestation and bestowal reveal themselves to us as being something infinitely and inexhaustibly valuable and fascinating.[24]

If Balthasar is right, then the neglect of beauty has been devastating not only for the other transcendentals but also for Christianity. He writes:

> The beautiful guards the other (transcendentals) and sets the seal on them: there is nothing true or good, in the long term, without the light of grace of that which is freely bestowed. And a Christianity which went along with modernity and subscribed merely to the true (faith as a system of correct propositions) or merely to the good (faith as that which is most useful and healthy for the subject) would be a Christianity knocked down from its own heights.[25]

For Balthasar, it is precisely the denigration of aesthetics in contemporary theology that constitutes its hidden, governing presupposition. This includes various forms of liberation theology with their overemphasis on the good, and the obsession with getting at the truth through the study of history ('historicism') that has characterised German theology (and much else) since the nineteenth century.[26]

One reason Balthasar gives for the 'elimination of aesthetics' from Catholic theology is that it followed Protestant biblical criticism in making a false distinction between Hebrew and Greek thought, the one being temporal and the other atemporal. This neat distinction between Hellenism and biblical thought had serious consequences for theology. Above all, it falsely separated the dogmatic (truth) from the mystical, the contemplative from the active (the struggle for the good and the just) and the aesthetic from the prophetic. For Balthasar, however, this was not how the early fathers or the great scholastics understood either theology or the relationship between the transcendentals. It is part of the price that Christianity has had to pay for allowing itself to become captive to the nominalist

[24] *Ibid.*, p. 118.
[25] Balthasar, *The Glory of the Lord: Vol. 2*, pp. 38f.
[26] Edward T. Oates, *Pattern of Redemption: The Theology of Hans Urs von Balthasar* (New York: Continuum, 1994), 145f.

tendencies in late scholasticism that came to full flower in modernity. Interestingly, Balthasar blamed the elimination of aesthetics from Protestant theology not on Calvin's theology but on Luther's espousal of nominalism.[27] Thus he saw his task as recovering something that was previously always part of Christian tradition. Again and again he identifies his position with that of the ancient fathers, notably at this point with St Augustine. 'No-one', writes Balthasar, 'has praised God so assiduously as the supreme beauty or attempted so consistently to capture the true and the good with the categories of aesthetics as Augustine'.[28]

Balthasar's critique of modernity is nowhere more evident than in the extent to which he, a German cultural historian by training, identified with Goethe's struggle against 'the dichotomising pathologies of his age' as typified by the Newtonian world-view.[29] Newton's mechanical universe was sterile in comparison with Goethe's world of natural beauty and wonder.[30] The modern world-view was essentially dualistic, separating matter and spirit, form and content, idea and history. This was a reflection of a Platonic hierarchy of values (the spiritual is more important than the physical) and of gnosticism, the ancient enemy of Christianity. But neither the Enlightenment's rational attempt to provide an objective, scientific basis for understanding reality nor the Romantic reaction which exalted beauty but inevitably fell prey to the subjective was able to fill the void. In their shared opposition to the acids of modernity, Balthasar and Karl Barth anticipated post-modernism's rejection of philosophical dualism, its recovery of narrative hermeneutics, its scepticism about inevitable progress, and its concern about un-checked technology.

The consequences of the developments that built on medieval nominalism and led to Enlightenment's modernity, Balthasar argued, have proved disastrous both for Christianity and for the moral formation of the world, as well as for our understanding of truth. Hence his insistence on the need to return to an affirmation of the transcendentals and their interrelatedness, and to recognise the importance and centrality of beauty in doing so. For if you take away beauty, you undermine the attractiveness of the good and of the true.

[27] *Ibid.*, p. 180.
[28] Balthasar, *The Glory of the Lord: Vol. 2*, p. 95. See also Carol Harrison, *Beauty and Revelation in the Thought of St. Augustine* (Oxford: Clarendon Press, 1992), 273.
[29] Oates, *Pattern of Redemption*, p. 85. [30] *Ibid.*, p. 81.

[Handwritten: IS IT POSSIBLE TO LIVE IN A WORLD WHERE TRUTH + GOOD ARE DEFINED BY BEAUTY?]

In a world without beauty – even if people cannot dispense with the word and constantly have it on the tip of their tongues in order to abuse it – in a world which is perhaps not wholly without beauty, but which can no longer see it or reckon with it: in such a world the good also loses its attractiveness, the self-evidence of why it must be carried out.[31]

Balthasar goes on to say that in 'a world that no longer has enough confidence in itself to affirm the beautiful, the proofs of truth have lost their cogency'.[32]

In attempting a summary of this key insight, I would put it this way. Truth without goodness and beauty degenerates into dogmatism, and lacks the power to attract and convince; goodness without truth is superficial, and without beauty – that is without graced form – it degenerates into moralism. Alternatively, we could say that truth and goodness without beauty lack power to convince and therefore to save. Hence the emphasis on power in much of Western theology has been associated with ecclesiastical and dogmatic triumphalism rather than the 'glory of the Lord'. Or, better, the glory of the Lord has implied the glorification of divine power exercised by God's representatives (hierarchy; elect people), rather than the redemptive beauty of God as the power to save and restore humanity and creation. There is a further dimension to the relationship between truth, goodness and beauty, or between the dogmatic, the moral and the aesthetic. The true and the good are not primarily perceived by the rational faculties as propositions and principles: they are experienced through hearing and seeing, through intuition and imagination. Hence the fundamental importance of the arts for Christian faith and life.

Despite the emphasis placed on vision in Balthasar's theology, he does not exalt sight above hearing, sacrament and symbol above Word. Given his great love of music, a passion shared with Barth, it is not surprising that Balthasar gives a privileged place to hearing, and especially to hearing the divine Word, in the construction of his theology.[33] Aesthetics embraces hearing as much as sight. In many respects hearing is more central to perception because it forces us to listen. Vision, on the other hand, has more ability to control things, to determine whether and what we see. Hence the importance of listening for the Word of God in Scripture.[34] Perhaps the reason why aesthetics is the starting point for Balthasar is, as Oates suggests, that

[31] Balthasar, *The Glory of the Lord: Vol. 1*, p. 19. [32] *Ibid.*, p. 19.
[33] Oates, *Pattern of Redemption*, p. 133. [34] *Ibid.*, p. 136.

'it is in an analysis of the nature of beauty that we see how sight and hearing can be fused into one total assent to God's gifts of creation and revelation'.[35]

There are strong affinities between Balthasar's theology and the Christian mystical tradition. He draws deeply on Denys the Areopagite,[36] one of those chosen for exposition in the discussion of 'clerical styles',[37] and St John of the Cross, the greatest of all aesthetic theologians.[38] The connection between the aesthetic and the mystical is nowhere to be seen more clearly than here. It is a deep strand that weaves its way throughout Balthasar's work, relating it profoundly to Eastern Orthodoxy. Yet, despite his great love for the early church fathers and his strong affinities with the mystical tradition, Balthasar is at pains to distance himself from certain Platonic or neo-Platonic tendencies in both,[39] especially the depreciation of the material and bodily. Partly under the influence of Barth, Balthasar always seeks to earth the vertical dimension, insisting that while we may not be able to penetrate the mystery of God and must remain silent before the Unknowable, God has freely chosen to reveal divine beauty, truth, and goodness in history, in flesh and blood. In this way, Balthasar works on the creative edge between the mystical, the neo-Platonic, represented historically by Denys, and the strongly anti-gnostic emphasis on creation and incarnation that we find in Irenaeus. Whether he always succeeds in maintaining his balance is a matter for debate. Some speak critically and with a degree of justification of his 'fundamental Platonism'.[40] What cannot be denied, however, is his insistence on the intrinsic relationship between creation and redemption, on the material as the medium of revelation and salvation.

Significantly, then, Balthasar begins his post-biblical explorations by examining Irenaeus, whose anti-gnostic and pre-Alexandrian (i.e. not yet Platonising) theology refused to set creation and redemption apart. Irenaeus' theology was based on the reality of the incarnation,

[35] *Ibid.*, p. 142.
[36] On Denys see Louth, *Origins of the Christian Mystical Tradition*, pp. 159ff.
[37] Balthasar, *The Glory of the Lord: Vol. 2*, pp. 144ff.
[38] Balthasar, *The Glory of the Lord; Vol. 1*, p. 125. On St John of the Cross's relationship to the patristic mystical tradition and Denys, see Louth, *Origins of the Christian Mystical Tradition*, pp. 179ff.
[39] Oates, *Pattern of Redemption*, p. 109.
[40] Rowan Williams, 'Balthasar and Rahner', in *The analogy of Beauty: The theology of Hans Urs von Balthasar*, ed. John Riches (Edinburgh: T. & T. Clark, 1986), 21.

and therefore on historical revelation ('theology begins by seeing what is'),[41] and found its eschatological goal in the recapitulation (ἀνακεφαλαίωσις) or fulfilment of all things in Jesus Christ.[42] For Irenaeus there is a clear line of connection which links together creation and eschatology via the cross, and the same is found in Balthasar and Barth. Their use of Irenaeus also provides us with a significant point of contact with Bonhoeffer's theology. For Bonhoeffer the reality of God and the reality of the world are not only brought together in Christ but, with reference to Irenaeus' 'magnificent conception', as Bonhoeffer puts it, everything is taken up, transformed and made transparent in Christ.[43] More of that in chapter 4.

This brings us to the heart of Balthasar's theology. Theological aesthetics is about the self-disclosure of the glory (*doxa*) of the triune God that validates itself in the historical form (*Gestalt*) in which the divine splendour is revealed and received. This means nothing less than 'the form of the divine revelation in salvation-history, leading to Christ and deriving from him'.[44]

Jesus is the Word, the Image, the Expression and the exegesis of God . . . He *is* what he expresses – namely, God – but he is not whom he expresses – namely, the Father. This incomparable paradox stands as the fountainhead of the Christian aesthetic, and therefore of all aesthetics![45]

This implies further that we 'ought never to speak of God's beauty without reference to the form and manner of appearing which he exhibits in salvation-history'.[46] The drama of the incarnation is, in fact, the supreme work of art, the art of the transformation of all things. In Christ, all the aesthetic categories (form, expression, meaning and symbol) become categories of action (deed, decision, choice, play and role). 'The whole movement of biblical revelation has as its goal to make image and glory coincide in Jesus Christ.'[47] From the perspective of Christian faith, then, Jesus is the true icon, the 'image of God', and the 'radiance of God's glory' (Hebrews 1:3). In him we discern the link between creation and redemption, the

[41] Balthasar, *The Glory of the Lord: Vol. 2*, p. 45.

[42] *Ibid.*, pp. 31–94.

[43] Dietrich Bonhoeffer, *Letters and Papers from Prison* (London: SCM, 1971), 170.

[44] Balthasar, *The Glory of the Lord: Vol. 1*, p. 29.

[45] *Ibid.*, p. 29. [46] *Ibid.*, p. 124.

[47] Breandán Leahy, 'Theological Aesthetics', in *The Beauty of Christ: An Introduction to the Theology of Hans Urs von Balthasar*, ed. Bede McGregor and Thomas Norris (Edinburgh: T. & T. Clark, 1994), 35.

word of power that upholds all things, the one through whose death on the cross our sins are forgiven, and through whom all things 'on earth or in heaven' are reconciled (Colossians 1:15). Moreover, just as 'it is in Christ that the Godhead in all its fullness dwells embodied', in him we 'have been brought to fulfilment' (Colossians 2:10).

We must return to this Christological focus in a while, but it is appropriate to pause briefly at this point and ask about the connection between our discussion of Balthasar thus far and a central theme of our enquiry, namely the relationship between Christianity and the arts. Looking back on what he set out to do in the first volume of *The Glory of the Lord*, Balthasar wrote in the Introduction to the next what might be regarded as a succinct summary of his project as a whole, and a preliminary response to our query:

> If everything in the world that is fine and beautiful is *epiphaneia*, the radiance and splendour which breaks forth in expressive form from a veiled and yet mighty depth of being, then the event of the self-revelation of the hidden, the utterly free and sovereign God in the forms of this world, in word and history, and finally in human form itself, will itself form an analogy to that worldly beauty however far it outstrips it. In Jesus Christ, to whom the revelation in creation and history leads, the 'yet greater unlikeness' of God over against all that is not divine is not simply inferred as it were from certain 'signs', nor simply known (in a *docta ignorantia*), but – no matter how strange the manner of its appearing – read off from the form of the revelation and from nowhere else.[48]

There is, in other words, an analogous relationship between the beauty revealed in the form of Christ and the beauty that we encounter in nature and in great works of art. We can discern a family resemblance even if the beauty of revelation far outstrips and even judges such expressions. The beauty we experience in art or a breathtaking sunset is an expression of God's glory and, as such, has the potential to deepen our faith. But it is in Jesus Christ alone that we ultimately discern the form of God's beauty; a form that expresses the nature of beauty itself; that beauty, which is the nature of God, we experience as transforming power through the Spirit in the life of the church. With Christ as the centre, the theologies of Balthasar, Barth and Bonhoeffer converge, making dialogue between them particularly fruitful.[49] Yet differences remain which need to be explored critically.

48 Balthasar, *The Glory of the Lord: Vol. 2*, p. 11.
49 Hans Urs von Balthasar, *The Theology of Karl Barth* (New York: Holt, Rinehart and Winston, 1971), 247ff.

TRANSFORMATION IS GOD'S INTENT FOR
IT IS THE RETURN TO GOD'S INTENT IN ✗.

GOD'S JOYFUL BEAUTY

Balthasar was as deeply concerned about the elimination of the aesthetic from Protestant theology as he was about its elimination from Catholic theology. But he believed that Barth's theology had the potential to remedy the situation. Barth's trinitarian development, Balthasar claimed, forced Barth 'to restore to God the attribute of "beauty" for the first time in the history of Protestant theology'.[50] Historically speaking, Balthasar was incorrect, for that distinction belongs to Jonathan Edwards, the New England Congregationalist divine who was influenced by neo-Platonism and like Balthasar made beauty an integral and central part of his theology.[51] It is surely noteworthy that it was this Calvinist Puritan who not only gave 'beauty a pre-eminent role amongst God's perfections' but regarded 'it as taking priority over power in the divine glory', even equating them at times.[52] The issue is not, however, who takes precedence in such matters, but whether Balthasar's hypothesis concerning the significance of Barth's introduction of beauty into his doctrine of God has merit. So what does Barth say about beauty, in what way does it differ from or confirm Balthasar's position, and how can it contribute to our own discussion?

Barth's discussion of the beauty of God comes relatively early in his *Church Dogmatics* (II/1) and reflects his personal discussions with Balthasar. Like his Catholic colleague, Barth affirms that God's beauty is uniquely God's. We cannot describe God's beauty on the basis of our own definition of what beauty might be,[53] but only with reference to the form in which God's beauty is revealed. From that perspective we can say that God's beauty is God's power to attract, to give pleasure, to create desire, to awaken joy and wonder. God does this precisely because God is 'pleasant, desirable, full of

[50] Balthasar, *The Glory of the Lord: Vol. 1*, p. 53.

[51] Roland Delattre, *Beauty and Sensibility in the Thought of Jonathan Edwards* (New Haven, Conn.: Yale University Press, 1992); Robert W. Jenson, *America's Theologian: A Recommendation of Jonathan Edwards* (New York: Oxford University Press, 1988), 15ff. As far as I can tell, neither Balthasar nor Barth mentions Jonathan Edwards. See Patrick Sherry, *Spirit and Beauty: An Introduction to Theological Aesthetics* (Oxford: Clarendon Press, 1992), 17.

[52] Sherry, *Spirit and Beauty*, p. 67. See also Jonathan Edwards, *A Treatise Concerning Religious Affections* (New Haven, Conn.: Yale University Press, 1959), 264f., 302f.; Jonathan Edwards, *Scientific and Philosophical Writings*, Works of Jonathan Edwards, 6 (New Haven: Yale University Press, 1980), 305; Jenson, *America's Theologian*, pp. 15ff.

[53] Karl Barth, *Church Dogmatics II/1: The Doctrine of God* (Edinburgh: T. & T. Clark, 1957), 656.

enjoyment'.[54] Thus far Barth and Balthasar are in agreement.
Differences begin to appear, however, as soon as Barth locates his
position in relation to the history of pre-Reformation theology.
Starting with Augustine, Barth focuses particularly on Pseudo-
Dionysius, for whom, he writes, 'the beautiful in its identification
with the good is the ultimate cause which produces and moves all
things'.[55] For Barth this is 'a hardly veiled Platonism' that is largely
avoided in the ancient church and completely ignored in Reforma-
tion theology, and later even by Schleiermacher the great Romantic
theologian and pioneer of Protestant liberal theology. Barth's nega-
tive reaction is expressed so forcefully that we would be forgiven for
thinking that this was his final word:

Owing to its connection with the ideas of pleasure, desire and enjoyment
(quite apart from its historical connection with Greek thought), the concept
of the beautiful seems to be a particularly secular one, not at all adapted
for introduction into the language of theology, and indeed extremely
dangerous.[56]

The fundamental problem for Barth is not a semantic one, however,
but his fear of neo-Platonism. His exposition might not capture all
the nuances in neo-Platonism, but his instincts are sharp and he
knows when and where danger lurks for evangelical faith. Barth
believes that Balthasar has embarked on a course down a very
slippery path and he does not want to accompany him. So there is,
Barth emphasises, a need for caution. But having entered this word
of warning, Barth takes us by surprise as his dialectical approach
springs into action. Caution is not enough. We must say 'No' to
Platonism, but 'Yes' to the beauty of God. We must, in other words,
avoid the slippery slope but still take the risky next step of affirming
the beauty of God as something that Hellenism helps Christianity to
recover. 'Joy, desire, pleasure, the yearning for God and the enjoy-
ment of' fellowship with God all have to do with the beauty of
God.[57] That, incidentally, is also why theology itself, for Barth as for
Balthasar, is 'the most beautiful of all the sciences'.[58]

Barth is clearly ambivalent as he walks the tightrope between the
gospel and Hellenism. All sources of goodness, beauty and truth
have been corrupted by human sin and need to be redeemed by
Christ. But they *can* be redeemed. So, as is seen in his discussion of

[54] *Ibid.*, p. 651. [55] *Ibid.*, p. 651. [56] *Ibid.*, p. 651.
[57] *Ibid.*, p. 655. [58] *Ibid.*, p. 656.

eros and *agape* elsewhere, Barth was not unmindful of the dangers of disparaging the contribution and insights of Hellenism in the name of biblical religion.[59]

> The violence displayed against Hellenism in recent theology is not a good thing, and its continuation can only mean that in a short time we shall again be exposed to the Greek danger. The Greeks with their *eros* – and it was no inconsiderable but a very real achievement – grasped the fact that the being of man is free, radically open, willing, spontaneous, joyful, cheerful and gregarious.[60]

We have already referred to the importance of Balthasar's holding together of the Hellenic and Hebraic concepts of time with regard to relating the contemplative and the active, the mystical and the prophetic. Barth's insistence on doing the same with regard to *eros* and *agape* is equally important for the way in which we understand the body and approach the relationship between divine and human creativity.

Barth holds fast to his dialectic. His 'No' to Hellenism always precedes his more cautious 'Yes' to its challenge. Our knowledge of God must not be brought under the idea of the beautiful as though that were the leading concept in theology. Apart from anything else, and this is quite crucial for Barth, it is not biblical in the way that glory (*doxa*) is, nor is it its equivalent. The Bible certainly speaks of the beauty of God, but not of beauty as the *being* of God. God's beauty is the beauty of his glory and holiness, and not the other way round. Such a reversal, which was equally rejected by Forsyth, as we have noted, is precisely the 'Greek danger' against which Barth warns. It is the danger of allowing Hellenism, not just Apolline or Dionysian but also Platonic, to become the controlling factor in faith and theology. Yet the way to counter this danger is not to reject what is good and true in Hellenism; rather it is to affirm and critically appropriate it within the framework of biblical faith much in the same way as some forms of Christianity came to embrace democracy. Thus, in distinction from neo-Platonism and the notion of beauty as a transcendental, Barth insists that God's beauty is an explanation of God's glory, not its equivalent. Nevertheless, it is an essential explanation, for the biblical understanding of glory, 'includes and expresses what we call beauty'.[61] By contrast, for

[59] Karl Barth, *Church Dogmatics III/2* (Edinburgh: T. & T. Clark, 1960), 282ff.
[60] *Ibid.*, p. 283. [61] Barth, *Church Dogmatics II/1*, p. 653.

Balthasar, beauty is far more than an 'explanation' of God's glory: it is transcendental and therefore a constituent of *Herrlichkeit*. Thus beauty becomes determinative for Balthasar's theology in a way that was impossible for Barth.

The difference between Barth and Balthasar is important even if it appears abstruse. We may regard beauty as transcendental in the sense that it can be applied to different categories of things (actions, virtues, theories, proofs, landscapes, works of art) without necessarily taking the ontological step of 'talking of being itself as beautiful'. We do not need to accept that beauty is *the nature* of God in order to affirm the beauty *of* God. That is why Balthasar's transcendentalism is a stumblingblock for the recovery of theological aesthetics by those who, like Barth, are uneasy about the dangers of its neo-Platonism as well as its absolutist and hierarchical consequences both within the life of the church and in the political arena.[62] Others find his transcendentalism unhelpful because it inevitably means that all Christian aesthetics has to be based on revelation.[63] There is a sense in which Balthasar's theology almost takes on the character of revelation, giving the impression of fulfilling all less adequate theological trends.

Barth's theology opens up an alternative way towards the recovery of a theological aesthetic in which God's grace and freedom remain sovereign and socially transformative. But if Barth does not regard beauty as a transcendental, if it is only an explanation of God's glory rather than of God's essence, how is the beauty of God to be understood in relation to God's being? In response Barth refers to the triunity (his preferred word for trinity) of God. God's triune being 'is radiant, and what it radiates is joy. It attracts and therefore it conquers. It is, therefore, beautiful.' In other words, the triunity of God, its difference in unity, its relationality and harmony, its being and economy, its loving interweaving of persons (*perichoresis*) as if in a cosmic dance[64] radiate beauty. For Barth, beauty is an explanation of God's triune glory revealed in creation and redemption.

[62] See Arnold Hauser, *The Social History of Art: Renaissance, Mannerism, Baroque*, The Social History of Art, 2 (London: Routledge, 1962), 38f.

[63] Frank Burch Brown, *Religious Aesthetics: A Theological Study of Making and Meaning* (Princeton: Princeton University Press, 1989), 19–20. See also Dorothy Sayers, 'Towards a Christian Aesthetic', 1944; reprinted in Nathan A. Scott, Jr., ed., *The New Orpheus: Essays Toward a Christian Poetic* (New York: Sheed & Ward, 1964).

[64] *Perichoresis* is the Greek for 'dance', and describes the interweaving actions associated with dancing. The early church theologians used it in their attempt to describe the inner

[The] triunity of God is the secret of His beauty. If we deny this, we at once have a God without radiance and without joy (and without humour); a God without beauty. Losing the dignity and power of real divinity, he also loses his beauty.[65]

That means losing the power to attract and redeem. Balthasar likewise argues that the non-trinitarian God of liberalism results in 'a lustreless and joyless (and also humourless!) – in short, an uncomely God'.[66] This claim may not be fair to those who have rejected the joyless and humourless character of much that passes for Christian Orthodoxy. But the point being made here is that modernity's deity is, in principle, cold, impassive, rational and mechanical, whereas a genuinely trinitarian theology expresses the beauty, joy, love, wonder and surprising creativity of God. The absence of such a theology may help explain why so many people who are sensitive to the aesthetic, whether in artistic creativity or in nature, are alienated from the church and prefer some kind of 'nature mysticism' or new-age gnosticism.

If the danger of neo-Platonism is one concern that bothers Barth in responding to Balthasar, another has to do with the doctrine of the 'analogy of being' (*analogia entis*) to which we earlier referred. This doctrine, so Barth argued, lies at the heart of the tension between Reformed and Roman Catholic theology. In another guise, namely the idea of the 'religious a priori' of natural theology, it infected liberal Protestantism, making it impotent in countering Nazi ideology and susceptible to complicity. Hence Barth's categorical 'No' to the human pretension implicit in natural theology and cultural Christianity, and his unequivocal 'Yes' to the triumph of grace alone as the way of redemption. Schleiermacher's Romantic interpretation of Christian faith, which had appeal for Barth despite his rejection of it, confused Christianity and culture and could become demonically distorted into the glorification of 'blood and soil' – an extreme example of the 'danger of Hellenism'. Despite the obvious differences between such perverted Protestantism and Roman Catholicism, the doctrine of the 'analogy of being', Barth contended, led Catholic theology into errors that amounted to the manipulation of God as object rather than obedience to God as

relationships between the persons of the trinity. See David F. Ford, *The Shape of Living* (London: HarperCollins, 197), 174.

[65] Barth, *Church Dogmatics II/1*, p. 661.
[66] Balthasar, *The Glory of the Lord: Vol. 1*.

sovereign subject.[67] Whether it was the anthropological turn in liberal theology that made human beings the subject, or the ecclesiastical control of God's grace through the Catholic sacramental system, God's freedom and grace were compromised.

The issues at stake here are fundamental. They have to do with how we conceptualise God and therefore take us 'to the very heartbeat of the Christian faith'.[68] An indication of their significance for our enquiry is Balthasar's claim that theological aesthetics would be meaningless 'if every analogical application of these categories (i.e. *analogia entis*) were forbidden'.[69] So while Balthasar took Barth's criticisms seriously as a Christological corrective to traditional readings of the doctrine of *analogia entis*, he nonetheless argued that Barth misunderstood the purpose of the doctrine and was in fact much closer to his own position.[70] In fact he claimed that Barth moved closer to that point of view as his theology developed,[71] something most of Barth's commentators reject.[72] For Barth the *analogia entis* remained the dividing line between Protestant and Catholic theology even though he acknowledged already in the first volume of his *Church Dogmatics* that at points he was only a 'hair's breadth' away from the Catholic teaching.[73]

There are important points of agreement between Barth and Balthasar that are not unrelated to this more fundamental disagreement. Balthasar was, after all, deeply affected by Barth's Christology.[74] He agreed with Barth in rejecting the anthropological turn in modern theology which derived from the Kantian 'obsession with subjectivity and the self-constitution of the subject', the point at which he also took issue with his fellow Catholic theologian Karl Rahner.[75] But Balthasar did not believe that the anthropological basis of liberal theology (or 'natural theology') was the Protestant equivalent of the 'analogy of being': quite the contrary. The reason is undoubtedly that his understanding of the *analogia entis* was so

[67] See Balthasar's response in Balthasar, *The Theology of Karl Barth*, pp. 25f.
[68] Eberhard Jüngel, *God as the Mystery of the World* (Grand Rapids: Eerdmans, 1983), 280.
[69] Balthasar, *The Glory of the Lord: Vol. 1*, p. 607.
[70] Balthasar, *The Theology of Karl Barth*, pp. 147ff.
[71] *Ibid.*, pp. 149, 100ff.
[72] See George Hunsinger, *How to Read Karl Barth: The Shape of his Theology* (New York: Oxford University Press, 1991), 6ff., 20ff.; Jüngel, *God as the Mystery of the World*, pp. 281ff.
[73] Karl Barth, *Church Dogmatics: The Doctrine of the Word of God*, Church Dogmatics, 1/1 (Edinburgh: T. & T. Clark, 1975), 239.
[74] See Balthasar, *The Glory of the Lord: Vol. 1*, pp. 463ff.
[75] Williams, 'Balthasar and Rahner', p. 23.

strongly influenced by his teacher Pryzwara, who had located the doctrine within a radically Christocentric framework. 'The way to God', wrote Pryzwara, 'and the image of God is only a shadowy hint of something which is brightly revealed by Christ alone; he is the unique exegesis that makes God visible to us.'[76] Thus Balthasar argued that the *analogia entis* did not mean that human beings could manipulate God but, on the contrary, it explained why God could not be grasped in this way.[77] It provided a radical critique of subjectivity. However, according to Balthasar, because Barth's own Christocentrism was not located within the framework of the *analogia entis* it pushed him into a tight corner. If there is to be a real incarnation, then a real priority of nature and reason must be presupposed.[78]

Of particular interest to us, as will become more evident in the next chapter, is that Balthasar believed that Bonhoeffer's treatment of the problem in *Act and Being*, where he seeks to mediate between Przywara's ontology and Barth's actualism, could show the way forward.[79] For while Bonhoeffer, following Barth, always insisted on the priority of God's act in Jesus Christ, he also maintained that act creates being. Hence Bonhoeffer's celebrated claim that 'Christ exists as Christian-community', that is God's revelation discerned concretely in the sociality of Christ and humanity.[80] The potential significance of this for our project, however, is that Bonhoeffer's mediating theology makes it possible to hold in creative tension the revelation of God's beauty in the event of Jesus Christ alone (Barth), and in nature and art as well (Balthasar).

Barth clearly recognised the need for analogy in our attempt to understand God, but this did not mean that there was some continuity of essence or being (similarity) between the divine and the human, a point of contact to which the divine could appeal. Our knowledge of God, Barth argued, derives solely from God's act of

[76] Balthasar, *The Theology of Karl Barth*, p. 249.

[77] Oates, *Pattern of Redemption*, p. 37. For a rejoinder in defence of Barth, see Colin E. Gunton, *The One, the Three and the Many* (Cambridge: Cambridge University Press, 1993), 139. Barth's own position is set out in Barth, *Church Dogmatics III/2*, pp. 283ff. Perhaps the difference between Barth and Balthasar is at the level of 'formal structure', not substantive issues. Oates, *Pattern of Redemption*, pp. 55, 65, n. 23.

[78] Balthasar, *The Theology of Karl Barth*, p. 270.

[79] *Ibid.*, p. 272. On the influence of Pyrzwara on Bonhoeffer, see Dietrich Bonhoeffer, *Act and Being: Transcendental Philosophy and Ontology in Systematic Theology*, Dietrich Bonhoeffer Works, 2, trans. Martin H. Rumscheidt (Minneapolis: Fortress Press, 1996), 61ff., 166f.

[80] See Clifford Green, *Bonhoeffer: Theology of Sociality* (Grand Rapids: Eerdmans, 1999).

grace in Jesus Christ, which calls forth a response of faith. Hence the only appropriate analogy to God's act is the event of faith (*analogia fidei*). Subsequently, as the trinitarian structure of his theology became more explicit, Barth adopted Bonhoeffer's language and spoke of the analogy of relationship (*analogia relationis*). As such, Barth's doctrine of analogy is theological rather than metaphysical; it is based on the triune God's free act of redemption of the world rather than on an ontology that precedes that event.[81] This is neither a denial of creation nor necessarily a complete rejection of 'natural theology', but the restoration of God's gracious relationship to the world. As Eberhard Jüngel suggests, Barth's rejection of the *analogia entis* in his later theology was no longer for the sake of preserving God's transcendence, but because he feared that it would not do justice to God's nearness to humanity in Christ.[82] This leads Jüngel to argue that much Protestant polemic against the *analogia entis* is misdirected and fails to appreciate the dynamic tension between 'similarities' and 'dissimilarities' which characterises Pryzwara's exposition and Balthasar's appropriation of it. Even so, Jüngel proposes that we need to develop an understanding of analogy that is more appropriate to the gospel claim that in Jesus Christ God, the Other, comes near to and embraces humanity in love – the 'analogy of advent'.[83] It is precisely because God is love that creativity and redemption are the form of God's self-expression, thereby establishing the most profound relationship with humanity.

If, for Jüngel, Przywara's understanding of *analogia entis* is like a pendulum which swings between similarity and dissimilarity, for John Milbank 'being' as understood by Pryzwara and Balthasar is 'an active, open – and not predetermined – possibility sometimes transcending given actuality'.[84] This is helpful when applied to theological aesthetics, for it allows for a more dynamic or 'poetic' understanding of 'the Beautiful' – 'poetic' meaning 'the realization or manifestation of the Beautiful'. Instead of focusing on the beautiful object or on perceptions of beauty, we can rather focus on the way in which 'the beautiful' manifests itself.[85] In other words,

[81] Colin E. Gunton, *Becoming and Being: The Doctrine of God in Charles Hartshorne and Karl Barth* (Oxford: Oxford University Press, 1978), 174f.
[82] Jüngel, *God as the Mystery of the World*, p. 282.
[83] *Ibid.*, pp. 285ff.
[84] John Milbank, *The Word Made Strange: Theology, Language, Culture* (Oxford: Blackwell, 1997), 15.
[85] *Ibid.*, p. 123.

the way in which 'the Beautiful' comes (advent) to us. Just as we derive our knowledge of the triune God from the revelation of God in Christ, so too do we derive our understanding of the beauty of God on the basis of his coming. On this Barth and Balthasar agree even if their positions on the *analogia entis* remain distinct.[86] The point which we have now reached in relating the two Swiss theologians in the light of Jüngel and Milbank's discussion corresponds, if I have rightly understood him, with the concluding statement in Milbank's essay on 'Christological poetics':

> our 'total hermeneutic situation' with regard to Christ *both* regards him aesthetically as he is given (Balthasar) *and* regards him *poetically* as he is still being given, re-born, through our spirit-inspired constructions. And since it more readily seems that what we can 'look at' is in our grasp, is 'given' as a controllable object, then it is rather – to invert the assumption of the most 'realisms' – that which comes out of us through our collective making which is more absolutely a *gift*, more absolutely un-possessable, and more absolutely *only there at all* if we contemplate it with love.[87]

Let us now consider the significance of the difference between Balthasar and Barth for Christianity and the arts, for they are of considerable importance for our journey. Like the iconoclasts, the Carolingian divines, and the Protestant Reformers, Barth resisted any attempt to *represent* visually the mystery of God's beauty revealed in Jesus Christ. It should come as no surprise, then, that in the course of his discussion of the form of God's beauty in Jesus Christ Barth comments negatively on artistic attempts to portray the 'face of Christ', which he calls the 'sorry story of the representation of Christ'. 'No human art', Barth insists, 'should try to represent – in their unity – the suffering God and triumphant man, the beauty of God which is the beauty of Jesus Christ.' There is not and cannot be any analogy. 'This picture, the one true picture, both in object and representation, cannot be copied, for the express reason that it speaks for itself, even in its beauty.'[88] Hence Barth's plea to all Christian artists to 'give up this unholy undertaking – for the sake of God's beauty'. This plea is reinforced by his insistence that Christian churches should not in any way be decorated by works of art.

But does Barth's practical conclusion necessarily follow from his theology? After all, if artists through the centuries had taken his

[86] See Balthasar, *The Glory of the Lord: Vol. 1*, p. 125.
[87] Milbank, *The Word Made Strange*, p. 142.
[88] Barth, *Church Dogmatics II/1*, p. 666.

advice and desisted from such undertakings, then some of the
greatest artistic masterpieces, from Russian icons to the murals in
the Sistine chapel to Pasolini's film *The Gospel according to St Matthew*,
would never have been created. Neither would so much art in
contemporary Asia or sub-Saharan Africa, through which Christ has
become enculturally represented.[89] This would undoubtedly be to
the impoverishment of the human spirit, but it would also be to the
detriment of the life and witness of the church. Could Barth possibly
have meant us to take his words in this way? And, if so, how do we
account for his deep appreciation of Grünewald's *Crucifixion* (the
Isenheim altar-piece), which so profoundly portrays the redemptive
suffering of Christ? How, indeed, are we to take his remarkable
claim that Mozart's music was a vehicle through which God revealed
something of the beauty and goodness of creation that was unknown
to the 'fathers of the church'?[90] Surely Barth cannot be numbered
amongst the theological despisers of art and culture?

There is an unresolved ambivalence in Barth at this point. The
fact is that artistic creativity is a response to God's free gift that
cannot avoid seeking to represent the heart of that gift. The Word
not only became deed, but also became image in Jesus Christ, and
it is this image which grasps hold of us, inspiring wonder and
artistic response. From this perspective, the true artist (and theo-
logian) is not someone who seeks to compete with God as creator
and redeemer, but someone whose creativity is a joyful and painful
reflection of and a response to that which is given and discerned in
creation and redemption. Genuine artistic creation is then under-
stood as a gift, a Spirit-inspired construction which breaks open
that which is hidden so that it may manifest itself, even if only for a
brief moment. If genuine theology must be beautiful because
revelation itself is beautiful, how can we not seek to express that
beauty in image as well as in word?

The gospels themselves are the pre-eminent example of Spirit-
inspired constructions through which Christ is continually pre-
sented afresh to us through the Spirit, calling forth a response of

[89] See examples in Hans-Ruedi Weber, *Immanuel: The Coming of Jesus in Art and the Bible* (Grand
Rapids: Eerdmans, 1984) and Masao Takenaka and Ron O'Grady, *The Bible through Asian
Eyes* (Auckland, New Zealand: Pace, 1991). It is noteworthy that both Weber (a former
student of Karl Barth) and Takenaka, who recognise the importance of the artistic
representation of Jesus Christ, stand within the Reformed tradition.

[90] Karl Barth, *Wolfgang Amadeus Mozart* (Grand Rapids: Eerdmans, 1986), 26.

faith, hope and love. It is not the letter of Scripture that gives life, but the Spirit that breathes through the words and penetrates our imagination. Of course, for Christians, the gospels are normative constructions, but they have redemptive power precisely because they evoke images through which Christ is present for us today within our own historical experience and reality. We know that Jesus the Christ was Jewish – that is 'given' yet we also appreciate that the representation of Jesus for 'us, today' can and must be African, Coptic or Japanese. We know that Jesus the Christ lived in first-century Palestine, yet this does not prevent us from contemplating him in medieval paintings where the setting is, as in the work of Piero della Francesca, undeniably Umbrian. Inspired by the gospel narrative and the Spirit, these images become gifts of grace through which we see who Jesus is with new eyes. There is, in fact, no other way whereby we can truly know something of the mystery of God incarnate in Christ than in terms of images that relate to our present reality and experience. On the one hand, we have to avoid the danger of assuming that a representation of Christ is actually 'the Christ' (idolatry), but on the other, we have to insist that Christ was truly God *incarnate*. This means that he entered fully into the life of the world and the historical context of his time, and can and of necessity must be represented as such today within our own context.

Yet, God entered our world in a particular way. The form and manifestation of the 'beauty that saves' is a strange and alien beauty that challenges and transforms all our assumptions. So it is only when theological aesthetics is liberated from the tyranny of superficial and facile images of the beautiful that it can begin to understand both the beauty of God and its redemptive power amidst the harsh reality of the world. For if the problem of evil is a major reason why many thinking people reject the existence of a God of love, the ubiquitous problem of ugliness might well be why some artists find it difficult to accept that beauty has redemptive power. In many ways, then, our journey of exploration is now entering territory which is at the same time the most theologically profound and aesthetically problematic. Yet we dare not evade the issues, for that would prevent Christian theological aesthetics from making its most distinctive contribution to our discussion, rendering it of little consequence and incapable of responding to the challenge presented to us by Dostoyevsky as well as Nietzsche.

THE ALIEN BEAUTY OF THE CROSS

Balthasar's theological aesthetics is a 'theology of the cross' (*theologia crucis*), not a theology of glory (*theologia gloriae*). In this he breaks with the triumphalism of late medieval scholasticism and identifies fully with Luther and Barth. At the centre of the drama of redemption stands the cross. In the redemptive suffering of Jesus Christ, the splendour of God is uniquely revealed. Jesus Christ, writes Balthasar, is 'the most sublime of beauties – a beauty crowned with thorns and crucified'.[91] So, too, for Barth, the 'work of the Son as such reveals the beauty of God in a special way and in some sense to a supreme degree'.[92] Christ is the perfect image of God. The beauty of Jesus Christ is the beauty of God. But it is the beauty of the 'suffering servant' (Isaiah 53:2–3), and as such it is a veiled beauty which is not self-evident. 'If the beauty of Christ is sought in a glorious Christ who is not the crucified, the search will always be in vain.' Barth goes on to say: 'God's beauty embraces death as well as life, fear as well as joy, what we might call the ugly as well as what we might call the beautiful.'[93] Balthasar likewise speaks of 'the inclusion in Christian beauty of even the Cross and everything else which a worldly aesthetics (even of a realistic kind) discards as no longer bearable . . . it embraces the most abysmal ugliness of sin and hell by virtue of the condescension of divine love '.[94]

The portrayal of the coming messianic figure in Isaiah 53:2 as one who had 'no beauty . . . to attract us to him' (NIV) highlights the way in which the beauty of God's righteousness and reign is not something normally associated with beauty. But by the same token it gives beauty a new and more profound meaning. We recall Hans Holbein's *The Entombment of Christ*, which so haunted Dostoyevsky. 'I believe', said Ippolit in describing his experience to Prince Myshkin, 'that painters are usually in the habit of depicting Christ, whether on the cross or taken from the cross, as still retaining an extraordinary beauty on his face; that beauty they strive to preserve even in his moments of greatest agony.' But in this picture, the one hanging over the gloomy doorway in Rogozhin's house, 'there was no trace of beauty'.[95] Beauty has been crucified; it has descended into hell. For

[91] Balthasar, *The Glory of the Lord: Vol. 1*, p. 33.
[92] Barth, *Church Dogmatics I/1*, p. 661. [93] *Ibid.*, p. 665.
[94] Balthasar, *The Glory of the Lord: Vol. 2*, p. 124.
[95] Dostoyevsky, *The Idiot*, p. 418.

Balthasar, the Christ of Holy Saturday is the most profound icon, for it portrays as nothing else can the mystery of the passion – that God in Christ has fully accepted the conditions and consequences of fallen humanity and entered into total solidarity with us.[96] If it be so that Christ can only 'redeem what he has assumed' (Irenaeus), then it must be the case that only by assuming the ugliness of death on a cross erected on a rubbish dump outside the city, where 'there is no trace of beauty', could Christ fully reveal the beauty of God and redeem the world. Which gives startling meaning to Van Gogh's discovery of beauty 'where the street cleaners dump the rubbish'.[97] Not surprisingly, then, some of the greatest works of art in the Western tradition have discerned and enabled us to see the beauty of God revealed on the cross or in the manger.

Christianity and its approach to art makes its break with classical culture precisely at this point, the point where, as St Augustine perceived, Platonism and Christianity part company.[98] The stumblingblock in reconciling them is invariably the divine condescension and self-emptying (*kenosis*) of the incarnation and the humiliation of the cross. This is not something that we discover either in nature or through reason. Nevertheless, what the divine *kenosis* demonstrates is that while the cradle and the cross are alien, they do not represent God's alienation from the world but rather God's affirmation and redemption of the world.[99] It is this understanding of *kenosis*, of God's self-emptying and humiliation, that Balthasar found in the writings of Johann Georg Hamann, the eighteenth-century Lutheran who profoundly influenced Kierkegaard even though his affirmation of the world and the aesthetic was strikingly different.[100] 'Hamann', Balthasar writes in appreciation, 'sees *glory as kenosis* as being proper not only to the God who became Man, but even before that to the

[96] Hans Urs von Balthasar, *Mysterium Paschale: The Mystery of Easter*, trans. Aidan Nichols (Edinburgh: T. & T. Clark, 1990).

[97] See p. 78 above.

[98] Saint Augustine, *Confessions and Enchiridion*, The Library of Christian Classics, VII (London: SCM, 1955), vii.9.

[99] Balthasar, *The Glory of the Lord: Vol. 1*, p. 462.

[100] See Ronald Gregor Smith, *J. G. Hamann: A Study in Christian Existence* (London: Collins, 1960). Balthasar believed that the whole development of theological aesthetics within Protestantism would have been different if Protestant theology in the nineteenth century had followed Hamann rather than Schleiermacher. For Hamann anticipated Barth in emphasising the gracious freedom of God in Christ, offering himself in humiliation in the flesh for the salvation of the world, and he also recovered the principle of analogy. Hans Urs von Balthasar, *The Glory of the Lord. Vol. 3: Studies in Theological Style: Lay Styles*, The Glory of the Lord, 3 (Edinburgh: T. & T. Clark, 1986), 277.

Creator who, by creating, penetrates into nothingness – proper, also, to the Holy Spirit, who conceals himself' in the letter of Scripture.[101] Thus Hamann spoke of the 'aesthetic obedience of the Cross' which enabled him to discern 'the folly of the Cross manifested vicariously' in the 'foolishness and ignorance of Socrates, and in the "*moron* of Homer's gods", which is precisely the "wonder-ful aspect of Homer's muse"'.[102] In other words, rather than the cross being the destruction of culture, it provides a way of discerning within culture that which anticipates and reflects God's way of redemption.

The cross, then, is the ultimate act of iconoclasm, the condemnation of all human pretension, will-to-power, and dehumanisation, but at the same time its judgement is a necessary prelude to redemption. With Dostoyevsky, but contra Nietzsche, the crucifixion is not the destruction of all that is beautiful and noble, but its redemption through identification with all that is ugly and ignoble. The crucifixion is certainly God's judgement on cultural idolatry, but it is even more the unveiling of that within culture which resonates with God's revelation. The paradox is profoundly evident in John's gospel in a text that Balthasar highlights: 'Now is the hour of judgement for this world; now shall the prince of this world be driven out. And when I am lifted up from the earth I shall draw everyone to myself' (John 12:31f.).

The death of Jesus on the cross was not the last word in the divine drama of redemption, even though it was and remains at its centre. From the perspective of the New Testament, the crucifixion is an eschatological event. It put an end to the strangle-hold of the 'old age' of death and sin, and opened up the 'new age' of eternal life (literally 'life in the new age', a quality of life rather than 'everlasting life'), the resurrected life of joy, peace and hope. In this way it anticipated the recapitulation (Irenaeus) or fulfilment of all things, the creation of a 'new heaven and earth'. The resurrection is not the Christian equivalent of the neo-Platonic flight of the individual soul (whether Christ's or ours) from the body to heavenly rest and bliss, but the transformation of the whole of created reality. That is the glory of God yet to be revealed, a glory hidden from sight. But the New Testament does indicate that there are moments in which what is hidden from sight can nevertheless be seen and grasped by those

[101] Balthasar, *The Glory of the Lord; Vol. 1*, p. 82.
[102] *Ibid.*, p. 82.

TRANSF. of SINNER TO FORGIVEN IS
A GLIMPSE of BEAUTY For THE CH.

who have eyes to see by faith. The chief example of this in the gospel narrative is, of course, the story of the transfiguration (Matthew 17:1–13). This plays a central role in the spirituality and aesthetics of Eastern Orthodoxy, and is quite fundamental to the understanding of the way in which icons depict the beauty of God (see plate 3).[103]

The transfiguration of Christ in which 'his face shone like the sun, and his clothes became as white as light' was not an escapist mystical experience on the part of Peter, James and John. It was, indeed, an experience of indescribable splendour, for that which was hidden and veiled is suddenly revealed – 'brighter than all light, but more veiled than all mystery'.[104] Yet this flash of brilliance on Mount Tabor prefigures the foreboding thunder clouds which soon after gathered above Golgotha, the Place of the Skull. Instead of the experience of God's beauty in the transfiguration of Jesus being a way of escape from reality, it becomes a sobering prelude to engaging the power of evil. In Balthasar's words, 'the glory of Christ unites splendour and radiance with solid reality'.[105] The disciples have to return from the mountain top to the plain, where Jesus casts out demons and heals the sick and where the disciples recognise their own lack of faith to do the same. There is, then, a direct relation between the transfiguration of Christ, the manifestation of God's glory in him, and the transformation of the human and social condition. This is corroborated by the fact that it was this gospel story, this experience of God's glory in the transfiguration of Christ, that became central to the spirituality and witness of Archbishop Desmond Tutu in South Africa. In the midst of the ugliness of apartheid and the struggle to bring about its downfall, the icon of the transfiguration opened up a window of hope through which the transformation of South Africa could already be anticipated.

Transfiguration spirituality, the spirituality of seeing the splendour of God even in the midst of ugliness and pain, is a transformative spirituality and therefore one which can only be understood in the light of the gift of the Spirit. The link is already made in the New Testament, where, in Paul's second letter to the Corinthians, the apostle distinguishes between the fading glory of the giving of the Law and the abiding glory of the Lord who is revealed through

[103] Leonid Ouspensky, *Theology of the Icon* (Crestwood, N.Y.: St Vladimir's Seminary Press, 1978), 35.

[104] Augustine, *Confessions*, p. 179, 9.1.

[105] Balthasar, *The Glory of the Lord: Vol. 2*, p. 124.

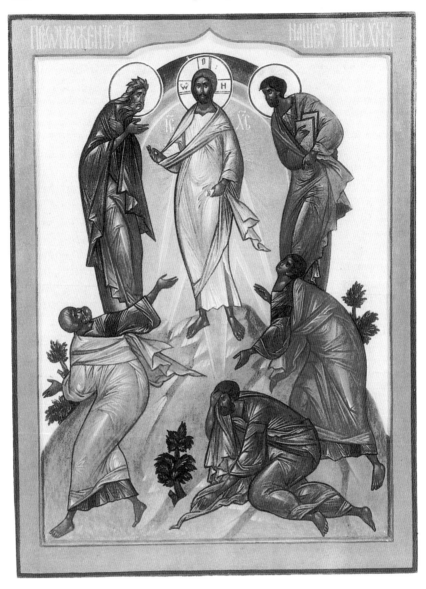

3 *Icon of the transfiguration.* Protodeacon Paul Hommes

the Spirit. This enables us all to 'see as in a mirror the glory of the Lord', with the result that 'we are being transformed into his likeness with ever-increasing glory, through the power of the Lord who is Spirit' (3:18). What is evident in such Pauline passages is that the beauty of God which is hidden in Jesus the Messiah, and supremely veiled from sight in the ugliness of the cross, can only be discerned through the gift of the Spirit. It is through the Spirit that we are enabled to see and hear what is manifest in God's revelation in Jesus Christ. Moreover, it is through the Spirit that the beauty of God in the form of Jesus Christ becomes the power that attracts and transforms, bringing us through the painfulness of death and rebirth into conformity with the image of Christ (Galatians 4:19).

The transforming work of the Holy Spirit is fundamental to the theologies of both Balthasar and Barth, even though not always as explicit as we might expect.[106] The fact that they both stand within the Western tradition which, with its strong Christocentric insistence that the Spirit proceeds from Christ (*filioque*), points to Christ, and reflects Christ's glory, has often failed to take the work of the Spirit in creation as seriously as it does in redemption. Even though Balthasar does speak of the Holy Spirit as 'the locus of the beauty of God',[107] his focus is far more on the role of the Spirit in salvation than in relation to natural beauty or artistic creativity.[108] This is obviously problematic if we believe that works of art are 'Spirit-inspired constructions'. For it is, as Sherry puts it, the Spirit of God who 'communicates God's beauty to the world, both through Creation, in the case of natural beauty, and through inspiration, in the case of artistic beauty'. He goes on to say:

> that earthly beauty is thus a reflection of divine glory, and a sign of the way in which the Spirit is perfecting creation; and that beauty has an eschatological significance, in that it is an anticipation of the restored and transfigured world which will be the fullness of God's kingdom.[109]

Despite this criticism, it is fundamental to Balthasar's theology that it is only through the Spirit that the inherent and unique form of Christ is given 'plasticity and vitality so that it can form, transform, the lives of believers'.[110] Balthasar's theological aesthetics is pro-

[106] See Nichols, *The Word has been Abroad*, p. 234.
[107] Balthasar, *The Glory of the Lord: Vol. 1*, p. 494.
[108] See Sherry, *Spirit and Beauty*, p. 105.
[109] *Ibid.*, p. 2.
[110] Nichols, *The Word has been Abroad*, p. 45.

foundly doxological, that is theology expressed through the Holy Spirit in prayer and praise rather than in propositions and systems. It also leads directly to his understanding of theological 'dramatics', for the liturgy is the re-enactment of the divine drama of redemption as this is worked out on the stage of human history, and is discerned analogously in the dramatic arts themselves.[111] But what does this mean for the mission of the church in the world? How does the drama of redemption and its expression in art relate to the task of transformation?

THE DRAMA OF WORLD REDEMPTION

In the West, argues Balthasar, the theatre, often in unrecognisable forms, continues the tradition of seeing the world as a stage, a tradition which Christianity took over from the ancient world, transformed through the gospel story, and handed on to the modern world.[112] This is why a *theo-dramatics* is so necessary, why it has immediate relevance to our existence in the world.

As human beings, we already have a grasp of what drama is: we are acquainted with it from the complications, tensions, catastrophes and reconciliations which characterise our lives as individuals and in interaction with others, and we also know it in a different way from the phenomenon of the stage (which is both related to life and yet at a remove from it). The task of the stage is to make the drama of existence explicit so that we may view it.[113]

But true drama is not only viewed, but draws us into the action; it exposes us to reality, to the creation of meaning, to new perspectives, and inexorably changes not just our view but our lives. That is why theological aesthetics flows directly into theological dramatics and becomes the point at which it relates directly to human and social transformation and therefore to Christian formation and the mission of the church in the world.

Christian formation in the image of Christ has to do with participation in the divine drama of redeeming the world on the stage of history. It is the *world* that is redeemed through beauty. If *aesthetics* is about perception, *Dramatik* has to do with God's dealings with humanity on the world stage.[114] Hence, as Balthasar puts it in

[111] Hans Urs von Balthasar, *Theo-Drama: Theological Dramatic Theory, Vol. 1: Prolegomena*, trans. Graham Harrison (San Francisco: Ignatius Press, 1988), 89ff.
[112] *Ibid.*, pp. 135ff. [113] *Ibid.*, p. 17. [114] *Ibid.*, p. 18.

the opening passage of his *Theo-Drama*, 'right at the heart of the *Aesthetics*, the "theological drama" has already begun. "Catching sight" of the glory (*die Erblickung*) always involves being "transported" by it (*die Entrückung*).' But now, he continues,

we must allow the encountering reality to speak in its own tongue, or rather, let ourselves be drawn into its dramatic arena. For God's revelation is not an object to be looked at: it is his action in and upon the world, and the world can only respond, and hence 'understand', through action on *its* part.[115]

Theological aesthetics does not encourage flight from the world but assumes Christian participation in God's mission to transform the world. There is, I would therefore argue, no reason why theological aesthetics and theologies of liberation and transformation need to be regarded as antithetical to each other. On the contrary, as I indicated at the outset of our journey, it is of considerable importance to relate them constructively to each other. As an important step in that direction, then, we need to consider the widely held view that Balthasar opposed liberation theologies, and that he and his followers supported politically and ecclesiastically conservative causes. Balthasar's theology, so it has been said, can more easily be hijacked to support an unjust *status quo* than social transformation.[116] But is this necessarily so, and is it an inevitable consequence of his theological aesthetics, or of theological aesthetics more generally?

Prior to his exposition of theology and drama in his *Theo-Drama*, Balthasar briefly notes some positive yet partial contributions in certain trends in modern theology. His aim is to show how each, in terms of its positive contribution, actually converges on *theo-drama*, and how its inadequacies are actually overcome in doing do.[117] It soon becomes evident that Balthasar was keenly interested in the burning issues of the day,[118] including the social responsibility of the church. Of particular interest to us are his comments on 'ortho-praxy' (as in liberation theology), 'dialogue' (the question of religious pluralism), 'political theology', and 'futurism' or 'utopianism', all key concepts in any theology of social transformation.

[115] *Ibid.*, p. 15.
[116] Gerard O'Hanlon, 'Theological Dramatics', in *The Beauty of Christ: An Introduction to the Theology of Hans Urs von Balthasar*, ed. Bede McGregor and Thomas Norris (Edinburgh: T. & T. Clark, 1994), 109.
[117] Balthasar, *Theo-Drama: Vol. 1*, p. 25.
[118] Oates, *Pattern of Redemption*, p. 167.

Let us begin by examining Balthasar's critique of liberation theology, keeping in mind that in some respects it is now *passé* because he was responding to Latin American liberation theology in its hey-day in the 1970s. His major criticism, which he also aims at all contextual theologies, is the loss of Catholic substance as contained above all in the Bible, the fathers and the writings of St Thomas Aquinas. In an essay on liberation theology published in 1977 he declared that his concern had to do equally with the form, the content and the method of Catholic theology. He feared that cultural specificity and contextuality were undermining the universality of the Catholic tradition; that the central facts of salvation history were being subsumed by a commitment to earthly justice; and that God's unique revelation in Jesus Christ was being undermined.[119] The Catholic theologian, he argued, had 'to be extremely wary and, indeed, on the lookout for ideological biases whenever theologians, using secularised theological analyses, read and interpret social structures in such a way that these are made to extract certain equally secularised theological actions'.[120]

We do not have to be Roman Catholic theologians to recognise the validity of Balthasar's concern. Theologians of other traditions would not deny the universality of the Christian tradition. When true to their confessions, the churches of the Reformation recognise the ecumenical character of the church and therefore of Christian faith and order. Protestantism is not simply, as Balthasar suggests, made up of national Christianities. There is, after all, a distinctly Reformed (or Lutheran, Methodist, Anglican, Baptist, Pentecostal) tradition that is embraced by many churches across the world, giving them a distinct universal identity. But, in any case, contextuality is not in principle antithetical to universality any more than diversity implies disunity. All theology is contextual, whether or not this is acknowledged. The notion that there is a 'Roman Catholic grand narrative' by which all else must be shaped and judged is giving priority to a particular contextuality as defining what is universal. Christianity by its very nature is multi-cultural rather than ethnocentric. The danger only arises when one contextuality claims to be normative, or when different expressions of Christian faith and life

[119] Hans Urs von Balthasar, 'Liberation Theology in the Light of Salvation History', in *Liberation Theology in Latin America*, ed. James V. Schall (San Francisco: Ignatius Press, 1982), 132f.
[120] *Ibid.*, p. 141.

no longer adequately cohere around the gospel in their understanding and practice of Christian faith.

We turn, then, to Balthasar's second fear, namely subsuming the gospel of salvation under social and political liberation. Balthasar was not against Christian involvement in the social, economic and political sectors of society.[121] The church has a responsibility to work for justice, and he insisted that Christians would always be engaged in a struggle against the forces of dehumanisation when faithful to the gospel. The Christian, he wrote, is 'committed to taking part in the total effort of humanity towards the humanising of the world'.[122] Indeed, he spoke of God as the partner of all 'deprived of their rights' and went on to say:

> Whoever is concerned about the demolition of injustice, lovelessness, and hard-heartedness in any shape or form – by helping the poor, by really taking up the cause of the rights of the proletariat (Marx was a Jew!), by fighting for the elimination of war, of nationalism, of racial hatred, or against whatever there is of unbearable injustice in the world – stands right at the place where one encounters God (in Jesus Christ) and the locus of injustice and of suffering in the world.[123]

With a clear reference to liberation theology's stress on God's preferential option for the poor, Balthasar likewise declared that Jesus 'sides with the poor' and, therefore, 'the church, too, must by preference side with the poor'.[124] He also recognised that direct non-violent political action to change society might be a necessary Christian response to injustice, insisting that this could demand the drastic reorganisation of living conditions in situations of extreme social misery.[125] This might even 'be the absolute prerequisite for fruitful evangelisation'.[126]

> Political liberation of the poor and the oppressed, where it is possible, is one of the signs demanded of the Christian to proclaim the deeper liberation from the power of sin and death by means of the cross. Christian evangelisation can and, indeed, should always begin with the direct proclamation to the poor of this deeper liberation, and with a corresponding pronouncement to the rich and the oppressors.[127]

On Good Friday, and the descent into hell of Holy Saturday, Jesus

[121] *Ibid.*, p. 146.
[122] Hans Urs von Balthasar, *The von Balthasar Reader*, ed. Medard Kehl and Werner Loser (Edinburgh: T. & T. Clark, 1982), 371.
[123] *Ibid.*, p. 374. This is an extract from his *Spiritus Creator: Skizzen zur Theologie III.*
[124] Balthasar, 'Liberation Theology', pp. 142f.
[125] *Ibid.*, p. 139. [126] *Ibid.*, p. 139. [127] *Ibid.*, pp. 138f.

not only died outside the city, but shared to the full in the abandon-
ment of those rejected and despised by society. Prince Myshkin
provided no verbal explanation for his claim that beauty would save
the world. Dostoyevsky knew that the 'idiot' saves the world not by
words but by being who he or she is, and by doing that which he or
she does in love and hope even if the world fails to see the mystery
that is being revealed.

Liberation theology, then, has a 'specific place in a theology of the
Kingdom of God'. Even though it is only '*one* aspect of the whole of
theology', yet, 'in practical terms, it demands the Church's commit-
ment to the shaping of the world as a whole in a manner conforming
with Christ'.[128] Nevertheless, Balthasar rejected any suggestion that
God's revelation can be reduced to social and political liberation.[129]
While orthopraxy 'drags Christianity out of the scholar's study and
sets it on the world stage', the danger is that it reduces faith to ethics.
Christianity becomes a 'guide to human endeavour' rather than
God's way of saving the world by grace.[130] While Christians should
take an option for the poor, they should not found a political party to
oppose the wealthy.

Balthasar firmly rejected the idea that Christians had a complete
programme of action that could fundamentally change the structures
of the world. This was not only untrue to the gospel, but also
politically irresponsible and condescending to victims of oppres-
sion.[131] Only by 'converting hearts to their political responsibility'
could 'something like the "conversion of structures" be effected'.[132]
This did not mean a withdrawal from the world and its challenges,
nor did it deny that under certain conditions direct political action
in the struggle for justice might be required of the Christian. But the
only effective way to convert the structures of the world from their
sinfulness and transform them was 'by the – dramatic! – collabora-
tion of all' rather than by violent revolution or brutal nationalisation
– that is the 'goals sought in utopian and unrealistic fashion'.[133]

[128] *Ibid.*, p. 146.
[129] See Balthasar, *The Glory of the Lord. Vol. 3*, pp. 449–54; Hans Urs von Balthasar, *The Glory of the Lord. Vol. 4: The Realm of Metaphysics in Antiquity* (Edinburgh: T. & T. Clark, 1989), 148–59. For a discussion of Balthasar's relevance for social theology in Ireland, see Gerald O'Hanlon, 'May Christians Hope for a Better World?', *Irish Theological Quarterly*, 54 (1988): 175–89.
[130] Balthasar, *Theo-Drama: Vol. 1*, p. 33.
[131] O'Hanlon, 'Theological Dramatics', p. 105.
[132] Balthasar, 'Liberation Theology', p. 138.
[133] *Ibid.*, p. 146. See also Balthasar, *Theo-Drama: Vol. 1*, p. 42.

Against unrealistic enthusiasm he insisted on political realism: 'the Church must not think in terms of utopias, but of realities'.[134] Hence his criticism of neo-Marxist philosophers such as Ernst Bloch, whose utopian vision inspired the theologies of hope and liberation during the 1960s. This, despite Balthasar's more general appreciation of Moltmann's theology.[135] 'Christianity', he wrote, 'has no direct competence in the realm of worldly structures; it simply sends Christians into the world with an image of the human whereby and according to which they are to organise its structures as responsibly and intelligently as they can.'[136]

Purpose of Transf. in Worship via Forg.

Balthasar's recognition and affirmation of the 'practical concerns' of liberation theology is important, and is perhaps sufficient to demonstrate that his theological aesthetics did not imply any withdrawal from the need to work for justice in the world. Rather, his theology is more in the tradition of Christian political realism as we find it from St Augustine to Reinhold Niebuhr. Indeed, part of the reason for his qualified pessimism about changing social structures was his painful awareness of the extent of their fallenness. For Balthasar, as Williams aptly puts it, 'the world is *not* a world of well-meaning agnostics but of totalitarian nightmares, of nuclear arsenals, labour camps and torture chambers'.[137] It is the world explored by the likes of Goethe and Dostoyevsky, an ugly world – one that can only be redeemed by the alien beauty of the cross. This is very important for our understanding of the way in which his theological aesthetics relates to the transformation of the world.

But there are a number of points on which we need to reflect a little more critically. If Balthasar's caution is accepted about the competency of theology, or the power of the church, to change the fundamental structures of the world and replace them with some kind of 'Christian political order', this cannot mean that Christians should not seek to change unjust structures. After all, sometimes they have succeeded. The statutory end of slavery and that of apartheid in South Africa are examples of the way in which Christians, along with many others, have brought about fundamental changes in social structures. Balthasar's cautions about 'political theology' are apposite, for it is true that the church is called to bear witness to the

[134] Balthasar, 'Liberation Theology', p. 144.
[135] O'Hanlon, 'Theological Dramatics', p. 177.
[136] Balthasar, *The Balthasar Reader*, p. 370.
[137] Williams, 'Balthasar and Rahner', p. 33.

reign of God within the political arena, not to put itself into a 'political pigeonhole'.[138] Yet his reluctance to allow theology to engage in critical social analysis lest it becomes the tool of secular ideologies actually prevented him from appreciating how important such analysis is for the witness of the church. Without doing so it is impossible to understand the nature of social structures and institutions including the church, or how societies both resist change and are transformed. 'After all if art, music, drama, philosophy and so on may be dialogue partners for theology, why not economics and politics?'[139]

There is a deeper theological issue at stake in Balthasar's ambivalence towards liberation theology. It is the dichotomy he maintains between the reign of God as ultimate promise and hope, the fulfilment of all things in Christ, and the reign of God as already present in our midst, as the penultimate foretaste of that which is yet to be. Part of the problem arises out of an apparent misunderstanding of the difference between what Karl Mannheim referred to as 'abstract' and 'concrete' utopianism.[140] The former is unrelated to reality and seeks the kind of ultimate change to social structures against which Balthasar rightly warns. But 'concrete' utopianism is that vision of a transformed society which is related to reality precisely because it is based not only on a vision of God's ultimate reign, but also on careful social analysis. So Balthasar's caution against social analysis is counter-productive in terms of his own fears – or his own acknowledgement that under certain circumstances Christians may well have to work to change the structures of society. The prophetic role of the artist in this regard as the visionary of new possibilities will be considered in chapter 5.

Balthasar's third fear, namely the denial of the uniqueness of God's self-disclosure in Jesus Christ, is, of course, a concern that has to do less with Catholic liberation theology than with more liberal or radical theologies such as those associated with feminism and multiculturalism. That such theologies were anathema to Balthasar is obvious and a reaction to the insistence by liberation theologians that we do theology 'from below'. A comparison between Balthasar's Christology and that of his fellow Catholic theologian Jon Sobrino

[138] Balthasar, *Theo-Drama: Vol. 1*, p. 39.
[139] O'Hanlon, 'Theological Dramatics', p. 108.
[140] Karl Mannheim, *Ideology and Utopia: An Introduction to the Sociology of Knowledge* (New York: Harcourt, Brace & World, 1936), 192ff. See also Balthasar, *Theo-Drama: Vol. 1*, pp. 41f.

highlights the difference as one between an ontological Christology 'from above' and a functional Christology 'from below'.[141] But this does not mean that the latter is a denial of the uniqueness of Jesus Christ as God's revelation. Not only are there points of convergence in Balthasar's and Sobrino's Christologies, notably with regard to *kenosis*, the centrality of the power of the cross, and the Lordship of Jesus Christ within the church, but they are complementary. For Balthasar, social action is a response to 'the beauty reflected in the Christ-form'; for Sobrino, Jesus calls his disciples to continue his witness to the reign of God as a reality in history. What we have here is a tension which is intrinsic to Christianity, a tension between the 'mystical' and the 'prophetic',[142] a tension that in many respects becomes creative through the arts.

Few theologians of the twentieth century have been as influential as Dietrich Bonhoeffer in helping us overcome the separation of faith and politics, and hence live creatively in the tension between the 'mystical' and the 'prophetic' in the struggle for human and social transformation. Reflection on his life and thought thus becomes appropriate at this point. But as we have already noted in this chapter, Bonhoeffer's theology provides insights that help us to go beyond Balthasar and Barth at some critical points, especially in his understanding of the analogy of relationships. His Christology, likewise, helps us positively to relate Christologies 'from above' (Balthasar and Barth) with those 'from below' (Sobrino), which is of considerable importance if we are going to make the connection between the concerns of theological aesthetics and those of liberation theology. But I shall argue that Bonhoeffer does more. He responds creatively to the challenge presented by Nietzsche's critique of Christianity as anti-aesthetic and, at the same time, to Kierkegaard's rejection of the aesthetic as antithetical to true discipleship. And, in doing so, he provides us with important clues for doing theology through the arts and recovering aesthetic existence in the life of the church and in the struggle for justice. Hence the significance of our discussion in the next chapter.

[141] Paul E. Ritt, 'The Lordship of Jesus Christ: Balthasar and Sobrino', *Theological Studies* 49 (1988): 709–29.
[142] *Ibid.*, pp. 725f.

Restoring broken themes of praise

There is a poem about the German theologian and martyr Dietrich Bonhoeffer written by Christopher Hill. Entitled 'Christmas Trees', it reflects on Bonhoeffer in Berlin's Tegel prison, where he was incarcerated by the Gestapo in April 1943.

> Bonhoeffer in his skylit cell
> bleached by the flares' candescent fall,
> pacing out his own citadel
>
> restores the broken themes of praise,
> encourages our borrowed days,
> by logic of his sacrifice.
>
> Against wild reasons of the state
> his words are quiet but not too quiet.
> We hear too late or not too late.[1]

Bonhoeffer was arrested because the Gestapo suspected that he was involved in helping Jews escape the Third Reich. The suspicion was well founded. But after the failure of the plot to assassinate Hitler on 20 July 1944 it became clear that he was also involved in that conspiracy. This led to his summary execution by the Gestapo on 9 April 1945 in Flossenbürg.[2]

Bonhoeffer's fragmentary prison reflections on 'Christianity in a world come of age' posthumously earned him the dubious reputation as the theologian who, going beyond Barth's critique of 'religion',[3] completed Nietzsche's work. Bonhoeffer, so some argued, initiated the 'death of God' theology of the 1960s which undermined

[1] Geoffrey Hill, *Collected Poems* (Harmondsworth, Middlesex: Penguin, 1985), 171.
[2] For a detailed account of Bonhoeffer's life, see Eberhard Bethge, *Dietrich Bonhoeffer: A Biography*, Revised Edition, ed. Victoria Barnett (Minneapolis: Fortress Press, 2000).
[3] On Bonhoeffer's critical appropriation of Barth's critique, see Ralf K. Wüstenberg, *Faith as Life: Dietrich Bonhoeffer and the Non-Religious Interpretation of the Biblical Message* (Grand Rapids: Eerdmans, 1998), 31ff.

Christian faith from within. Bonhoeffer undoubtedly followed Barth – and Kierkegaard before – in radically challenging bourgeois religion in the name of Christ. He also took seriously Nietzsche's claim that Christianity denied living life on earth to the full. But whereas Kierkegaard remained the iconoclast, Barth was trapped in 'revelational positivism',[4] and Nietzsche's life ended in despair, Bonhoeffer sought to recover a 'worldly Christianity' rooted in God's revelation in Christ yet able to celebrate the polyphony of life amidst the tragedies of our time. The Bonhoeffer who inspires us by his sacrifice is not the agent of Christianity's secularisation. Confined to the drab ugliness of a prison cell, bereft of family, fiancée and friends, and acutely aware of the fragmentary nature of life, he 'restores the broken themes of praise'.

As intimated in my introduction, I had no intention of writing this chapter when I set out on my exploration of the relationship between Christianity and the arts. But as I journeyed I was surprised by the extent to which Bonhoeffer's life and work intruded until finally I discovered clues for my task that I had not anticipated at all. In crucial respects his theology has strong affinities with those of both Balthasar and Barth, not least with regard to the centrality of the incarnation and the 'theology of the cross'. But just as he so often opens up new perspectives that enable us to go beyond classic theological positions, so he opens up fresh possibilities for reconstructing theological aesthetics and redefining the relationship between theology and the arts in a post-modern age. The purpose of this chapter is to explore these possibilities in three interrelated stages. In the first we examine Bonhoeffer's aesthetic judgement as it evolved in relation to his own theological development within his historical context. In the second our focus shifts from aesthetic judgement to 'aesthetic existence' and Bonhoeffer's hope that the church would become an 'area of freedom' within which such an existence could flourish. In the third we shall reflect on the way in which the arts, especially music, provided Bonhoeffer with key categories for his reflections on Christianity in a 'world come of age'. A critical sub-text woven throughout is Bonhoeffer's response to Kierkegaard's rejection of aestheticism in affirming faith, and Nietzsche's rejection of Christianity in espousing the aesthetic.

[4] Whatever the merits of this charge, it was Bonhoeffer's opinion as expressed in prison. Dietrich Bonhoeffer, *Letters and Papers from Prison* (London: SCM, 1971), 280, 286, 329.

AESTHETIC JUDGEMENT IN DOING THEOLOGY

Bonhoeffer provides us with no essay on the arts or aesthetics. What we have is fragmentary intimations of the way in which art influenced him, as well as comments of aesthetic judgement which reveal an intimate grasp of the subject. Such knowledge, along with his ability as a musician, was not remarkable given the family and cultural milieu in which he was nurtured. What is surprising is the way in which this related to his theological development,[5] the range of his aesthetic insight, and the extent to which his experience of other cultures influenced both his theology and his aesthetic judgement.

Bonhoeffer did not give serious consideration to the theological implications of his aesthetic interests until his imprisonment, but references to art and aesthetics occur in his earliest writings and are scattered through much of the rest. In *Sanctorum Communio*, his doctoral dissertation, there are allusions that suggest, at the age of twenty-one, an awareness of the broader debates about aesthetic theory. He challenges, for example, Max Scheler's contention that values such as the beautiful, the good, and especially the holy, have a unifying power. He also expresses reservations about the use of Thorwaldsen's neo-classical sculptures or Mendelssohn's music in church, expressing a preference for Dürer, Rembrandt and Bach.[6]

During the church struggle against Nazism (*Kirchenkampf*) his published comments on art and aesthetics are rare but illuminating. He was critical of the way in which the great Romantic musical tradition (Wagner, Beethoven) had been hijacked by the Nazis, preferring the classical works of Bach for their witness to the truth of the gospel. At that time Bonhoeffer made a clear distinction between what was appropriate within the church (Bach) and the Romantic tradition which he enjoyed outside that sphere despite its political abuse. In a sermon preached in London on Cantate Sunday (29 April 1934), he speaks about the danger of music, because of its great beauty and power, preventing us from hearing the Word of God and truly praising God in the new song of our redemption in

[5] On the place of music in Bonhoeffer's life and its influence on his theology, see Andreas Pangritz, *Polyphonie des Lebens: Zu Dietrich Bonhoeffers, 'Theologie der Musik'* (Berlin: Alektor-Verlag, 1994).

[6] Dietrich Bonhoeffer, *Sanctorum Communio: A Theological Study of the Sociology of the Church*, Dietrich Bonhoeffer Works, 1 (Minneapolis: Fortress Press, 1998), 128, 273, n. 430.

THE INTENT OF LITURGY IS TRANSF.

Christic.[7] Even Bach is suspected of 'outward beauty' at the expense of true 'inner beauty'.[8] Church music, Bonhoeffer insists, is not meant to decorate but to express the truth. Hymn singing, as at the time of the Reformation, is a means whereby Christians protest against unjust authority in the struggle for faith and freedom.[9] This is also expressed in his aphorism: 'only he who cries out for the Jews may sing Gregorian chants'.[10] Just as external beauty should not be allowed to take the place of internal beauty within the context of worship, so appreciation of the beauty of church music was contingent upon a commitment to justice. Only in this way could the broken themes of praise be restored.

Although deeply rooted in German 'high culture', Bonhoeffer's early exposure to other cultures set in motion a process that continued throughout his life, broadening and deepening his aesthetic appreciation and influencing the shape of his theology. One noteworthy example was his discovery of African-American 'spirituals' during his student year at Union Theological Seminary in 1930/1. It is remarkable that someone as deeply embedded in the classical traditions of European music should have responded so enthusiastically to the popular gospel songs of slaves and their descendants. Several years afterwards Bonhoeffer tried to introduce the spirituals to his students at the Confessing Church seminary in Finkenwalde, much to their puzzled amazement. But his attempt to do so reveals the cultural inclusivity of his taste. Perhaps reflecting back on this attempt at 'multi-cultural' aesthetic exposure, Bonhoeffer later commented in one of his prison letters:

I wonder whether a knowledge of other countries and an intimate contact with them are not more important for education today than a knowledge of the classics. In either case, of course, there is the possibility of philistinism; but perhaps one of our tasks is to see that our contacts with other peoples and countries reach out beyond politics or commerce or snobbishness to something really educational. In that way we should be tapping a hitherto unused source for the fertilizing of our education, and at the same time carrying on an old European tradition.[11]

[7] Dietrich Bonhoeffer, *London 1933–1935*, Dietrich Bonhoeffer Werke, 13 (Gütersloh: Chr. Kaiser/Gütersloher Verlagshaus, 1994), 351ff.

[8] See Pangritz, *Polyphonie des Lebens*, p. 15.

[9] See *ibid.*, pp. 21ff.

[10] Referred to by Bethge in Eberhard Bethge, *Dietrich Bonhoeffer*, p. 607.

[11] Bonhoeffer, *Letters and Papers from Prison*, pp. 230f.

Openness to other cultures did not mean ditching European tradition but rather its enrichment.

Also in prison, Bonhoeffer criticised the notion of art as 'a museum piece' separate from the rest of life.[12] Cultural or intellectual life (*geistige Existenz*) since the eighteenth century, he complains, has become a torso.[13] At Finkenwalde, by contrast, he showed his appreciation of the 'worldly art' of the Dutch masters, his love for the sacred sensuality of the music of Heinrich Schütz (1585–1672), to which Eberhard Bethge introduced him, and his enjoyment of both Romantic music and the spirituals. In Bethge's words:

> Every week a different series of drawings and etchings from Rembrandt's Bible illustrations were hung in the entrance hall: these came from a large Dutch edition owned by Bonhoeffer. His collection of gramophone records, remarkable for those days, was at everyone's disposal; the rooms often rang with then little known Negro spirituals such as 'Swing low, sweet chariot . . .'[14]

But how did Bonhoeffer understand the role of the artist in the life of the church and society? Bonhoeffer's thinking about such matters was, I suggest, influenced by Bishop George Bell of Chichester, who became his closest confidant during the two years he spent as a pastor in London prior to his appointment as the director of the Finkenwalde seminary. Bell's support for the ecumenical movement and his commitment to the Confessing Church in Germany, as well as his advocacy of Jewish immigration and his equally unpopular support for the German resistance, found common cause with Bonhoeffer's own life and work. What is generally less known is that Bell was also the church leader most responsible for the renewal of the arts in the life of the church of England at the time.[15] In 1928, as Dean of Canterbury, he had reintroduced drama into the life of the Church with the production of John Masefield's *The Coming of Christ*, and later commissioned T. S. Eliot's *Murder in the Cathedral*, which was performed in 1935.[16] In his enthronement address as Bishop of

[12] *Ibid.*, pp. 230f. [13] *Ibid.*, p. 219.

[14] Bethge, *Dietrich Bonhoeffer*, p. 427.

[15] Ronald C. D. Jasper, *George Bell Bishop of Chichester* (London: Oxford University Press, 1967), 121ff.; Giles C. Watson, 'Catholicism in Anglican Culture and Theology: Responses to Crisis in England (1937–1949)', dissertation (Australian National University, 1998), 121ff.; Keith Walker, *Images or Idols?: The Place of Sacred Art in the Churches Today* (Norwich: Canterbury Press, 1996), 48ff.

[16] Barbara Reynolds, *Dorothy L. Sayers: Her Life and Soul* (London: Hodder & Stoughton, 1998), 309.

Chichester, Bell expressed the hope that there would be a 'reassocia-tion of the Artist and the Church' in and through which each would learn from the other to the benefit of Christian worship and witness. 'Whether it be music or painting or drama, sculpture or architecture or any other form of art, there is', Bell declared, 'an instinctive sympathy between all these and the worship of God.'[17]

There is no documentary evidence to indicate whether Bonhoeffer ever discussed such matters with Bell. Nonetheless, it is almost inconceivable that he did not, and therefore not unreasonable to assume that he imbibed something from Bell on the role of the arts in the life of the church. There is at least one piece of corroborative evidence. In various sections of Bonhoeffer's *Ethics* there are passages that echo Bell's discussion of the role of culture in his *Christianity and World Order*, a book published in 1940 and read by Bonhoeffer at the time when he was beginning to draft his *Ethics*. Although Bell's book is primarily about politics and economics, it is noteworthy that he refers, even if only in passing, to the 'specialised ministry' of artists within the context of creating a new world order. 'Why', he asks, 'should not the artist receive the grace, and carry the commission, of the Church, as he paints?'[18] Surely this was a sentiment shared with and by his younger friend. Certainly what Bonhoeffer says about the connections between justice, morality, politics, science, art and culture in his *Ethics*[19] resonates with Bell's own argument, even if references to art are not as explicit as in this passage from *Christianity and World Order*:

Believers in justice and truth, mercy and love, in art and poetry and music, have this as common ground: that the things they believe are indestructible. They are not the same things as the Christian religion. But they can be truly regarded as auxiliaries to it. The Christian religion can stand without them (as it could not stand without justice and truth). It can, and would, survive without them, in the Catacombs.[20] I do not dispute it. But they have noble gifts to bring to Christianity. And without Christianity will *they*, and justice and truth, mercy and love, in the long run be able to survive? How great then is the need that those who stand for the indestructible things should live with, work with, and worship with the Christian Church![21]

[17] Quoted in Jasper, *George Bell*, p. 121.
[18] G. K. A. Bell, *Christianity and World Order* (Harmondsworth, Middlesex: Penguin, 1940), 57.
[19] For example, Dietrich Bonhoeffer, *Ethics* (London: Macmillan, 1965), 57f.
[20] Bell must have known that some of the earliest examples of Christian art are to be found in the catacombs, so it is difficult to understand what he meant here unless he also assumed that early Christianity was aniconic.
[21] Bell, *Christianity and World Order*, pp. 146f. cf. Bonhoeffer, *No Rusty Swords*, p. 55.

Bonhoeffer was aware of the dangers of politicising art (Nazism), or of profaning beauty through moralising, but he was equally concerned about the opposite danger of aestheticism, of deifying values such as beauty in a way that lacks moral responsibility.[22] This dialectic is of fundamental importance, for it insists on giving art appropriate space and freedom within both society and the church, while recognising its social location and the need for accountability. In the *Ethics* art is, in fact, part of the divine mandate which Bonhoeffer defines as 'labour' or more broadly as 'culture' whereby human beings participate in the action of creation.[23] This sets art free from ideological control while giving it a status in the divine nature of things. To be sure, human beings may well challenge the creator through their creative endeavours, as encouraged by Nietzsche but feared by theologians from the early fathers to the Reformers as a prime example of hubris. Such alienation from God is also reflected in the fact that 'even truth, justice, beauty and love come into opposition with one another, just as do pleasure and displeasure, happiness and sorrow'.[24] But genuine human creativity expresses a yearning for reconciliation with God and the creation, and thus is an analogy for and a sign of the overcoming of human alienation.[25] Hence, too, Bonhoeffer refers to the remarkable fact that in the struggle against the barbarity of Nazism, 'justice, truth, science, art, culture, humanity, liberty, patriotism, all at last, after long straying from the path, are once more finding their way back to their fountainhead'.[26] In other words, art, morality, technology and politics truly fulfil themselves and their distinct role within society when they serve God's purposes of redemption as revealed in Jesus Christ.

A significant link between Bonhoeffer's ethical reflections and his prison theology was his essay 'After Ten Years', which he wrote as a Christmas gift for his co-conspirators in 1942. Nowhere else in his writings do we find such explicit reference to the connection

[22] Bonhoeffer, *Ethics*, pp. 226f.
[23] *Ibid.*, pp. 209, 286f. In his *Ethics* Bonhoeffer relates Christian faith to public life in terms of what he names the divine mandates in contrast to the traditional 'orders of creation' developed by Lutheran theologians in the nineteenth century. This was his way of avoiding the 'autonomy of spheres' (whether church, state, family or culture) which prevented the church from exercising a prophetic role in society.
[24] Bonhoeffer, *Ethics*, pp. 25f.
[25] *Ibid.*, pp. 22f. [26] *Ibid.*, p. 109.

between the struggle against the destruction of society and 'good taste', between ethics and the aesthetic. 'Quality', Bonhoeffer writes, 'is the greatest enemy of any kind of mass-levelling.'

Culturally it means a return from the newspaper to the book, from feverish activity to unhurried leisure, from dispersion to concentration, from sensationalism to reflection, from virtuosity to art, from snobbery to modesty, from extravagance to moderation.[27]

Nazism was symptomatic of a much deeper cultural problem. As much as they cherished the freedoms of the Weimar period, Bonhoeffer and the rest of his family would have regarded the aesthetic abuse of those freedoms as part of the problem he is addressing.[28] Certainly Bonhoeffer did not have a high regard for much of the artistic production of the pre-war Weimar years. But he was even more repulsed by the boorish taste of Hitler and his cronies. In his *Ethics*, he makes these terse statements, obviously mindful of the racist arrogance of European society and the Nazis in particular:

It is uncultured to laugh at a film when negro dances are performed.
It is uncultured to ridicule something merely because
it is different from oneself.
It is uncultured to parade one's 'culture'.[29]

As Theodore Gill suggested in his exploratory essay on 'Bonhoeffer as Aesthete', it was 'taste that was the operative and efficient ethical organ in the Bonhoeffer family's instant rejection of Adolf Hitler in the moment of his investiture'.[30]

In the *Letters and Papers from Prison* Bonhoeffer's references to art proliferate, revealing the range of his knowledge and aesthetic insight. There, too, we find him writing a novel, a play, and expressing his deepest thoughts and longings in some remarkable poetry. Paradoxically it is in the confines of a cell bereft of beauty, separated from those whom he loved, especially his fiancée,[31] that

[27] Bonhoeffer, *Letters and Papers from Prison*, p. 13.
[28] Theodore A. Gill, 'Bonhoeffer as Aesthete' (American Academy of Religion, November 1975), 4f.
[29] Bonhoeffer, *Ethics*, p. 187.
[30] Gill, 'Bonhoeffer as Aesthete,' p. 6.
[31] Bonhoeffer was engaged to Maria von Wedemeyer, whom he had really known for less than a year, on 17 January 1943. He was thirty-seven years old and she was eighteen. Bonhoeffer was arrested by the Gestapo on 5 April. By the time their engagement was announced to the wider family circle, he was already in prison. See Bethge, *Dietrich Bonhoeffer*, pp. 780ff. Maria was allowed to make several visits to Bonhoeffer, but they were never able to

Bonhoeffer has the time and space to reflect in depth on beauty and art. With no pictures to adorn the walls and no music other than that which was embedded in his memory or faintly heard in the distance, Bonhoeffer found inspiration and solace in recalling those works of art he had previously come to know and love. Time and again he refers to them and discusses their merits in his correspondence with Bethge.

Some of his reflections express a Romantic longing prompted by memories of his childhood and his engagement. But they also reveal a sharp critical mind even when he is writing about the literary tastes of his fiancée and his niece. Rather than indulge in sentimentality, he judges Maria's and Renate's 'bad taste' in literature, declaring that the 'more we come up against really good things, the more insipid the weak lemonade of more recent productions has become to us, sometimes almost to the point of making us ill'.[32] Such work simply did not equip a person to be responsible. By comparison Bonhoeffer refers to the romantic woodland scenes portrayed by the nineteenth-century Austrian author Adalbert Stifter which make him long for the 'quiet glades of Friedrichsbrunn', the family holiday home.[33] In another reference to Stifter, he comments on the difference between 'simpleness', an aesthetic idea that is a gift, and 'simplicity' as an ethical notion. 'One can acquire "simplicity", but "simpleness" is innate. Education and culture may bring "simplicity" – indeed, it ought to be one of their essential aims – but simpleness is a gift.'[34] This is an important distinction. While artists may have the creative gift of 'simpleness', the possibility of acquiring the ability to see reality 'simply' and to live accordingly is open to all. It is, in fact, 'one of the greatest' intellectual

embrace in freedom. Their correspondence during this period is published in Dietrich Bonhoeffer and Maria von Wedemeyer, *Love Letters from Cell 92* (London: HarperCollins, 1994).

[32] Bonhoeffer, *Letters and Papers from Prison*, p. 148.

[33] *Ibid.*, p. 40. Stifter's volume was entitled *Wisdom of the Heart: Thoughts and Observations by Adalbert Stifter. A Breviary* (Berlin, 1941). It was also a book through which Bonhoeffer communicated with Bethge and his family in coded messages. Stifter's thoughts, especially in the novel *Witiko* which Bonhoeffer read at the time, were influential in shaping Bonhoeffer's ideas about the concept of life, friendship and marriage. See Eberhard Bethge, *Friendship and Resistance: Essays on Dietrich Bonhoeffer* (Geneva: WCC, 1995), 89f.; Wüstenberg, *Faith as Life*, pp. 113f. Adorno's sharp criticism of Stifter as 'the idol of a noble and backward-looking bourgeoisie' is tempered by his further comment that his work was different from 'the average edification literature' W. Adorno, *Aesthetic Theory* (London: Routledge & Kegan Paul, 1984), 331.

[34] Bonhoeffer, *Letters and Papers from Prison*, p. 212.

achievements.[35] In acquiring this 'simplicity of the eye', seeing (the aesthetic) and acting (the ethical) differently are brought together.[36] Christian ethics, he previously wrote, requires the combination of simplicity with wisdom which alone enables one to act freely and responsibly, not 'fettered by principles, but bound by love for God'.[37]

In the same letter in which he comments on Stifter, Bonhoeffer shifts his attention to painting and talks about Italian landscape paintings in a way which likewise indicates critical discernment. 'Is there any Italian school of landscape painters, anything comparable to Thoma, or even to Claude Lorrain, Ruysdael, or Turner? Or is nature there so completely absorbed into art that it cannot be looked at for its own sake? All the good pictures I can think of just now are of city life; I can't remember any that are purely landscape.' In a later letter he returns to the subject of landscape painting, responding to some comments that he had meanwhile received from Bethge:

You're quite right about the rarity of landscape painting in the South generally. Is the south of France an exception – and Gauguin? Or perhaps they weren't southerners? I don't know. What about Claude Lorrain? Yet it's alive in Germany and England. The southerner *has* the beauties of nature, while we long for them wistfully, as for a rarity.[38]

Such comments clearly indicate Bonhoeffer's knowledge of the visual arts and his ability to engage in aesthetic judgement. His overall opinion of the visual arts since the Enlightenment was, however, not very complimentary.[39]

There are innumerable references to music in the *Letters and Papers from Prison*, and it was music that provided him with most of his aesthetic categories and analogies when engaged in theological reflection. Indeed, his theological thought in prison develops in tandem with his reflection on musical concepts.[40] Moreover, it is through music that Bonhoeffer has his profoundest 'aesthetic experi-

[35] Bonhoeffer refers to Bethge in this regard. *Ibid.*, p. 385.
[36] The unity of the act of seeing and the act of living was, according to Adolf Schlatter, Bonhoeffer's New Testament Professor at Tübingen, 'the fundamental postulate of the act of theological recognition, in that the act of living (the obedience to the revelation which is brought about in man through revelation) is the basis of the act of seeing'. See Hans Urs von Balthasar, *The Glory of the Lord. Vol. 7: Theology: The New Covenant* (Edinburgh: T. & T. Clark, 1989), 15.
[37] Bonhoeffer, *Ethics*, p. 68.
[38] Bonhoeffer, *Letters and Papers from Prison*, p. 239.
[39] *Ibid.*, p. 219.
[40] This connection has been thoroughly explored in Pangritz, *Polyphonie des Lebens*.

ence', undeniably religious, even mystical, in quality, yet profoundly Christological in character. The work of Schütz, especially his settings of the Psalms and his devotional hymn 'O Bone Jesu', is singled out for special praise as providing 'one of the greatest enrichments' of Bonhoeffer's life.[41] What is perhaps most remarkable is that in prison Bonhoeffer overcomes the divisions between the various musical traditions (Reformation, classical, Romantic) which he had hitherto always kept in separate compartments. So he overcame 'thinking in two spheres' not only in ethics (i.e. faith and politics, church and world), but now also in aesthetics.

In one of his letters to Bethge, Bonhoeffer refers to the way in which 'the music that we hear inwardly can almost surpass, if we really concentrate on it, what we hear physically'.[42] He admits that he does not know too many pieces sufficiently well for this to be the case, but it is true of some Easter hymns. To hear inwardly, he says, also gives him 'a greater appreciation of the music which Beethoven composed after he had gone deaf', referring in particular to 'the great set of variations from Opus III, which we once heard played by Gieseking'. A line follows this from the musical score. But there is one reference, in an earlier letter to his parents, which stands out. It shows the extent to which music made an impact upon his life – a truly 'aesthetic experience' which even drove from his mind the commendation he had just received from no less than Adolf von Harnack, his esteemed teacher.

For years now I've associated it [B Minor Mass] with this particular day [Repentance Day, 17th November], like the St Matthew Passion with Good Friday. I well remember the evening when I first heard it. I was eighteen, and had just come from Harnack's seminar, in which he had discussed my first seminar essay very kindly, and had expressed the hope that some day I should specialize in church history. I was full of this when I went into the Philharmonic Hall; the great *Kyrie Eleison* was just beginning, and as it did so, I forgot everything else – the effect was indescribable. Today I'm going through it, bit by bit, in my mind, and I'm glad the Schleichers can hear it, as it's my favourite work of Bach.[43]

This passage, more than most, indicates the close connection between Bonhoeffer's aesthetic judgement and his aesthetic experience. In prison the two are virtually inseparable elements in his life

[41] Bonhoeffer, *Letters and Papers from Prison*, p. 40.
[42] *Ibid.*, p. 240; cf. Pangritz, *Polyphonie des Lebens*, pp. 12f.
[43] Bonhoeffer, *Letters and Papers from Prison*, pp. 126f.

and thought. It is no wonder, then, that in reflecting on Christianity in a 'world come of age' he writes about the need to recover 'aesthetic existence' in the life of the church.

RECOVERING AESTHETIC EXISTENCE

On the 23 January 1944, Bonhoeffer wrote a letter to Eberhard and Renate Bethge in which he reflected on the meaning of friendship. Friendship, he suggested, is unlike marriage in that it has no recognised rights but must depend on its inherent quality. In distinction from marriage, work, state and the church, each of which has its own divine mandate, friendship belongs to 'the broad area of freedom'.[44] 'The man who is ignorant of this area of freedom', Bonhoeffer wrote, 'may be a good father, citizen, and worker, indeed, even a Christian' but he doubted whether he could be 'a complete man and therefore a Christian in the widest sense of the term'. He continued with the following comment, upon which we will anchor much of our discussion:

> I wonder whether it is possible (it almost seems so today) to regain the idea of the church as providing an understanding of the area of freedom (art, education [*Bildung*], friendship, play), so that Kierkegaard's 'aesthetic existence' would not be banished from the church's sphere, but would be re-established within it? I really think that is so, and it would mean that we should recover a link with the Middle Ages. Who is there, for instance in our times, who can devote himself with an easy mind to music, friendship, games, or happiness? Surely not the 'ethical' man, but only the Christian.[45]

Although Bonhoeffer does not specifically refer to 'aesthetic existence' in any of his other letters, several important clues about what he meant and its importance for him are found in this brief passage which are also commented on elsewhere.[46] One is his striking suggestion that the church should be an 'area of freedom' in which 'aesthetic existence' could be re-established.[47] Another is his

[44] See also *Ethics*, where Bonhoeffer discusses Mandates, and where the editor, Bethge, quotes this letter from prison in a footnote. Bonhoeffer, *Ethics*, p. 253. Bethge subsequently expressed surprise that this passage was neither noted nor discussed in the new critical edition of the *Ethik*, Dietrich Bonhoeffer, *Ethik*, Dietrich Bonhoeffer Werke, 6 (Munich: Chr. Kaiser, 1992). See also Bethge, *Friendship and Resistance*, p. 92.

[45] Bonhoeffer, *Letters and Papers from Prison*, p. 193.

[46] Volumes have been written on other tantalising fragments in Bonhoeffer's prison letters (for example, the *disciplina arcanum*), though references to such key ideas are also few in number.

[47] The translation of our key passage in Balthasar's *The Glory of the Lord* (vol. 7, p. 20) is misleading. According to that translation Bonhoeffer says that 'it is only the concept of the

implicit rejection of the dualisms of modernity, including the split between Christian and aesthetic existence, through renewing links with the Middle Ages. Yet another is the inclusive nature of 'aesthetic existence', so that art is related to friendship, education or formation, play, and happiness. And then there is the distinction he makes between the 'ethical' person and the Christian, which reflects a shift in his thinking about the divine mandates. Art is no longer part of the mandate of labour or even culture but a part of 'aesthetic existence' in the realm of creative freedom.

Underlying each of these clues about the meaning of 'aesthetic existence' is Bonhoeffer's concern to counter Kierkegaard's banishment of the aesthetic from Christian existence as this had generally been understood at the time amongst Kierkegaard scholars.[48] Bonhoeffer, it may even be surmised, was implicitly interpreting his own life as a reversal of the Danish philosopher's three stages,[49] that is, the process in which the journey to faith required a turning away, first from the aesthetic to the ethical, and then, in a leap of faith, to the religious. Even though this can only be an informed conjecture on our part, it is suggestive and helps us to compare their understandings of 'aesthetic existence' in relation to Christian faith and ethics. Yet the comparison is not intended to suggest that Bonhoeffer's life's journey simply moves in the opposite direction to that of Kierkegaard. That would be a misunderstanding of what Bonhoeffer is suggesting and equally a misunderstanding of Kierkegaard's own approach to aesthetics within the stages of his life as we have previously noted.[50] Nonetheless, the comparison is striking and worth exploring for the possible light it throws on Bonhoeffer's interpretation of Christian faith at this late stage in his life.

Barth has had a remarkable influence on the way in which

church that will be the source of the rediscovery of the free space for the freedom of art'. This makes the role of the church more absolute than Bonhoeffer intends. Nonetheless, the church for Bonhoeffer should play a crucial role in our understanding of the recovery of 'aesthetic existence'.

[48] This is noted in the new critical edition of the letters. See Dietrich Bonhoeffer, *Widerstand und Ergebung*, Dietrich Bonhoeffer Werke, 8 (Gütersloh: Chr. Kaiser/Gütersloh Verlagshaus, 1998), 291, nn. 23–4.

[49] See the discussion of Kierkegaard's 'three stages' on pp. 8off. above.

[50] See above, p. 81. The difficulty of interpreting Kierkegaard on this subject as on many others is notorious, and there is no consensus amongst Kierkegaardian scholars on what he meant by 'the aesthetic', or how it relates to the ethical and religious. My own understanding has been influenced by Sylvia Walsh, *Living Poetically: Kierkegaard's Existential Aesthetics* (University Park, Penn.: Pennsylvania State University Press, 1994).

twentieth-century theologians have read Kierkegaard, including Bonhoeffer himself. According to Barth, theologians related to Kierkegaard in three different ways. Some ignored him, refusing to accept the radical demands he made upon their faith. Some became captivated by Kierkegaard and worked themselves ever deeper into his thought, ironically turning it into a system. But then there were others, amongst whom Barth placed himself, who were so profoundly shaken by Kierkegaard's insistence on the 'tremendous otherness of Christianity' that they 'could not put behind them the stimulus received from him, and could no longer succumb to the slumber of a merely aesthetical piety'. There was no way of return to bourgeois Christianity. Nevertheless, having worked through Kierkegaard's challenge never to be the same again, they affirmed that the 'Yes' of the gospel was even greater than the 'No' which Kierkegaard had so devastatingly pronounced. They could not remain in existential angst; 'they had to become really serious and also burst into peals of laughter'.[51] Bonhoeffer certainly fits into this third category along with Barth.

Bonhoeffer's response to Kierkegaard did not mean that he opposed the Dane's protest against aestheticism, moralism or cheap grace, nor did it mean a lack of emphasis upon personal decision and commitment. Quite the contrary is true. Bonhoeffer's *Cost of Discipleship* resonates strongly with Kierkegaard's understanding of discipleship as expressed in his critique of the national church in Denmark.[52] Discipleship was not the 'cheap grace' of bourgeois Lutheran piety and morality, but the 'costly grace' of suffering and martyrdom. Being a Christian requires that one stand over against the world even if this means standing alone.[53] Here Bonhoeffer reflects most clearly Kierkegaard's single-minded religious commitment, the final stage in his journey of life. For Bonhoeffer, by contrast, the acceptance of the radical call to discipleship marks the beginning of his journey as a Christian as distinct from being merely a student of theology.[54] Although he was later critical of the *Cost of Discipleship*, he never went back on its call to commitment.[55] Just as

[51] 'Kierkegaard and the Theologians', in Karl Barth, *Fragments Grave and Gay* (London: Collins, 1971), 103f.
[52] The connection is made in many footnotes in Dietrich Bonhoeffer, *Nachfolge*, Dietrich Bonhoeffer Werke, 4 (Munich: Chr. Kaiser Verlag, 1989).
[53] *Ibid.*, p. 92 cf. 34f., 260.
[54] Bethge, *Dietrich Bonhoeffer*, 202ff.
[55] Bonhoeffer, *Letters and Papers from Prison*, p. 369.

Kierkegaard's aesthetics was taken up and transformed by the ethical and religious, so Bonhoeffer's costly discipleship was carried forward but expressed differently in the next phase of his life, that of worldly ethical engagement.

As Bonhoeffer became disillusioned with the ability of the Confessing Church to counter Nazism and then joined the anti-Hitler conspiracy, so his understanding of what Christ demanded took an important turn. Bonhoeffer moved from a pacifist interpretation of the Sermon on the Mount, necessary and costly as that had been, to the risky road of an ethics of free responsibility. Here, of course, he is very close to Kierkegaard's stress on the need for personal decision making and his 'teleological suspension of the ethical'. Ethics on the boundaries meant an acceptance of responsibility and the freedom to act in a way which corresponded to reality rather than to principle.[56] Hence Bonhoeffer's involvement in the conspiracy against Hitler. The radical single-minded discipleship characteristic of the *Cost of Discipleship* gave way to the ambiguously complex stage of what it means to be a Christian fully engaged in the life of the world. Living obediently in the penultimate required neither a radicalism (the 'pure Christianity' of Kierkegaard) which hates the world nor compromise that is based on self-justification, but rather following Christ in ethical responsibility in the midst of the world.[57] Such 'this-worldliness' obviously did not mean the 'shallow and banal this-worldliness of the enlightened, the busy, the comfortable, or the lascivious, but the profound this-worldliness, characterised by discipline and the constant knowledge of death and resurrection'.[58]

But there are already strong intimations in his *Ethics* that Bonhoeffer is aware of the need to overcome the split between Christian ethical existence and what it means to be a truly cultured person. That is, a 'Christian in the widest sense of the term', as he puts it in his prison letter in which he refers to 'aesthetic existence'. Such 'aesthetic existence' was an essential part of his own education and cultural formation (*Bildung*) and thus predates his becoming a Christian. Yet it was never consciously integrated into his vision of what it meant to be a Christian, and even less so into his ecclesiology.[59] But this is precisely what is suggested in the prison

[56] Bonhoeffer, *Ethics*, pp. 227ff.
[57] *Ibid.*, pp. 129ff. See the reference to Kierkegaard in Bonhoeffer, *Ethik*, p. 146, n. 34.
[58] Bonhoeffer, *Letters and Papers from Prison*, p. 369.
[59] In a letter to me (3 March 1998) Renate Bethge wrote: 'I just read DB's letter of 23.1.44, to

letter we have highlighted. As the next step along the path of
Christian formation, following on from single-minded discipleship
and ethical responsibility, Bonhoeffer proposes the recovery of
'aesthetic existence' within the life of the church. If he had lived long
enough to develop this proposal more fully it might now be seen as a
critical development in his prison theology despite the fact that it is
generally ignored.[60]

Bonhoeffer was not retreating into what Barth referred to as
'aesthetical piety'. His 'aesthetic existence' is not to be equated with
'aestheticism', any more than with Idealist aesthetics as represented
by Kant or Hegel. On this he is at one with Kierkegaard. His proposal
is more akin to, though not to be equated with, Schiller's 'art of life',
Nietzsche's 'fundamentalization of aesthetic activity', Kierkegaard's
'living poetically' or John Dewey's 'integration of art into life'.[61] The
aesthetic, Dewey had written, 'is no intruder from without, whether
by way of idle luxury or transcendent ideality, but it is the clarified and
intensified traits that belong to every normally complete existence'.
This, Dewey maintained, had to do with 'experience as appreciative,
perceiving, enjoying'.[62] In all likelihood Bonhoeffer was seeking a
way to christen such insight. But it was above all Wilhelm Dilthey's
'philosophy of life' that helped him make the decisive move.[63] It was
from Dilthey's writings, which Bonhoeffer avidly read in prison,[64]
that he derived the key insights not only for his understanding of a
'world come of age', but also for his 'theology of life'. Dilthey's
'philosophy of life' was particularly attractive to Bonhoeffer as an
alternative not only to Kierkegaard but also to Nietzsche because it
located life within an objective historical framework rather than
reducing it to the subjective alone.[65] If, in affirming 'aesthetic

which you pointed. I would not have come to your idea, but I can see it now. The basis to
what DB wrote here was so normal for us and for him, as we played music often, even
games sometimes, that I did not see that there was much new like a 'turn to the aesthetic'.
But his reasoning, which puts the Christian opposite the 'ethical person,' is new. I often find
this with him, that he is looking for Christian arguments for the way in which the family
was living.'
[60] An early but rare exception being Gill, 'Bonhoeffer as Aesthete'.
[61] Wolfgang Welsch, *Undoing Aesthetics* (London: Sage Publications, 1997), 79.
[62] John Dewey, *Art as Experience* (New York: G. Putnam's Sons, 1934). Quoted in *Aesthetics*, ed.
Susan Feagin and Patrick Maynard (Oxford: Oxford University Press, 1997), 53f.
[63] Bonhoeffer, *Letters and Papers from Prison*, p. 193.
[64] Notably his *Weltanschauung und Analyse des Menschen seit Renaissance und Reformation* and his
German Poetry and Music. See Bonhoeffer, *Letters and Papers from Prison*, pp. 209, 189, 204, 227.
See also the discussion on the influence of Dilthey in Wüstenberg, *Faith as Life*, p. 104ff.
[65] Wüstenberg, *Faith as Life*, p. 105.

existence', Bonhoeffer was consciously reacting to Kierkegaard's rejection of 'aestheticism', he was equally responding to Nietzsche's rejection of Christianity because of its denial of the aesthetic. Bonhoeffer's relation to Nietzsche is complex.[66] He accepted the validity of much in his critique of Christianity, not least the hypocrisy of those whose declared love for others is really love of self.[67] He also recognised the extent to which Nietzsche's espousal of classical Greek culture was a legitimate reaction to the rejection of the natural in German Lutheranism.[68] For much of his theological development, especially from the early 1930s marked by his lectures on 'Creation and Sin', Bonhoeffer was engaged in an ongoing debate with Nietzsche's critique of Christianity.[69] Hence his affirmation of the body and the earth; his 'theology of the cross', in which joy is only discovered through struggle and suffering; and his celebration of human freedom and life. These themes, which burst forth with renewed energy in the *Letters and Papers from Prison*, indicate the extent to which his attempt to formulate the meaning of Christian faith in a 'world come of age' was a response to Nietzsche.

Bonhoeffer, however, explicitly rejects 'Nietzsche's crude alternatives, as if the only concepts of beauty were on the one hand the 'Apolline' and on the other the 'Dionysian', or, as we should now say, the demonic'.[70] This leads him to a discussion of beauty in a way that takes us back to our earlier discussion of the relationship between Christianity and Hellenistic culture. While there may well be a thin line dividing the erotic or earthy from the demoniacal, as there is between some forms of art and pornography, it is simply not the case that we have to choose between the 'crude alternatives' of the Apolline or Dionysian.

Take, for example, Brueghel or Velasquez, or even Hans Thoma, Leopold Kalckreuth, or the French impressionists. There we have a beauty which is neither classical nor demonic, but simply earthly, though it has its own

[66] P. Köster, 'Nietzsche als Verborgener Antipode in Bonhoeffers "Ethik" ', *Nietzsche Studien* 19. (1990): 367–418; Peter H. Van Ness, 'Bonhoeffer, Nietzsche, and Secular Spirituality', *Encounter* 52, no. 4 (Autumn 1991): 327ff. ,
[67] Bonhoeffer, *Ethics*, p. 259.
[68] *Ibid.*, p. 91.
[69] Published as Dietrich Bonhoeffer, *Creation and Fall: A Theological Exposition of Genesis 1–3*, Dietrich Bonhoeffer Works, 3 (Minneapolis: Fortress Press, 1997), 76f.,175f. Already in his reflections on ethics while a vicar in Barcelona (1928) Bonhoeffer engages Nietzsche. Dietrich Bonhoeffer, *Barcelona, Berlin, Amerika 1928–1931*, Dietrich Bonhoeffer Werke, 10 (Munich: Chr. Kaiser Verlag, 1991), 323ff.
[70] Bonhoeffer, *Letters and Papers from Prison*, p. 239.

proper place. For myself, I must say that it's the only kind of beauty that really appeals to me. I would include the Magdeburg virgins and the Naumburg sculptures. May not the 'Faustian' interpretation of Gothic art be on altogether wrong lines? How else would there be such a contrast between the plastic arts and architecture?[71]

Bonhoeffer's response to Nietzsche was a rejection of the dualisms of both gnosticism and modernity which separate creation and redemption, body and spirit, earth and heaven, faith and politics, prayer and action, rationality and experience. For the Christian, and what Bonhoeffer refers to in the same breath as the 'cultured' person, life cannot be separated into different spheres of existence, no matter how fragmentary life itself may be.[72] But Bonhoeffer's critique of dualism was also a call to affirm the earth and the sensual, to live, as he paradoxically put it, 'without God yet before God' in the world.[73] Beauty is earthy! Yet it is God's earth, not the earth of Teutonic Romanticism which provided the basis for the Nazi affirmation of 'blood and soil' with all its demonic consequences. That is why Bonhoeffer questions the 'value of classical antiquity' as well as the Renaissance in comparison with the 'mature "worldliness" of the thirteenth century' which is essentially Christian, even if anti-clerical.[74]

Bonhoeffer developed a particular interest in the Middle Ages while in prison. This undoubtedly contributed to his desire to reunite theology, ethics and aesthetics. He was not suggesting that we can return to the Middle Ages in the way that Romanticism tried to do. But he was claiming that the medievals provide 'a source of valuable insights' because, to use Umberto Eco's words, they 'tried to allow both for an autonomy of aesthetic values and for its place within a unitary scheme of values'.[75] This was the period in which, as Eco puts it, 'aesthetic custom and theological doctrine went hand in hand'.[76] It was also during the twelfth century in Europe that beauty began to acquire the status of a transcendental, and musical polyphony was invented. This return to the medieval on the part of Bonhoeffer at the same time as he was reflecting on Christianity in a

[71] *Ibid.*, p. 239. [72] *Ibid.*, p. 200.

[73] *Ibid.*, p. 360; Bonhoeffer's 'love for the earth' is found much earlier in his writings, for example, in his essay 'Dein Reich komme!' Dietrich Bonhoeffer, *Berlin 1932–1933*, Dietrich Bonhoeffer Werke, 12 (Munich: Chr. Kaiser Verlag, 1997), 264ff.

[74] Bonhoeffer, *Letters and Papers from Prison*, p. 229.

[75] Umberto Eco, *Art and Beauty in the Middle Ages* (New Haven: Yale University Press, 1986), 16.

[76] Eco, *Art and Beauty in the Middle Ages*, pp. 22, 35, 40.

'world come of age' is surprising, forcing us to reflect more deeply on what he meant. Certainly he could not have meant a facile reductive Christianity as assumed by those who commented in the 1960s on Bonhoeffer's 'non-religious' interpretation.

If Bonhoeffer's renewed interest in the Middle Ages helped him to envisage the recovery of 'aesthetic existence', it was the Old Testament, which he avidly read several times in prison, that provided him with the basis for an 'earthy' style of being Christian in the world.[77] Unlike Kierkegaard, to whom he critically refers in this regard, Bonhoeffer was in the process of retrieving the Old Testament as the book that bears testimony to God's blessing of 'the whole of earthly life'.[78] The cross does not lead away from living fully in the world, in suffering rather than in blessing as in Kierkegaard as Bonhoeffer interpreted him,[79] but to the discovery that in the midst of the world suffering and blessing belong together. Christ not only calls us to follow him to the death, but also gives us life to the full in every respect as we do so. This includes, as Bethge put it in one of his letters to Bonhoeffer, having 'a good conscience about the things of the earth',[80] a comment sparked off by their ongoing conversation on the significance of the Old Testament.[81] As Bonhoeffer had earlier written: 'it is only when one loves life and the earth so much that without them everything seems to be over that one may believe in the resurrection and a new world'.[82] This was, as much as anything, a response to Nietzsche's critique of Christianity as life denying.

All of this is reflected both in some of Bonhoeffer's comments on the psalmody of Heinrich Schütz – in which the spiritual and sensuous combined so remarkably – and those on the Song of Songs.

Even in the Bible we have the Song of Songs; and really one can imagine no more ardent, passionate, sensual love than is portrayed there (see 7:6). It's a good thing that the book is in the Bible, in face of all those who believe that the restraint of passion is Christian.[83]

[77] Bonhoeffer, *Letters and Papers from Prison*, pp. 156f. While Bonhoeffer read the Old Testament from a Christological perspective, there is a hint here that he has moved away from a traditional supercessionist interpretation and is seeking to read the Hebrew Bible in terms of its own presuppositions. For the influence of the Old Testament on Bonhoeffer's prison theology, see Martin Kuske, *The Old Testament as the Book of Christ: An Appraisal of Bonhoeffer's Interpretation* (Philadelphia: Westminster, 1976), 132ff.
[78] Bonhoeffer, *Letters and Papers from Prison*, p. 374.
[79] See the editorial note in Bonhoeffer, *Widerstand und Ergebung*, p. 549, n. 5.
[80] Bonhoeffer, *Letters and Papers from Prison*, p. 181.
[81] *Ibid.*, pp. 336f., 374 et al. [82] *Ibid.*, p. 157. [83] *Ibid.*, p. 303.

This is an important insight in the development of our discussion. Brueggemann speaks of the Song of Songs as 'an extreme case of the aesthetic dimension of Yahweh's wisdom'; extreme, precisely because of the absence of reference to God. Yet, 'this literature is the fullest articulation in the tradition of Israel of celebrative well-being that affirms in exotic, erotic detail the goodness of life as given by the hidden God'. For Bonhoeffer, remarks Brueggemann, the Song of Songs 'is an affirmation of the wholeness, goodness, and joyousness of life ordered by Yahweh'.[84]

But what moved Bonhoeffer to such a bold and earthy affirmation of 'aesthetic existence' as integral to what it means to be a Christian? Surely in his case it could not have been something simply motivated by academic interest awakened by his prison reading? In reflecting on these questions a comparison with Kierkegaard becomes especially suggestive. If the *Kirchenkampf* provided the context within which the previous stages of his life and theology developed, Bonhoeffer's forced and painful separation from his loved ones and friends is the context within which his theological reflections take their final albeit fragmentary shape.[85] Kierkegaard, by way of contrast, lived his life in freedom, yet as its stages unfolded he sadly broke off his engagement, became alienated from his father, and lived out his life in increasing loneliness and social alienation.

Bonhoeffer's life had been immeasurably enriched through his family life and his friendship with Eberhard Bethge.[86] Nowhere is this better expressed than in his poem 'The Friend' with its striking image of the cornflower, which he sent to Bethge as a birthday present in August 1944:

[84] Walter Brueggemann, *Theology of the Old Testament: Testimony, Dispute, Advocacy* (Minneapolis: Fortress Press, 1997), 341. Cf. Balthasar's comment that the Song of Songs finds its fulfilment in 'every authentic Christian theology' in contrast to 'humourless . . . Protestantism' and 'grumpy . . . Catholicism.' Hans Urs von Balthasar, *The Glory of the Lord. Vol. 1: Seeing the Form*, The Glory of the Lord: A Theological Aesthetics, 1 (Edinburgh: T. & T. Clark, 1982), 494.

[85] There are many passages in the prison letters where Bonhoeffer speaks of his terrible feelings of homesickness, for example, his letter to Bethge of 18 December 1943. And then, in a letter written on Christmas Eve 1943, to both Renate and Eberhard, he suggests how they might deal with their impending separation. Amongst his words of counsel are these: 'the dearer and richer our memories, the more difficult the separation. But gratitude changes the pangs of memory into tranquil joy.' Bonhoeffer, *Letters and Papers from Prison*, p. 176.

[86] See Bethge's essay on 'Bonhoeffer's Theology of Friendship', in which he comments 'it is impossible to imagine him [Bonhoeffer] without his friends . . . they were essential to his very life'. Bethge, *Friendship and Resistance*, p. 81.

Beside the cornfield that sustains us,
tilled and cared for reverently by men
sweating as they labour at their task,
and, if need be, giving their life's blood –
beside the field that gives their daily bread
men also let the lovely cornflower thrive.
No one has planted it, no one watered it;
it grows, defenceless and in freedom,
and in glad confidence of life untroubled
under the open sky.[87]

Bonhoeffer's circle of friends was larger than his very special relationship with Bethge, but it is obvious that it was this latter friendship which became central during these final years of his life. And it is Bethge who, late in his own life, perceptively and poignantly explores 'Bonhoeffer's theology of friendship' and the way in which, for Bonhoeffer, friendship breaks open the divine mandates 'in fruitful illogic'.[88] Friendship belongs within the sphere of freedom;[89] its main purpose is not to provide 'daily bread' but the enrichment of life like the 'lovely cornflower'. Friendship is, then, a key element in 'aesthetic existence'; there is something beautiful about it, as Kierkegaard also recognised.[90] But for Kierkegaard friendship is beautiful because of shared ethical commitment, whereas for Bonhoeffer, while such commitment is important, friendship is gratuitous and therefore beautiful.

Friendship was undoubtedly important for Bonhoeffer in his thinking about 'aesthetic existence', but it is impossible to appreciate fully what he meant except in the light of the way his engagement had awakened the erotic side of his life. As the prison correspondence between Dietrich and Maria shows, there is a profound connection between their love for each other and Bonhoeffer's stress on the earthiness of faith, of living with both feet on the ground. On 29 May 1944, just nine days after his comments on the Song of Songs to which we referred, Dietrich writes to Maria, trying to provide perspective on how to handle their desire for each other, body and soul:

But this mutual longing mustn't always connote frenzy and insensate desire, it mustn't always afflict and torment us, it needn't be forever fretting

[87] Bonhoeffer, *Letters and Papers from Prison*, p. 388.
[88] Bethge, *Friendship and Resistance*, p. 96.
[89] There is, of course, a 'friendship' of convenience or unholy alliance that undermines personal freedom. But this is unworthy of the name.
[90] At least if Kierkegaard's own opinions are to be equated with Judge Williams in *Either/Or*. See Walsh, *Living Poetically*, pp. 122f.

over what is still denied us. It should surely be like one's longing for a glorious spring morning, when one sees the sky already tinged with red by the sun's first rays. It means waiting, desiring, and yearning, assuredly, but doing so with happiness and utter certainty.[91]

And then, in a poem 'For you, and you alone', in which he reflects on the past and his sense that life is slipping away, Bonhoeffer speaks in a language in which life and Maria merge:

> I yearn to inhale the fragrance of your being,
> absorb and linger therein,
> just as, on a hot summer's day,
> heady blossoms make bees welcome
> and intoxicate them.

There is one last element to be noted in Bonhoeffer's taxonomy of 'aesthetic existence'. Along with friendship and erotic love, he includes 'play'. Although he does not elaborate on this except by references to his childhood, Jürgen Moltmann helps us to capture what must surely have been in Bonhoeffer's mind. Play 'goes beyond the categories of doing, having and achieving and leads us into the categories of being, of authentic human existence and demonstrative rejoicing in it. It emphasises the creative against the productive and the aesthetic against the ethical.'[92] Play is not unrelated to ethics, for it is often integral to the struggle for liberation from domination and oppression. But it is different from ethical struggle. Like that of friendship, its role is to break open fresh possibilities and provide other perspectives, demonstrating 'the value of aesthetic joy against the absolute claims of ethics'.[93]

Bonhoeffer's concept of 'play' links well with that quality of 'being in the world' which he referred to as *hilaritas*, a quality he found so appealing in Luther, Lessing, Rubens, Hugo Wolf and Karl Barth. By this Bonhoeffer did not mean 'serenity' but a 'confidence in their own work, boldness and defiance of the world and of popular opinion, a steadfast certainty that in their own work they are showing the world something *good* (even if the world doesn't like it), and a high-spirited self-confidence'. Yet even in affirming Kierkegaard in this way, Bonhoeffer goes on to distinguish him – along with Michelangelo, Rembrandt and Nietzsche – from the others he

[91] Bonhoeffer and von Wedemeyer, *Love Letters from Cell 92*, p. 208.
[92] Jürgen Moltmann, *Theology and Joy* (London: SCM, 1971), 46. See also David Tracy, *The Analogical Imagination: Christian Theology and the Culture of Pluralism* (London: SCM, 1981), 108f.
[93] Preface to Moltmann, *Theology and Joy.*

mentions. For 'there is something less assertive, evident, and final in their works, less conviction, detachment, and humour'.[94] Kierkegaard holds out considerable appeal for Bonhoeffer, not unlike that shown in his love for Don Quixote.[95] *Hilaritas*, that rare quality in which seriousness and humour blend together in suffering and joy, was an essential ingredient in the theology of life that was evolving in prison in tandem with his thoughts about 'aesthetic existence'. Bernard Lonergan expresses this quality of aesthetic existence in a passage in his *Insight* that sums up the matter well:

There exists in man an exuberance above and beyond the biological account-books of purposeful pleasure and pain. Conscious living is itself a joy that reveals its spontaneous authenticity in the untiring play of children, in the strenuous games of youth, in the exhilaration of sun-lit morning air, in the sweep of a broad perspective, in the swing of a melody . . . one is led to acknowledge that experience can occur for the sake of experiencing, that it can slip beyond the confines of serious-minded biological purpose, and that this very liberation is a spontaneous, self-justifying joy.[96]

The contours of Bonhoeffer's 'aesthetic existence' are now evident. The question that faces us is how this can remain Christian and flourish in the church as a 'sphere of freedom'. Can the Christian and the 'cultured' person find common ground on which to stand? And what does all this imply for our understanding of Christianity and the arts? Bonhoeffer provides us with an answer as he reflects on the metaphors of music in relation to his own experience.

CHRIST AND THE POLYPHONY OF LIFE

The *St Matthew Passion* was undoubtedly Bonhoeffer's favourite work of Bach, but it was the *Art of Fugue* which provided him with a way of understanding the fragmentary nature of life and the ambiguities of the ethics of free responsibility. Such thoughts were prompted by his awareness of the way in which culture itself had become a fragmented torso, as well as by the failures of the resistance.[97]

The important thing today is that we should be able to discern from the fragment of our life how the whole was arranged and planned, and what

[94] Bonhoeffer, *Letters and Papers from Prison*, p. 229.
[95] See, for example, Bonhoeffer, *Ethics*, p. 67.
[96] Bernard J. F. Lonergan, *Insight: A Study of Human Understanding* (New York: Philosophical Library, 1973), 184f.
[97] See Pangritz, *Polyphonie des Lebens*, pp. 47f.

FORGIVENESS DEALS W/ THE FRAGMENTS
+ BRINGS IT ALL INTO THE MAJOR

Symphony of God's PLAN FOR US.

material it consists of. For really, there are some fragments that are only worth throwing into the dustbin (even a decent 'hell' is too good for them), and others whose importance lasts for centuries, because their completion can only be a matter for God, and so they are fragments that must be fragments – I'm thinking, e.g., of the *Art of Fugue*.[98]

The fragmentary nature of Bonhoeffer's prison theology and much of his adult life resonates with these comments.[99] Just as the *Art of Fugue* with its several voices weaves a complex pattern out of fragments without coming to a conclusion, so Bonhoeffer seeks to make some sense of his life, especially his attempt to resist 'fate' and submit to God. Just two days before, he had written to Bethge about this. 'Only so can we stand our ground in each situation as it arises, and turn it to gain.'[100]

If our life is but the remotest reflection of such a fragment, if we accumulate, at least for a short time, a wealth of themes and weld them into a harmony in which the great counterpoint is maintained from start to finish, so that at last, when it breaks off abruptly, we can sing no more than the chorale, 'I come before thy throne', we will not bemoan the fragmentariness of our life, but rather rejoice in it.[101]

This reminds us of earlier comments Bonhoeffer made on the doctrine of recapitulation (Irenaeus), a 'magnificent conception, full of promise'. In Christ everything is taken up and restored without the distortion of sin. This leads him to reflect on a passage from Schütz's 'O Bone Jesu' which, 'in its ecstatic longing combined with pure devotion', suggests 'the bringing again' of all earthly desire, the fulfilment of life in the new creation made possible by the Holy Spirit.[102] With this in mind, Bonhoeffer requested that this hymn be sung at his funeral. For only in Christ could the 'broken themes of praise' be finally restored. Nowhere is Bonhoeffer's sense that the fragments of life would only find their fulfilment in Christ beyond this life more poignantly expressed than in his poetic testimony 'Stations on the Road to Freedom'.[103] From the discipline of obedience, through daring to do right in free responsibility, through suffering – suspended 'for one blissful moment' (Maria?) – to death,

[98] Bonhoeffer, *Letters and Papers from Prison*, p. 219.
[99] See the comparison with Adorno and the music of Schoenberg on the 'aesthetic' fragmentary method and style of Bonhoeffer's theology in Wayne Whitson Floyd, Jr, *Theology and the Dialectics of Otherness: On Reading Bonhoeffer and Adorno* (Lanham, Md.: University Press of America, 1988), 286ff.
[100] Bonhoeffer, *Letters and Papers from Prison*, p. 218.
[101] *Ibid.*, p. 219. [102] *Ibid.*, p. 170. [103] *Ibid.*, pp. 370f.

the 'greatest of feasts' when 'at last we may see that which here remains hidden': so he describes his life's journey.

Yet is fulfilment only something for the future? Is there no connection between the ultimate and the penultimate as we seek to live our lives here and now? Is there no way in which the fragments of life can enrich our lives today even if their ultimate significance and recapitulation remains hidden? This is the significance of Bonhoeffer's use of the musical metaphor of polyphony, a medieval invention that enables the blending of diversity, of reason and passion, of faith and joy, of responsibility and freedom, into a meaningful and enriching whole in which previously broken themes of praise are restored.

Bonhoeffer coined the phrase 'polyphony of life' at a time when he was feeling most alone. It occurs for the first time in two letters written on 20 and 21 May 1944 to Bethge, in which he calls it his own 'little invention.' In that of 20 May, he gently yet firmly rebukes Eberhard for some comment he had made in a recent letter. Bethge, a soldier on the Italian front (though on home leave for the baptism of his son), had expressed his pain at his long periods of separation from his wife Renate and son Dietrich. He complained about the fact that Bonhoeffer's letters to his parents, which were shared with his siblings and Maria, were not passed on to him.[104] He also hinted that perhaps Bonhoeffer was better off in prison than he was in the Italian theatre of war. Bonhoeffer, uneasy about what his friend had said, and feeling lonely at a time of family reunion and celebration, an emotion intensified by his separation from Maria, agrees that Bethge has every right to live happily with, and for the sake of, his wife and young son. At the same time he insists that this should not result in actions based on 'any personal emotion'. He continues, introducing a further musical model:

There's always a danger in all strong, erotic love that one may love what I might call the polyphony of life. What I mean is that God wants us to love him eternally with our whole hearts – not in such a way as to weaken or injure our earthly love, but to provide a kind of *cantus firmus* to which the other melodies of life provide the counterpoint . . . Where the *cantus firmus* is clear and plain, the counterpoint can be developed to its limits.[105]

104 Bethge, *Friendship and Resistance*, p. 91.
105 Bonhoeffer, *Letters and Papers from Prison*, p. 303.

Within this context Bonhoeffer makes two observations which are significant for our discussion. The first is a reference to the Song of Songs, with its portrayal of 'ardent, passionate, and sensual love', which we have previously mentioned.[106] There is an intrinsic connection between polyphony and the erotic.[107] What is particularly remarkable, however, is Bonhoeffer's later comment to Bethge that the Song of Songs understood 'as an ordinary love song . . . is probably the best "Christological" exposition'.[108] The second observation concerns the two natures of Christ that, according to the Chalcedonian Definition, are 'undivided and yet distinct'. Bonhoeffer comments: 'May not the attraction and importance of polyphony in music consist in its being a musical reflection of this Christological fact and therefore of our *vita christiana*?'[109] The Christian life is a blending of the bodily and the spiritual without their confusion, *eros* and *agape*.[110] 'Do you see what I am driving at?' Bonhoeffer asks his friend.

I wanted to tell you to have a good, clear *cantus firmus*; that is the only way to a full and perfect sound, when the counterpoint has a firm support and can't come adrift or get out of tune, while remaining a distinct whole in its own right. Only a polyphony of this kind can give life a wholeness and at the same time assure us that nothing calamitous can happen as long as the *cantus firmus* is kept going.[111]

And, then, in the letter of the following day, somewhat afraid that his statements could have been misconstrued, Bonhoeffer picks up on the same theme. The 'image of polyphony is still pursuing me', he writes. 'When I was distressed today at not being with you, I couldn't help thinking that pain and joy are also part of life's polyphony, and that they exist independently side by side.' He goes on to say:

[106] The parallels between aesthetic and spiritual beauty, evident in the Song of Songs, were often commented on in patristic and medieval literature, but the erotic dimension was usually left implicit. See Patrick Sherry, *Spirit and Beauty: An Introduction to Theological Aesthetics* (Oxford: Clarendon Press, 1992), 37, 71; Karl Barth, *The Doctrine of God*, Church Dogmatics, II/1 (Edinburgh: T. & T. Clark, 1964), 653, 664.

[107] See John Vignaux Smyth, *A Question of Eros: Irony in Sterne, Kierkegaard, & Barthes* (Tallahasee, Fl.: Florida State University Press, 1986), 242f.

[108] Bonhoeffer, *Letters and Papers from Prison*, p. 315.

[109] *Ibid.*, p. 303.

[110] In *Sanctorum Communio* as well as in *Life Together*, following the 'early' Barth and Kierkegaard, Bonhoeffer had kept these apart. Bonhoeffer, *Sanctorum Communio*, p. 167; Dietrich Bonhoeffer, *Life Together: Prayerbook of the Bible*, Dietrich Bonhoeffer Works, 5 (Minneapolis: Fortress Press, 1996), 40, n. 17.

[111] Bonhoeffer, *Letters and Papers from Prison*, p. 303.

the advantage that you see in my position is relatively small. Isn't it rather the case that you experience life in all its sides, in happiness and in danger, and that that is better than when one is to some degree cut off from the breath of life, as I am here? I certainly don't want to be pitied, and I don't want to grieve you in any way, but I do want you to be *glad* about what you have: it really *is* the polyphony of life.[112]

This same concern is reflected in the 'homily' that Bonhoeffer wrote from prison for the baptism of his godchild Dietrich Bethge and sent on 18 May 1944 to Eberhard and Renate:

In the general impoverishment of intellectual life you will find in your parents' home a storehouse of spiritual values and a source of intellectual stimulation. Music, as your parents understand and practise it, will help to dissolve your perplexities and purify your character and sensibility, and in times of care and sorrow will keep a ground-bass of joy alive in you.[113]

In the midst of all the chances and changes of life, amidst its polyphonous sounds, there was the sure and constant melody of a parent's love and values which, especially in times of pain, would keep joy alive. Indeed, for Bonhoeffer in prison, music itself was liberated precisely because of the *cantus firmus* enabling him to rehabilitate theologically the musical tradition of the nineteenth century.[114] But more generally, the point about the *cantus firmus* is that it makes the polyphony of life possible within the life of the Christian and the church rather than excluding such richness with a categorical iconoclastic 'No'. 'In Jesus, God has said Yes and Amen to it all, and that Yes and Amen is the firm ground on which we stand.'[115]

The multi-dimensional character of life, its polyphony, recurs in two further letters written soon after. On 29 May, Bonhoeffer, reflecting on reactions amongst his fellow prisoners and their warders to a bombing raid and the menaces of life, comments on how they 'miss the fullness of life and the wholeness of an independent existence; everything objective and subjective is dissolved for them into fragments. By contrast', he writes, 'Christianity puts us into many different dimensions of life at the same time; we make room in ourselves, to some extent, for God and the whole world.'[116] Living in a single dimension (perhaps Kierkegaard came to mind) is

[112] *Ibid.*, p. 305.　　[113] *Ibid.*, p. 295.

[114] Pangritz, *Polyphonie des Lebens*, pp. 54ff.

[115] Bonhoeffer, *Letters and Papers from Prison*, p. 391.

[116] *Ibid.*, p. 310.

the opposite of the multi-dimensional life which faith makes possible.[117] In reply, Bethge asked for a more precise explanation of 'How the basis for "God in health, power and action" lies in the "revelation in Jesus Christ"', and 'what does the "midst of life" mean?'[118] As Bonhoeffer's scribbled notes on the other side of Bethge's letter suggest, such questions prompted those further reflections that subsequently proved so controversial yet fruitfully evocative for twentieth-century theology. I believe that they are also significant for our own reflections on theological aesthetics and transformation. So we return now to Bonhoeffer's 'aesthetic existence' and the church as a sphere of freedom, and the suggestion that this somehow renews an important link with the Middle Ages.

Like Kierkegaard's, Bonhoeffer's theological quest was a struggle to overcome the gap between idealism and reality. His resolution of the problem was Christological, a response to the question 'Who is Jesus Christ, for us, today?' Bonhoeffer's initial answer was provided in his two academic dissertations, *Sanctorum Communio* and *Act and Being*, where he spoke of 'Christ existing as church-community'. Revelation in Christ took concrete form in the common life of the believing community, a position he maintained in different ways to the end. Kierkegaard, by contrast, so Bonhoeffer argued in his dissertation, failed to overcome idealism precisely because of his individualism.[119] For Bonhoeffer the person only comes into being through the 'other'; for Kierkegaard the 'other' is important, but the person comes into being through individual decision, not through relationships. This difference between himself and Kierkegaard, as Bonhoeffer perceived it, surfaces time and again in his writings, finding its final expression in the prison letters. It is not that the former finally espouses the aesthetic while the latter rejects it, for both integrate the aesthetic within the ethical and religious. But they do this differently. Whereas Kierkegaard turned from the individualism of aestheticism to an ethics and discipleship of individual decision in which the true Christian stood alone, albeit 'living poetically', Bonhoeffer sought to integrate the aesthetic, the ethical,

[117] *Ibid.*, p. 311. [118] *Ibid.*, p. 318.

[119] Bonhoeffer, *Sanctorum Communio*, p. 57. In this respect as well as in his stress on the incarnation, Bonhoeffer stands in close relationship to N. F. S. Grundtvig, the influential Danish theologian who often had to bear the brunt of Kierkegaard's criticism. A. M. Allchin, *N. F. S. Grundtvig: An Introduction to his Life and Work* (Aarhus, Denmark: Aarhus University Press, 1997), 129, 310 et al.

and Christian faith in the church as a 'sphere of freedom'. For Kierkegaard the individual is primary, while aesthetics is always existential;[120] for Bonhoeffer social relations are primary, and that is why he seeks to recover 'aesthetic existence' within the believing community.

Bonhoeffer is not suggesting that the realm of freedom in which 'aesthetic existence' becomes possible should be free without qualification. Its freedom is a freedom for creativity, not a freedom for banality or 'aestheticism', to return to our thoughts on bad taste. Kierkegaard's aesthete embraced polyphony for its own sake with the inevitable consequence that the fragmentary nature of life became the controlling factor, and art itself imploded in a thousand disconnected pieces.[121] To avoid such self-destruction and to become truly creative, art has to recover its true freedom. The necessary and inevitable improvisation that life demands, to use a metaphor from jazz, only makes sense when it reworks the familiar. Artistic freedom demands discipline, coherence and form. Hence Bonhoeffer's insistence on a *cantus firmus* which, writes Gill, is the 'most striking single indication of Bonhoeffer's basically aesthetic bent', for it enables us to relate God's love and our loves, *agape* and *eros*, indeed, the ultimate and the penultimate. 'It is', Gill continues, 'a perfect image for establishing the prior necessity and initiative of one element along with the absolute necessity of both elements. And it is an image right out of the most sophisticated musical intelligence and appreciation.'[122]

Bonhoeffer's insistence on the *cantus firmus* brings us back to his primary Christological question, which weaves like a thread through his theological development and becomes central to his explorations in prison. In seeking an answer Bonhoeffer was addressing more than one item on his theological agenda. But underlying them was the challenge presented to Christian faith by Feuerbach, Nietzsche and other critics of religion, and his sense that both the response of liberal theology (Ernst Troeltsch) and the response of dialectical theology (Barth) were, separately, inadequate to the challenge.[123] It is within the framework of this challenge that we have located his expressed need to recover 'aesthetic existence' within the church,

[120] Walsh, *Living Poetically*, p. 7.
[121] On the place of the 'fragmentariness of life' in Romantic aesthetics, see *Ibid.*, pp. 63f., n. 1.
[122] Gill, 'Bonhoeffer as Aesthete', p. 11.
[123] Bonhoeffer, *Letters and Papers from Prison*, p. 327.

and thereby to respond in part to Kierkegaard, on the one hand, and Nietzsche, on the other. But Bonhoeffer addresses both on the basis of his Christological *cantus firmus*. For if Bonhoeffer's response to Kierkegaard, with whom he shared commitment to Christ, was to develop an appropriate ecclesiology within which aesthetic existence and discipleship were possible, his response to Nietzsche, with whom he shared a 'lust for life', was to show how life in its fullness was to be found in Jesus Christ.[124] These are not just academic philosophical or theological responses, but are immediately relevant to social praxis. They relate directly to the larger canvas of Bonhoeffer's concerns: the alienation of the proletarian masses from Jesus; the alienation of his secular compatriots from the church; and the failure of the church to share with Christ in solidarity with the victims.[125]

Who, then, is Jesus Christ, for us today? Bonhoeffer's 'theology of the cross', which characterises his Christology at least from 1932, remains central to his probing answer. In many respects this is no different from that which we have discussed at greater length in our treatment of Balthasar and Barth, and much that was stated there must be assumed here. Yet, as we noted in the previous chapter, Bonhoeffer does help us to go beyond Barth's 'actualism' without necessarily affirming Balthasar's ontology.[126] This is reinforced in Bonhoeffer's prison theology. Jesus is the one who is truly human, the one who truly lives life fully on earth, the one who lives totally for others, Jesus the liberator. In this 'hidden' way God is most truly revealed.

However, if Bonhoeffer helps us see our way through the impasse between Barth and Balthasar, he also helps us move beyond the impasse between Balthasar and liberation theologies,[127] by enabling us to integrate the ethical and aesthetic within Christian life and the life of the church. Jesus the 'man for others', the foundation for Christian engagement with the world and solidarity with victims, is also the Christ of the cultured despisers of religion and of those for whom the church is no longer an 'area of freedom'. The recovery of 'aesthetic existence' is, then, an essential element in both our

[124] cf. Thomasma's conclusion that Bonhoeffer 'has socialized Kierkegaard and christified Nietzsche'. D. Thomasma, 'Dietrich Bonhoeffer: Religionless Christianity', *Revue de l'Université d'Ottawa* 39 (1969): 420.

[125] Bonhoeffer, *Letters and Papers from Prison*, pp. 381f.

[126] See above, p. 117.

[127] See above, pp. 134f.

personal transformation and the liberation of the church as an agent of transformation. The Christological *cantus firmus* is not a fulcrum on which everything else balances in systematic equivalence irrespective of context, but rather the centre within which everything finds coherence in the midst of life without losing its distinctive character and quality. For where 'the *cantus firmus* is clear and plain, the counterpoint can be developed to its limits'. God's revelation in Christ is, as Balthasar put it, 'an instrument upon which every melody can be played'.[128]

There is an important connection here with another key idea that emerges at this time in Bonhoeffer's prison writings, namely the 'discipline of the secret' (*disciplina arcanum*). Bonhoeffer is referring to an ancient practice in the post-Constantinian church whereby the mysteries of Christian faith (the creeds, the eucharist) were protected against profanation. As the church opened up to the world, it ran the risk of becoming conformed to its values. Precisely the same danger of secularism faced the church if it became the 'church for others' in the 'world come of age'. The 'discipline of the secret' was the counterpoint to a genuinely Christian worldliness, in some ways similar to Kierkegaard's 'hidden inwardness' of religious existence.[129] It was the life of prayer and worship in which the great doctrines of the creed and the mysteries of redemption were proclaimed and celebrated without being thrust on the world in a triumphalist 'take it or leave it' manner. The 'discipline of the secret' as Bonhoeffer described it in some detail in his *Life Together* anchored Christian 'worldliness' in the *cantus firmus*, a life 'hid with God in Christ', as Paul put it (Colossians 3:3). So amidst his writings on 'secular Christianity' Bonhoeffer speaks with passion and appreciation of the Roman Catholic and Greek Orthodox liturgies for Holy Week and Easter as well as of their aesthetically satisfying ritual, candles, music and bells.[130] There is an indispensable connection between the 'discipline of the secret' which nurtures faith, and engagement in the life of the world – the dialectic of 'prayer and righteous action' that is at the heart of his prison theology.[131]

128 Quoted from *Man in History*, p. 244, in John Saward, 'Youthful Unto Death: The Spirit of Childhood', in *The Beauty of Christ*, ed. Bede McGregor and Thomas Norris (Edinburgh: T. & T. Clark, 1994), 144.
129 George Pattison, *Kierkegaard and the Crisis of Faith* (London: SPCK, 1997), 92.
130 Bonhoeffer, *Letters and Papers from Prison*, p. 218.
131 *Ibid.*, p. 300.

WHY WE LIGHT GAUDETTE CANDLE IN ADVENT !

The recovery of 'aesthetic existence' and the recovery of the 'discipline of the secret', then, were both essential to a genuine Christian 'worldliness' as Bonhoeffer began to articulate it in prison. If the 'discipline of the secret' anchored Christian involvement in the world within the tradition of Christian faith, then 'aesthetic existence' enabled Christians to be at home in God's world without feeling guilty about enjoying art, friendship and play, even at a time of political turmoil and struggle. Theologically speaking, this was interpreting the incarnation in a 'worldly' sense, so that repentance, faith, justification, rebirth and sanctification related to living fully in the world in a way that affirmed biblical earthiness.[132] 'Worldliness' for Bonhoeffer meant neither secularism nor aestheticism, but rather an affirmation of the creation and an anticipation of the 'resurrection of the body'. True 'worldliness' was therefore a way of being *Christian* in the world which is *fully human, truly of the earth*. Such worldliness not only was a matter of ethical responsibility, but implied the recovery of 'aesthetic existence'. So the 'church for others' is also the sphere of freedom in which a genuinely 'aesthetic existence' becomes possible, affirming the polyphony of life amidst the struggle for justice. The fragments do not fly apart but find their coherence in Christ, in whom the broken themes of praise are restored.

Our exploration of theological aesthetics is now complete. The task awaiting us is to reflect on the possibility of doing theological aesthetics in a South African (or any other) context using the resources and insights that we have gathered. In my introduction I commented that theologians in South Africa have been concerned about truth and goodness, not beauty; about theology and social ethics, not aesthetics. But if what we have discerned in this part of our study is true, then there is good reason to overcome what is, with hindsight, a serious lack. Amidst the ugliness of the legacy of apartheid, we need to recover an awareness of the redemptive power of beauty as this has been revealed in Jesus Christ crucified. At the same time, in the midst of the urgent need to continue the struggle for a just and equitable society, we need to discover the importance of 'aesthetic existence' as integral to Christian life within the community of faith. An essential element in doing so is that the church, its members and theologians, learn to hear and see reality

[132] *Ibid.*, pp. 286f.

through the words, music and images of artists; that we participate together with them in making the world a more just place; and that we recover the ability to be lost in 'wonder, love and praise'.[133]

[133] The concluding line to Charles Wesley's hymn 'Love divine, all loves excelling'.

PART III

Aesthetic praxis

Art in the public square

Cape Town is a city of contrasts, awesomely beautiful, tragically ugly. Lying beneath Table Mountain, which rises sharply out of the Atlantic Ocean, it is situated on a peninsula that is the heartland of one of the six floral kingdoms of the world. The southern tip of the peninsula has been described as both the Cape of Good Hope and the Cape of Storms, depending on how it has been experienced by those who have sailed around its craggy sentinel. Cape Point represents the end of Africa, or its beginning, cleaving the icy cold waters of the Atlantic from the warmer currents of the Indian Ocean. Tourists are awed by what they see. Those who climb Lion's Head to watch the summer sun set over the Atlantic are stunned by the beauty. Yet the city and its environs are saturated with aesthetic and moral ambiguity, the co-mingling of exuberance and pathos, creativity and destruction. A city of many cultures and political persuasions competing for space and control, yet bound together as one in the need to shape a common destiny.

As a human construct of several centuries, Cape Town embodies beauty in its architecture and its gardens. But alongside this beauty, whether natural or constructed, lies another, ugly reality, much of it the creation of colonial and apartheid legislation and oppression, an architecture that reinforces alienation from social others and the environment. Natural beauty has been scarred by greed and racism; by highways that separate citizens from the sea and its beaches; and by public works that reflect modernity at its worst. The stylish homes of the wealthy often reflect a vulgar opulence rather than the beauty of the surrounding habitat. Not too far from them, though designed to be out of sight and sound, are conditions of widespread poverty. These have spawned street children, gangs, drug trafficking, prostitution, and violent crime. The contrasting worlds of Cape Town are no different from those of many other cities around the world where

rich and poor live and work cheek by jowl. But there are few cities where the contrasts are experienced so keenly simply because the beauty of the city and its environment is so breathtaking.

Travellers on the freeway into Cape Town pass District Six before dipping into the older inner city or the newer foreshore reclaimed from the sea. District Six was already inhabited when the first Dutch East India Company officials arrived in the seventeenth century, but speculative building only began in the 1840s, when it was known as Kanaldorp. Situated on prime land in the shadow of Table Mountain, it was proclaimed the city's sixth district in 1887.[1] During the decades that followed it became a thriving community of sixty thousand people of many different backgrounds, though most were 'coloured' according to the norms of racial classification, and many were descendants of freed slaves. Neglected by the city authorities, District Six lacked adequate resources and became, in the fearful imagination of white citizens, a denizen of undesirables. In February 1966 the architects of apartheid declared it a whites-only group area. Its peoples were relocated on the sandy, barren Cape Flats far removed from the city and places of employment, where even the natural flora struggles to survive the encroachment of alien vegetation. By 1981 the process was complete, leaving District Six a bulldozed wasteland dotted by a handful of mosques and churches which survived to recall the past. Richard Rive, a noted author who grew up there, called it 'South Africa's Hiroshima'. There is a large mural on the wall of the Holy Cross Catholic Church hall, one of the buildings still standing on the once bustling Hanover Street. Named *Res Clamant – the Earth Cries Out*, the mural captures the anguish of a vibrant community as it remembered the past and feared for the future.[2]

Travellers into Cape Town from further afield would have already passed kilometres of squalid townships; some hidden from sight, others lining the highways. Older townships, like Langa (the 'sun'), are now well established. But Langa was planned and built in 1927 with social control in mind.[3] Alongside its very basic houses

[1] See *The Struggle for District Six*, ed. S. Jeppie and C. Soudien (Cape Town: Buchu Books, 1990); on the social history and architecture of Cape Town, see Nigel Worden, Elizabeth van Heyningen and Vivian Bickford-Smith, *Cape Town: The Making of a City* (Cape Town: David Philip, 1998) and Vivian Bickford-Smith, Elizabeth Heyningen and Nigel Worden, *Cape Town in the Twentieth Century* (Cape Town: David Philip, 1999).

[2] See Peggy Delport, *'Res Clamant – the Earth Cries Out': Background and Pictorial Guide to the Holy Cross Mural* (Cape Town: District Six Museum Foundation, 1991).

[3] *Cape Town in the Twentieth Century*, p. 87.

resembling concrete blocks were barracks or hostels built for migrant workers, designed to make them recognise their status as outsiders welcome only for their labour. All they needed was a concrete bunk and a few rudimentary amenities. The hostels soon became overcrowded and by the late apartheid era were mostly dilapidated and unsanitary. Recent years have witnessed an exponential growth of informal settlements of wood, iron and cardboard structures rapidly filling vacant space.

Most white South Africans were nurtured in a way that blinded them to the realities of European domination and apartheid oppression. Bantu education attempted to do the same for the rest of the population. The introduction of television in South Africa was prevented by Afrikaner Nationalist rule until 1976 lest the population was introduced to a different picture. Once its potential for propaganda was recognised, it became a major tool in projecting false images and reinforcing misrepresentation. Seductive explanations denied the obvious. Images of reality were selectively chosen for publicity brochures and advertising films. The natural beauty of the region with its splendid white(s-only) beaches and game parks, coupled with limitless sporting possibilities and economic opportunities, was all that potential tourists and investors were shown. Most whites were glad that this was so, for blindness and deafness to the other images and sounds made life in abundance less problematic. Yet the vast majority of South Africans, who experienced the sharp end of apartheid, saw and heard things very differently. Those dumped on the Cape Flats longed to return to their homes on the slopes of Table Mountain; those forced to live in Langa's migrant labourers' hostels dreamt of their families in rural Transkei. The beauty of Cape Town was an alien beauty, 'a lousy city in a beautiful environment'.[4]

The architecture of Cape Town, like that of any other town or city, tells the story of its social history making visible its moods and rhythms in the same way as paintings may capture its environment or express its pain and hope. But architecture shapes the environment in a far more conspicuous way, creating the location within which human discourse and interaction occur. It also reflects the interests and taste of those with power and wealth. As such,

[4] Andrew Boraine, City Manager of the Cape Town Metropolitan Council, in speaking about the urgent need for transformation in post-apartheid Cape Town, 9 March 1999, University of Cape Town.

architecture is not only but perhaps primarily an urban art; its terrain is the city rather than the village and the countryside. When architects are employed in rural contexts they often create spaces of urbanity to which the wealthy can retreat, thereby accentuating the divide between the centre and the peripheries of power and influence. In creating the public square architecture can help us discern the values of a culture, indicating its power relations in a most concrete way. The use of colossal scale conveying power and inducing a sense of impotence; solid formal images suggesting social stability; space designed to disorient, encourage spending or segregate according to race and class; mechanisms of surveillance denying privacy and controlling access. Churches have too often emulated the architecture of power and wealth without recognising the idolatrous. Even nineteenth-century missionaries in South Africa used architecture to subvert native culture, insisting that their converts replace round 'pagan' huts with civilised rectangular houses.[5]

Architecture, along with urban planning, design and art, too often creates environments that inhibit the flourishing of life, public squares that prevent meaningful discourse, creativity, and good human relationships. Whether architecture has the power to do the opposite and play a socially transformative role has been hotly contested during the course of the twentieth century. Much architectural theory has claimed more than has been borne out in practice. So our assessment today must be more sober than that made by some earlier in the century who believed that architecture could create utopia. But this is not to deny that architecture can play an important, albeit modest role.[6] Along with art more generally, architecture can contribute to making life more humane and sustainable.[7] It can open up instead of preventing possibilities for living that are both functional and fulfilling. Understood as social process, it can intervene in the public interest, transgressing boundaries that divide people into mistrusting ghettos of race, class, or religion. Public space matters because what we do in that space, how we

[5] See the discussion in John L. Comaroff and Jean Comaroff, *Of Revelation and Revolution: The Dialectics of Modernity on a South African Frontier*, vol. II (Chicago: Chicago University Press, 1997), 274ff.

[6] Andrea Dean, 'Socially Motivated Architecture', in *Critical Architecture and Contemporary Culture*, ed. William J. Lillyman, Marilyn F. Moriarty and David Neuman (New York: Oxford University Press, 1994), 125–32.

[7] See M. Miles, *Art, Space and the City: Public Art and Urban Futures* (London: Routledge, 1997).

decorate it, for example, can hinder public life, and may well enhance it. We may not spend time in aesthetically contemplating a city as we might do a work of art in one of its galleries, but we do have a sense of whether its architecture and design contribute to our sense of well being or not.[8]

The well being of the city, and a country such as South Africa, depends to a great degree on the achievement of the right balance between urban and rural society over a whole range of interrelated spheres. Rural society reminds us of the importance of the natural environment. In some countries that remain largely rural but are equally very modern, such as Finland, there are many examples of the way in which sensitivity to the natural environment and a modernist architectural tradition has resulted in splendid urban architecture. One of the tragedies of modern-day Cape Town is that some of its architecture has simply ridden rough-shod over the beauty of the environment. So it is in the city that we see most clearly the effect of good or bad architecture on the lives of people, which is why it is the place to focus our attention. But it is also true that it is in the city that cultural creativity normally occurs.[9] The reasons for this are not difficult to discern. The chief being the fact that creativity is linked to innovation, and innovation arises when there is a critical mass of people struggling and experimenting together in technology and the arts to find solutions to the problems and needs of the city. The greatest cities, Peter Hall reminds us, were not utopias, but 'places of stress and conflict, and sometimes actual misery'. Cities, unlike arcadian suburbs, are 'places where the adrenalin pumps through the bodies of people and through the streets on which they walk; messy places sometimes, but places nevertheless superbly worth living in, long to be remembered and long to be celebrated'.[10] Cape Town is such a city, a city that I have discovered in new ways through the eyes of architects and artists after having lived there for most of my life.

Although my journey is centred in these final two chapters on Cape Town and, more broadly, South Africa, it is not confined to this context. Important as such specificity is, my exploration begins with some general reflections on the role of architecture as that art

[8] See Nicholas Wolterstorff, *Art in Action* (Grand Rapids, Mich.: Eerdmans, 1980), 178ff.
[9] See Peter Hall, *Cities in Civilization: Culture, Innovation, and Urban Order* (London: Weidenfeld & Nicolson, 1998).
[10] *Ibid.*, p. 989.

which has to do with the construction of the public square, symbol for the heart of the city. If some readers regard this as remote from my theme on Christianity and the arts, I ask them to think back to chapter 1, where we noted Calvin's interest as a theologian and pastor in town planning arising out of his concern for the well being of social life. The contemporary emphasis on theology and development should surely focus as much on urban society as it does on rural. Following that discussion we shall consider the relationship between the arts and culture, paying special attention to the role of art in social transformation. If architecture creates the space within which urban living occurs, the visual arts have to do with what we may or may not do to enhance and transform life.

CONSTRUCTING THE PUBLIC SQUARE

In some respects architecture is 'on the periphery of the fine arts',[11] but it is unavoidable art, as well as being 'our biggest, toughest, most complex, most permanent, and most powerful art'.[12] Architecture is that art which shapes the space in which we live, move and have our being. The *architecton* in ancient Greece was the master builder responsible to society for building temples, monuments and public works. Architecture represented the soul of the city, the power of its authority, the memory of its past glories, and symbolically embodied the connection between the cosmos and culture, the ideal world and the real. The same public spirit motivated the great European medieval architects, though they sought to embody the vision and values of scholastic theology in their achievements. Metaphysics and aesthetics combined to create the grandeur of Gothic cathedrals.[13] In the sixteenth century, European architecture gradually separated from the crafts of the medieval guilds as well as from the Gothic vision, and was identified along with painting and sculpture as an art in its own right. Goethe spoke of architecture as 'crystallized music'.[14] But the melodies expressed in the towns of medieval and Renaissance Europe are not those embodied in the cities of our own time.

[11] Wolterstorff, *Art in Action*, p. 6.
[12] Stanley Abercrombie, *Architecture as Art: An Esthetic Analysis* (New York: Van Nostrand Reinhold, 1984), 171.
[13] Erwin Panofsky, *Gothic Architecture and Scholasticism* (New York: New American Library, 1976).
[14] Quoted in Deborah J. Haynes, *The Vocation of the Artist* (Cambridge: Cambridge University Press, 1997), 3.

The primary role of the architect as artist lasted until the twentieth century, when modern building requirements, economic considerations, and particular construction problems undermined consensus on the nature of architecture as a discipline. Nonetheless, many architects continued to regard their craft as an art, and some considered constructing towns and cities as a collective work of art. No one expressed this better than Lewis Mumford in his *Culture of the Cities*, published shortly before the outbreak of the Second World War. Although the city is 'a fact in nature, like a cave, a run of mackerel or an ant-heap', Mumford wrote, 'it is also a conscious work of art, holding within its communal framework many simpler and more personal forms of art'.

Mind *takes form* in the city; and in turn, urban forms condition mind. For space, no less than time, is artfully reorganized in cities: in boundary lines and silhouettes, in the fixing of horizontal planes and vertical peaks, in utilizing or denying the natural site, the city records the attitude of a culture and an epoch to the fundamental facts of its existence. The dome and the spire, the open avenues and the closed court, tell the story, not merely of different physical accommodations, but of essentially different conceptions of man's destiny. The city is both a physical utility for collective living and a symbol of those collective purposes and unanimities that arise under such favoring circumstance. With language itself, it remains man's greatest work of art.[15]

Mumford belonged to a group of urban planning and architectural visionaries whose ideas have shaped many of the world's cities since the end of 1945, for good and ill. He knew only too well that when 'the city ceases to be a symbol of art and order, it acts in a negative fashion: it expresses and helps to make more universal the fact of disintegration. In the close quarters of the city, perversities and evils spread more quickly; and in the stones of the city, these anti-social facts become embedded: it is not the triumphs of urban living that awaken the prophetic wrath of a Jeremiah, a Savonarola, a Rousseau, or a Ruskin'.[16]

The connection between architecture and theology is implicit in Mumford's claim that the designing of the city has to do with 'the fundamental facts' of our existence, the values which shape our common life, and competing claims concerning human nature and destiny. For architecture shapes the kind of world in which we live,

[15] Lewis Mumford, *The Culture of Cities* (London: Secker & Warburg, 1938), 5.
[16] *Ibid.*, p. 6.

linking us to the past in healing or unhelpful ways, and opening up or closing possibilities for the future.[17] If architecture is about the creation of public space, theology, understood as critical reflection on praxis from the perspective of Christian faith, has to do with the transactions which take place within that space. This is not to deny the ecclesial function of theology, but it implies that <u>the church exists for the sake of transforming the world</u> and not the other way round. Theology, as servant of the servant church, must be a form of cultural criticism. This is essential if the church is to understand its milieu, protest in a more astute way against that which is inimical to human life and the common good, and come to a more profound understanding of its own faith and hope.

Architects and artists more generally may or may not always warm to engagement with theologians who take their craft seriously, but there is surely a need for mutual understanding and co-operation in constructing the public square as a place conducive to human flourishing. In entering into such a dialogue theologians have to heed Dillenberger's warning that 'a theological interpretation that is grounded in theological seeing without faithfulness to the artworks themselves is unconvincing to critics and art historians'.[18] Architects would also have to be open to fresh insights from an unanticipated quarter and share a common concern for social transformation. Some architects, of course, in reaction to ideologically motivated attempts to control their craft, have purposely excluded moral, social and political considerations from their work. Yet there are others who have sought to pursue their tasks in ways that are socially and ethically responsible.[19] Irrespective of how they may understand their role, architects share the same political responsibility as any other citizen. What they do is not ideologically neutral. Some even go so far as to argue optimistically that architecture not only implements social change but also is 'one of the preconditions, facilitators and creators of change'.[20] But irrespective of the side we may choose in this debate, architecture

[17] See Karsten Harries, *The Ethical Function of Architecture* (Boston, Mass.: MIT Press, 1997).

[18] John Dillenberger, *A Theology of Artistic Sensibilities: The Visual Arts and the Church* (London: SCM, 1986), 221.

[19] On the debate on socially responsible architecture in the course of the twentieth century, see Dean, 'Socially Motivated Architecture', pp. 125–32.

[20] Pauline von Bonsdorff, 'Future Architecture', in *Art and Beyond: Finnish Approaches to Art*, ed. Ossi Naukkarinen and Olli Immonen (Lahti, Finland: International Institute of Applied Aesthetics, 1995), 46–65.

should not be reduced to some politically correct pattern. If architecture is to remain an art (amongst other things), it should not be turned into an instrument of social engineering but seek to represent the best of human aspiration and hope.[21] Modesty is of the essence, for architecture left to itself can produce ambiguous results, creating socially destructive environments even with the best of intentions. Nothing illustrates this better than 'modern architecture' as it developed between the two World Wars of the twentieth century.

The celebrated pioneers of architectural modernity, such as Walter Gropius, Le Corbusier and Mies van der Rohe, were committed to simplification, concentration and egalitarianism. Their endeavours were a reaction to the evils of the cities identified and excoriated by the likes of Ruskin and Marx: 'the plight of the millions of poor' trapped in Victorian slums – the nineteenth-century equivalent of the ubiquitous informal settlements and shanty towns of the third world.[22] Their vision of the city of the future was utopian and even millenarian.[23] Architecture was the art that united all others, and its goal was to transform the world. This was how the architects (and artists such as Wassily Kandinsky and Paul Klee) associated with the Bauhaus understood their vocation. The Bauhaus was founded in Germany in 1919 in the wake of the First World War; its leadership, indebted to Marx and William Morris, sought to reconstruct Germany in a way consonant with strivings for a more egalitarian, democratic order. To begin with, emphasis was placed upon the recovery of the connection between art and craft, a romantic return to the Middle Ages. But by the mid 1920s the movement had embraced modernity and set out to master the techniques of industry, though the tension between art and technology was never resolved.

For Gropius, the one-time head of the Bauhaus and in many ways its pioneering spirit, architecture was an expression of the highest

[21] There are many examples of architecture as a form of social engineering. For a positive though now dated account, see Alan Lipman, 'The Architectural Belief System and Social Behavior', in *Designing for Human Behavior: Architecture and the Behavioral Sciences*, ed. Charles Burnette, Jon Lang and Walter Moleski (Stroudsburg, Pa.: Dowden, Hutchinson & Ross, 1974), 23–30. See also the critique in Gillian Rose, 'New Jerusalem, Old Athens: From "The Broken Middle"', in *The Postmodern God*, ed. Graham Ward (Oxford: Blackwell, 1997).

[22] Peter Hall, *Cities of Tomorrow: An Intellectual History of Urban Planning and Design in the Twentieth Century* (Oxford: Blackwell, 1996), 7.

[23] On the utopian vision of the city in Christian tradition and architecture, see Harries, *The Ethical Function of Architecture*, pp. 326ff.

and noblest of human sentiments, virtually a religion.[24] After all, had not Hegel described architecture as 'the first pioneer on the highway toward the adequate realization of the Godhead?'[25] This makes a comparison between Gothic and modern architecture apposite, though we must be careful not to simplistically romanticise the former and demonise the latter. If the Gothic cathedral, ideally speaking, represented a human response to God, the crystal palaces of modernity suggest a confidence in the power of technology to set humanity free. The origins of this architectural hubris can be traced much further back in human history and mythology, at least to the Tower of Babel. But nothing symbolised it more at the birth of modernity than the Eiffel Tower, unveiled as the centre-piece of the Paris World Fair in 1889, the centenary of the French Revolution. Just as Gothic cathedrals were built to the 'glory of God', the Eiffel Tower, the 'master-image' of modernity,[26] was built to glorify human achievement so that we could enjoy it for ever. The architects of modernity envisaged a city that would celebrate human freedom and achievement, a city sufficient unto itself. The New Jerusalem that the ancient seer on Patmos observed descending to earth at the dawning of the millennium of everlasting peace could now be constructed by human skill and effort. The architecture of modernity resembled 'nothing so much as secular versions of the seventeenth-century Puritan's Celestial City set on Mount Zion, now brought down to earth and made ready for an age that demanded rewards there also'.[27] Gillian Rose aptly comments that Le Corbusier and van der Rohe were engaged in reinventing 'architecture by combining classical virtue with modern will-to-power' and that in doing so they were drawing quite explicitly on Thomas Aquinas and Nietzsche in creating a new architectural ethic.[28] Nowhere is the connection between theology and architecture more obvious.

In pursuing their vision the architects of modernity were strongly opposed to nostalgic recovery, whether classical, Gothic or Romantic. True form was to be found in simplicity of design determined by function. Function was neither incidental nor

[24] *Ibid.*, p. 329.　　[25] Quoted *ibid.*, p. 352.

[26] Robert Hughes, *The Shock of the New: Art and the Century of Change* (London: Thames and Hudson, 1991), 9, cf. 38.

[27] Hall, *Cities of Tomorrow*, pp. 2f.

[28] Rose, 'New Jerusalem, Old Athens', p. 332.

supplementary but of the essence.[29] This was undoubtedly related to the need to reduce building costs, architecture being the most expensive of all the arts. But functionality was also guided by a radical break with tradition and an equally radical commitment to the spirit of the modern age. <u>Form, at least in theory, followed function.</u> I say 'in theory' because modernist architecture sometimes functioned more powerfully at a symbolic level than at a practical one. The relationship between form and function is certainly complex. Nevertheless, the desire for functionality provided the basis for an international style that was intended to be appropriate for the emerging technological society within which modern people lived. 'We claim, in the name of the steamship, of the airplane, and of the motorcar, the right to health, logic, daring, harmony, perfection', declared Le Corbusier.[30]

A great epoch has begun. There exists a new spirit . . . Architecture has for its first duty, in this period of renewal, that of bringing about a revision of values, a revision of the constituent elements of the house . . . We must create the mass-production spirit. The spirit of constructing mass-production houses. The spirit of living in mass-production houses. The spirit of conceiving mass-production houses.[31]

In blunt terms, the architects of modernity were not simply in the business of creating new buildings, though the '*complete* building' was the means to their end, <u>but of creating new people who lived according to the values of modernity.</u> And they succeeded in a way that was more unified than any other art form.[32] No one achieved this better than Oscar Niemeyer, the Brazilian architect who created the capital city of Brasilia with its futuristic cathedral *ex nihilo* on a desolate landscape at enormous cost.[33]

The architects of modernity could not have achieved their goals without the co-operation of urban planners driven by the same vision. According to the Athens Charter formulated after the First World War and intended to guide urban planning in the twentieth century, <u>the key to urbanism was design that was faithful to the four functions of inhabiting, working, recreation and circulation.</u>[34] These

[29] Steven Connor, *Postmodernist Culture: An Introduction to Theories of the Contemporary* (Oxford: Blackwell, 1989), 67.
[30] Le Corbusier, *Towards a New Architecture* (Oxford: Butterworth, 1987), 19.
[31] *Ibid.*, p. 6. [32] Connor, *Postmodernist Culture*, p. 68.
[33] Niemeyer, aged ninety-one, was awarded the gold medal for architecture by the Royal Institute for British Architecture in 1998. See *The Independent* (London), 19 March 1998, 18.
[34] Wolfgang Welsch, *Undoing Aesthetics* (London: Sage Publications, 1997), 111.

WHOLENESS WHOLENESS
IN IN
URBANISM BEING

were not to be confused or blended, but each was to be respected
and catered for in its own right. But the implementation of the post-
war urban planners' vision, often in places and circumstances
different from their own, sometimes had bizarre and even cata-
strophic results. Their intention was undoubtedly good – to change
the living conditions of those condemned by urbanisation and
industrialisation to inequity and oppression, and anticipate the New
Jerusalem. But there is often a chasm between good intention and
end product, and the tragic irony of such utopian vision is apparent
in hindsight. Perhaps the Athens Charter should have included
remembrance in their list of functions, for that would have high-
lighted the need for planning to be in continuity with the best of the
past in urban design.

 Artificially converting cities into utopias always runs the danger of
making them worse, especially when urban planning takes no
account of communal consensus. The utopia of today is too often the
dystopia of tomorrow. Concrete, glass and steel multi-national
temples and skyscrapers dwarfed human beings; massive apartment
blocks became concrete jungles; four-laned highways split commu-
nities and contributed to the pollution of the cities; and the market
place was replaced by the self-contained, aestheticised mega shop-
ping mall dedicated to Mammon. Of course, architects cannot be
held solely or even chiefly responsible for all of this. They were but
part of a much larger whole comprising city officialdom, town
planners, and financial institutions who made the final decisions on
grounds usually far removed from aesthetic or moral considerations.
Nonetheless, driven by its passion for function, the architecture of
modernity succumbed to formalism and uniformity. Its attempt to
foster an egalitarian society premised upon rationality too often led
to the glorification of power, which invariably meant the dehumani-
sation of people and societies, the destruction of the environment,
and the reinforcement of economic values which exacerbated the
growing gap between wealth and poverty.

 The Bauhaus was closed down by Hitler because of its leftist
ethos, but its motivating vision of a socialist egalitarian society in the
service of creating the 'new man' was equally open to fascist
perversion. There was even, at least to begin with, an affinity
between Nazi architectural aspirations and those of the Bauhaus.[35]

[35] Peter Adam, *Art of the Third Reich* (New York: Harry N. Abrams, 1992), 211.

Its social vision was also evident in the art and public works of Soviet Russia which glorified the 'narcissism of power', and in the well-intentioned 'social hygiene' of top–down socialist technocratic town-planning schemes in Berlin and elsewhere.[36] Indeed, the cultural connections between Weimar Germany and post-revolutionary Russia were particularly strong, facilitating the flow of ideas from the one to the other.

Totalitarian regimes do not need a particular form of architecture to pursue their goals, and yet some buildings are undeniably designed for that purpose, turning 'men into ants', as Hitler the architectural draftsman put it in pursuing plans to transform Berlin into Germania. Such architecture remains 'monumentally kitsch' at best,[37] and morally repulsive at its worst. The key ideas and techniques of modern architecture were taken over and subverted by those who sought to glorify power, whether political or economic, irrespective of their ideological persuasion. Robert Hughes makes the point in the very different context of the United States by referring to the state legislature complex in Albany, New York:

One could see any building at Albany Mall with an eagle on top, or a swastika, or a hammer and sickle; it makes no difference to the building. For if one considers what it actually built (rather than what was said about what it built), there can be no doubt that modernist culture has its own language of political power. It is not linked to any particular ideology. It is value-free and can mean anything the patron wants. It is, in essence, an architecture of coercion.[38]

Yet again we are confronted by an issue that is of concern to critical theology in its commitment to a liberating social praxis, and therefore to an aesthetic praxis that is rooted in moral values which promote the common good. No one expressed the dangers of separating aesthetic praxis from ethical constraints better than George Moore in his *Confessions of a Young Man*:

What care I that some millions of wretched Israelites died under Pharaoh's lash or Egypt's sun? It was well that they died that I might have the pyramids to look on, or to fill a musing hour with wonderment. Is there one among us who would exchange them for the lives of the ignominious slaves that died?[39]

[36] Hughes, *The Shock of the New: Art and the Century of Change*, pp. 97, 167, 184.
[37] Harries, *The Ethical Function of Architecture*, p. 332.
[38] Hughes, *The Shock of the New: Art and the Century of Change*, p. 108.
[39] George Moore, *Confessions of a Young Man* (New York: Brentano, 1917), 144, quoted by Monroe Beardsley, *Aesthetics* (Hackett, 1981), 563.

It may be questioned whether the pyramids were, in fact, built by slaves. But this passage, as Monroe Beardsley comments, 'contains a profound warning to those who, in their eagerness to exalt the arts, forget that they are after all human products of human activities, and must find their value in the whole context of human life'.[40] A profoundly theological insight.

ARCHITECTURE AND ETHICS IN A COLONIAL CONTEXT

The moral ambiguity of much modern architecture derives from the gap between the high ideals of its pioneers and the ends to which their work was often put. South Africa provides several examples of the achievements of modern architecture compromised by social reality and the will-to political and economic power. A classic example is Johannesburg, whose architectural and urban development was shaped by the interests of 'tough-minded business men' in tension with the 'representatives of metropolitan high style'.[41] Following trends set in London, Paris, Berlin, New York and Chicago, yet reflecting the fickleness of a city built on the fortunes of gold mining and inhumane, racially determined labour practices, and apartheid legislation, modern Johannesburg is a city in search of a soul. But all South African cities suffer from similar ailments, not least because of the ravages of colonial urban planning and apartheid legislation. At a discreet distance from the temples of modernity are the concrete boxes of township hostels and houses which fill the 'blank spaces',[42] not originally built for the sake of solving a housing crisis but to contain cheap labour. Quite the reverse of what the great architects of modernity had in mind when they responded to the housing needs of Europe following the First World War. But then the cities of South Africa were initially an expression of colonial expansion and exploitation, and not inspired by an inclusive vision of the common good.

If the Cape Dutch settlement has left a legacy of gracious homesteads serviced by slaves dotting the rural landscape, British colonial

[40] Beardsley, *Aesthetics*, p. 563.
[41] Clive M. Chipkin, *Johannesburg Style: Architecture & Society 1880s-1960s* (Cape Town: David Philip, 1993), 320.
[42] Gary Minkley, '"Corpses Behind Screens": Native Space in the City', in *blank—Architecture, Apartheid and After*, ed. Hilton Judin and Ivan Vladislavic (Cape Town: David Philip, 1999), 203ff.

settlement has left an architectural legacy in South Africa that sought to reflect the glories of empire in the building of cities. The vision of the great advocates of utopian twentieth-century town planning in Britain found expression in the colonies prior to its incarnation in its homeland. The most spectacular example of this was in the British Raj in India between 1910 and 1935. This was no accident, for the Colonial Office was seeking to 'establish what were often new and precarious holds on conquered territory' and was, therefore, anxious to build 'visible symbols of authority and domination', quite apart from providing accommodation suitable for colonial civil servants.[43] One of the architects chosen for this historic task was Herbert Baker, a protégé of Cecil John Rhodes, who had already made his mark in South Africa. Baker and his colleague Edwin Lutyens are regarded by many as 'the greatest English architects of their generation, the architects of a new age of classicism, a rearguard architecture to celebrate the rearguard of Imperialism'.[44]

Colonial town planning in British Africa (Salisbury, Lusaka, Nairobi and Kampala) assumed that the cities were the domain of white settlers and administrators. While an Indian market might be permissible on the periphery, Africans had no right to be in the city, and were forced either to live in reservations or have their movements strictly controlled. This was the case in South Africa long before apartheid, as can be seen in Durban and Kimberley, as well as Cape Town, though there, unlike the rest of British Africa, Africans were not regarded as farmers but as labourers. One reason given for such segregated town planning was hygiene, which meant that the best, that is the healthiest land, land not subject to flooding or conducive to the breeding of mosquitoes, was appropriated for white habitation.[45] But whatever reasons were given, it all had to do with power and privilege. In fact, no reason had to be given; it all seemed so obvious to the colonial mind. Africans simply did not exist except for the service they could render colonial officials and settlers alike. So what was required was the development of cities, towns and suburbs which were not only transplants from Britain, but also designed to ensure that settlers remained and others came. In this regard there was a remarkable split between the private and the

[43] Hall, *Cities of Tomorrow*, p. 183. [44] Chipkin, *Johannesburg Style*, p. 37.
[45] Hall, *Cities of Tomorrow*, p. 190.

public sphere. If some of the more grand private homes reflected a blending of hybrid cultural identities, public life was shaped by a severe Eurocentrism. This allowed for the more privileged to be assimilated to European culture, but for the vast majority such a notion was unthinkable.[46]

Power and identity found their symbolic expression in the many monuments now inhabiting the public square (and sacred space) around the country, remembering British royalty and the victories of empire.[47] Nowhere is this more evident than in Cape Town, whose architecture and town planning provide a case study of the way in which power relations and social stratification developed in colonial society. Within short walking distance of Government Avenue and the historic Company Gardens, the Houses of Parliament, the Supreme Court, the Groote Kerk (mother church of the Dutch Reformed Church) and St George's Cathedral (Anglican) stand cheek by jowl, with Queen Victoria viewing all from her granite pedestal. Sandwiched in between lay the slave quarters, now a cultural history museum which until very recently ignored its former notoriety. Within a wider circumference, though still within easy access to the centre, stand the Great Synagogue, the Roman Catholic Cathedral and the Central Methodist Church. All of these are imposing buildings. Gradually, as you move away from the centre of power, up Bo-Kaap on the one side and District Six on the other, you encounter mosques and churches, the spiritual homes of the largely coloured population, many of whom were subsequently uprooted by apartheid legislation and dumped elsewhere. The black townships lie far beyond the peripheries of the city, symbolising the outsider status of the indigenous inhabitants and migratory labourers.

Apartheid has also left its architectural legacy.[48] Structures that glorify Afrikaner nationalism, such as the Voortrekker Monument in Pretoria, are in a class of their own, paralleled only by similar massive memorials in Germany. But they characteristically evoke the

[46] Daniel Herwitz, 'Modernism at the Margins', in *blank—Architecture, Apartheid and After*, ed. Hilton Judin and Ivan Vladislavic (Cape Town: David Philip, 1999), 411.
[47] David Bunn, 'Whited Sepulchres: On the Reluctance of Monuments', in *blank—Architecture, Apartheid and After*, ed. Hilton Judin and Ivan Vladislavic (Cape Town: David Philip, 1999), 93ff.
[48] A powerful exposé was provided in the exhibition blank—Architecture, Apartheid and After which went on display in Rotterdam in January 1999. See *blank—Architecture, Apartheid and After*, ed. Hilton Judin and Ivan Vladislavic (Cape Town: David Philip, 1999).

laager[49] mentality of the Voortrekkers, symbolising a culture under threat even when ascendant. Many public buildings, notably in Pretoria, reflect the Afrikaners' years of dominance after the Second World War, just as the architecture of Afrikaner-controlled banks reflected the success of *Volkscapitalisme.*[50] If the central Post Office in Cape Town, built of Table Mountain sandstone and completed as Afrikaner nationalism came to power, embodies the granite-like spirit of a totalitarian society in the making, more recent skyscrapers patterned on international style speak of the economic boom that followed the post-Sharpeville repression of African nationalism in the early sixties.[51] There was another side to apartheid architecture as well, one associated with the Bantustans, namely the attempt to develop an architecture that was 'culturally African', though designed by state architects. This can be seen in many of the government buildings erected in the capital 'cities' of the Bantustans, such as Bisho and Mmabatho, including ethnic universities and colleges.

There was an attempt to develop an Afrikaner style of architecture, notably in Pretoria, in the post-Second World War years.[52] But the apartheid regime as such did not *purposefully* develop a distinctive architectural expression. It adopted international trends and adapted indigenous forms to express its mind-set. Just as the development of apartheid was influenced by National Socialist ideas of race and *Volk*, so its favoured architecture often resembled that which was in vogue in Germany in the 1930s. But architectural styles did not become politicised under apartheid rule in the same way as in Nazi Germany, where the iconographies of modernity and abstraction were in mortal combat with tradition and representation.[53] It was more a matter of adapting the colonial heritage,

[49] 'Laager' refers to the way in which the Afrikaner Voortrekkers formed their wagons into protective circles during the Great Trek.

[50] Melinda Silverman, '"Ons Bou Vir die Bank"': Nationalism, Architecture, and the Volkskas Bank', in *Architecture, Apartheid and After*, ed. Hilton Judin and Ivan Vladislavic (Cape Town: David Philip, 1999).

[51] Clive M. Chipkin, 'The Great Apartheid Building Boom: The Transformation of Johannesburg in the 1960s', in *blank—Architecture, Apartheid and After*, ed. Hilton Judin and Ivan Vladislavic (Cape Town: David Philip, 1999). The Sharpeville Massacre occurred in March 1960, signalling the beginning of a new era of repression and leading to the banning of the African National Congress and the Pan-African Congress in 1963.

[52] Roger C. Fisher, 'The Third Vernacular: Pretoria Regionalism', in *blank—Architecture of the Transvaal*, ed. Roger C. Fisher and Schalk le Roux (Pretoria: UNISA, 1998), 123ff.

[53] Barbara Miller Lane, *Architecture and Politics in Germany, 1918–1945* (Cambridge, Mass.: Harvard University Press, 1968).

building public works suited to their goals (segregated facilities, etc.), and going along with the development of modernist European architecture as it spread its influence around the world. Indeed, most South African government buildings of the post-war period are the products of the global post-war modernism that Habermas described so vividly as 'dominant but dead'.[54] This stands in contrast to the legacy left by architects like Baker whose many churches, homes and public buildings, despite their colonial connection, retain their aesthetic quality and blend into the new South Africa with remarkable ease. Nowhere is this more evident than in the stately Union Buildings in Pretoria, the site of President Mandela's inauguration in 1994, and the executive seat of government.

The challenge to the architecture of modernity and its various ideological abuses came from within the guild of the architects of modernity itself, notably with the post-modern protest by the American architect Robert Venturi in 1966. Analysing the contradictions in European and American architecture, Venturi pleaded for an alternative approach which would reflect, not the mythical uniformity and singularity of modernity, but the complex richness and ambiguity of modern life and experience.[55] Following Venturi, others have called for an architecture that breaks with the aestheticisation of the world, one which is not captive to the demands of the 'glossy brochures and architectural journals, but for people and users'.[56] A fundamental implication would therefore be that of consultation with the communities in and for which they build. Yet this does not mean simply designing according to the whims, fancies and values of communities, for this too carries dangers. Community architecture, as Rose observes, also runs the risk of becoming utopian, trying to create the kingdom of God.[57] Mass taste is by no means synonymous with good taste. But what is good taste, and how does it correlate with the need to construct an environment that is both ethically defensible and aesthetically satisfying?

The debate sparked off by post-modernism has opened up a discussion of considerable relevance even though post-modernist architecture is not everything its proponents sometimes claim. Of

[54] Derek Japha, unpublished seminar paper, September 1997, University of Cape Town.
[55] Robert Venturi, *Complexity and Contradiction in Architecture* (New York: Museum of Modern Art, 1966), 22.
[56] Welsch, *Undoing Aesthetics*, p. 136.
[57] Rose, 'New Jerusalem, Old Athens', p. 336.

particular importance for us is that it has helped stimulate an architecture appropriate to the multi-cultural environment in which most people now live, not least in South Africa. In contrast to the imposition of values that are socially homogenised, ethnically centred, and closed to intercultural activity, a transcultural approach is proposed. 'Planners and architects should', Welsch argues, 'take an urgent look at the perspective of transculturality and design cities and living spaces in its spirit – instead of once again turning the clock back in the direction of musty "ownness" which always stands at the threshold to intolerance'.[58] Architecture has a global social responsibility to ensure that our children will have a world to inhabit, and one worth inhabiting. An architecture that accepts such a responsibility will allow for diversity and plurality. It will equally allow for the unprogrammable, unpredictable and spontaneous, pay careful attention to living functions, and refuse to be confined by some ideologically, quasi-religious, absolute set of criteria.

The underlying theological problem with 'modern architecture' is that it was too vulnerable to ideological manipulation by those opposed to the common good. We are back with the issues previously referred to in comparing Gothic cathedrals and the Eiffel Tower. We need not unduly romanticise the former or demonise the latter in recognising a fundamental difference in their symbolic ethos. Which brings to mind that both Balthasar, perhaps predictably, and Bonhoeffer, perhaps surprisingly, turned to the Middle Ages as a guide to overcoming the problems of modernity. It also connects with John Milbank's proposal that in order to transcend the modern predicament without lapsing into resignation, we must 'consider again the claims of the "gothic vision" in its socialist, Christian variant'.[59] This requires that 'every act of association, every act of economic exchange, involves a mutual judgement about what is right, true and beautiful, about the order we are to have in common'.[60]

We cannot return to the Middle Ages, nor should we uncritically acclaim its achievements. But there is something about its vision, its linking of earth and heaven along with its concern for both beauty and the common good, that resonates with human hope and the

[58] Welsch, *Undoing Aesthetics*, p. 143.
[59] John Milbank, *The Word Made Strange: Theology, Language, Culture* (Oxford: Blackwell, 1997), 285.
[60] *Ibid.*, p. 279.

promise of the Christian gospel. Although Karsten Harries, who has perhaps thought most deeply about architecture and ethics, rightly does not believe that architecture should try to build utopia, or that its ethics depends on belief in God, his conclusions resonate with this penultimate vision. Without claiming to have the authority they once had, architects, he insists, 'can and must keep themselves open to the always-mediated claim of a reason and a reality that they have not created, keep themselves open especially to the claims of the other, to the claims of the community, and the claims of coming generations'. There is, he continues, the need for 'the creation of festal places' which enable us to celebrate 'those central aspects of our life that maintain and give meaning to existence'.[61] But festal places are always located within particular cultural settings, and it is within such settings that cultures interact and the possibilities for transformation are broken open. Hence Bonhoeffer's hope that the church, at least, would become a sphere of freedom within which the aesthetic dimension of life would be recovered.

The choices that face town planners in post-apartheid South Africa, Mark Swilling suggests, are those of completing 'the task of building an authentic, post-colonial sense of the future of South Africa's cities'. His choice of the word 'sense' is important because it eschews the need for 'codified vision in another unread policy document'. The 'sense' that is needed is 'of place that emerges from continuous practice as we re-engage our cities in a new set of conversations about their identities, structures, forms, functions, conflicts, poverties and potentials'.[62] Churches and theologians have a contribution to make to this set of conversations if they engage with the issues in an informed way. And their contribution is best made if they reflect critically on the issues from their own faith perspective within the broader ecumenical and multi-religious context within which we live.

Our discussion thus far has opened up at least two issues that are of relevance for our consideration of the role of art in society. The first has to do with the capacity of art in enabling social transformation; the second is its possible role within a multi-cultural context such as we find in countries like South Africa and cities like

[61] Harries, *The Ethical Function of Architecture*, p. 365.
[62] Mark Swilling, 'Rival Futures: Struggle Visions, Post-Apartheid Choices', in *blank— Architecture, Apartheid and After*, ed. Hilton Judin and Ivan Vladislavic (Cape Town: David Philip, 1999), 299.

Cape Town. Architects may help to create the space in which urban life is lived, but what we do with and in that space is up to those who live there. If Hall's analysis is correct, namely that cities become great as a result of the flowering of creativity in all spheres, not least the arts, then we have to ask about the way in which artistic creativity relates to the transformation of culture and society.

TRANSFORMATION, ART AND CULTURE

All art is located within a particular cultural matrix. Unless we have an understanding of its milieu, it is difficult to appreciate its significance. Art is an expression of a culture, a means of its memory, representation (*mimesis*), enrichment and hope, all key themes for the discussion to follow. Clifford Geertz expresses well the connection between art and culture:

> The capacity, variable among peoples as it is among individuals, to perceive meaning in pictures (or poems, melodies, buildings, pots, dramas, statues) is, like all other fully human capacities, a product of collective experience which far transcends it, as is the far rarer capacity to put it there in the first place. It is out of participation in the general system of symbolic forms we call culture that participation in the particular we call art, which is in fact but a sector of it, is possible. A theory of art is thus at the same time a theory of culture.[63]

Awareness of this intrinsic connection between art and culture is important not only for appreciating art and the vocation of the artist, but also for understanding their role in the public square and the shaping of corporate and personal identities. In exploring key aspects of this connection we begin with what is widely acknowledged as the most important paradigmatic shift in the history of modern art, one brought about by the encounter of European and African cultural traditions.

European art and hence culture itself was dramatically altered through Pablo Picasso's encounter with African carvings. With specific reference to his path breaking *Les Demoiselles d'Avignon* (see plate 4), Hughes writes that Picasso

was stating what no eighteenth-century artist would ever have imagined suggesting: that the tradition of the human figure, which had been the very

[63] Clifford Geertz, '"Art as a Cultural System"', *Modern Language Notes* 91 (1974). Quoted in *Aesthetics*, ed. Susan and Feagin and Patrick Maynard (Oxford: Oxford University Press, 1997), 115.

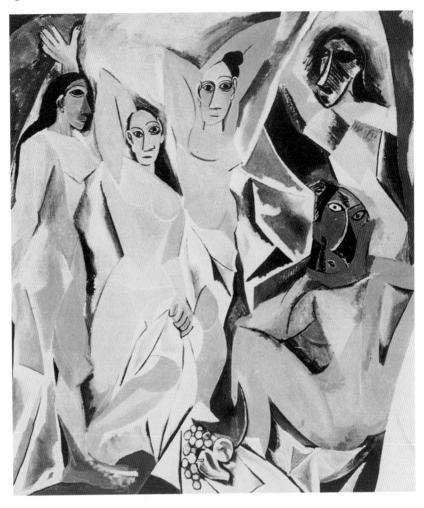

4 *Les Demoiselles d'Avignon*. Pablo Picasso (1907)

spine of Western art for two and a half millennia, had at last run out; and that in order to renew its vitality, one had to look to untapped cultural resources – the Africans, remote in their otherness.[64]

Picasso was not alone in making this breakthrough, for about the same time, 'Die Brücke', a group of young Dresden painters which included Emil Nolde, were profoundly affected by 'African art', as

[64] Hughes, *The Shock of the New: Art and the Century of Change*, p. 21.

his paintings of the gospel narratives so wonderfully show. African art, in turn, has been influenced by European culture, Islam, and forms of Christianity,[65] while the interaction between African and European culture in the production of art in South Africa has been evident for many decades.[66] There have also been influences coming from sources other than European. Black South African music, for example, has been shaped by African-American jazz during the second half of the twentieth century, just as the latter itself is the product of multi-cultural experience.[67] This process is presently escalating as cultural traditions interact and fuse in greater freedom, and artists interact with each other in pursuit of their craft. The fact is, art and culture petrify when they close in upon themselves, excluding any intrusion of new possibilities. But artistic creativity has the capacity to break culture open in ways that make transformation possible, and multi-cultural experience spurs new initiatives in the arts. Picasso's *Les Demoiselles d'Avignon* demonstrates, then, that when the art of one culture encounters another it renews itself, and contributes in turn to the renewal of culture more generally.

There is a sense in which Picasso's work breaks open the hegemony of Western aesthetics through encountering afresh what he himself referred to as 'a type of magic which stands between the hostile universe and us, a way of seizing power, by giving shape to our fears and desires'.[68] But there is reason for cautious reflection at this point. Hughes refers to Picasso's appropriation of African art forms as 'a kind of cultural plunder' and speaks of his 'parody of black art'.[69] The colonial European rape of African and other cultures needs no elaboration here. Nor do we need to comment on the extent to which European Christian missionaries regarded the art of Asia or Africa as idolatrous, barbaric or, at best, childish. African art has also been relegated to the status of objects of anthropological curiosity, the products of some idyllic, static past, and subjected to the ill-informed judgements of European aesthetic

[65] An interesting account of this interaction is in Herbert M. Cole, *Icons: Ideals and Power in the Art of Africa* (Washington, D.C.: Smithsonian Institution Press, 1989), 136ff.

[66] Esmé Berman, *Art and Artists of South Africa* (Cape Town: Southern, 1996), 12ff.

[67] Samuel A. Floyd, Jr, *The Power of Black Music: Interpreting its History from Africa to the United States* (New York: Oxford University Press, 1995).

[68] Quoted in Léopold Sédar Senghor, 'Picasso en Nigritie' (1972), in *Seven Stories About Modern Art in Africa*, ed. Clémentine Deliss (Paris: Flammarion, 1995), 228.

[69] Hughes, *The Shock of the New: Art and the Century of Change*, p. 21.

theory.[70] Not surprisingly, the very concept of 'African art' is contested as a European construct which long assumed that the history of art has to do with the history of Western art, and that all African art is, in Okwui Enwezor's phrase, 'marooned in the mist of a mythical past'.[71] Yet neither the history of art nor aesthetic understanding is a European prerogative or the basis upon which everything else – including good taste – must be evaluated. What, after all, is *African* art, given the history and cultural complexity of the continent, and on what basis must it be judged?[72] After all, most modern artists are cultural hybrids, a fact which makes the heated debate about 'representation' more complex than might at first be assumed.[73]

There is yet another side to Picasso's appropriation of African art that pertains to our theme. Given the fact that he completed *Les Demoiselles d'Avignon* shortly after the public became aware of military atrocities committed by their troops in Central Africa, Patricia Leighten has suggested that Picasso embraced African art in critical reaction against French policy in Africa.[74] In like manner, those artists of European ancestry in South Africa who, in the past, embraced African culture were signalling their rejection of the attempt by segregation and apartheid to separate people according to ethnicity. Such art is undoubtedly a form of political protest, but it is at the same time of considerable aesthetic significance, as Picasso's

[70] Rosalind I. J. Hackett, *Art and Religion in Africa* (London: Cassell, 1996), 3ff.; Cole, *Icons*, pp. 20f.

[71] From an extract to an extended essay in Sue Williamson and Ashraf Jamal, *Art in South Africa: The Future Present* (Cape Town: David Philip, 1996), 6.

[72] 'African art' is a contested term, not least because it suggests that there is a uniquely African artistic paradigm to which all African artists conform. Nonetheless, there is a recognisable African art tradition, varied and complex as it may be, just as there is a comparable tradition in Europe and elsewhere. See V. Y. Mudimbe, 'African Art as a Question Mark', *African Studies Review* 29, no. 1 (1986); Werner Gillon, *A Short History of African Art* (London: Penguin, 1991); *Seven Stories About Modern Art in Africa*, ed. Clémentine Deliss (Paris: Flammarion, 1995); Hackett, *Art and Religion in Africa*, pp. 4ff.

[73] The debate about the right of artists to represent 'the other' is a critical issue amongst contemporary theorists. During the past decade it has been especially heated in South Africa, where issues of race, class and gender have been in the forefront of the discussion of what has been referred to as 'representational aesthetics'. See Brenda Atkinson, Introduction to *Grey Areas: Representation, Identity and Politics in Contemporary South Africa*, ed. Brenda Atkinson and Candice Breitz (Johannesburg: Chalkham Hill Press, 1999), 15.

[74] Roy Richard Grinker and Christopher B. Steiner, 'Introduction to Arts and Aesthetics', in *Perspectives on Africa: A Reader in Culture, History, and Representation*, ed. Roy Richard Grinker and Christopher B. Steiner (Oxford: Blackwell, 1997), 425. For a more philosophical response that links Picasso's breakthrough to 'Negritude', see Senghor, 'Picasso en Nigritie', p. 1995.

work testifies. The work of the South African artist Cecil Skotnes, which was initially influenced by Picasso, is equally indicative of this connection between the aesthetic and the political. Skotness helped pioneer what came to be known as 'Township Art', one of several art forms that have had far-reaching political significance in South Africa.[75] They became 'a vehicle for advancing the perceptive and interpretative capacities of all people, as also their sense of potency within this world'.[76] But they have also made a significant contribution to the development of art itself both locally and internationally in doing so, as we shall see later in the chapter.

What we have just discussed highlights the importance of the human right 'to freely participate in the cultural life of the community [and] enjoy the arts' as enshrined in the Universal Declaration of Human Rights.[77] But there is the need also to go one step further as in the Bill of Rights of the Constitution of South Africa, which upholds the right of 'freedom of artistic creativity'.[78] According to the White Paper on 'Arts, Culture and Heritage' adopted by the South African government in June 1996,[79] this provides the basis for the vital role played by 'the arts, culture and heritage . . . in development, nation building and sustaining our emerging democracy'. Human beings, we are told, 'are holistic beings'. As such they 'not only need improved material conditions in order that they have a better quality of life. Individuals have psychological, emotional, spiritual, and intellectual expression, all of which require nurture and development for them to realise their full potential, and act as responsible and creative citizens'.[80] It follows that a failure 'to invest in the arts, culture and heritage would constitute grave short-sightedness on the part of government and a failure to recognise the healing and recreational potential of arts and culture in a period of national regeneration and restoration'.[81] In telling the story of the early development of black art in South Africa, Elza Miles speaks of art as an 'intervention' which introduces a deeper discourse into the

[75] Esmé Berman, *Painting in South Africa* (Cape Town: Southern, 1993), 252ff.

[76] Peggy Delport, 'Signposts for Retrieval: A Visual Framework for Enabling Memory of Place and Time', in *Place and Embodiment: Proceedings of XIII International Congress of Aesthetics, 1995,* ed. Pauli Tapani Karjalainen and Pauline von Bonsdorff (1997), 134.

[77] Article 27. Quoted in *The South African Handbook on Arts and Culture*, ed. Mike van Graan and Nicky du Plessis (Rondebosch, Cape Town: Article 27 Arts and Culture Consultants, 1998), 6.

[78] Bill of Rights, para. 16.

[79] Published in *The South African Handbook on Arts and Culture*, pp. 3ff.

[80] *Ibid.*, p. 5. [81] *Ibid.*, p. 5.

public square, resisting structures of power which dehumanise. Such
art intervention may 'provoke outrage, as in the case of the art of
AIDS activism', yet it is essential for the well being of democratic
society.[82]

One matter of considerable importance with regard to the role of
arts in society is clearly structural. Unless public policy and other
initiatives are taken to enable disadvantaged communities to develop
their creative skills, the potential of art as a medium of trans-
formation is undermined. There are two major reasons for this in
South Africa. The first derives from the fact that the legacy of
apartheid is still very much part of the social fabric. So the issues
facing art in South Africa and many other countries today are not
simply matters of aesthetic choice but of access to educational,
economic and social resources. Some church groups played an
important role in seeking to counter this during the apartheid era.
The internationally renowned Rorkes' Drift art centre established by
the Lutheran Church in KwaZulu-Natal and community art centres
in Soweto, on the Cape Flats and elsewhere are but some examples.
But there is an urgent need for the churches and the ecumenical
community to build on this heritage.

The second reason, which gives substance to the first, has to do
with the importance of releasing the spirit of creativity within all
sectors of society, just as it is important, following Bonhoeffer, to
encourage 'aesthetic existence' in the life of the church. Reflecting
on the outburst of innovative creativity in the history of the city, Hall
observes that it is often people who are 'outsiders' to the social
mainstream who lead the way.[83] In South Africa many of the most
creative artists have not chosen to be 'outsiders' for the sake of it; it
was thrust upon them by virtue of race, gender or class. Some, but
by no means all, have now been able to move inside. But 'outsider
art' is a genre that includes many other marginalised people who are
normally excluded from making their contribution to cultural
transformation and social change, or who consciously exclude
themselves.[84] How this happens, and whether or not the artist is
necessarily conscious of serving such goals in seeking to be a 'good

[82] Elza Miles, *Land and Lives: A Story of Early Black Artists* (Cape Town: Human & Rousseau,
 1997), 207. Cf. Atkinson, Introduction to *Grey Areas*, pp. 24ff.
[83] Hall, *Cities in Civilization*, p. 22.
[84] *Outsider Art: Contesting Boundaries in Contemporary Culture*, ed. Vera L. Zolberg and Joni Maya
 Cherbo (Cambridge: Cambridge University Press, 1997).

artist', is admittedly a complex and ambiguous matter. But it is certainly the case that an artist's particularity, while limiting in some respects, provides a potentially less restrictive and more transformative sphere of imagination than that which is regarded as mainstream. This is one reason why some of the most creative artists are those who are anti-establishment, choosing to be on the 'outside' because of the stifling character of society. Public outcries against their work, censorship by officialdom and even death threats often result. This highlights the social significance of such art compared to the sterility of that which is religiously or politically correct.

Too often in the past, churches and other religious communities, along with their respective theologians, have initiated, aided and abetted such denunciation, without any genuine attempt to understand. This brings to mind our earlier discussion on iconoclasm and the power of images. There are, of course, boundaries to what is appropriate art in the public square. Works that may, for example, encourage sectarian violence, racism or sexual abuse are clearly inappropriate. However, the church should be careful not to act as a self-righteous but ill-informed moral guardian of the aesthetic and of artistic creativity. It should recognise that many so-called anti-social works of art are a form of protest against the ills, the meaninglessness, and the blind hypocrisies of society, rather than support for them. There is far more danger to society in the seductive art of certain kinds of advertising which promote questionable values than there is in the work of those artists who employ the tactics of shock to awaken social conscience.

The issues at stake here are complex, touching as they do on the relationship between artistic merit, human freedom, and the public good, as well as on the relation between art, culture and context. But churches and theologians should at least seek to understand the public role of the arts and discern what artists are really seeking to do before expressing an opinion or making a judgement. This is not to say that they should refrain from critical engagement and remain indifferent or aloof. Rather, there is an urgent need for the sake of democratic transformation that civil society exercise judgement on what is in good or bad taste in the public square. Nonetheless, the intense debates in the past century about the way in which fascist and communist ideologies sought to manipulate art should make us wary of control by those in positions of power, whether ecclesiastical or political. We recall, too, the way in which the apartheid regime

controlled public resources for the development of 'the arts', and tried, unsuccessfully, to repress those on the outside of dominant society. By contrast, the White Paper to which we have referred explicitly states that government 'will not pass judgement on artistic expression'.[85]

Artistic autonomy is essential if the arts are to fulfil their proper social function. Activist art under one political dispensation can too easily become the 'politically correct' art of the next, thereby undermining its aesthetic value and contribution to the common good. For this reason, Donald Kuspit, one of the sharpest British critics of 'moralistic art', argues that 'activist art is inherently anti-art, for the task of art is to find new ways of articulating desire, freeing it of all ideological – that is, didactic – predetermination'. Indeed, he argues, 'art is at its best when it is decadent', by which he means when it undermines 'consciously held meaning'. Such 'aesthetic decadence', he continues, 'is a revolt against the superego ideals and tasks the world wants to burden art with, whether they be philosophical, moral, decorative, economic – all of which cross-fertilize'.[86] Art should be allowed to be art. To that extent Kant's insistence on 'disinterestedness' and the protest of nineteenth-century 'aestheticism' remain valid.

None of this means, however, that art is ideologically neutral. As Marxist aesthetic theory rightly argues, art is vulnerable to false consciousness and the maintenance of bourgeois cultural values and privilege. In so far as Christianity has been captive to such values, this has been reflected in both its art production and in its appreciation of art. We recall Forsyth's claim that pre-Raphaelite Romantic art was the most Christian of all visual art. Even Bonhoeffer's appreciation of art and his understanding of 'aesthetic existence' are susceptible to this tendency. What ultimately prevented their succumbing was Forsyth's critique of art and culture from the perspective of God's 'holy love' and Bonhoeffer's sensitivity to other cultures, his commitment to social justice, and underneath it all, the *cantus firmus* of his Christology. The attempt to separate art from life as happened during the 'aesthetic movement' of the nineteenth century is, then, based on a dangerous illusion. Art is always embedded in culture, even when it is counter-cultural in its

[85] *The South African Handbook on Arts and Culture*, p. 8.
[86] Donald Kuspit, *Signs of Psyche in Modern and Post-Modern Art* (Cambridge: Cambridge University Press, 1993), 146f.

aim. It does not exist in an autonomous sphere separate from the rest of life without any public accountability. That is precisely why it can and does have social significance. But art, we must go on to say, is more than a social fact.

Accepting in part the validity of the Marxist position, neo-Marxist aesthetic theorists such as Adorno and Herbert Marcuse have been more nuanced, refusing to reduce art to material causes. Art is not simply the production of a social class, but of individual intelligence, passion, imagination and conscience. Even 'elitist art', Peter Fuller, a Marxist art critic, argues, is not merely the product of social forces and the servant of ideology.[87] The power of art does not lie primarily in any overt political content or didactic intention, but precisely in its aesthetic form and creative character. Art, argues Adorno, exercises its critical power by being art, by simply being there.[88] Yet this is not apolitical, for the necessity of art's autonomy derives from and is dependent on its ability to stand in opposition to society. 'Art', Adorno insists, 'will live on only as long as it has the power to resist society'.[89] With this in mind, Deborah Haynes speaks of the need for an *ethical aesthetics* which is not ideologically hardened but 'flexible and helpful, combining care with judgment'.[90]

What, then, to return to our discussion in earlier chapters, is the role of beauty in the transformation of the individual and society? Even if beauty alone does not liberate, Marcuse claims, art cannot fulfil its transformative function if the expression of beauty is excluded as a goal. 'Striving for beauty is simply an essential part of human sensibility'.[91] The beautiful is representative of the pleasure principle rebelling against the principles of domination and death. 'The work of art', writes Marcuse, 'speaks the liberating language, invokes the liberating images of the subordination of death and destruction to the will to live.' This, he adds, is 'the emancipatory element in aesthetic affirmation'.[92] So it is that the beautiful serves transformation by supplying images that contradict the inhuman,

[87] Peter Fuller, 'In Defence of Art', in *Beyond the Crisis in Art*, ed. Peter Fuller (London: Writers and Readers Co-operative, 1980), 259.

[88] Theodor W. Adorno, *Aesthetic Theory* (London: Routledge & Kegan Paul, 1984), 321.

[89] *Ibid.*, p. 321.

[90] Haynes, *The Vocation of the Artist*, p. 8. Haynes, a professor of fine arts and Director of Women's Studies at Washington State University, has helpfully explored connections between theology, social responsibility and the visual arts.

[91] From an interview with Marcuse in Richard Kearney, *Dialogues with Contemporary Continental Thinkers: The Phenomenological Heritage* (Manchester: Manchester University Press, 1984), 83.

[92] Herbert Marcuse, *The Aesthetic Dimension* (Boston, Mass.: Beacon Press, 1968), 62.

and thus provide alternative transforming images to those of oppres-
sion.[93] We are, in a profound sense, redeemed by such beauty, for art
does not simply mirror reality but challenges its destructive and
alienating tendencies, making up what is lacking and anticipating
future possibilities.

Art, then, has the potential to change both our personal and
corporate consciousness and perception, challenging perceived
reality and enabling us to remember what was best in the past even
as it evokes fresh images that serve transformation in the present.
This it does through its ability to evoke imagination and wonder,
causing us to pause and reflect and thereby opening up the
possibility of changing our perception and ultimately our lives. In
this way art serves the cause of human liberation in all its several
dimensions even if, from a theological perspective, it cannot deliver
all it may promise.

If what I have said is true, then artists are an essential element
within civil society. This prompts Haynes to propose the recovery of
the medieval notion of art as a vocation that has moral and religious
significance.[94] Her model artist is a combination of Hebrew
prophet, Romantic visionary and avant-garde activist, linking the
ethical and aesthetic in self-reflection and the critical analysis of
culture.[95] The prophetic analogy is particularly apt, for the utter-
ances of the Hebrew prophets were not always self-evidently rele-
vant, but their images and metaphors disrupted and destabilised
dominant portrayals of reality and, in turn, offered alternative
perceptions of reality.[96] Artists, by analogy, are not passive onlookers,
but potentially agents of social transformation by being true to their
vocation as artists, not necessarily as social activists.

Contrary to the view that the prophetic tradition is anti-art,
Haynes suggests how that tradition can be sustained through art. In
particular, Haynes refers to the four moments of biblical prophecy
that should be embodied in the work of her model artist,[97] moments
that correlate well with our understanding of what it means to do

[93] Haynes faults Marcuse for the fact that his notion of 'the Beautiful' is too morally neutral,
as in his affirmation of Leni Riefenstahl's Nazi films as 'compelling and "beautiful"'.
Haynes, *The Vocation of the Artist*, p. 65.

[94] *Ibid.*, p. 18.

[95] *Ibid.*, pp. 166, 182ff., 247.

[96] Walter Brueggemann, *Theology of the Old Testament: Testimony, Dispute, Advocacy* (Minneapolis:
Fortress Press, 1997), 625.

[97] Haynes, *The Vocation of the Artist*, pp. 185f.

theology contextually. The ability to discern and analyse critically what is happening in society in relation to the past; the ability to identify with the plight of society's victims; the ability to unmask hypocrisy; and the ability to evoke hope which results in action. As social critics, then, artists continue the iconoclastic tradition of the prophets, but like the prophets they also express the possibility of healing and redemption and thus envisage new futures. And they do so quite concretely within given situations, which implies that historical circumstance is a key determinant for the social role of art. Genuine prophecy is not the enunciation of universal ideals, but the addressing of specific issues within particular contexts in such a way that those who see and hear are challenged to respond.

One of the best-known paintings which illustrates much of what I have been saying is *The Execution of the Third of May*, which Francisco Goya painted following the Napoleonic conquest of Spain in 1808 (see plate 5). The brutality of the French soldiers led to acts of retaliation, and these in turn were punished by the execution of people, often at random. Goya's imaginative depiction of one such event is celebrated as a great work of art, a masterpiece of composition, of the use of colour, light and shade, a painting of energy communicating its message without compromising its artistic achievement. Yet its genius also lies in the power and passion with which that message is communicated to us today wherever we may live. 'What we have', writes one commentator, 'is the direct confrontation of the passionate desire for freedom challenging the symbols of unfeeling, unreflective power'.[98] It is a painting that expresses a desire for peace and justice that is universal. But it is also a painting that can change attitudes through its depiction of the brutality of war and violence, its inevitable futility and destruction of innocent victims. In other words, the prophetic criticism portrayed in Goya's painting opens up the possibility for envisaging a future without war, and as such challenges us to participate in the struggle for justice and peace. When we encounter such art, what theologian David Tracy refers to as 'classic works', then, in his words,

We find ourselves 'caught up' in its world, we are shocked, surprised, challenged by its startling beauty *and* its recognizable truth, its instinct

[98] James L. Empereur, 'Art and Social Justice', in *Art as Religious Studies*, ed. Doug Adams and Diane Apostolos-Cappadona (New York: Crossroad, 1993), 168.

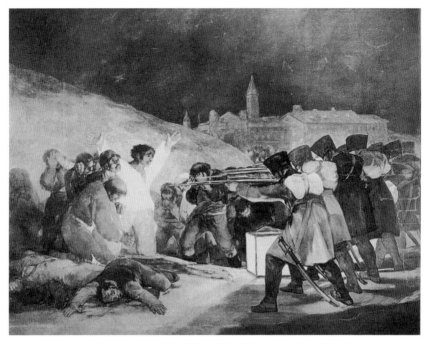

5 *The Execution of the Third of May.* Francisco Goya (1808)

for the essential. In the actual experience of art we do not experience the artist *behind* the work of art. Rather we recognize the truth of the work's disclosure of a world of reality transforming, if only for a moment, ourselves: our lives, our sense of possibilities and actuality, our destiny.[99]

The relationship between art and culture inevitably means that the actual way in which art functions in and serves society will be determined to a significant degree by its specific historical and cultural location. Goya's classic work of art has universal appeal, but that appeal is rooted in the way in which it represents a specific event in Spanish history, and does so in a way which is undeniably shaped by that cultural experience. We turn, then, to consider in more detail the role of art in the struggle for liberation and transformation in South Africa.

[99] David Tracy, *The Analogical Imagination: Christian Theology and the Culture of Pluralism* (London: SCM, 1981), 110.

IMAGING RESISTANCE AND HOPE IN SOUTH AFRICA

The beginnings of the visual arts in southern Africa can be traced back to the remarkable San rock art that predated the colonial era by several centuries, if not longer.[100] San rock art is full of religious symbolism reflecting the spiritual insight and wisdom of its painters, just as the rock art of subsequent African pastoralists reflects their struggle for land against colonial settler incursions. There is no dichotomy here, for spiritual insight and political protest are united in a deep concern for the land, the sustenance of life, and human dignity. This legacy provides the foundation for an art tradition in South Africa that is rooted in the environment, marked by resistance against injustice, and expressive of hope and healing.[101]

The transplanting of European art traditions, beginning with seventeenth-century Dutch settlement, occurred gradually as the settler community enlarged and took root at the Cape. But the development of the settler art tradition to the middle of the twentieth century need not concern us here.[102] What is germane to our discussion is how, during the apartheid years (1948–94), international trends were increasingly expressed in ways that reflected not just the landscape of South Africa but its social and political context. During the early part of this apartheid period European art traditions became contextual through the work of a new generation of 'settler artists', notably Maggie Laubser, Irma Stern,[103] Walter Batiss, Alexis Preller and Cecil Skotnes. At the same time black artists, such as Gerard Sekoto, Michael Zondi and Gladys Mgudlandlu,[104] emerged who were destined to change the face of the visual arts in South Africa as they expressed the reality of life in apartheid's townships and the struggle to affirm identity within a dehumanising political order. There was also interaction of black and white artists as they sought to express their 'Africanness', as in

[100] Gillon, *A Short History of African Art*, pp. 36ff.; J. D. Lewis-Williams, *Discovering Southern African Rock Art* (Cape Town: David Philip, 1990). The Rock Art Research Centre at the University of the Witwatersrand (Johannesburg) has pioneered much of the work on rock-art sites in South Africa.

[101] See Pippa Skotnes, *Heaven's Things: A Story of the /Xam* (Cape Town: University of Cape Town Press, 1999).

[102] For a detailed survey of the history of art in South Africa, see Berman, *Art and Artists of South Africa*, pp. 1ff.

[103] On the work of women artists such as Laubser and Stern, see Marion Arnold, *Women and Art in South Africa* (Cape Town: David Philip, 1996).

[104] The story of early black artists is told in Miles, *Land and Lives*.

the Amadlozi Group formed in 1963, which included painters (Giuseppe Cattaneo and Cecily Sash), a wood-engraver (Cecil Skotnes) and sculptors (Sydney Kumalo and Edoardo Villa).[105] Much could be said about these developments in which international trends interacted in a variety of creative and imaginative ways with the African ethos and the particularities of South Africa's own political conflicts and multi-cultural character. This was linked to the emergence of 'protest art' elsewhere in the world, and to many innovations in style and technique that have since become universal. Yet it remained distinctly South African.

Let us now consider more specifically the art of resistance that emerged during the years which followed the Soweto uprising in 1976.[106] Nadine Gordimer, the celebrated South African novelist, has rightly noted that art was 'at the heart of liberation'.[107] The struggle against apartheid certainly produced an artistic creativity of a remarkable kind and intensity, of which Sue Williamson's *Resistance Art in South Africa* provides the classic documentary text. In her brief Introduction, Williamson traces the beginnings of contemporary resistance art to the Soweto uprising in 1976, and remarks that

Before 1976 a trip around South African art galleries would have given very little clue to the socio-political problems of the country. Strangely divorced from reality, landscapes, experiments in abstraction, figure studies, and vignettes of township life hung on the walls. The work most admired was that which appeared in the international art magazines.[108]

White artists tended to bury their heads in the safety of their cultural enclaves; black artists produced non-confrontational works for white consumption. Yet there were signs of change which predated the Soweto uprising, such as the manifesto sent out by the Organization of South African Artists when it was formed in 1975 to challenge artists to participate in the transformation of the country and realise the cultural potential of Africa.[109] Then, in May 1977, the Commun-

[105] See Berman, *Painting in South Africa*, pp. 241ff.

[106] Although our focus here is on the visual arts, and even then cannot embrace them all (photography, for example), the art of resistance was expressed through the other artistic media as well. See *Culture in Another South Africa*, ed. William Campschreur and Joost Divendal (London: Zed Books, 1989); *Writing South Africa: Literature, Apartheid, and Democracy, 1970–1995*, ed. Derek Attridge and Rosemary Jolly (Cambridge: Cambridge University Press, 1998).

[107] The Introduction to *Culture in Another South Africa*, p. 12.

[108] Sue Williamson, *Resistance Art in South Africa* (Cape Town: David Philip, 1989), 8.

[109] Gavin Younge, *Art of the South African Townships* (London: Thames and Hudson, 1988), 58.

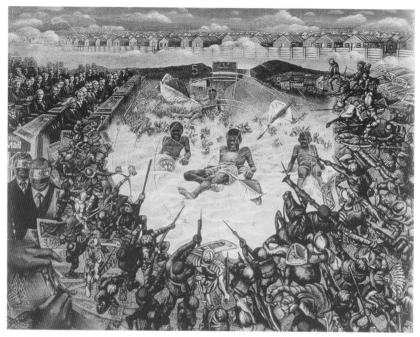

6 *Games*. Manfred Zylla (1985)

ity Arts Project (CAP) was formed in Cape Town as a joint initiative by individuals from ecumenical and church organisations, the universities and other organisations.[110] A further development aimed at the fostering of art in the townships as part of the struggle for political and cultural transformation came with the establishment in 1980 of the Federated Union of Black Artists.

These initiatives, together with two major art conferences, the first in Cape Town in 1979 and the second in Gaborone, Botswana, in 1982, opened up a debate amongst both black and white artists that radically altered the face of South African art during the next decade. Art became an instrument of political resistance, as Manfred Zylla's *Games* so powerfully demonstrates (see plate 6). In a sense this

[110] The Christian Institute, Holy Cross Church in Nyanga, the South African Council for Higher Education (SACHED), the Institute for Race Relations and the University of Cape Town. Younge, *Art of the South African Townships*, p. 58. The fact that both Younge's book and the first of Williamson's volumes have Forewords by Archbishop Desmond Tutu is also indicative of the connection between the development of the art of resistance and Christians engaged in the struggle against apartheid.

was not an entirely new departure but 'a development of the old principle governing traditional African art, which is that art must have a function in the community'. But there was a new twist, namely that this 'function' could bring about political change.[111] Menán du Plessis, a South African author, spoke of this new direction in a speech in 1986:

It is not the morally self-conscious art of liberal protest, nor is it the defiant art of outrage, it is the diverse, complex, extraordinarily rich art of resistance. It is rooted directly in the context of struggle. It seems inconceivable that any of these living forms of art could be isolated from their directly political context and placed up on a stage, behind footlights, or mounted on the walls of a picture gallery.[112]

Building on the foundations laid by others but now energised by the political struggle and the glimmer of hope that was gradually awakening, a new generation of black artists began to set the scene for a veritable explosion of art in all its many and different variations.[113] The distinctions between 'popular art' and 'fine art' crumbled, just as the separation of aesthetics and ethics, art and politics, made no sense whatsoever. An outburst of imaginative and colourful posters, T-shirts, graffiti (alongside township poetry and street-theatre), along with some remarkable photography,[114] to mention but some examples, became the 'works of art' for communities engaged in the final years of the struggle against apartheid. The extent to which this was perceived as a threat to law and order by the apartheid regime can be judged by the fact that it banned the Cape Town Arts Festival on the eve of its opening in December 1986, an event sponsored by the End Conscription Campaign. But this could not stop the contribution made by artists to what now, in retrospect, can be seen as the final phase in the anti-apartheid struggle.

Although he never lived to see the end of apartheid, having been killed in Botswana in 1985 in a cross-border raid by South African soldiers, Thamsanqa Mnyele, a year before his death, spoke of the

[111] Williamson, *Resistance Art in South Africa*, p. 9.
[112] Quoted *ibid.*, p. 9.
[113] For example, Younge, *Art of the South African Townships*.
[114] See the important work of Peter Magubane, and the collection of photographs and essays in *Democracy's Images: Photography and Visual Art After Apartheid*, ed. Jan-Erik Lundström (Umeå, Sweden: BildMuseet, Umeå University, 1999).

vision and hope which was the task and joy of the artists of resistance:

Our people have taken to the streets in the greatest possible expression of hope and anger, of conscious understanding and unflinching commitment. This calls for what all progressive art should be – realist, incisive and honest. We must restore dignity to the visual arts. The writing is on the wall.[115]

The fulfilment of that prophecy came sooner than was generally expected, and with the changing historical circumstances came a change in the production of art.

In the Introduction to her second volume, *Art in South Africa: The Future Present* (1996), Williamson commented that the political changes in the 1990s led to a new level of aesthetic freedom. This was so great that 'the idea of producing a book devoted purely to the socio-political themes underlying the visual arts' seemed absurd.[116] So what has taken its place? Clearly the demise of apartheid has not meant the end of massive social problems that may be traced back to its legacy. It is not surprising, then, that works of art still reflect such issues, nor is it surprising that many others have broken out of the 'struggle mode' in order to embrace the new and hopeful signs of transformation. Referring to the now much over-used but still important notion of *ubuntu*, Williamson notes that it is this spirit of becoming human through others 'which has led many artists into projects aimed at empowering an ever-widening circle of people through creative action'.[117] But like so much of the country's life, art re-entered the world and became part of its 'normalcy' and as subject to market forces as anything else. As various international art Biennials, some held in South Africa itself, have demonstrated, South African art has burst onto the global scene refusing, along with African art more generally, to be consigned to the exotic category of 'the other'. This has not meant that many of the critical theoretical issues concerning aesthetics have been shelved. On the contrary, as Brenda Atkinson puts it, 'the country's reintegration into "international art", culture, and politics, has given fuel to – and perhaps even made possible – greater critical openness around the politics of identity and representation'.[118]

[115] Quoted in Williamson, *Resistance Art in South Africa*, p. 10.
[116] Williamson and Jamal, *Art in South Africa*, p. 7.
[117] *Ibid.*, p. 7.
[118] Atkinson, Introduction to *Grey Areas*, p. 16.

The politics of identity and representation in South Africa has led to the use of several metaphors as a way of understanding its multi-cultural character. The most popular of these, 'the rainbow nation', was employed with great rhetorical skill by Desmond Tutu. The metaphor is evocative and helpful. But it is also problematic because of the way in which it can be abused to sanctify the status quo. Furthermore, a rainbow may dazzle us for a lingering moment, but it cannot by itself deliver what it promises. Artists amongst others have both used the rainbow metaphor and been sceptical of its power to heal the nation's historic divisions.[119] A preferred symbol that signifies not so much the presence of many cultural shades but the more dynamic and less transitory process of cultural trans-formation is the Garieb.[120] The Garieb is the Khoi[121] name for the Orange River, which runs through the heartland of South Africa from the mountains of Lesotho to the Atlantic coast. Journeying westward, the Garieb waters a sun-drenched land, gathering strength from its many tributaries. Each tributary has its own source, which affects the character and quality of its water. As each flows towards the mainstream, it contributes to life along its banks. But it is in the blending, that even the smallest tributary makes its contribution to the enrichment of the whole. Streams that do not flow into the Garieb run into the sand. Yet even this metaphor, if pushed, is inadequate because in the blending differences are swallowed up and, in becoming absorbed in the mainstream, they are in danger of losing their creative potential. Perhaps the metaphor of an opera might be more appropriate, for in opera voices and instruments blend and enrich each other without losing their distinct quality and character. Indeed, during the past few years opera production in South Africa has increasingly become Africanised without denying its European origins as an art form.[122]

The search for appropriate metaphors to describe the creative possibilities of multi-cultural diversity in the building of one nation

[119] *Ibid.* p. 14; Brian Keith Axel, 'Disembodiment and the Total Body: A Response to Enwezor on Contemporary South African Representation', *Third Text* 44 (Autumn 1998): 10.

[120] First proposed by Neville Alexander, anti-apartheid activist and intellectual, and Director of the Project for the Study of Alternative Education in South Africa at the University of Cape Town.

[121] The Khoi were the indigenous people of the region.

[122] Most notably, *Enoch: Prophet of God*, first performed in Cape Town in 1995. It tells the story of the Bulhoek Massacre in 1923 in the Eastern Cape of the followers of the African prophet Enoch Njima.

reflects the fact that culture, and art as intrinsic to it, remains a site of struggle in South Africa though the terrain has shifted. Apartheid ideology insisted that because cultures differed they were to be separated and kept pure from contamination. This thinly disguised ploy to entrench white power led to the abuse of culture, making differentiation a source of conflict and forcing its opponents to deny its importance. Now in the post-apartheid period we have begun to retrieve culture as a vital and positive ingredient in human and social well being, and to revel in difference as a source of enrichment.[123] We have also come to recognise that we are all, to varying degrees, cultural hybrids. 'Cultural experience or indeed every cultural form', as Edward Said reminds us, 'is radically, quintessentially hybrid, and if it has been the practice in the West since Immanuel Kant to isolate cultural and aesthetic realms from the worldly domain, it is now time to rejoin them'.[124] Being a cultural hybrid means rejoicing in the manifold riches of all cultures at their best. Challenging the hegemony of European culture does not mean its rejection out of hand, for European culture, to quote Said again, is 'no less complex, rich, or interesting for having supported most aspects of the imperial experience'.[125]

The debate about 'representation' became a particularly intense one within South African art circles during the early years of transition to democracy. This was not confined to artists or art critics, as the question regarding 'who represents whom' has long been at the heart of South African politics and society, as well as the churches. The rise of the black consciousness movement in the late 1960s under the leadership of Steve Biko signalled a clear rejection of the historic tendency of white liberals to speak on behalf of blacks and was the main ideological force that sparked off the Soweto uprising. But the issues go back to the nineteenth century, when Africans, having failed to defeat the colonial adventure on the battlefield, opposed white hegemony within the mission churches and initiated the Ethiopian movement. So the eruption of the debate within art circles is rooted deeply in the historical development of South Africa and it goes to the heart of our enquiry. In what way is

[123] See especially the White Paper on Arts, Culture and Heritage (June 1996) adopted by the South African Cabinet as government policy, *The South African Handbook on Arts and Culture*, pp. 1ff.
[124] Edward W. Said, *Culture and Imperialism* (New York: Alfred A. Knopf, 1994), 58.
[125] *Ibid.*, p. 163.

art connected to morality, aesthetics to ethics, and memory and representation to 'truth'?

Although the debate was simmering for some time, it reached boiling point following the critique levelled against white women artists in South Africa by the Nigerian art critic Okwui Enwezor in 1997.[126] Enwezor's argument has to do with the legitimacy of the use of the black 'other' as subject in the work of white artists, even those whose credentials appear politically progressive and whose intentions may be worthy. Their work, he claims, perpetuates the racist oppression of the past. Underlying this is the awareness that the present struggle for identity in South Africa – the 'rainbow nation' – has to do with the control of the images and symbols within the body politic and that white artists are in a privileged position in this regard. Such a charge is difficult to shake off given the role of whites in South Africa's past, and yet it is not one that can go unchallenged. For how can artists engage in their task without in some way relating to and representing reality as they experience and perceive it? Colin Richards states the case clearly: 'To exclude art . . . from the process of working through exactly these questions seems simultaneously to deny and affirm the power of art . . . In the first (as denial) art seems not to be up to the historical moment and requires purging. In the second (as affirmation) art is dangerous and needs containment'.[127] The fact is, no artist can avoid 'speaking for', and therefore is inevitably caught up in a web of paradoxes. Pippa Skotnes' remarkable art installation *Miscast*, which portrayed the destruction of the Khoi-San over the past three centuries, is one example of the issues that have been debated. *Miscast* represented one of the most shameful stories of genocide in human history, a narrative often forgotten because of the dominant focus on apartheid. Yet the Khoi-San were the victims of both Europeans and Africans, and the recalling and re-presenting of their story is part of the necessary dealing with the past that is required in negotiating a more just South Africa.[128]

The representation debate has opened up important issues that

[126] Okwui Enwezor, 'Reforming the Black Subject: Ideology and Fantasy in Contemporary South African Art', *Contemporary Art from South Africa*, Catalogue for an Art Exhibition (Oslo: Riksutstillinger, 1997).

[127] Colin Richards, 'Bobbit's Feast: Violence and Representation in South African Art', in *Grey Areas: Representation, Identity and Politics in Contemporary South Africa*, ed. Brenda Atkinson and Candice Breitz (Johannesburg: Chalkham Hill Press, 1999), 173.

[128] *Miscast: Negotiating the Presence of the Bushmen*, ed. P. Skotnes (Cape Town: University of Cape

relate to our overall concern.[129] Enwezor later reformulated his argument in the light of the controversy he had generated, but also in relation to the work of the Truth and Reconciliation Commission, then drawing to a close. The issue at stake was how 'to truly represent history without spectacularizing it'.[130] Or, to put it differently, who controls the national archive and, to go one step further, does recourse to the archive actually help us to remember correctly? Consider, by way of example, the erection of monuments and memorials in the public square. How often, as we noted previously in discussing colonial architecture, have the skills of the sculptor been abused to produce public works that instead of healing the past perpetuate its wrongs. Memorials become monuments to prejudice and hatred; as such they do not simply remember the suffering of the past and honour its victims, but they become means to honour ourselves and legitimate our own chauvinistic, nationalistic and ethnocentric goals. South Africa has far too many such monuments. If we are to erect memorials, they must be memorials that redeem the past not monuments that continue to glorify a triumphant nation or keep alive ethnic hatred.[131]

The question concerning who controls the interpretation of the past lies at the heart of the debate about representation. But the substantive issue is not simply the control of memory but how remembering helps redeem the past and images the future. It is about whether or not remembering brings healing or destruction, despair or hope, or simply leads to amnesia through the aesthetic trivialising of history. Does memory, in other words, enable transformation? Hence the importance of Enwezor's later and more reflective comment:

Town Press, 1996). See also Skotnes' reflections on the debate in her unpublished essay 'The Politics of Bushman Representation'.

[129] See the critical responses to Enwezor in Axel, 'Disembodiment and the Total Body', pp. 3–16 and various essays in Atkinson, *Grey Areas*.

[130] Okwui Enwezor, 'Remembrance of Things Past: Memory and the Archive', in *Democracy's Images: Photography and Visual Art After Apartheid*, ed. Jan-Erik Lundström (Umeå, Sweden: BildMuseet, Umeå University, 1999), 24.

[131] For the distinction between 'memorials' and 'monuments', see Johan Snyman, 'Suffering in High and Low Relief: War Memorials and the Moral Imperative', in *Pledges of Jubilee: Essays on the Arts and Culture, in Honor of Calvin G. Seerveld*, ed. Lambert Zuidervaart and Henry Luttikhuizen (Grand Rapids: Eerdmans, 1995), 179–209. Snyman compares the 'Women's Memorial' in Bloemfontein, South Africa, which remembers the suffering of Boer women in the South African War and has been used in the interests of Afrikaner nationalism, with the Vietnam Veterans' Memorial in Washington, D.C., and the Dachau Memorial to the Holocaust in Germany.

What I am proposing here is not just merely a revisionary, politically correct 'History of Looking' but an ethics of usage, a sensitivity to and respect for those images that have deeply coded meanings . . . There is a curious intersection of art and morality here, whether as a critical project of representation or of disingenuous sentimental abuse. This is a minefield. Nonetheless to dismiss the emotional trauma that has been the legacy of the interaction between art and politics in South Africa is to neglect the responsibility of art as being not just an interpretation or facsimile of history, but a moral force in the production of a new reality and hope for a damaged society.[132]

Hope is about the production of a new reality for a damaged society. This is a far cry from an easy optimism about the future, but it is also a refusal to succumb to despair. Hope alone provides the vision and dynamic for a transforming social praxis. During the struggle against apartheid, keeping hope alive was of the essence. To lose hope was to surrender the power to bring about change. The same remains true for the process of social healing and transformation in the post-apartheid era. But keeping hope alive is universally one of the most urgent demands of our time, as is the need to offer alternative ways of conceiving reality and how we envisage the future.

Anyone familiar with theological developments in the twentieth century will immediately recognise that there is a convergence at this point between artistic imagination and Christian faith.[133] Readers may also recall our discussion of the drama of divine redemption in chapter 3. In seeking to respond to this profoundly human need to keep hope alive in a transforming way, theologian and artist need to engage each other in critical yet supportive conversation. Of course, not all artists are hopeful: many despair of the human condition, as have and do some of the greatest theologians. But even when it reflects despair, art expresses the human urge to creativity, and as such it is indicative of the hope that continually seeks to break through into human consciousness. Artistic creativity can never be satisfied by Nietzsche's nihilism even when it despairs of the world, for it is of the essence of creativity that it continually imagines new futures as it seeks to transcend the cul-de-sacs of the past. Hope enables us to transgress the boundaries of what is presently deemed realistic and possible. That is the promise of the Christian gospel.

[132] Enwezor, 'Remembrance of Things Past', p. 27.
[133] For a useful overview, see Richard Bauckham and Trevor Hart, *Hope Against Hope: Christian Eschatology at the Turn of the Millennium* (Grand Rapids: Eerdmans, 1999).

CHAPTER 6

Art in the life of the church

We now bring together key themes of our study – the power of sacred images, good and holy taste, the alien beauty of the cross, aesthetic existence, culture and transformation – in focusing on the place of art in the life of the church. Art in the life of the church serves a variety of functions. But chiefly it is an aid to worship and a means of theological and spiritual formation.[1] In that way art enables the church to fulfil its ministry in society. As before, our focus is on the visual arts and architecture, but much would apply to other art forms such as liturgical drama and dance. Music is obviously of considerable importance in the life of the church, but it is a subject that requires special treatment far beyond the scope of what I have attempted. Throughout, we need to keep firmly in mind that the church is not a building but a believing, worshipping and witnessing community of people. It is this community, both corporately and individually, which represents the church in the world. Nonetheless, church buildings also visibly represent what the church stands for, physically and symbolically linking sanctuary and the public square. Appropriately, then, our point of departure for this concluding phase of our journey of exploration is church architecture, paralleling the first part of the previous chapter.

CONNECTING SANCTUARY AND PUBLIC SQUARE

Crossroads is one of the several large black townships on the edge of Cape Town. According to apartheid legislation it was never meant

[1] An excellent example of the way in which visual art can be used in Christian formation is the three-volume 'Arts and Lectionary Resource' of the United Church of Christ in the United States. This demonstrates not only the revival of the visual arts in certain sections of the Reformed family of churches, but also how the visual arts can enable people to read the Bible with new eyes. *Imaging the Word: An Arts and Lectionary Resource* (3 vols., Cleveland, Ohio: United Church Press, 1994).

to be there. Established in the early 1980s by migrant workers from the hostels who had brought their families to Cape Town, and many others from the rural homelands who came in search of work, it emerged in defiance of government policy. Soon it became the scene of violent confrontation between residents and the security forces. The shanties of wood, cardboard and iron were regularly bulldozed by officialdom in an effort to enforce the law, evoking resistance not only from those who lived there but also from those who came from elsewhere in the city to express solidarity. Many of the latter were church members and representatives of ecumenical agencies. The Truth and Reconciliation Commission would later confirm what many already knew at the time: Crossroads was the scene of some of the most vicious acts of state terror during the final years of apartheid. During one of the worst periods of repression in Crossroads, ministers of churches in other parts of the Peninsula were asked to lead services of prayer for peace and justice in one of the 'shanty churches' erected there by the adherents of African Initiated Churches. Not many responded to this call, but I found it a deeply moving experience. As the worshippers began to pray in the ill-lit, cold, damp, make-shift sanctuary, a young girl dressed in white entered, carrying a lit candle entwined by barbed wire which she placed on the altar. Symbolic of light amidst darkness and hope amidst despair, this simple act transformed the shanty into a sacred place. The building had little aesthetic merit to attract the attention of those who passed by. But it was a sanctuary of 'holy beauty' for those had who entered to pray and who returned home to face the bulldozers.

One of the most remarkable Christian sanctuaries is the Coptic Church of St Samaan the Shoemaker. Situated in an immense grotto at the bottom of the Mokattam Hill overlooking Cairo, it serves the city's informal garbage collectors. Their extensive settlement of twenty-seven thousand inhabitants, characterised as much by mounds of refuse, ubiquitous pigsties and an all-pervasive stench as it is by its overcrowded dwellings, cafes, and narrow roads, surrounds the church complex. In terms of size, design and furnishings which express the richness of Coptic tradition, there is no comparison between the Church of St Samaan and the 'shanty churches' of Crossroads and many other places in the informal settlements of the world's poor and marginalised. Yet both relate to their contexts and express their particular ethos in appropriate and remarkable ways.

They also remind us that many Christians today do not worship in what are traditionally regarded as 'churches', but in the open air under trees or beside rivers, in multi-functional halls, store fronts, in houses, or in sanctuaries such as we have described. This recalls the earliest days of the Christian movement when the liturgy was celebrated in homes, catacombs and grottoes long before the Constantinian settlement legalised the erection of church buildings. Whereas previously the intention was often to avoid attention, church buildings were now designed to make a statement to the world about the triumph of Christianity.

The long tradition of church architecture that has resulted reflects the styles of an ever-expanding, diversifying and dominant Christendom in a variety of contexts. Numbered amongst them are some of the greatest achievements of architecture. Yet, in contrast to the sanctuaries of the marginalised, they reflect as much the power of prelates and princes and the wealth of bourgeois Christianity as they do the faith of the people of God. Many of them in the 'third world' also reflect the legacy of colonial conquest, imitating the styles of the distant metropolis. This is certainly the case in South Africa, where, with the possible exception of some Dutch Reformed church buildings, church architecture, whether constructed of stone, corrugated iron or reinforced concrete, embodies styles imported at various stages from Europe. The buildings range from those built in a Greek classical style, through those reflecting the neo-Gothic revival, to churches influenced by modernism.[2]

Many church buildings and cathedrals house art treasures that reflect the long connection between Christianity and their cultural contexts. Despite their link with imperial or colonial power, few if any people would wish their decay or demolition, or even renovation that would distort the past. The critical question is how best to use their often considerable resources. Cathedrals and basilicas provide the most obvious examples of church buildings that have become centres for the flourishing of the arts in the life of the church in the twentieth century.[3] During the struggle against apartheid, St Geor-

[2] A brief but useful overview is Dennis Radford, 'South African Christian Architecture', in *Christianity in South Africa: A Political, Social and Cultural History*, ed. Richard Elphick and Rodney Davenport (Cape Town: David Philip, 1997), 327. See also John Oxley, *Places of Worship in South Africa* (Cape Town: Southern, 1992).

[3] See the account of the rebirth of religious architecture and art in British cathedrals in the twentieth century in Horton Davies, *The Ecumenical Century, 1900–1965*, Worship and

ge's Anglican Cathedral in Cape Town, well known for the beauty of its liturgy, its music and its openness to the creative arts, provided sanctuary for many political activists. In linking the sanctuary and the often turbulent public square outside its walls, it followed a noble tradition that stretches back to the Middle Ages.

Most Christians do not worship in cathedrals or in buildings that are particularly aesthetically attractive. This is especially true for those belonging to dissenting, non-conformist or free churches which were, in their early years, persecuted and prevented from erecting places of worship. When they could, severe strictures were placed upon them, and economic constraints ensured that the buildings they erected would usually be modest affairs, though by no means always unattractive.[4] While the contrast remains, as Nonconformist and free churches became more established and affluent, so their church buildings changed, though not always for the better. Even so, the best examples generally embody a different theological and liturgical ethos from that of established churches, and appropriately so. Unfortunately, as Horton Davies puts it, too many still reflect 'the continuing Puritan suspicion of aesthetics as a substitute for ethics'.[5] A reasonable fear, but one which prevents genuine creativity, and the ethical concern is too often surrendered when wealth and culture permit.

The sanctuary is undoubtedly the focal point for the life of the church, and while other adjacent church buildings are usually only functional in design, the architecture of the sanctuary should, as Dillenberger puts it, 'combine function with a spatial reality that transcends function'.[6] Or, to put it the other way round, a primary function of the sanctuary is to provide space that enables the worshipping community to experience a sense of the transcendent. An obvious illustration of this is the fact that even in multi-purpose church buildings, which are the norm in many places today, the sanctuary area is often demarcated in ways that signify its special

Theology in England, 5 (Princeton: Princeton University Press, 1965), 50ff. In chapter 4 we noted the role of Bishop Bell of Chichester in this regard and his influence on Bonhoeffer.

[4] On the architecture of free churches in England in the twentieth century see Davies, *The Ecumenical Century, 1900–1965*, p. 69ff; Christopher Stell, 'Puritan and Nonconformist Meetinghouses in England', in *Seeing Beyond the Word: Visual Arts and the Calvinist Tradition*, ed. Paul Corby Finney (Grand Rapids: Eerdmans, 1999), 49ff.

[5] Davies, *The Ecumenical Century, 1900–1965*, p. 74.

[6] John Dillenberger, *A Theology of Artistic Sensibilities: The Visual Arts and the Church* (London: SCM, 1986), 212.

purpose. This elicits the comment that art may play a more important role in the life of congregations that meet for worship in multi-purpose buildings than in those specifically designed for worship. If people who live in ugly environments and in dull council flats or the unpainted matchbox houses of the township have to worship in a building which is equally ugly and dull, then the church is failing to meet a basic need as important as daily bread. This is surely a challenge to the church as it seeks to minister to those crowded into the drab ghettos and townships of many modern cities.

There is, however, an important addendum. No congregation should have to worship in a sanctuary that is unredeemed by beauty. Even a multi-purpose hall can be better designed than many are, and in any case such buildings can often be transformed for worship without great expense just as the 'shanty church' in Crossroads was transformed by a lit candle. Sometimes that is all that may be required. This is why art in the sanctuary is not just a subject for those interested in cathedrals, but perhaps should be more so for those who have to worship in places which lack any aesthetic merit. What is required is, in fact, the awakening of an aesthetic sensibility within congregations that is able to generate creativity and the imaginative use of available space. This includes the stimulation and production of appropriate art that can help transform a hall or school room into a sanctuary. The more this arises from within the life of the community where the church is located, the more authentic and appropriate it will be.

The design of church buildings may not be based, as was the temple in Jerusalem, on a divine plan, but church architecture, however humble or grand, is of critical importance in terms both of enabling worship and relating the sanctuary to the public square.[7] So the question of what is fitting and appropriate, whether liturgically, theologically, ethically or contextually speaking, is as important when it comes to the construction of the sanctuary as it is with regard to art that may be placed within it. After all, the church buildings in which Christians gather for worship are the most visible artistic symbols of their faith and its significance for the world. We may insist that the church is the community of people who believe, pray, worship, witness, yet the church building is synonymous in the

[7] See journals such as *Faith and Form: Journal of the Interfaith Forum on Religion, Art and Architecture* (Washington, DC)

popular mind with 'the church', and as such it is a symbolic representation of what the church is and believes. In this sense the church building is an icon in the world.[8] Just as architecture reflects, reinforces or helps create the values of society, so church architecture gives visibility to the values upheld by the church. Unfortunately, it too often reflects questionable values and bad taste. This has little to do with whether a building is a shanty building or a cathedral; it has to do with what is fitting and appropriate. As Peter Hammond put it in his pioneering work *Liturgy and Architecture* published in 1960, many 'of the most satisfactory churches which men have ever made are the humble, anonymous structures' which simply provide a place where the people of God can meet for eucharistic worship.[9]

Hammond's approach to church architecture is functional and has been criticised for being so. There are, after all, many dimensions that need to be taken into account. Yet Hammond's understanding of function is by no means narrow. Church buildings, he insists, should be symbolic of Christian faith, fit appropriately into their context, and contribute to the formation and nurturing of the congregation for witness. This holistic approach to church architecture is important. But the heart of the matter is providing an appropriate space for worship that involves the whole church community. Sanctuaries are meant for the celebration of the liturgy, so this should determine the way in which it is constructed. This applies to the internal decoration of the sanctuary as much as it does to its design. 'The cardinal principle to be observed in the decoration of the house of God', Hammond writes, 'is that *all* decoration should be related to liturgical function; it must never become an end in itself.'[10] Church architecture, then, needs to express a theological understanding of what the church is and what it does when gathered for worship.

Of course, there are varieties of ecclesiologies and different models of what the church is or is meant to be, and these have been reflected in the development of church architecture through the centuries.[11] But there is a broad ecumenical consensus today that

[8] Steven J. Schloeder, *Architecture in Communion: Implementing the Second Vatican Council through Liturgy and Architecture* (San Francisco: Ignatius Press, 1998), 168, 238.

[9] Peter Hammond, *Liturgy and Architecture* (London: Barrie and Rockcliff, 1960), 28.

[10] *Ibid.*, pp. 38f.

[11] For a brief historical overview and useful bibliography see Peter G. Cobb, 'The Architectural Setting of the Liturgy', in *The Study of the Liturgy*, ed. Geoffrey Wainwright, Cheslyn Jones and Edward Yarnold (London: SPCK, 1978), 473ff.

the congregation is not a conglomeration of individual spectators, but active participants in prayer, in listening to the Word read and proclaimed within the context of the celebration of the eucharist.[12] Hence the need for the congregation to be gathered around the pulpit and the holy table or altar, something generally recovered in the West at the time of the Reformation. The location and style of the baptismal font is also important. Unfortunately this has by no means always been given its due prominence in some Protestant church architecture, perhaps reflecting a lack of theological conviction and liturgical understanding of Christian initiation.

Just as there are various ecclesiologies, so there are various understandings of liturgy. In many ways the Reformation was centred as much on the renewal of the liturgy as it was on matters of dogma, for the two were so closely related. Unfortunately Reformed liturgies soon became far too didactic, so emphasising the sermon that they lost a sense of actually celebrating the divine drama of world redemption in sacramental action. The twentieth-century liturgical movement, which originated within Catholic circles, has helped considerably in the recovery of that understanding of worship. In so doing it has helped recover an awareness of the liturgy itself as a work of art, and thereby encouraged liturgical artistic creativity within churches of the Reformed tradition.

The church does not only gather for worship; it is also called to be a witness to the gospel in public life. Liturgy properly understood refers not only to worship in the sanctuary but also to service in the world. The two are integrally connected. Worship and mission comprise the liturgy, and when they are separated, both are impaired. If the liturgy is only what the church does in the sanctuary, then the sanctuary is reduced to a ghetto. On the other hand, if the church's attempt to serve society does not arise out of its worship in the sanctuary, then the church is unable to fulfil its unique task in the world and is reduced to a welfare organisation. We may recall here Bonhoeffer's insistence on the need for prayer and righteous action, the maintenance of the 'discipline of the secret' and political engagement. For this reason church buildings should not only provide appropriate space for the liturgy as worship, but also symbolise what the church believes and stands for in the midst of the

[12] Schloeder's approach in some ways challenges this consensus from the perspective of a more conservative reading of Vatican II emphasising the 'sacrifice of the Mass' rather than congregational participation, Schloeder, *Architecture in Communion*.

world. Only then can we really think seriously about the role and function of art in the sanctuary. Hammond writes:

> Until architects have learned to build churches which, in themselves and apart from any decoration, are symbolic structures, it is beside the point to commission painters and sculptors and stained-glass artists to provide 'works of art' for a new church. We want *churches*, not museums of religious art. The basic need is for *architecture* to recover its symbolic function.[13]

The symbolic function of architecture goes beyond the representation of the church in the world. It also influences the way in which Christians are nurtured in the faith and equipped for their ministry in society. Just as architecture and art communicate to the world what the church is about, so they contribute to Christian theological and spiritual formation. Hence Hammond's further comment:

> Bad churches do not merely corrupt the aesthetic sensibilities of those who use them: they obscure the nature of the *ecclesia* itself and of the gospel which it is called to proclaim and make manifest. They prevent the family of God from realising the full meaning of what it does when it meets for the liturgy.[14]

The design and decoration of the sanctuary should not only enable the congregation to participate fully in the liturgy, but also be consistent with the faith that is believed and proclaimed. 'How can one speak, without intolerable irony, of poverty and humility and truth in churches which are monuments to pride and worldliness and falsehood?'[15] Can we condone the building and adornment of huge, ostentatious and costly cathedrals, or the beautiful yet expensive vestments of clergy, in a world that is racked by poverty? Church architecture should reflect the virtues of poverty, humility and simplicity. This has always been a concern of church reformers irrespective of their particular tradition, and it has been part of the vision of the liturgical movement of the twentieth century. Hammond provides several examples of Roman Catholic churches that were built in post-Second World War France which exhibit these characteristics.

> There is no seeking after effect, no attempt to create a conventionally religious atmosphere by theatrical tricks or historical allusion. Only the honest use of modern building materials, of proportion and space, to create a place of recollection and silence and prayer: a valid symbol of the purity of heart that stands so high in the scale of evangelical virtues.[16]

[13] Hammond, *Liturgy and Architecture*, p. 161.
[14] *Ibid.*, p. 167. [15] *Ibid.*, p. 168. [16] *Ibid.*, p. 158.

Such architectural modesty is not without aesthetic style: quite the contrary. But in order to achieve goals such as these, the church needs architects who are willing to be part of a team of people who reflect together on the nature and purpose of the church before any decisions are taken on the designing of church buildings. Church architects need to work with aesthetic integrity, which means ensuring that their designs not only reflect the purpose for which the church exists, but also interpret the tradition in the light of the particular historical context within which the sanctuary is placed. The building of a neo-Gothic or, rather, a pseudo-Gothic cathedral in Africa today (or at any time) is surely out of place. Church architecture must have an integral relation to its social and cultural environment if the church is not to be regarded as an oddity but a sign of relevant faith, love and hope.

We have alluded at several points to the decoration of church buildings, but now we must turn our attention more specifically to the role and place of visual art within the sanctuary and how this relates to our concern for transformation. As a way of opening up our discussion, I suggest that we reflect on a singularly appropriate biblical passage – the call of the prophet Isaiah, while worshipping amidst the beauty of holiness in the temple in Jerusalem, to proclaim social justice amongst the nations (Isaiah 6:1ff.).

THE BEAUTY OF HOLINESS

Isaiah's call to be a prophet of social justice was an intense 'aesthetic moment' of vision and audition. The awesome glory of Yahweh's holiness was revealed to the startled worshipper with such power that it led directly to his own personal transformation. When he later recounted the happening, Isaiah could only tell of what he had seen and heard in symbols and metaphors which stretch the imagination to breaking point.

MODEL FOR OUR TRANSF.:

In the year that king Uzziah died I saw the Lord seated on a throne, high and exalted, and the skirt of his robe filled the temple. Seraphim were in attendance on him. Each had six wings: with one pair of wings they covered their faces and with another their bodies, and with the third they flew. They were calling to one another:

'Holy, holy, holy is the Lord of Hosts:
the whole earth is full of his glory.'

Isaiah's experience of the wholly otherness of God evoked repen-
tance, *metanoia*, and changed the direction of his life. Ecstatic in
character, his experience of God's glory did not turn him away from
the world but sent him to proclaim God's demand for social justice.
To announce Yahweh's judgement upon those nations that failed to
heed that prophetic word: 'Pursue justice, guide the oppressed;
uphold the rights of the fatherless, and plead the widow's cause'
(1:16b). 'Is it nothing to you', Isaiah enquires of the elders in
Jerusalem, 'that you crush my people and grind the faces of the
poor?' (3:14) But neither the nations surrounding Israel nor the
leaders of Judah were able to see the plight of the poor or hear their
cry. Yahweh's perpetual exasperation is sensed as experienced by the
prophet:

> Go, tell this people:
> However hard you listen, you will never understand.
> However hard you look, you will never perceive.
> This people's wits are dulled;
> they have stopped their ears and shut their eyes,
> so that they may not see with their eyes,
> nor listen with their ears,
> nor understand with their wits,
> and then turn and be healed. (Isaiah 6:9–10)

Isaiah's vision of God's holy beauty enabled him to perceive
reality in a totally new and different way. Yet in pursuing his new
vocation he soon discovered that most of his hearers would neither
see nor hear what God had commanded him to declare. Their eyes
and ears were closed to the awesome beauty of God's holiness just as
they were closed to the cries of the poor and oppressed. These were
not unrelated. Although there is a tension in the Old Testament
between seeing God's glory in the temple and hearing God's
command to do justice in the world,[17] Isaiah knew from his own
experience that true contemplation and social action are comple-
mentary. He also knew that when worship in Israel was reduced to
empty ritual it failed to engender social righteousness, anticipating
the cleansing of the temple when it had lost its character as a place
of prayer for all nations. The temple was sacred space, but it was not
a religious ghetto separated from the realities of the world of politics
and justice.

[17] See Walter Brueggemann, *Theology of the Old Testament: Testimony, Dispute, Advocacy*
(Minneapolis: Fortress Press, 1997), 429.

There is, then, an intrinsic connection between Israel's call to do justice and Israel's call to worship in the 'beauty of holiness'.[18] This phrase is the King James Version's translation of Psalm 96:9. The psalm was sung during the ceremony of enthronement celebrating the New Year in the temple in post-exilic Jerusalem. It invites those who are worshipping to sing a new song to Yahweh and so declare 'his glory among the nations'.[19] It reminds them that Yahweh is 'the Lord most worthy of praise', unlike the idols of the nations, for Yahweh is the creator of all things, and 'might and beauty are in his sanctuary'. Then follows its call to the worshipping throng to enter the temple to bring an offering and worship Yahweh in 'the beauty of holiness'. And finally it speaks of the Lord who reigns as the one who 'judges the people with equity' and declares that when 'he comes to judge the earth' he will do so 'with justice'.

But what precisely does 'the beauty of holiness' mean? The original Hebrew (שדק ההדדת ליהזה השתחוו) is ambiguous and can be variously translated. Following the Septuagint (προσκυνήσατε τῷ κυρίῳ ἐν αὐλῇ ἁγίᾳ αὐτοῦ), the Jerusalem Bible (a Roman Catholic translation) has 'worship Yahweh in his sacred court'. The translation thus refers to the holiness of the temple, to sacred space. The New Revised English Bible prefers to translate the verse so that it refers to the holiness of the attire worn by the worshippers, presumably the vestments of the priests. This would fit in with the Levitical requirement that temple priests should wear garments ritually clean and appropriate for the occasion (Numbers 9:1–14; Leviticus 11:24–8). The phrase could refer, then, to that which has been consecrated (the temple, its furnishings, its vestments) and set apart for the worship of God and therefore made holy by God.

So the encounter between Yahweh and Isaiah, between Yahweh and Israel, which results in the obligation to pursue social righteousness, occurs 'in an environment of beauty, which makes communion possible and reflects Yahweh's own character'.[20] Or, as Brueggemann goes on to say, 'the liturgical experience in the temple has a powerful aesthetic dimension, for the God of Israel is known to be present in an environment of physical, visible loveliness'.[21] But

[18] *Ibid.*, p. 425. See also Samuel Terrien, *The Elusive Presence: Toward a New Biblical Theology* (New York: Harper and Row, 1978).

[19] The translation used here is that of the New Revised English Bible.

[20] Brueggemann, *Theology of the Old Testament*, p. 425.

[21] *Ibid.*, p. 427.

this is not to be confused with 'any easy or artistic coziness' or aestheticism. For the beauty referred to is that of 'holy splendour'. To avoid this and the allied danger of ritualism, more evangelical translators, such as those of the New International Version, have eschewed any possible confusion of holiness with place or vestments by translating the verse as 'the splendour of God's holiness'. This echoes the KJV and is clearly the preferred Protestant reading of the Hebrew text. John Monsell's well-known nineteenth-century paraphrase of the psalm is apposite. The offerings we are to bring are the 'gold of obedience', 'truth in its beauty', 'love in its tenderness' and the 'incense of lowliness'.

The Protestant tradition has usually drawn a distinction between worship in the temple and worship in the Christian sanctuary. This is based on the assumption that church worship derives from the synagogue rather than the temple and is therefore quite different. While the prophetic word and its summation in the Decalogue has been strongly affirmed, instructions regarding the temple cultus have generally been disregarded or at best treated as matters of indifference (*adiaphora*). After all, according to Pauline theology, the temple is the human person or the corporate body in whom the Spirit dwells (I Corinthians 3:16; 6:19). Therefore true worship (λειτουργία) has to do with the 'living sacrifice' of a holy life (Romans 12:1–2) far more than the right performance of a ritual, the design and furnishing of the sanctuary, or the splendour of priestly vestments. Undoubtedly this emphasis is correct. But we must be careful of positing a false dichotomy between temple and church worship, or assuming that the prophetic tradition regarded temple worship as unimportant. What the prophetic tradition opposed was the hypocrisy of worship unrelated to mercy and justice.[22] The New Testament not only speaks of the body as the temple of the Spirit, but also is saturated with the symbolism of the temple in Jerusalem,[23] a symbolism rich in meaning for Christians and often represented in early Christian art. Beauty and holiness in the Hebrew Scriptures are taken together, so that the beauty of a holy life and the beauty of

[22] It is noteworthy that a conservative evangelical author like Francis Schaeffer was very critical of the evangelical tendency to exclude visual art from the life of the church, and based much of his argument on the use of art in the temple. Francis A. Schaeffer, *Art and the Bible* (Downers Grove, Ill.: Inter-Varsity Fellowship, 1973).

[23] Margaret Barker, *On Earth as it is in Heaven: Temple Symbolism in the New Testament* (Edinburgh: T. & T. Clark, 1995).

the holy place are both reflections of the beauty of the holy God. Therefore it is possible for an Isaiah to be overwhelmed and transformed in the sanctuary by the beauty of holiness which is both seen and heard. *+ The Holiness of His Life.*

Prior theological commitments invariably play a role in the various translations of Psalm 96, and there is a sense in which the Hebrew text allows this. Rich enough to encompass all these meanings, it can refer to the holiness of the sanctuary or the vestments, as well as the holiness of Yahweh with its concomitant requirement that the worshippers themselves be holy. Yet neither the sanctuary nor the vestments, neither the art nor the worshippers, have intrinsic holiness. Their holiness is derived from God's, and it is that beauty which also makes them beautiful. A clear inference is that values such as beauty – along with truth and goodness – are problematic from the perspective of biblical faith when divorced from God's revelation as true, good and beautiful. But the Hebrew text is ambiguous on whether the emphasis should be placed on Yahweh's beauty or holiness. Is it Yahweh's beauty that is holy, or is it Yahweh's holiness that is beautiful? We recall here the differences between Balthasar, for whom the beauty of God is ontological, and Barth, for whom the beauty of God is the beauty of God's glory and holiness. We also recall the many areas on which they agreed and on which we can now focus in order to sketch a genuinely theological aesthetic praxis in the life of the church.

The first of these areas of agreement is that our knowledge of God's beauty is derived not from a general definition of the beautiful, but from the revelation of God's glory in creation and redemption. Whether it is God's beauty that is holy or God's holiness that is beautiful, there is something awesome about God's beauty and something splendid about God's holiness as we discern it in creation and in Jesus Christ. This means that any art in the sanctuary should not detract from the beauty of God's revelation, but reflect it in some, albeit small, measure. There may be qualitative difference but not radical disjunction between 'the beauty of holiness' and other forms of beauty. Recall Forsyth's comment that we 'shall not go far in a true sense of the beauty of holiness without gaining a deeper sense of the holiness of beauty'.[24]

[24] P. T. Forsyth, *Religion in Recent Art* (London: Hodder & Stoughton, 1905), 84f.

The second theological insight is that the 'beauty' of the cross does not stand in judgement on beauty but on the ugliness that results from human sin. For that reason it is an 'alien beauty', a beauty that takes upon itself the contradictions of the human condition that repel us. But paradoxically, such beauty is redemptive. It is a power that attracts us to worship and propels us into society; it is a power that transforms us and seeks the just transformation of the world. This leads to a third theological insight, namely the transforming work of the Holy Spirit in and through the life and witness of the church. For if it is true, as both Balthasar and Barth insisted, that genuine artistic creativity is a gift of the Spirit, then creativity, as a gift of the Spirit, should not be quenched in the life of the church any more than other spiritual gifts. Artistic creativity is a response, whether joyful or painful, whether acknowledged as such or unacknowledged, to that given and discerned in creation and redemption. This links creativity to something far more fundamental than the artist's own imagination and skill, and opens up the possibility that art may be a means of grace. But if so, how do we decide what art is appropriate within the sanctuary?

Eastern Orthodoxy answered that question after the long and protracted Iconoclastic Controversy. Visual art was permissible, but only in the form of icons. These were not considered, as we noted previously, primarily as works of art, though many are now recognised as such. Icons were windows into the kingdom of God, a strictly controlled art form designed to enable the worshipper to 'see' God's holiness in the sanctuary. Hence the painting of icons in the Orthodox tradition, whether Greek, Russian or Coptic, still demands certain conventions and disciplines. Only art produced representing certain themes and produced by artists who are immersed in prayer and worship themselves can be considered appropriate. From this perspective, not all art, even 'religious art', is iconic in nature or, to put it differently, not all art has the ability to lead the worshipper beyond the visual to a prayerful encounter with God. This is an attractive position to adopt, but there is an attendant danger that such an exclusive approach to iconography might stifle rather than release artistic creativity in the church. An indication that this need not be so is Robert Lenz's *Madre de los desaparecidos* (*Mothers of the Disappeared*), a Marian icon which reflects the pain of the mothers of Chile whose husbands, sons and fathers disappeared

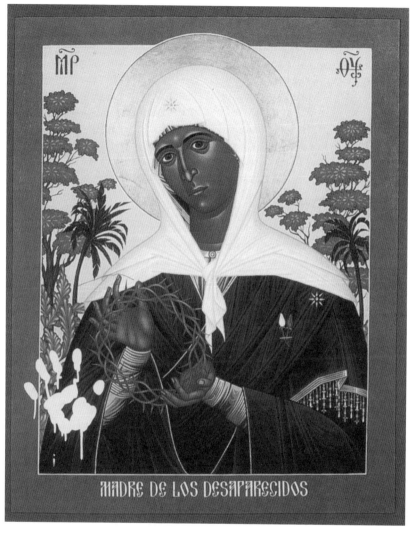

7 *Mothers of the Disappeared.* Robert Lenz

during the Pinochet regime (see plate 7). Nonetheless, Byzantine iconography, whether ancient or contemporary, is not the only form of visual art available for the life of the church. Keeping in mind our discussion on good and sinful taste in chapter 2, we turn to consider other appropriate possibilities.

SACRED, RELIGIOUS OR SPIRITUAL ART?

'Art cannot serve spiritual ends when it has been created in sin.' So read a headline in *The Independent*, the British daily newspaper, on Wednesday 29 April 1998. This succinctly stated the argument of a correspondent, Margaret Kennedy, who felt it necessary to speak out against the famous sculptures by Eric Gill of the 'stations of the cross' in Westminster cathedral in London.[25] Kennedy, a devout Catholic, was not objecting to the sculptures as works of art, but she was offended by their presence in the Cathedral. Gill, a distinguished sculptor in the first half of the twentieth century and a pioneer in liturgical renewal in English Roman Catholicism,[26] had been accused of paedophilia in a recent publication. While some of Gill's work had been erotic, there was, according to those who knew him, nothing perverse in his attitude towards sex.[27] But for Kennedy, who had been sexually abused as a child, the charge provided an opportunity to challenge the church's apparent lack of concern about such matters. Gill's sculptures had sparked off controversy when first placed in the cathedral in 1918 because the church authorities of the time had tried to emasculate one of the images even though Gill himself explicitly worked from within Catholic tradition. But now, years later, it had become the subject of a controversy that reflected the growing public awareness of sexual abuse. It was no longer the case that the hierarchy was offended – quite the reverse, for Kennedy objected to Cardinal Hume's support for the sculptures and his extolling their virtues. She wrote:

My concern is with the juxtaposition of Gill's art (and therefore the man), Westminster Cathedral and prayer. And also with the invisibility of Gill's victims and all Catholic (or Christian) victims by patriarchal churches. It is a pastoral/spiritual concern not an aesthetic one.

Kennedy insisted that it was impossible to separate 'Gill the artist from Gill the paedophile, especially as you gaze on a piece of work and try to pray!'. In support of her complaint she quoted a comment

[25] Carved in Hoptonwood stone between 1914 and 1918 and regarded by many as among Gill's most significant work. In his book *Social Justice and the Stations of the Cross* (London, 1939) Gill interprets each 'step along the Via Dolorosa as a direct warning against the iniquities of the bankers, the warmongers' and industrial society as a whole. Malcolm Yorke, *Eric Gill: Man of Flesh and Spirit* (London: Constable, 1981), 98.

[26] See Davies, *The Ecumenical Century, 1900–1965*, p. 38, n. 34, 51, 57. Davies describes Gill (1882–1940) as one in whom 'William Morris seemed reborn as a catholic', p. 93.

[27] Yorke, *Eric Gill*, pp. 99ff.

from *The Tablet*, a Catholic periodical: 'The question is not whether these carvings are beautiful, but whether they are fit for their purpose.' In sum, Gill's sculptures were unacceptable because the sculptor was morally unfit.

Even though the accusation against Gill appears unfounded, the question it raises requires an answer. To what extent are the credentials of an artist important in evaluating a work of art? Would we, for example, invite architects responsible for Auschwitz to design works for the public square? The answer seems self-evident. But which moral virtues are in question in forming our judgement? Must artists be more morally blameless than the average church member, or is some latitude permitted? The question sounds trite, yet once we evaluate a work of art on the basis of the artist's morality we cannot avoid such queries. However, as Richard Yeomans points out, some artists 'who have led the most degenerate lives . . . have often given us the noblest and profoundest spiritual insights'. Moral strength in art, he continues, 'has little to do with morality and more to do with personal courage, conviction, originality and vision, which are qualities least likely to precipitate those actions which most conform to conventional Christian codes of conduct'.[28] This is a damning judgement of conventional Christianity, for it suggests that such values are not prized within the life of the church, or are at best regarded as second-rate. But what if we turn the matter around and put a premium on these values both for the artist and the church member?

The issues raised by such controversies are neither new nor exhaustive of the full spectrum of possibilities. More common are those that, as in the case of the Iconoclastic Controversy, have to do with idolatry or blasphemy. These invariably spill over from the sanctuary into the public square, especially in countries with a strong religious heritage. Films depicting Jesus are notorious in this regard. The public debate about Martin Scorsese's *Last Temptation of Christ* (1988) and Denys Arcand's *Jesus of Montreal* (1989) are cases in point, indicating that the boundaries between the church and public opinion cannot be drawn too tightly even in a largely secular society. There was, it is worth recalling, a ban in Britain on portraying Jesus in film until after the Second World War. More notorious is the fact

[28] Richard Yeomans, 'Religious Art and Spiritual Art: Spiritual Values and Early Modernist Painting', in *Religion and the Arts in Education*, ed. Dennis Starkings (London: Hodder & Stoughton, 1993), 72.

that during South Africa's apartheid era, censorship of anything which might be regarded as blasphemous was severe, seriously compromising artistic integrity, causing a great deal of injustice, and often resulting in sheer silliness.

One celebrated painting of the crucifixion, entitled *Black Christ*, by the Cape Town artist Ronald Harrison, even had to be smuggled out of the country.[29] Depicting Christ as Chief Albert Lutuli and the Roman soldier piercing his body as Prime Minister Verwoerd, it was painted at the time of the Rivonia Trial in 1962, when Nelson Mandela and others were found guilty of treason. The painting hung for a short while in St Luke's Anglican Church, Salt River. But the Dutch Reformed Church lodged an official complaint and shortly afterwards the Censorship Board declared it unfit for public exhibition because it gave 'offence to the religious convictions and feelings of a section of the population'. This political sensitivity to the power of sacred images proved to be counter-productive. The painting immediately gained international interest and was shown on CBS television in the United States. Harrison was hounded by the security police, but the confiscation of the painting was anticipated, and it was smuggled out of South Africa. It was then used in Britain as a means of raising funds for the anti-apartheid movement and eventually stored in the basement of a London home, where it remained for thirty years, unbeknown to Harrison. The announcement of an exhibition, Art against Apartheid, to be held in Parliament in Cape Town in 1996, prompted Harrison to find and eventually recover the painting. In 1997 it was returned to South Africa, hung for a while in St George's Cathedral, and is now exhibited in the National Gallery. The *Black Christ* may not be a great work of art, but it exemplifies how 'religious art' can challenge political power and be condemned as blasphemous. In those terms, the painting represents the crucifixion in a remarkable way (see plate 8).

In the last chapter we commented briefly on the problem of determining what might be appropriate art in the public square, and on the danger of ill-informed and hasty judgements on the part of churches. The need to avoid such errors of judgement remain when it comes to the church evaluating art in the sanctuary, but the role of the church in this regard is undoubtedly different. This is so because

[29] *Cape Times*, 21 November 1962; *Cape Argus*, 25 September 1996, 21; *Weekly Mail*, 1–7 August 1997.

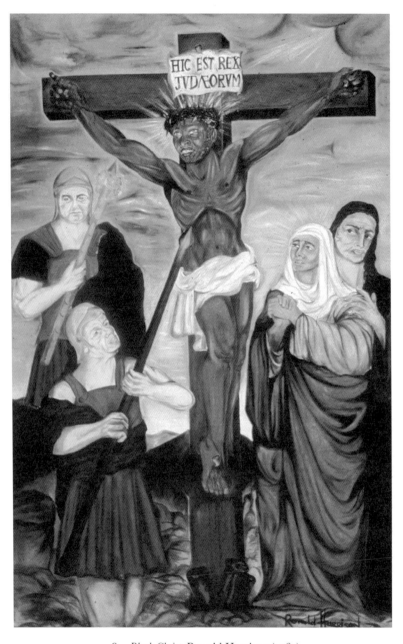

8 *Black Christ*. Ronald Harrison (1962)

the place and purpose of art in the sanctuary or more broadly in the life of the church are not the same as in the public square. National icons, the flag, for example, are certainly appropriate in the public square, but are regarded by some Christian traditions as inappropriate in the sanctuary, for good reason. On the other hand, specifically 'Christian art works' might be problematic or unacceptable in the public square for citizens of other faiths or secularists. Moreover, what might be acceptable at one time may, in the light of changing circumstances, become unacceptable later on, or vice versa. Harrison's *Black Christ* is, again, a good example of a painting condemned by one regime and now honoured under a new dispensation. Much depends on the historical and cultural context in which works of art are located. This would apply as much to the sanctuary and other church buildings as it does to the public square. But is this in any way related to aesthetic judgement, or is it simply pragmatic or a matter of political or ecclesiastical correctness?

Contrary to Gill's latter-day critics, whether or not a work of art 'fits' its context is, as Wolterstorff points out, an aesthetic matter. 'For what is aesthetically excellent considered in isolation may in context prove incongruous and jarring.' Referring specifically to art in the sanctuary, Wolterstorff continues: 'A good many factors in a liturgical whole must be taken note of if its aesthetic value is to be assessed.'[30] Renaissance scholars used the aesthetic category of 'appropriateness' (*decoro*) to describe not only a painting which rightly depicted its subject (appropriate gestures, etc.), but also a painting which fitted its surroundings.[31] This is not to deny that a work of art has aesthetic qualities in itself, but it recognises that a work of art originates within a particular context, and that it is often placed in a location, a museum or gallery, for example, not necessarily intended by the artist. Any aesthetic evaluation of a work of art has to take this into account.

Not all 'Christian art works' would be appropriate or acceptable in all Christian churches, or in all historical and cultural contexts, even though they are all dedicated to the worship of God revealed in Jesus Christ. Michelangelo's *Pietà* fits into St Peter's basilica rather than a Quaker meeting house or a Reformed church because the *Pietà* represents a tradition and milieu which are quite different.

[30] Nicholas Wolterstorff, *Art in Action* (Grand Rapids, Mich.: Eerdmans, 1980), 186.
[31] See Giorgio Vasari, *Lives of the Artists* (Harmondsworth, Penguin, 1981), 20.

Protestants, following Calvin, might admire such works of art but not wish to place them in their sanctuaries. If they did, it would suggest a change in theological and liturgical ethos, and even if it did not, given the power of images, such works of art might bring about such change in due course, however subtly. Of course, this opens up some interesting ecumenical possibilities, for if churches are seriously engaged in seeking to express their unity, then the role of art could be a powerful means to that end. The use of Orthodox icons in the Church of the Reconciliation at Taizé Community (which was founded by a French Reformed pastor) is an excellent indication of this possibility and one which is widely practised. So perhaps placing the *Pietà* in a Quaker meeting house is not as outlandish as it sounds for those with ecumenical conviction. Yet it is precisely the fact that art can change convictions and perspectives that churches have normally insisted on in establishing criteria for placing works of art in the sanctuary or using them in Christian formation.

Vatican II formulated its position in a brief chapter in its decree on the Constitution of the Sacred Liturgy.[32] The chapter provides an update of the traditional Roman Catholic position and, despite its brevity, a useful reference point for our discussion. The fact that the matter was dealt with in the framework of the liturgy is, in itself, instructive. It indicates that the bishops and their advisors did not regard art primarily as decorative – turning church buildings into art galleries – but as contributing in some significant way to the liturgical life of the church and, therefore, being evaluated accordingly. The key passage reads as follows:

Very rightly, the fine arts are considered to rank among the noblest expressions of human genius. This judgment applies especially to religious art and to its highest achievement, which is sacred art. By their very nature both of the latter are related to God's boundless beauty, for this is the reality which these human efforts are trying to express in some way. To the extent that these works aim exclusively at turning men's thoughts to God persuasively and devoutly, they are dedicated to God and to the cause of His greater honor and glory.[33]

[32] Chapter 7, 'Sacred Art and Sacred Furnishings', in Walter M. Abbott, *The Documents of Vatican II* (London and Dublin: Geoffrey Chapman, 1966), 174ff. The decree as a whole is important for the rebirth of sacred art and in providing artists with direction and encouragement in their work. Josef Andreas Jungmann, 'Constitution on the Sacred Liturgy', in *Commentary on the Documents of Vatican II: Volume One*, ed. Herbert Vorgrimler (New York: Herder and Herder, 1967), 81.

[33] Section 122 Abbott, *The Documents of Vatican II*, p. 174.

Several observations and recommendations follow from this state-ment. The first is that the Roman Catholic Church has 'always been the friend of the fine arts and has continuously sought their noble ministry'. This ministry is not understood in didactic terms but rather as an aid to worship through reflecting something of the beauty of God. Hence the decree states that the Catholic Church has not only trained artists, but also reserved the right to evaluate works of art in order to ascertain their liturgical suitability. This has nothing to do with a particular style of art, for the church has treasured the art of all ages, races and regions. Rather, the criteria are those of noble beauty rather than extravagance; the encourage-ment of faith, morality and piety; and the avoidance of mediocrity and pretence, as well as 'a faulty sense of devotion'.[34] In order to pursue these goals, bishops are encouraged to obtain the advice of art experts; to 'instil artists with the spirit of sacred art and of the sacred liturgy'; to establish academies of sacred art for the training of such artists; and to include teaching on the history and develop-ment of sacred art in the theological education of priests.[35]

There is much here that should be affirmed, but there is room for critical comment. As we have noted in a previous chapter, 'fine art' is a contested term. If, as Vatican II suggests, all art appropriate for the sanctuary is to fit this category as normally understood, we shall get off on the wrong track. 'Popular art', meaning here art that emerges from within the life of a faith community, often has far more spiritual and liturgical value than 'fine art' as traditionally understood. As Pelikan puts it: 'One could be so impressed with the artistic magnificence of Christian cultural forms that the dynamic which produced these forms was entombed in the forms which it had developed.'[36] So we should not see 'sacred art' as a sub-category of 'fine art' unless we break open the notion to include all art that meets certain qualitative norms irrespective of style, origin or context. The qualitative norms here would be those that exclude the shoddy, banal, sentimental and superficial. Such art is simply bad art even though it may have religious meaning for many people.[37] Just

[34] Sections 123–5 Abbott, *ibid.*, p. 175.
[35] Sections 126–9 Abbott, *ibid.*, pp. 175f.
[36] Jaroslav Pelikan, *Human Culture and the Holy: Essays on the True, the Good, and the Beautiful* (London: SCM, 1959), 132.
[37] See David Morgan, *Visual Piety: A History and Theory of Popular Religious Images* (Berkeley, Calif.: University of California Press, 1998).

as we were able earlier to identify canons of good taste in evaluating art, so too we can identify canons for distinguishing between good and bad art in the sanctuary, keeping in mind the importance of cultural contexts in doing so. 'Sacred art', if we are to employ that term, should be good rather than bad, irrespective of whether it is 'fine' or 'popular'. But what, precisely, is 'sacred art'?

'Sacred art' is specifically intended for liturgical purposes; it is the art of the icon, the crucifix or the 'Stations of the Cross', normally but not necessarily produced by artists who are themselves Christians. When I speak of 'sacred art' I understand it in this sense. Yet there is a danger of dichotomising art into the sacred and secular in an unhelpful way. Likewise 'religious art' narrowly understood refers to art that represents biblical stories for didactic purposes, or art that stimulates what Vatican II referred to as 'a faulty sense of devotion'. There is a great deal of such 'religious art' which, no matter how pious and well intended, is trivial, sterile and lacking in creativity, inhibiting rather than aiding spiritual transformation. But there are other examples of 'religious art' which are qualitatively different. In this regard Vatican II speaks of art that expresses 'noble beauty rather than extravagance' and of art that avoids 'mediocrity and pretense'. Rembrandt's painting of biblical scenes, Karl Rahner suggests, provides us with an example of 'religious art' at its finest, but even if the subject painted is not overtly religious, it awakens fundamental questions of human existence.[38] As Timothy Gorringe puts it: 'Rembrandt is almost entirely free of religious cliché but he is a profoundly religious painter, just as Mozart is a profoundly religious composer or George Eliot a novelist.' Moreover, each is rooted in the soil of Christian faith and 'nourished at the Christian table'.[39] Such art avoids didacticism. Like a great icon it provides a window onto mystery and transcendence rather than simply stating the obvious. It is profoundly sacramental (see plate 9).

There is a connection between Rembrandt's 'religious art' and Bonhoeffer's 'non-religious understanding' of Christianity, for Rembrandt's work undermines the neat distinctions between the religious or sacred and the secular in the same way as Bonhoeffer challenged 'thinking in two spheres'. Much African art does the same, refusing to dichotomise reality. The work of Azaria Mbatha

[38] See Karl Rahner, 'Theology and the Arts,' *Thought* 57, no. 224 (March 1982): 27.
[39] Tim Gorringe, 'Rembrandt's Religious Art', *Theology* 98, no. 781 (1995): 19.

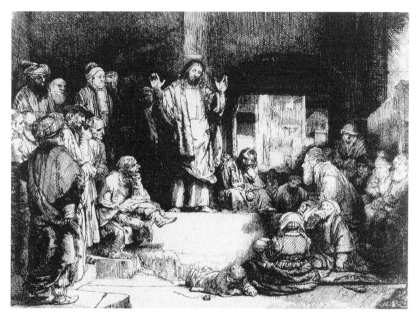

9 *Christ Preaching.* Rembrandt (1652)

and John Muafangejo, both of whom worked within an African Christian ethos, immediately come to mind (see plate 10).[40] If we are to apply Bonhoeffer's understanding of the gospel to the church and art, we should begin, as Gorringe suggests, 'by rejecting all attempts to narrow down understandings of 'religious art' and, by taking into our churches pictures which challenge more deeply, as Rembrandt's portraits do, our understanding of the image of God'.[41] There is some irony in all this. For whereas Rembrandt's art is not recognised as 'sacred', much art that was specifically created for the sanctuary is now admired for its aesthetic quality rather than its theological or liturgical significance. Many visitors do not visit the Sistine chapel for liturgical but for artistic reasons, and understandably so for the power of the art speaks to them more than the subject matter even though the latter is evocative and often profound.

Art like religion expresses a world-view, and the greater the art,

[40] See Azaria Mbatha, *Azaria Mbatha: Retrospective Exhibition* (Durban: Durban Art Gallery, 1998); Orde Levinson, *The African Dream: Visions of Love and Sorrow – the Art of John Muafangejo* (London: Thames & Hudson, 1992).
[41] Gorringe, 'Rembrandt's Religious Art', p. 19.

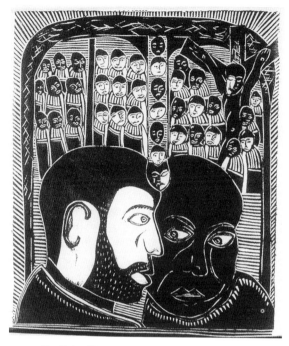

10 *Crucifixion/Reconciliation.* Azaria Mbatha (1967–8)

the more powerfully it represents that perspective. We had occasion
to reflect on this when considering Leni Reifenstahl's film *Triumph of
the Will*, which glorified Nazism through supreme artistry. But in a
different way the same is true of the work of other great artists whom
we would not associate with such debased world-views, and whose
art adorns some of the greatest Christian church basilicas. The fact
is, artists do not simply mirror reality: they construct reality, and
they do so from a particular point of view. 'Works of art are not
simply the oozings of subconscious impulses', writes Wolterstorff;
'they are the result of beliefs and goals on the part of the artist.'[42]
 The work of Leonardo da Vinci, like many other great artists, a
person with deep humanist and religious insight rather than an
orthodox believer,[43] reflects as much a classical as it does a Christian
world-view. As Nicholas Berdyaev put it: 'The men of the Renais-

[42] Wolterstorff, *Art in Action*, p. 89.
[43] Brenda Watson, 'The Arts as a Dimension of Religion', in *Religion and the Arts in Education*,
 ed. Dennis Starkings (London: Hodder & Stoughton, 1993), 98.

sance were split Christians: in them two conflicting streams of blood gushed against each other. The Christian pagans were divided into two worlds.'[44] The creativity of many artists in the West since the Renaissance is, as Dillenberger observes, 'only tenuously related to the faith conviction and shape of the liturgical, believing life of the church'.[45] There are also many artists who are not Christian and whose art does not reflect a Christian milieu, but who are profoundly spiritual in their approach to their craft. Much of their work is intended as a focus for meditation, as in the case of Wassily Kandinsky, who specifically labelled his work 'spiritual art'.[46] This additional category is evocative, but it may also be problematic because it assumes a generalised 'spirituality' which, on reflection, is invariably rooted in a particular tradition or world-view. Claude Monet's art, for example, was profoundly influenced by Zen and Tao,[47] just as Kandinsky's was influenced by theosophy. This does not immediately exclude such art from the sanctuary, but it may be problematic for liturgical purposes if it communicates something contrary to Christian faith.

In many ways, 'spiritual art' as expressed by Kandinsky and others is a reaction to the secularisation of art that has occurred in tandem with the secularisation of the modern world, as both Hegel and P. T. Forsyth observed with regard to Romanticism, an earlier form of such art. 'Spiritual art' expresses the quest for transcendence, and as such it reflects the search for spirituality that has become important to our post-modern world. By way of example, Van Gogh's paintings are not examples of orthodox Christian iconography, but some of his work, such as his Provençal landscapes, 'are utterances of the religious heart'.[48] Such art is not a 'repository for piety' but an act of creation which, in Keith Walker's words, 'touches us at a dimension deeper and more living than encapsulated formulae and superficial emotion'.

A spiritual work of art will arrest us, prize open our minds and hearts, and bring us into relation with a world beyond the ordinary. The landscapes of

[44] Nicolas Berdyaev, *The Meaning of the Creative Act* (London: Victor Gollancz, 1955), 230f.

[45] John Dillenberger, 'Artists and Church Commissions: Rubin's "The Church at Assy" Revisited', in *Art, Creativity, and the Sacred*, ed. Diane Apostolos-Cappadona (New York: Continuum, 1996), 196.

[46] Wassily Kandinsky, *Concerning the Spiritual in Art* (New York: Dover Publications, 1977).

[47] Alexander Liberman, *The Artist and his Studio* (London: Thames and Hudson, 1988), 18.

[48] Robert Hughes, *The Shock of the New: Art and the Century of Change* (London: Thames and Hudson, 1991), 276.

Constable and Turner, the apples of Cézanne and the interiors of Matisse offer well known examples of spiritual art. These works are not religious but spiritual.[49]

But does this necessarily make their work appropriate for the sanctuary and its liturgical purpose? Is it not the case that what may be entirely appropriate in the church hall, a work of art which, for example, helps us appreciate another religious tradition, or one which expressed a spiritual quest without reference to the gospel, would normally be problematic in the sanctuary?[50] Reflecting on the various gradations of art we have considered, Catholic theologian Aidan Nichols proposes that as long as they are consonant with Christian belief they can be included in the sanctuary.[51] After all, just as the 'Christian liturgy has an aesthetic order of its own', so 'the incorporation of works of art into the liturgy is itself an art the malpractice of which can be spiritually as well as aesthetically harmful'.[52] After all, liturgy at its best is a creative work of art in and through which we are enabled to discern the redemptive beauty of God. So if art is to find a meaningful place in the Christian sanctuary, it surely has to be at the service of the church's liturgical actions and not simply for the purpose of aesthetic contemplation. This may mean that some great works of art are excluded because they distract from the liturgy, while others of a lesser quality are included because they are genuine aids to worship. But where does this leave us? Does it mean that art in the church must, almost by definition, be mediocre, lacking in creative integrity and dynamism? If not, how do we reconcile artistic creativity and Christian faithfulness, artistic integrity and the service of the liturgy?

ARTISTIC CREATIVITY AND CHRISTIAN CONVICTION

Great art, like authentic religion, seeks to express awe and wonder, and to overcome the superficiality of life by exploring its depths. It is concerned about personal integrity in its endeavour to communicate the truth as it is perceived; and it evokes deep emotion, whether of

[49] Keith Walker, *Images or Idols?: The Place of Sacred Art in the Churches Today* (Norwich: Canterbury Press, 1996), 106.

[50] Walker, *Images or Idols?*, p. 107.

[51] Aidan Nichols, *Scribe of the Kingdom: Essays on Theology and Culture, vol. II* (London: Sheed & Ward, 1994), 191f.

[52] Frank Burch Brown, *Religious Aesthetics: A Theological Study of Making and Meaning* (Princeton: Princeton University Press, 1989), 105.

sadness or joy, dread or elation.[53] So it is no surprise that many of the most distinguished artists of the twentieth century irrespective of their cultural context have been people of deep spiritual perception, and some have been committed Christians. Paul Cézanne, in some ways the father of modern painting, was a devout Catholic who confessed to a friend that he could not paint if he did not believe.[54] But many others have been alienated from the church either because they have felt rejected or else because it has been lacking in aesthetic richness and depth. Experiencing an absence of the aesthetic in the church, they have found sanctuary in art.

One classic example is Ruskin, who has figured in our study as a person of both aesthetic sensibility and moral passion amidst the social injustices of Britain during the industrial revolution in the nineteenth century. Ruskin grew up under the influence of the evangelical Puritan faith of his Scottish mother, but during his later adolescent years he began a slow and sometimes painful journey of 'deconversion'.[55] At the heart of his disillusionment was a sense of aesthetic alienation from his Protestant inheritance spurred on by a growing appreciation of the aesthetic wealth of the Roman Catholic Church. Even so, his turning away from evangelicalism did not result in a conversion to Catholicism because of, as he described it, its exclusivity and triumphalism.[56] The final turning point in the long process occurred one Sunday morning after he attended a dreary Protestant service in Piedmont. Going to the art gallery in Turin, Ruskin gazed afresh at Paul Veronese's *Solomon and the Queen of Sheba*, glowing in the full afternoon light.

The gallery windows being open, there came in with the warm air, floating swells and falls of military music, from the courtyard before the palace, which seemed to me more devotional, in their perfect art, tune, and discipline, than anything I remembered of evangelical hymns. And as the perfect colour and sound gradually asserted their power on me, they seemed finally to fasten me in the old article of Jewish faith, that things done delightfully and rightly, were always done by the help and in the Spirit of God.[57]

[53] See Watson, 'The Arts as a Dimension of Religion', pp. 95ff.

[54] Liberman, *The Artist and his Studio*, p. 6.

[55] Ruskin's own account of the process is contained primarily in his autobiographical *Praeterita*. See the detailed discussion of this process in John D. Barbour, *Versions of Deconversion: Autobiography and the Loss of Faith* (Charlottesville, N.C.: University Press of Virginia, 1994), 52ff.

[56] These are discussed in John Ruskin, *Praeterita: Outlines of Scenes and Thoughts Perhaps Worthy of Memory in my Past Life* (London: George Allen & Sons, 1910), 2ff.

[57] *Ibid.*, p. 38.

Ruskin's experience highlights one of the key themes that has surfaced repeatedly in our discussion, the uneasy tension and conflict between the world of culture and the reign of Christ. The contest, as we phrased it in the first chapter, is between Christ, Apollo and Dionysus, with Nietzsche as the main antagonist against Christianity. But Nietzsche is only a radical representative of a wider and more complex phenomenon in the history of the church. Ruskin's aesthetic alienation from the church did not arise out of an anti-religious or anti-Christian disposition, but one nurtured in evangelical piety. Although he gradually turned away from this heritage, he never lost his religious sensitivity. On the contrary, in telling of his deconversion he speaks of 'the Spirit of God' as the source of aesthetic creativity and appreciation. Many others both before and since Ruskin bear testimony to the same sense of aesthetic alienation yet awareness of the Spirit as the source of their creativity.

In her delightful essay on 'Artful Theology', Sara Maitland convincingly argues that the renewal of the church as a transforming community in society is related to the extent to which it takes seriously the creative arts. Her reason is profoundly theological: 'because we create in this particular and conscious way only in the light of the creative power of our God'. In other words, artistic creativity is not only God-given but one of the main ways whereby the power of God is unleashed, awakening both a thirst for justice and a hunger for beauty. Artistic creativity, we may say, is a sacramental act that moves both heart and mind. Yet, writing as both a poet and feminist theologian, Maitland, like Ruskin, is disturbed by the way the church shuts out such creativity. 'If poets want to stay within the cultural boundaries of faith, if they know that they need that succour, that nourishment; then they have to pay for it by accepting the often rigorous limitations that the priestly authorities choose to impose upon them.' She continues:

The real danger of not treating the creative imagination with real love is that this involves a rejection of God – or at least of a huge and magnificent dimension of God. Such a rejection seriously impedes the work of religion in the transformation of the world. Any movement for social change requires a revolution of the imagination.[58]

Maitland here neatly sums up what we have been saying about the way in which the arts can enable the church to contribute to the

[58] Sara Maitland, *A Big-Enough God: Artful Theology* (London: Mowbray, 1995), 142f.

transformation of the world through a revolution of the imagination. This relates to Bonhoeffer's desire for the rebirth of 'aesthetic existence' in the life of the church, a subject to be kept in mind throughout our discussion. A revolution of the church's imagination cannot happen unless the church becomes a community within which aesthetic existence is part of what it means to be Christian in the world.

In restoring the creative arts to their rightful and necessary place in the life of the church the issue at stake is, then, not the decoration of the sanctuary in ways that are pleasing to the senses, 'art for art's sake in the church', but something more profound. We are concerned with the recovery of a genuinely theological aesthetics which, as we discussed in chapter 3, is rooted in the triune life of God, and the *cantus firmus* of the cross, and related to the transformation of the world. And, in agreement with Bonhoeffer, we are concerned about rebirth of the creative spirit through the recovery of aesthetic existence in the life of the church. Without the *cantus firmus* the enriching polyphony that follows creative imagination is impossible. But the *cantus firmus* rightly understood creates space for the expression of the creative imagination with freedom and integrity. With this in mind we turn to consider some criteria for evaluating the place of art in the life of the church which may help us discern what is appropriate, whether in worship, formation or witness.

Art in the sanctuary is not primarily for the sake of contemplation apart from the world (as in Platonism), but a way of enabling responsible action in the world. So faithful creativity also has to do with the way in which art in the sanctuary engenders Christian involvement in society. For the church to acquiesce in tasteless shoddiness will not inspire its members to creative expressions of response to the gospel in the world. There are undoubtedly remarkable exceptions to this rule. But it is self-evident that the environment within which people are nourished normally affects their development and their perspective on life. The same is true when it comes to the life of the church. Christian formation takes place not only through teaching (truth) or example (goodness), but also through the cultivation of a sense of taste for what is genuinely beautiful in a world of competing images and ugliness. This is not to reduce art to didactic purposes, yet it has a similar concern.

In recovering the links between aesthetics and social ethics in the life of the church, 'holy beauty' provides a fundamental criterion for

evaluating art from a Christian perspective in determining whether it is liturgically appropriate. The category of 'beauty' links the Christian approach to art to the traditionally aesthetic touchstones of value and taste, while 'holiness' indicates that the Christian understanding of 'beauty' is also distinct, that it is theologically derived. 'Holy beauty' is the Old Testament foundation for a Christian aesthetic when it comes to determining what art may be appropriate within the sanctuary. It speaks of a God whose transcendent mystery cannot be captured through artistic representation, for that is idolatry. Following our earlier discussion on idolatry and political power, 'holy beauty' demands the exclusion not only of representations of God as such, but of all signs and symbols of human pretension, hubris and absolutist claims. We must neither compromise the hiddenness and mystery of God ('the holy of holies') nor confuse the glory and power of God with images that invariably reflect or reinforce our own interests, whether personal, national, ethnic or class. Iconoclasm in this regard is a necessary outworking of the prophetic trajectory in the biblical tradition.

Yet the God who is holy is also present in the sanctuary and, as Isaiah and many others testify, can be experienced. 'I have looked upon you in the sanctuary, beholding your power and glory', declares the psalmist (Psalm 63:2 NRSV). For the Christian this other side of the dialectic of 'holy beauty' is especially affirmed in the incarnation and experienced through the Holy Spirit. The hidden God is the revealed God; the mystery of God has been made known in Jesus Christ and is present for us through the Spirit. So the awesome holiness of sacred space, which is common to many religions, must not override the sense of God's presence 'where two or three are gathered together' in the name of Jesus Christ, who makes himself known through the Spirit in word and 'the breaking of bread'.

This trinitarian confession lies at the heart of the Christian faith and is the basis of genuinely Christian worship, as can be seen in all classic liturgies and great eucharistic prayers of thanksgiving. The latter begin by acknowledging God's creative power, love and holiness, (Isaiah's trisagion 'Holy, holy, holy'), then they affirm Christ's incarnation, crucifixion, resurrection and second advent, and conclude by invoking the presence and action of the Holy Spirit. So it is that in the 'breaking of bread' (nothing could be more materialist and available to the senses) and the proclamation of the

word, God is known in Christ through the Spirit evoking our response of praise, confession, thankfulness and service. It is in this way that the beauty of God revealed in Christ makes its appeal to us, drawing all humanity into the life of the triune God in anticipation of the fulfilment of all things. Art in the sanctuary is appropriate when it is consonant with this triune confession of faith. That is when it contributes to a sense of the presence of this God who seeks to draw us into the divine life, and send us into the world to bear witness to God's love, grace and justice. As such, art in the sanctuary is not crassly didactic but eminently liturgical and formative for Christian life and witness.

There are various corollaries that can be drawn from this triune confession of faith with regard to visual art in the sanctuary, though the same would apply to other forms of art. The first refers to the connection that is made between God as creator, redeemer and sanctifier. If God as creator of the world is the supreme artist, then the natural world provides the point of departure for artistic response to God. The Bible 'exults in the artistry of God, in the beauty of the created order, culminating in a response of amazement and astonishment'.[59] We have already noted, in chapter 1, how this was embodied in the tabernacle and temple in ancient Israel, where many of the works of art were representations of nature. This is something often lost sight of in considering what is appropriate art for the Christian sanctuary because we tend to start with redemption and quite literally lose sight of creation. Flower arrangements in the sanctuary are important, for this reason if no other, and are often the only way in which something so fundamental to biblical faith is represented. This may explain why too often Christians have failed to recognise the integral connection between their faith and the environment. There is an urgent need to bring back into the sanctuary appropriate representations of God's creation.

The incarnation makes the connection between creation and redemption by its very nature, for 'the Word becomes flesh and makes its sanctuary amongst us' (John 1:14). The Protestant rejection of Mariology has unfortunately also meant the exclusion of images of Mary from the sanctuary, though not as a theme in the work of Protestant artists.[60] The exclusion of Marian images, however valid

[59] Brueggemann, *Theology of the Old Testament*, p. 339.
[60] See, for example, Rembrandt's etchings of *Our Lady of Sorrows*, and *The Virgin and Child with*

some of the reasons, reinforces the danger of docetism, that is the denial of the full humanity of Christ. Of course, many Catholic representations of Mary have the same effect for different reasons. But any docetic 'spiritualising' of art that denigrates creation, the body or the material runs counter to the Christian confession. The incarnation reinforces the biblical conviction that creation is good, and in so doing evokes an aesthetic praxis that is rooted in the material world. By the same token, the artist is free to use all appropriate material forms in creating works of art for the sanctuary. What is important is the synergy between form and content. But there is a danger in making the incarnation, if understood as a principle apart from the narrative of cross and resurrection, the sole confessional basis for art. Like the abuse of the 'orders of creation' in theologies that legitimated Nazism and apartheid, it can become a mechanism for sanctifying a given order. This leads not only to a static form of art but also to the misuse of religious images within society. Icons can be abused. Hence the need for a 'theology of the cross' which provides artistic creativity with the theological basis for criticism.

The crucifixion uncovers the depths of human depravity and the extent of human fallenness. In so doing it evokes an artistic response that explores the brokenness of creation, the dehumanising powers at work in the world, the alienation of people from God, from each other and from nature, indeed the demonic nihilistic force that continually erupts in human history and experience. Any romanticising of art that denies the reality of evil, the pervasive suffering of creation, the human will-to-power and the experience of the absence of God runs counter to the Christian confession. But the crucifixion also reveals, even more so, the extent of God's solidarity with creation and humanity in its suffering, and the quality of God's redemptive grace and love. Therefore, any idealising of art or notion of beauty that removes God from involvement in the struggles of human history and denies God's pathos or redemptive purpose runs counter to the Christian confession. The alien yet redemptive beauty of the cross is the heart of the Christological *cantus firmus*. The cross is the supreme icon of the transformation of ugliness into beauty, as many paintings of the crucifixion themselves demonstrate.

the Cat and the Snake. Victoria Charles, *Rembrandt the Engraver* (Bournemouth, UK: Parkstone Press, 1997), 168, 174.

Nothing that I have said is meant to suggest that ugliness is an aesthetic virtue even though the expression of the ugly may often be an aesthetic necessity. The Canadian author Robertson Davies, in commenting on Bronzino's painting of the *Virgin with Christ and St John*, put the matter differently but appositely:

> The holy figures of Bronzino appear to me just as evocative of religious belief as the most hideous, decaying Christs of Grunewald or the haloed Flemish runts of Rembrandt; it is simply that they do it in a different way and the belief they evoke is of a different quality. Beauty is just as devout as ugliness.[61]

The fact that I have stressed the 'alien beauty of the cross' is not meant to detract from the need for art that celebrates life in all its fullness: quite the contrary, for that is what aesthetic existence is about. But just as we cannot really appreciate the transforming power and beauty of the transfiguration or the resurrection except from the perspective of the horrors of crucifixion, so redemptive beauty can only be fully appreciated when we, with Dostoyevsky and many others, have some sense of the ugliness from which we are redeemed.

The resurrection proclaims God's triumph in Christ over the ugly power of sin, evil and death; it speaks of a 'hope which is against hope' and the promise of the fulfilment (recapitulation) of all things in Christ. Art in the sanctuary must express the victory of Christ over that which dehumanises people and destroys creation, and affirms hope for a transformed world. But such art must not perpetuate the triumphalism of so much in Christian history and tradition. Any art that glorifies the church must be excluded from the sanctuary. So too must art that denies the possibility of the redemption and transformation of human beings and the world. Art may well depict the human descent into hell, but given that every Christian act of worship is premised on the resurrection of Christ and anticipates the transfiguration of reality, art in the sanctuary should speak above all of the transfiguration of life.

Obviously not all art in the sanctuary can capture the whole of the Christian confession of faith any more than one sermon can do so. Moreover, the sanctuary should not become an art gallery, cluttered up with 'works of art' trying to express the sum of Christian faith. That is why art, even within the canon of appropriateness, needs to

[61] Robertson Davies, *The Merry Heart* (New York: Viking, 1996) 70.

be carefully selected and even changed from time to time, in order to represent the drama of creation and redemption. Dillenberger thus poses an important question when he asks whether the work of individual artists 'without a consistent iconographic scheme, provide a religious ambience, susceptible to and encouraging of, the life of faith'.[62] Works of art in the sanctuary should represent and recall our interconnectedness with nature, keep us aware of injustice and human suffering, open us up to the healing power of God's grace and beauty and, making us sensitive to God's surprising incursions into human history, keep hope alive. Sometimes the 'grand narrative' of redemption will be powerfully represented, but art in the sanctuary should also reflect the many and varied narrative by-paths of the Bible and Christian tradition whose rich and diverse wisdom provides guidance and meaning to our fragmentary lives.

The gift of the Holy Spirit is an article of faith that connects our themes of faithfulness and creativity, art and transformation, in a remarkable way. The Spirit is, from a Christian perspective, both the source of artistic creativity and the source of empowerment in the struggle for justice and transformation. The Spirit of creativity is the Spirit of Mission. As we have noted several times, theologians through the centuries have insisted that all artistic creativity is inspired by the Spirit, whether the artists are Christian or not. As Calvin acknowledged, some of the best artists inspired by the Spirit are not Christians. In the history of Christianity it is not infrequently the case that 'pious artists produced banal works'.[63] One of the most remarkable developments in religious art in Asia today is that many of the artists who paint Christian themes belong to other religious traditions, whether Hindu or Buddhist. In turn, Christian artists in Asia are also influenced by these religious traditions precisely because they are wrestling with issues and questions that have not traditionally been contemplated by Western artists.[64] So art which is appropriate for the sanctuary is not necessarily art produced by insiders.[65] Dillenberger reminds us that 'some of the great art produced for the church in our time has come from non-believers, or those residually related to the life of the church'. He goes on to say that 'many of the perceptions needed and absent in the church are

[62] Dillenberger, 'Artists and Church Commissions', p. 199. [63] *Ibid.*, p. 199.
[64] Masao Takenaka and Ron O'Grady, *The Bible through Asian Eyes* (Auckland, New Zealand: Pace), 1991, 8f.
[65] See the discussion in Dillenberger, *A Theology of Artistic Sensibilities*, pp. 193ff.

being formed afresh by the artists themselves. That intensifies the
issue as one moves from the virtual divorce of the two to new
potential alliances and possibilities.'[66] Any denial of creativity as a
gift of the Spirit runs counter to the Christian confession, for
creativity is inherent in human beings made in the image of God the
creator.[67] Art as a gift of the Spirit has to do, then, with a 'revolution
of the imagination' which relates directly to engagement in the
struggle for healing and justice in society.

By this stage in my journey I needed no additional reason to
affirm Rahner's comment, quoted in the introduction, that the visual
arts are an 'intrinsic moment of theology itself'. Theology has
traditionally regarded philosophy and, in more recent times, so-
ciology as its handmaidens. Whatever the pros and cons in doing so,
it seems to me that art is at least as important, if not more. So we
turn, in conclusion, to the making of some comments that are
intended to provide an agenda for doing theological aesthetics in my
own as well as other contexts.

DOING THEOLOGICAL AESTHETICS IN CONTEXT

Throughout our discussion we have been mindful of the importance
of context and culture for understanding the relationship between
Christianity and art, and especially for the role of art in social
transformation. Art as integral to culture must always be contex-
tually rooted, no matter how universal its appeal. But this also
means that art is historically situated, so that the relationship
between Christianity and art has to be constantly renegotiated and
freshly understood. As Pattison puts it: 'the relationship between art
and religion does not stand outside history and cannot be fixed
definitively once and for all. Instead that relationship is constantly
acquiring a new shape as each continues on its separate – yet related
– way.'[68] As culture changes, so also will the way in which
Christianity expresses itself in art change. That is one reason why
the task of doing theological aesthetics has to be engaged in in every
context and generation.

Whereas in much of the West artists became alienated from
Christianity and the church following the Renaissance, in Asia,

[66] Dillenberger, 'Artists and Church Commissions', p. 196.
[67] Schaeffer, *Art and the Bible*, p. 34.
[68] George Pattison, *Art, Modernity, and Faith* (London: SCM, 1998), 9.

Africa and Latin America, artistic creativity has increasingly flour-ished within the life of the churches. While the production of art in the West has become more problematic for the church the more it has cut itself free from its roots in the Christian ethos, elsewhere a great deal of art reflects that ethos in culturally fresh and dynamic ways. The significance of this for our theme is self-evident. Not only does it mean that the remarkable shift of the demographic centre of Christianity from Europe to the 'third world' has 'immense impli-cations for the future of Christian art'.[69] It also means that when we speak of art in the church we must not simply have in mind the art of a post-Christian Europe. Much art in Africa today, and the same is true in other contexts, fits quite naturally into the life of the church precisely because Christianity is the source of its inspiration. Such observations are crucial when we turn to the task of considering what art is appropriate for the Christian sanctuary – the place where Christians liturgically confess and celebrate their faith in God the creator and redeemer. Art in the South African sanctuary should not simply mirror that of Europe or North America but express the African and culturally hybrid character of our context. Art has potential to help reshape Christianity in South Africa in ways that make it far more rooted in the soil of our sub-continent.

Historically, European Christianity has sought to control and dominate African Christianity. This relationship of power was expressed in different ways, some blatant and others more subtle, but none more destructive than through cultural hegemony. Both settler and missionary Christianity were insensitive to the rich texture of African culture, and insisted that African Christianity should conform to the norms of European culture. African converts had to accept the truth of the gospel as interpreted through the lenses of European Christendom. They had to live according to the ethical norms of European (usually Victorian) Christianity. And they could only express their newly found faith in ways that were aesthetically appropriate for European Christians. The point needs no elaboration. But what does evoke comment is the fact that the inevitable revolt of indigenous Christianity against this straitjacket found its most vivid expression in aesthetic praxis. Indigenous African Christians worshipped through dance, donned colourful

[69] Andrew F. Walls, *The Missionary Movement in Christian History: Studies in the Transmission of Faith* (New York; Edinburgh: Orbis; T. & T. Clark, 1996), 173.

vestments to replace the sombre robes of Protestantism, and created hymns and music from the soul.

As the missionary movement became more sensitive to the need for indigenisation in the course of the twentieth century, so some mission churches also encouraged graphic and visual artists to produce works that expressed their faith in ways appropriate to African experience and culture. In South Africa, the work of Jackson Hlungwani, whose crucifixion embodies both Christian and Tsonga symbols and is reproduced on the jacket of this book, is one powerful example. In the 1960s the Swedish Mission established the renowned Rorke's Drift art school which produced, amongst many others, Azaria Mbatha, whose work is deeply shaped by both his Zulu heritage and his Christian faith.[70] Another example is the work of the Anglican priest Ned Paterson, a missionary in Zimbabwe (then Rhodesia) until his death in 1974. Deeply influenced by the 'arts and crafts movement' associated with William Morris and the work of Eric Gill, Paterson was the midwife of African Christian art in Zimbabwe and helped unleash a flood of remarkable Zimbabwean art, especially sculpture, on the rest of the world.[71] Unlike so much art produced for the tourist trade, the work of Paterson's students has been described as 'an outpouring of the spirit' and 'a journey of discovery'. Its honesty and truth often disturbs as it forces 'the patron to make a decision about his outlook on life, not just about his bank balance'.[72] In such work the neat distinctions between 'fine' and 'popular' art, between 'sacred' and 'secular' art, fall apart.

While there are many examples of such artistic creativity emanating from the churches in Africa, the sad truth is that artistic creativity within African Christianity is largely untapped, and much of it remains trapped in alien cultural forms. This is so even though there is such a flourishing of African artistic expression in society at large, some of which originated within church circles. But, just as many artists in Western Christianity have felt alienated from the church, so artistic talent and creativity is in danger of becoming alienated from the church in Africa, including South Africa. The challenge facing the church if it is serious about transformation is

[70] Mbatha, *Azaria Mbatha: Retrospective Exhibition*.
[71] Examples of Paterson's work and that of his students can be seen in many places in southern Africa. For a comprehensive account of his life and work, see David A. C. Walker, *Paterson of Cyrene* (Gweru, Zimbabwe: Mambo Press, 1985).
[72] *Ibid.*, p. 74.

how to harness the creative energy and insight of local artists for this purpose. The relationship between European and African forms of Christianity will never become mutually enriching and complementary unless they, too, follow the path chosen by South African artists who have creatively worked at the interface of the multi-cultural realities of our context. The Africanisation of 'mainline' Christianity in South Africa requires a tapping into the cultural resources of the whole and a liberating of creative spirit. In other words, it requires the recovery of aesthetic existence in the life of the church in South Africa, for without this liturgical renewal, architecture, and the production of art, will remain superficial. Christians of European background and African Christians are more likely to discover one another at the aesthetic level than through doctrine or ethics, important as these are and must always be.

Such interaction requires experiencing the different ways in which they express what they believe in visual arts, in architecture, in music, in dance, in dress, in poetry and in song. The representation of Jesus Christ in African art as distinct from European art or the attempt to copy it is an indication of how the same faith may be differently and appropriately expressed without losing its integrity. But it also indicates how Christian insight may be enriched, whether African or European, or any other, and how churches, as they become cultural melting-pots in our multi-cultural world, can serve the renewal of culture beyond their confines and uncover resources for their own renewal. The Western 'discovery' of Russian icons, not as museum pieces or tourist memorabilia, but as 'aids to devotion', has led to a deeper appreciation and understanding of Eastern Orthodox theology and spirituality. That Western Protestant Christians, often aesthetically malnourished, find help for their faith in this way and that some become Orthodox as a result obviously raises interesting and important questions. But part of it has to do with the fact that, in the West, 'the link between religion and art has been almost severed. We expect to see a Madonna and Child in an art gallery, not in a church.'[73] The same is more generally true, to the general impoverishment of culture, for we have long tended to separate the gallery from the public square. What is desperately

[73] See the feature article on 'Incense, Icons and Faith' which appeared in the British newspaper *The Independent* on Thursday 19th March 1998, p. 19. The article was commenting on the opening of an exhibition of Russian Icons at the Royal Academy in London.

needed is an awareness of its irreplaceable role in the enhancement of life.

Some of the most important variables within Christianity are aesthetic in character. Christians and church denominations are divided not only by differences of doctrine, liturgical or moral teaching, but also and sometimes chiefly in regard to the aesthetic. This can be seen, for example, in different styles of church architecture and adornment, works of art and icons – or their absence – within the sanctuary, the use or design of vestments, altar-pieces or contemporary banners. Varieties of style and taste are also obvious in the use of music, in different forms of hymnody and psalmody, in the use of drama and dance, of poetry or of silence. The ecumenical significance of such variations is often forgotten amidst debates about faith and order or social ethics. Yet aesthetic style in worship and spirituality can be as divisive as matters of doctrine and morals. By the same token, an informed sensitivity towards denominational aesthetics can and sometimes does contribute to ecumenical understanding. This would obviously also apply to the development of understanding between different faiths. While this is not something we can explore in any detail, there can be no denying its importance within a multi-cultural context such as South Africa.

Art, as Pattison has helpfully shown, has a particularly important role to play in revealing the specific character of a religious tradition.[74] For this reason the attempt to understand another tradition through an appreciation of its art may well open up possibilities that are otherwise closed. Mutual engagement at the aesthetic level between people of different faiths provides opportunities that are potentially rich and rewarding. The importance of this for the life of the church in many countries and contexts today cannot be stressed sufficiently. A failure to understand and appreciate the culture of the other, whether ethnic or religious, lies behind much modern-day conflict, just as it has in the past. If we are serious about the interface between Christianity and art in the transformation of society, then we have to be equally serious about the way in which other faiths express their life and hope through their art.

There is a complementary point that needs to be made as theologians and artists engage each other, namely the importance of

[74] Pattison, *Art, Modernity, and Faith*, p. 155.

understanding the religious traditions and spirituality which often provide the rootage and nourishment for many works of art. As Peter Fuller acknowledged:

Incorrigible atheist and aesthete that I am, I believe it to be a moot point whether art can ever thrive outside that sort of living, symbolic order, with deep tendrils in communal life which, it seems to me, a flourishing religion alone can provide.[75]

This is one reason why it is difficult to appreciate the history of art without having some understanding of the religious traditions that have been fundamental to the shaping of culture. And why the appreciation of modern and post-modern art requires an understanding of the cultural transformations that have shaped our contemporary world.

But there is a deeper issue that must be highlighted. Whether people are Christians, adherents of other faith traditions, or, for whatever reason, unbelievers, we are all human beings who should be engaged in a struggle for a more just world. Essential to that struggle is the need to challenge those powerful images that surround us in the media, on television, on film, on the Internet, which lead to the destruction of human life and the environment. Developing countries are particularly powerless in countering such inroads. We are only too familiar with images that degrade the 'other' and which aid and abet various responses of violence from war to rape and child abuse. Art in the life of the church can provide an alternative vision and set of images of what it means to be human and what it means to live justly in the world with others who are different. Of course, art in itself cannot change society. That is a far too optimistic view of its capacity. But good art, whatever its form, helps us both individually and corporately to perceive reality in a new way, and by so doing, it opens up possibilities of transformation.

Nothing better expresses the connection between aesthetics and a concern for social transformation than the linking of the liturgy within the sanctuary and the liturgy of daily life that occurs in the public square, as we do justice, love mercy, and walk humbly with each other and with God. For in this way the beauty of holiness confronts ugliness and redeems human life. This sums up the heart of the matter and provides a fitting end to our journey, though much remains to be explored and discussed. But let us note in concluding

[75] Peter Fuller, *Images of God: The Consolations of Lost Illusions* (London: Hogarth Press, 1990) 189.

that the awakening of aesthetic sensibility and the formation of 'aesthetic existence' in the life of the church are not the only key to its renewal or its relevance in the world. That would be a misunderstanding of what we have attempted to describe. Just as art in itself cannot bring about social transformation, so it would be foolish to believe that art in the life of the church can alone revitalise either its worship or its witness. What I have argued is that recovery of aesthetic existence is of considerable importance for the renewal of the church and its mission in the world, and that its neglect has serious consequences to the contrary. In the course of my own journey of exploration I have also become convinced that art belongs to the soul of the church and that a church that neglects it is in danger of losing its soul. The same is true for society at large. A society that relegates the arts to the periphery of its life may be technologically advanced but is spiritually and culturally poor; it may be committed to transformation, but it has neglected one of the key resources for reaching towards that end. It has, in fact, misconstrued the goal of transformation itself.

Select bibliography

Abercrombie, S. (1984) *Architecture as Art: An Esthetic Analysis.* New York: Van Nostrand Reinhold

Adam, P. (1992) *Art of the Third Reich.* New York: Harry N. Abrams

Adorno, T. W. (1984) *Aesthetic Theory.* London: Routledge & Kegan Paul

Apostolos-Cappadona, D. ed. (1988) *Art, Creativity, and the Sacred.* New York: Crossroad

Arnold, M. (1996) *Women and Art in South Africa.* Cape Town: David Philip

Balthasar, H. U. von (1982) *The Glory of the Lord. Vol. 1: Seeing the Form.* Edinburgh: T. & T. Clark

(1984) *The Glory of the Lord. Vol. 2: Studies in Theological Style: Clerical Styles.* Edinburgh: T. & T. Clark

(1986) *The Glory of the Lord. Vol. 3: Studies in Theological Style: Lay Styles.* Edinburgh: T. & T. Clark

(1988) *Theo-Drama: Theological Dramatic Theory, Vol. 1: Prolegomena.* San Francisco: Ignatius Press

(1989) *The Glory of the Lord. Vol. 4: The Realm of Metaphysics in Antiquity.* Edinburgh: T. & T. Clark

Barzun, J. (1975) *The Use and Abuse of Art.* Princeton: Princeton University Press

Beardsley, M. C. (1966) *Aesthetics from Classical Greece to the Present.* New York: Macmillan

Begbie, J. S. (1991) *Voicing Creation's Praise: Towards a Theology of the Arts.* Edinburgh: T. & T. Clark

Berdyaev, N. (1955) *The Meaning of the Creative Act.* London: Victor Gollancz

Berger, J. (1972) *Ways of Seeing.* London: Penguin

Berman, E. (1993) *Painting in South Africa.* Cape Town: Southern

(1996) *Art and Artists of South Africa.* Cape Town: Southern

Bernstein, J. (1992) *The Fate of Art: Aesthetic Alienation from Kant to Derrida and Adorno.* Oxford: Polity Press

Bowie, A. (1990) *Aesthetics and Subjectivity: From Kant to Nietzsche.* Manchester: Manchester University Press

Brown, F. B. (1989) *Religious Aesthetics: A Theological Study of Making and Meaning.* Princeton: Princeton University Press

Camille, M. (1989) *The Gothic Idol: Ideology and Image-Making in Medieval Art.* Cambridge: Cambridge University Press

Campschreur, W. and J. Divendal. eds. (1989) *Culture in Another South Africa* London: Zed Books

Cole, H. M. (1989) *Icons: Ideals and Power in the Art of Africa.* Washington, D.C.: Smithsonian Institution Press

Connor, S. (1989) *Postmodernist Culture: An Introduction to Theories of the Contemporary.* Oxford: Blackwell

Cooper, D. E. ed. *A Companion to Aesthetics.* Oxford: Blackwell

Dewey, J. (1934) *Art as Experience.* New York: G. Putnam's Sons

Dillenberger, J. (1986) *A Theology of Artistic Sensibilities: The Visual Arts and the Church.* London: SCM

Dunaway, J. M. and E. O. Sprinsted. eds. (1996) *The Beauty that Saves: Essays on Aesthetics and Language in Simone Weil.* Macon, Ga.: Mercer University Press

Feagin, S. and P. Maynard. eds. (1997) *Aesthetics.* Oxford: Oxford University Press

Finney, P. G. ed. (1999) *Seeing Beyond the Word: Visual Arts and the Calvinist Tradition.* Grand Rapids: Eerdmans

Forsyth, P. (1905) *Religion in Recent Art.* London: Hodder & Stoughton
(1911) *Christ on Parnassus.* London: Hodder & Stoughton

Freedberg, D. (1985) *Iconoclasts and their Motives.* Maarssen: Schwartz
(1989) *The Power of Images: Studies in the History and Theory of Response.* Chicago: Chicago University Press

Gadamer, H. (1986) *The Relevance of the Beautiful and Other Essays.* Cambridge: Cambridge University Press

García-Rivera, A. (1999) *The Community of the Beautiful: A Theological Aesthetics.* Collegeville, Minn.: Liturgical Press

Gaunt, W. (1957) *The Aesthetic Adventure.* Harmondsworth, Middlesex: Penguin

Gillon, W. (1991) *A Short History of African Art.* London: Penguin

Hackett, R. I. (1996) *Art and Religion in Africa.* London: Cassell

Hall, P. (1996) *Cities of Tomorrow: An Intellectual History of Urban Planning and Design in the Twentieth Century.* Oxford: Blackwell
(1998) *Cities in Civilization: Culture, Innovation, and Urban Order.* London: Weidenfeld & Nicolson

Hammond, P. (1960) *Liturgy and Architecture.* London: Barrie and Rockcliff

Harries, K. (1997) *The Ethical Function of Architecture.* Boston, Mass.: MIT Press

Haynes, D. J. (1997) *The Vocation of the Artist.* Cambridge: Cambridge University Press

Hegel, G. (1975) *Aesthetics: Lectures on Fine Art, Vol. 1.* Oxford: Clarendon Press

Hughes, R. (1991) *The Shock of the New: Art and the Century of Change.* London: Thames and Hudson

Judin, H. and I. Vladislavic. eds. (1999) *blank—Architecture, Apartheid and After.* Cape Town: David Philip

Kandinsky, W. (1977) *Concerning the Spiritual in Art.* New York: Dover Publications

Kant, I. (1952) *Critique of Judgement*. Oxford: Clarendon Press

Kemal, S. (1992) *Kant's Aesthetic Theory: An Introduction*. London: Macmillan

Kochan, L. (1997) *Beyond the Graven Image: A Jewish View*. London: Macmillan

Kuspit, D. (1993) *Signs of Psyche in Modern and Post-Modern Art*. Cambridge: Cambridge University Press

Le Corbusier. (1987) *Towards a New Architecture*. Oxford: Butterworth

Levinson, J. ed. (1998) *Aesthetics and Ethics: Essays at the Intersection*. Cambridge: Cambridge University Press

Liberman, A. (1988) *The Artist and his Studio*. London: Thames and Hudson

Maitland, S. (1995) *A Big-Enough God: Artful Theology*. London: Mowbray

Marcuse, H. (1968) *The Aesthetic Dimension*. Boston, Mass.: Beacon Press

Michalski, S. (1993) *The Reformation and the Visual Arts: The Protestant Image Question in Western and Eastern Europe*. London: Routledge

Miles, E. (1997) *Land and Lives: A Story of Early Black Artists*. Cape Town: Human & Rousseau

Miles, M. (1997) *Art, Space and the City: Public Art and Urban Futures*. London: Routledge

Morgan, D. (1998) *Visual Piety: A History and Theory of Popular Religious Images*. Berkeley, Calif.: University of California Press

Mothersill, M. (1984) *Beauty Restored*. Oxford: Oxford University Press

Mumford, L. (1938) *The Culture of Cities*. London: Secker & Warburg

Murphy, F. A. (1995) *Christ the Form of Beauty: A Study in Theology and Literature*. Edinburgh: T. & T. Clark

Murray, M. C. (1977) 'Art and the Early Church'. *Journal of Theological Studies*, 28 (Part 2), October, 303–45

Naukkarinen, O. and O. Immonen. eds. (1995) *Art and Beyond: Finnish Approaches to Art*. Lahti, Finland: International Institute of Applied Aesthetics

Nichols, A. (1980) *The Art of God Incarnate: Theology and Image in Christian Tradition*. London: Darton, Longman and Todd

Novitz, D. (1992) *The Boundaries of Art*. Philadelphia: Temple University Press

Oates, E. T. (1994) *Pattern of Redemption: The Theology of Hans Urs von Balthasar*. New York: Continuum

Ouspensky, L. (1978) *Theology of the Icon*. Crestwood, N.Y.: St Vladimir's Seminary Press

Panofsky, E. (1976) *Gothic Architecture and Scholasticism*. New York: New American Library

Pattison, G. (1998) *Art, Modernity, and Faith*. London: SCM

Pelikan, J. (1986) *Bach among the Theologians*. Minneapolis: Fortress Press

Rahner, K. (1982) 'Theology and the Arts'. *Thought*, 57, no. 224 (March 1982), 17–29

Riches, J. ed. (1986) *The Analogy of Beauty: The Theology of Hans Urs von Balthasar*. Edinburgh: T. & T. Clark

Rodley, L. (1994) *Byzantine Art and Architecture: An Introduction*. Cambridge: Cambridge University Press

Rookmaker, H. R. (1970) *Modern Art and the Death of a Culture*. Leicester, UK: Inter-Varsity Fellowship

Schaeffer, F. A. (1973) *Art and the Bible*. Downers Grove, Ill.: Inter-Varsity Fellowship

Schloeder, S. J. (1998) *Architecture in Communion: Implementing the Second Vatican Council through Liturgy and Architecture*. San Francisco: Ignatius Press

Sherry, P. (1992) *Spirit and Beauty: An Introduction to Theological Aesthetics*. Oxford: Clarendon Press

Starkings, D. ed. (1993) *Religion and the Arts in Education*. London: Hodder & Stoughton

Vasari, G. (1981) *Lives of the Artists*. Harmondsworth: Penguin

Venturi, R. (1966) *Complexity and Contradiction in Architecture*. New York: Museum of Modern Art

Walker, K. (1996) *Images or Idols?: The Place of Sacred Art in the Churches Today*. Norwich: Canterbury Press

Walsh, S. (1994) *Living Poetically: Kierkegaard's Existential Aesthetics*. University Park, Penn.: Pennsylvania State University Press

Welsch, W. (1997) *Undoing Aesthetics*. London: Sage Publications

Williamson, S. (1989) *Resistance Art in South Africa*. Cape Town: David Philip

Williamson, S. and A. Jamal. (1996) *Art in South Africa: The Future Present*. Cape Town: David Philip

Wollheim, R. (1996) *Art and its Objects*. Cambridge: Cambridge University Press

Wolterstorff, N. (1980) *Art in Action*. Grand Rapids, Mich.: Eerdmans

Younge, G. (1988) *Art of the South African Townships*. London: Thames and Hudson

Zolberg, V. L. and J. M. Cherbo. eds. (1997) *Outsider Art: Contesting Boundaries in Contemporary Culture*. Cambridge: Cambridge University Press

Zuidervaart, L. and H. Luttikhuizen. eds. *Pledges of Jubilee: Essays on the Arts and Culture, in Honor of Calvin G. Seerveld*. Grand Rapids: Eerdmans

Index of names

Index of biblical references

Index of subjects and places